Learner Services

Please return on or before the last date stamped below

CITY COLLEGE NORWICH

− 2 NOV 2005	0 7 JAN 2010
	2 6 JAN 2010
1 9 OCT 2006	1 3 OCT 2010
2 0 NOV 2006	− 6 JAN 2011
2 0 MAR 2007	
17/4/07	2 8 JAN 2013
	2 July 2014
0 8 OCT 2007	
2 3 FEB 2009	
1 3 OCT 2009	
24 0 4 NOV 2009	

A FINE WILL BE CHARGED FOR OVERDUE ITEMS

Women Artists

Edited by Uta Grosenick

Women Artists

IN THE 20TH AND 21ST CENTURY

TASCHEN

KÖLN LONDON LOS ANGELES MADRID PARIS TOKYO

Preface

The present book is devoted exclusively to women artists. Copiously illustrated and enriched with informative and lucid commentaries, *Women Artists* presents a broad survey of the various forms taken by women's work in art in the 20th century – and it accomplishes this without lapsing into polemics or stereotyped categories.

Traditional critics of feminism, who prefer to evade the debate on societal mechanisms and the very real war of the sexes, argue that good art is genderless; in contrast, contemporary critics point out that gender should in fact not be seen as a given, but rather as a social construct. In all probability neither point of view had – or now has – a significant influence on the (self-)awareness which has been an intrinsic element in the process by which women become artists. The present volume offers impressive proof that art by women is not the same as "feminine" or feminist art. The very phrase "art by women" covers as great a multitude of approaches and expressive options as there are women artists.

Because this is so, we have deliberately chosen to arrange the artists included here in alphabetical rather than chronological order. The resulting juxtaposition allows us to present positions that have become central to art history side by side with youthful, experimental trends only recently registered on the art scene. *Women Artists* showcases 56 women artists of the Western world, placing women whose art has brought them global fame alongside women whose careers in art have only just begun.

In selecting the artists for the book, we attempted to present the greatest possible array of the currents and persuasions in which women worked in the 20th century. The techniques and media employed by these artists are many: painting and drawing, collage and assemblage, sculpture, photography and film, performances and actions, video and the Internet, work with nature or with the artist's own body. It should be emphasised that the women featured in this book are merely a selection; the list of artists who could not be included for reasons of space is a long one indeed.

Through its generous array of reproductions, *Women Artists* is the first publication to afford an introduction to the life and work of the women artists who made a lasting impact on 20th century art and who are today influencing the art (whether by women or by men) of the 21st century.

Uta Grosenick
Cologne, January 2005

Contents

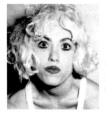

Katharina Fritsch
88-93

Ellen Gallagher
94-99

Isa Genzken
100-105

Nan Goldin
106-111

Natalia Goncharova
112-117

Barbara Hepworth
118-123

Eva Hesse
124-129

Hannah Höch
130-135

Candida Höfer
136-141

Nancy Holt
142-147

Jenny Holzer
148-153

Rebecca Horn
154-159

Magdalena Jetelová
160-165

Frida Kahlo
166-171

Toba Khedoori
172-177

Germaine Richier
268-273

Bridget Riley
274-279

Pipilotti Rist
280-285

Susan Rothenberg
286-291

Niki de Saint Phalle
292-293

Carolee Schneemann
294-299

Cindy Sherman
300-305

Kiki Smith
306-311

Elaine Sturtevant
312-317

Rosemarie Trockel
318-323

Adriana Varejão
324-329

Kara Walker
330-335

Pae White
336-341

Rachel Whiteread
342-347

It's a women's world

At the beginning of the 20th century, women artists were already reaping the benefits that other women had fought for in the 19th century. They were able to study at the same art academies as men, apply for scholarships, participate in life classes, enter competitions and win prizes. Furthermore, they could present their work at international exhibitions and sell it in galleries, they received commissions, and they played an active part in the art scene.

The first exhibition devoted exclusively to drawings by women had been held in Amsterdam in 1884, and in 1908 and 1913 Paris became the site of two further invitational shows devoted to women artists.

A cursory view might therefore suggest that, by the early 20th century, there was no longer any great difference between the positions of male and female artists. The prevailing opinion was that true talent would find its way to the fore and that the gifted artist would reap success. But in reality this vaunted equality of opportunity lacked substance. Few women were teaching at art colleges or were members of the academies; they remained under-represented in exhibitions; and in comparison to the work of male artists, theirs was far less frequently accorded critical attention or acquired for public or private collections.

In the early decades of the 20th century, a multiplicity of art movements sprang up in Europe within a short period of time: Art Nouveau (or *Jugendstil*), Expressionism, Fauvism, Cubism, Futurism, Constructivism, Dadaism, Abstract Art, the New Objectivity (*Neue Sachlichkeit*), and Surrealism constituted a plurality of styles that would have been inconceivable previously. Moreover, there were also the new media of photography and film, which were slowly but surely establishing their credentials as art forms and bringing significant visual changes in their wake.

Though women had at last attained access to educational and training institutions, and were less restricted by social convention than they had been earlier, they nonetheless often found it necessary to use their individual contacts with men already established in the art world in order to further their own careers.

In the avant-garde of the early years of the century, there were a number of women artists (such as Sonia Delaunay and Natalia Goncharova) who had evolved their style in Russian academies and then perfected it through study in Paris. By the second decade of the century, women artists were producing paintings and sculptures that spanned every area of visual art, from the male nude to the wholly abstract.

The First World War saw the emergence of the Dadaists, whose work reflected anarchist and pacifist tendencies (among others). A young student by the name of Hannah Höch found a natural home in this group.

As early as the 1920s, Georgia O'Keeffe was already creating her world-renowned flower paintings, but when later describing her experience of a male-dominated art world, she remarked that at first the men did not want her in: they found it impossible to take a woman artist seriously. O'Keeffe let them talk; she knew that she could paint as well as they.

In the 1930s and 1940s, a number of women artists (such as Meret Oppenheim) discovered Surrealism. In the visual metaphors of surrealist art, the poetic imagination is of greater moment than technique. These women gravitated to the new movement and gained wide recognition.

Sculpture, too, ceased to be a purely male domain. In France, Germaine Richier had begun casting her bizarre, fantastical bronze sculptures, while in Britain Barbara Hepworth was achieving fame with her modernist work. It was distinctly more difficult, however, for women to achieve a position in Abstract Expressionism, which emerged in Eastern America in the late 1940s. Not until the following decade did Lee Krasner achieve her breakthrough, using her personal contacts with artists and critics within the movement. Another woman associated with Abstract Expressionism was the Canadian artist Agnes Martin. She had begun with figurative painting, but before the 1950s ended, she evolved a reduced, formless visual idiom that made her a precursor of Minimal Art – though it was not until the early 1970s, long after she had opted for self-imposed isolation by moving from New York to New Mexico, that her importance was recognised.

In the 1960s, the conventional conception of art expanded radically; as a result, the number of co-existing styles and approaches became greater than ever: Pop Art (Niki de Saint Phalle), Op Art (Bridget Riley), Conceptual Art (Hanne Darboven), Land Art (Nancy Holt), Minimal Art (Agnes Martin), happenings and fluxus (VALIE EXPORT, Carolee Schneemann), performance (Marina Abramović) and Body Art (Yoko Ono) emerged almost simultaneously – and in every new trend, women played a part.

If the late 1960s felt like the beginning of a new era, feminism too seemed possessed of a new strength. In museums and art academies, women artists protested for equal rights. They organized their own exhibitions, operated their own galleries, held their own autonomous art classes. They also sought for political means to break through male-dominated structures.

In the early 1970s, Judy Gerowitz shed the surname she had acquired through marriage and adopted the name of her birthplace, Chicago. Her monumental work *The Dinner Party,* 1974–79, created with the assistance of numerous other women, was a homage to 39 female historical figures gathered at an imaginary dinner, similar to Jesus Christ's last meeting with his disciples.

It was also the 1960s that finally discovered Louise Bourgeois, who had been exploring her childhood experiences and fears in drawings and sculptures ever since the 1930s. Meanwhile, feminist critics began interpreting Georgia O'Keeffe's flower paintings as symbolic of female sexuality – much to her own chagrin.

Since the 1960s, particularly women performance artists have been asserting control over what happens to their own bodies. In various actions they have undergone physical injury, subjected themselves to self-torment, and exposed themselves to psychological duress. In *Cut Piece*, 1965, Yoko Ono had the audience cut her dress off her body. In *Rhythm 2,* 1974, Marina Abramović went so far as to swallow medicine used in treating schizophrenia without knowing what effect it might have on her: she continued to take it until she fell into unconsciousness.

Most women artists of the 1980s shared a deep feeling of disappointment at the stubborn survival of gender differences and the lack of true emancipation in art and other areas of life.

The first artist to document her life on the social periphery with merciless candour was Nan Goldin, who captured her own story and that of her friends in photographs, and in her slide show *Ballad of Sexual Dependence* (1986) provided an, at the time, completely new and unknown view of a youth marked by drugs, alcohol, prostitution and AIDS.

In order to avoid having to engage with the role of the woman in their works, several female artists worked in a manner that was completely separate from their own biography, in the style of Appropriation Art, which emerged in the early 80s. This approach involved taking existing images from different contexts, such as art history, the mass media and advertising, and recording them, i. e., giving them other meanings. Among the most famous representatives of this school are the Americans Sherrie Levine and Elaine Sturtevant, who has meantime abandoned her first name and simply calls herself, neutrally, Sturtevant.

A younger generation of women self-confidently availed itself of what feminism had accomplished and adopted a more playful approach in their exploration of gender and identity. Laurie Anderson distorted her voice in order to showcase her sexual ambivalence. In her large-format photographs, Cindy Sherman presented herself as the object of various projections – but an object whose identity was not ascertainable, given the ever-changing roles she slipped into. And Barbara Kruger confronted a putative male beholder with provocative statements.

In the last two decades of the century, contemporary women artists finally conquered the pre-eminent institutions of art. The Guggenheim Museum in New York mounted solo shows of Jenny Holzer (1989) and Rebecca Horn (1993), while in 1993 in Britain Rachel Whiteread became the first woman to receive the Turner Prize, the most coveted prize

for younger artists awarded annually by the Tate Gallery in London. The commercial market, too, saw the work of women artists such as Susan Rothenberg and Rosemarie Trockel fetching very high prices.

In the 1990s, photography achieved an unanticipated boom as an art medium in its own right. The male pupils of photographic team Bernd and Hilla Becher had long since become stars, and now their female colleague Candida Höfer likewise entered upon an international career. Younger photographic artists such as Rineke Dijkstra and the Australian Tracey Moffatt have been making an impact in recent years with their large-format images. Rineke Dijkstra takes portrait shots of young people on the threshold of adulthood at various sites throughout the entire world; while Tracey Moffatt, who is of half aboriginal ancestry and grew up as an adopted child in an Australian family not her own, combines socio-critical commentary on her own background with narrative elements.

Other women artists as well have made their multicultural identity or the situation of women in their homelands the subject of their work in various manners ranging from the subtle to the flagrantly attention-getting. The image of women wearing the chador, for example, is a recurring motif in the photographs and film installations of Shirin Neshat, who left Iran for the United States. The African-American artists Ellen Gallagher and Kara Walker address the theme of discrimination to which ethnic minorities in the USA – and elsewhere – are exposed. Both artists use the motif of exaggerated "negroid" physiognomies, of the kind common in the early 19th century when Whites dressed up as Blacks in so-called Minstrel Shows. In her larger than life silhouettes Kara Walker also depicts the enslavement of Blacks, which involved regular violence and sexual duress. The Brazilian artist Adriana Varejão also engages with the past, this time with the history and culture of her own country, which have been marked by colonialism. She transports its influences, for example, tile painting, into modern times in expansive installations.

Some women artists experiment with handicraft techniques that have manifestly female associations in order to carry those associations ad absurdum, as Rosemarie Trockel strikingly demonstrated when she reworked the *Playboy* bunny, the logo of a magazine aimed at male desire, as embroidery on fabric mounted on a canvas stretcher.

Other artists matter of factly use female clichés in their works and openly exploit the voyeurism of their spectators. For example, the performances of Italian artist Vanessa Beecroft, who lives in the USA, always attract full houses: she hires professional models and puts them on show scantily dressed or completely naked in groups as tableaux vivants. In the early 1990s Sylvie Fleury also seemed to find nothing reprehensible about shopping sprees – a preoccupation mainly of women, supposedly to satisfy their unfulfilled longings. While in 1987 Barbara Kruger freely adapted Descartes and had "I shop therefore I am" printed on cotton shopping bags almost with a touch of irony, in 1993 Sylvie Fleury presented a collection of carrier bags with the most coveted designer labels, and in 2000 outshone that relatively "conceptual installation" with an arrangement on a circular table of the finest stiletto-heeled shoes, which a wealthy client had apparently just tried on.

Since the late 1990s, women artists have also been highly successful in using digital media and the Internet. Pipilotti Rist's lurid videos employ a synthesizer, an amplifier and the Avid programme, while a recent installation by Mariko Mori, *Dream Temple,* 1999, calls for a complex audio system and a 3-D display to transport the user to another world.

Some women artists increasingly blur the borders between design, graphics and art. Thus the Californian Pae White works in all three fields simultaneously, and the playful ease with which she produces her works is infectious.

The transition from supposedly gender-specific behaviour patterns and their male or female variants also seems to have become easier, and yet the experimental treatment of the alternation between the stereotypical ascriptions still seems to have an attraction for younger female artists. In the meantime, most universities have installed an independent interdisciplinary faculty of Gender Studies with the aim of treating the complex role of, and power relations between, the

sexes as of equal importance. Whereas the English word "sex" refers to the biological difference, "gender" concerns its great social and societal consequences.

Gender-crossing or gender-surfing involves traversing the frontiers between the genders and adopting, if only for a limited period, the role(s) of the other gender. Painter Elizabeth Peyton often presents the artist-friends and prominent people from magazine illustrations she has been portraying in recent years as androgynous creatures, relieving them of unambiguous gender definition. The work of Elizabeth Peyton represents a new generation of artists who once again employ painting or drawing, but seem to have left behind all possible thematizations of specific role characteristics. Thus Toba Khedoori draws fragile architectural elements on gigantic sheets of paper.

The question of whether women's art will remain a central issue in the 21st century – whether entire books will continue to be devoted to the subject, or whether women artists will continue to stake their positions in a world still dominated by men and insist that art be seen as the distinctive statement of a unique individual, regardless of gender – remains open. Let us hope they will succeed in their effort.

Uta Grosenick

Marina Abramović

* 1946 in Belgrade, Yugoslavia; lives and works in Amsterdam, The Netherlands

Selected solo exhibitions: **1974** "Rhythm 0", Galleria Studio Morra, Naples, Italy / **1982** "Nightsea Crossing", Stedelijk Museum, Amsterdam, The Netherlands; Museum of Contemporary Art, Chicago (IL), USA / **1992/93** "The Biography", International Biennial of Innovative Visual Art, Madrid, Spain / **1997** "Marina Abramović. Works", Kitakyushu Center of Contemporary Art, Kitakyushu, Japan / **1998** "Artist Body – Public Body", Kunstmuseum Bern, Berne, Switzerland

Selected group exhibitions: **1977** "Expansion in Space", documenta 6, Kassel, Germany (with Ulay) / **1982** documenta 7, Kassel, Germany / **1989** "Magiciens de la Terre", Musée national d'art moderne, Centre Georges Pompidou, Paris, France / **1992** documenta IX, Kassel, Germany / **1995** "fémininmasculin. Le sexe de l'art", Musée national d'art moderne, Centre Georges Pompidou, Paris, France / **1997** "Future, Present, Past", XLVII Esposizione Internazionale d'Arte, la Biennale di Venezia, Venice, Italy / **1998** "Out of Actions: Between Performance and the Object, 1949–1979", The Museum of Contemporary Art, Los Angeles (CA), USA

Body material

When Marina Abramović and her partner Ulay arrived in the Chinese town of Er Lang Shan on 27 June 1988, they had covered 2,000 kilometres in 90 days – the entire length of the Great Wall – for this rendezvous at the end of the world. It was also their last collaborative work as an artist-couple. With this performance, *The Lovers,* Abramović and Ulay transformed the personal experience of having reached the end of their path together into a simple act performed at an actual geographical location. They walked towards each other from the opposite ends of the Great Wall, only in order to separate again – forever. This staging of a geometry of love made the painful division in their individual biographies appear to be the inevitable result of a law of life.

Abramović and Ulay had been collaborating since 1976, in works that made their symbiotic relationship the basis of existential experiences. In the performance *Breathing In/Breathing Out*, 1977, they exchanged their breath until all the oxygen had been exhausted (having previously blocked their nostrils with cigarette filters). In *Interruption in Space*, 1977, the two artists repeatedly ran and crashed into a wall to the point of exhaustion, and in *Light/Dark* of that same year they slapped each other in the face until one of them stopped. The point of these exercises was to subject the body to extreme physical states and test its limits. The audience's reaction formed a key component of this physical self-experience – whether in the form of mental attention or actual intervention, as in the performance *Incision*, 1978, during which Abramović was attacked by a spectator.

For the performance series *Nightsea Crossing*, 1981–86, in contrast, the participants were carefully selected. Abramović was especially interested in the conjunction of individual and political history, so she and Ulay took their own, shared birthday as the occasion for a performance, *Communist Body – Fascist Body*. On 30 November 1979, they invited friends to their apartment for the birthday party. The guests found Abramović and Ulay lying on a mattress asleep, or pretending to be asleep, and next to them two tables set with plates, champagne and caviar from their respective countries of origin. The performance reflected the circumstances of two biographies that had involuntarily been marked by a dictatorship: Marina's birth certificate was officially stamped with a red star, and Ulay's with a swastika.

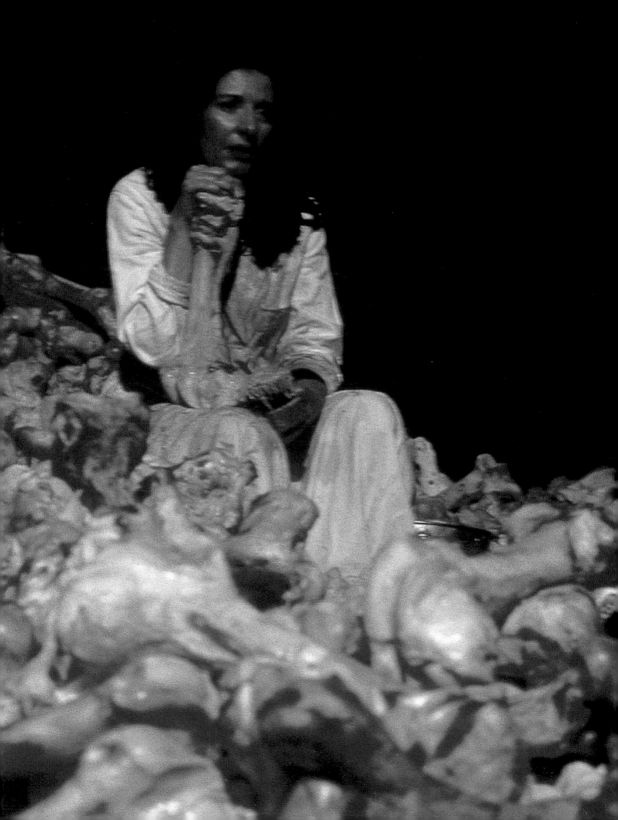

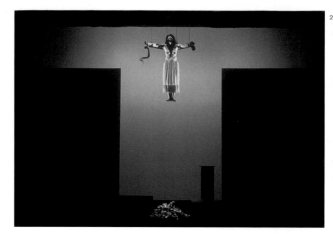

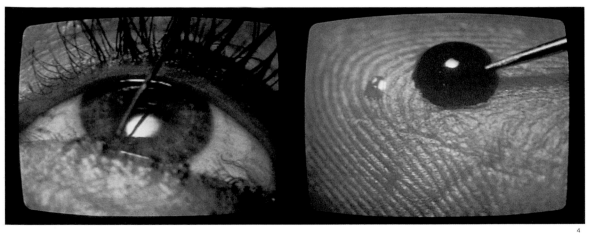

4

"Keep body and soul together = remain alive."

1 **Balkan Baroque,** 1997. Performance, XLVII Esposizione Internazionale d'Arte, la Biennale di Venezia, Venice, Italy

2 **Biography,** 1994. Opening scene with snakes, Hebbeltheater Berlin, Berlin, Germany

3 **Nightsea Crossing,** 1982 (with Ulay). Toronto, Canada

4 **In-Between,** 1996. Video stills

5 **Shoes For Departure,** 1991. Amethyst, c. 45 x 30 x 12 cm

6 **Rhythm 10,** 1973. Museo d'arte Contemporaneo, Villa Borghese, Rome, Italy

7 **Imponderabilia,** 1977 (with Ulay). Performance, Galleria Communale d'Arte, Bologna, Italy

8 **The Lovers (Walk on the Great Wall of China),** 1981 (with Ulay). Performance, China

5

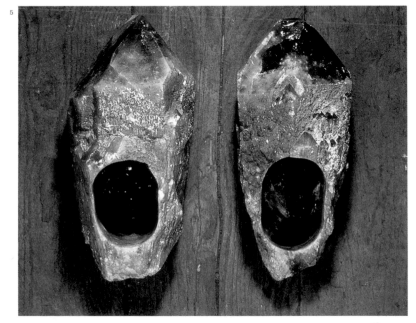

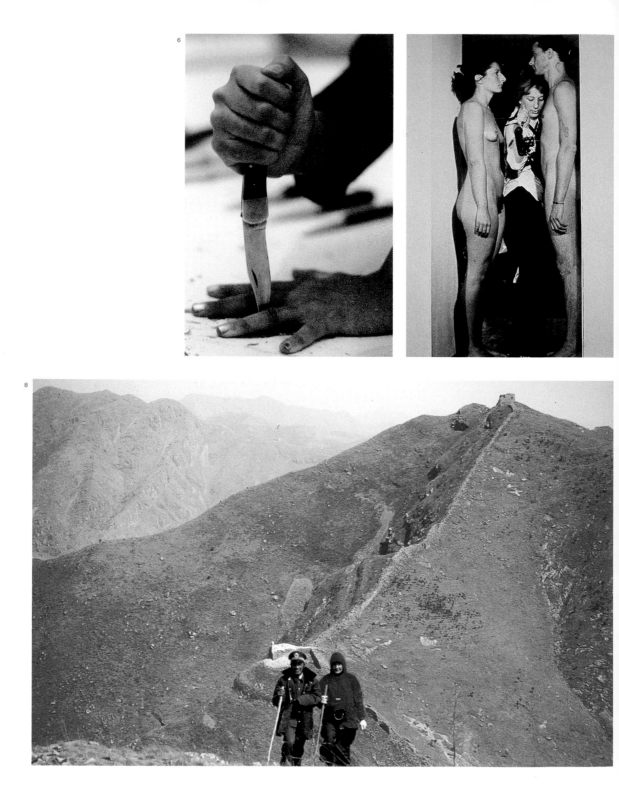

Marina Abramović

Dangerous rituals

Abramović heightens elements of her biography to fundamental mental situations, simultaneously dramatising them. Her body is her "material" and, together with the space it occupies, forms what she terms her "performing field". She frequently goes to the limits of the physically and mentally bearable, and sometimes even beyond. She became widely known with a series of performances in the 1970s in which she purposely subjected herself to physical pain, repeatedly injuring herself by incising her skin or cutting her hand with sharp knives. In *Rhythm 10*, 1973, she drove a knife as fast as she could between her fingers, recorded the sounds, and then repeated the procedure. Frequently the scenarios of her performances recalled ecstatic, religious practices, such as *Thomas' Lips*, 1975, into which the Christian rituals of self-flagellation and stigmatisation entered. Like Gina Pane and other performance artists of the period, Abramović inflicted bleeding wounds on herself, with the intent of escaping from her culturally determined and disciplined body. In *Rhythm 0*, 1974, she functioned solely as an object among others, offering the audience free access not only to such everyday objects as a mirror, a newspaper or bread, but to a pistol and bullets as well. Some viewers rapidly succumbed to their dark urges and abused the power they had over the helpless "object".

The body suffers

By comparison to this conscious abandonment of the ego, Abramović's works of the late 1980s had a more detached and narrative character. At this time she also developed a series of *Transitory Objects* designed to give the audience wider leeway for participation. Theatre stages were often used for performances, or the video medium was employed to increase the complexity of the artist-audience relationship. In *Dragon Heads*, 1990–92, a wall of ice blocks separated the artist – her body entwined with live pythons – from the audience. The theatrical effect of the stage-like division of the space was augmented by the use of spotlights. In the video installation *Becoming Visible*, 1992, Abramović was again surrounded by snakes. She also continued to focus on the central motifs of her activity, such as physical suffering, in works like *Dissolution*, 1997. A multiple-episode performance developed in collaboration with Charles Atlas, *Delusional*, 1994, contained passages from her biography in the form of allegorical imagery.

The treatment of traumatic memories in Abramović's major work, *Balkan Baroque*, which won an award at the 1997 Venice Biennale, gained additional political thrust due to the war in Bosnia. In the midst of an installation of three video projectors showing the artist and her parents, and three copper vessels full of water, Abramović sat for over four days, cleaning 1,500 cattle bones and singing songs from her childhood. The spiritual act of cleansing in preparation for death had once before concerned the artist, in the video installation *Cleaning the Mirror I*, 1995, where she thoroughly cleaned a skeleton with a brush and water.

Her work in progress, *The Biography*, also finds Abramović returning to certain set pieces. She repeats and varies earlier performances, narrates her biography on tape, introduces a little girl as the figure of the narrator, and integrates visual material into this multi-layered stage piece, which has been presented in various theatres since 1992. *The Biography* permits the artist to deal with the story of her life with the same freedom that she brings to her work – and, by so doing, to recreate herself continually.

Petra Löffler

Marina Abramović in
Sardinia, 1977

Marina Abramović in
Thailand, 1983

Marina Abramović and Ulay
in Australia, 1981

Laurie Anderson

* 1947 in Chicago (IL), USA; lives and works in New York (NY), USA

Selected solo exhibitions: **1973** "O-Range", Artists Space, New York (NY), USA / **1983** "Laurie Anderson. Works from 1969 to 1983", Institute of Contemporary Art, Philadelphia (PA), USA / **1996** Solomon R. Guggenheim Museum, New York (NY), USA / **1998** Dal Vivo, Prada Gallery, Milan, Italy / **1988** Artists Space, New York (NY), USA

Selected group exhibitions: **1994** "La Visite Guidée", Museum Boijmans Van Beuningen, Rotterdam, The Netherlands / **1996** "Electra", Henie-Onstad Art Center, Oslo, Norway

Website: www. laurieanderson.com

Language,
a virus from outer space

In 1981, with her song "O Superman", Laurie Anderson entered the pop mainstream. The heartbeat rhythm of the digitally altered vocoder voice and tone configurations, the strange collage of lyrics and minimalist composition took the song to number two in the British charts. It established a first link between performance art and pop culture that has lasted to this day. By that point Anderson had been active as an artist for nearly ten years, since 1972. In 1981, the year of Ronald Reagan's inauguration as US president, she made the anonymity and subliminal power of mass culture, the broken myths of the American Dream and the nuclear era the subject of a song ("So hold me, Mom, in your long arms, in your petrochemical arms, your military arms, in your arms").

"O Superman" was released as a single in 1981 by 110 Records, initially as an edition of 1,000 copies (Later Anderson would sign with Warner Brothers). Dedicated to the composer Jules Massenet, the song referred to an aria in his opera *El Cid*, in which the hero addresses God as "O souverain, o juge, o père …" The première of "O Superman" had taken place as part of Anderson's first extended music performance, *United States, Part 2*, held at the Orpheum Theatre, New York, in 1980. The artist accompanied herself with a subtext, formed by the sign language of her raised right hand, projected as a gigantic shadow on a wall.

During her art history studies at Barnard College in New York, Anderson experienced the 1968 campus revolt sparked off by the assassination of Martin Luther King, Jr. At the School of Visual Arts, her teachers included Carl Andre and Sol LeWitt. In the early 1970s, while immersing herself in Buddhist texts and the writings of the phenomenologist Maurice Merleau-Ponty at Columbia University (where she graduated in 1972), Anderson circulated in the downtown New York art scene, making the acquaintance of Joel Fisher, Philip Glass, Gordon Matta-Clark, Keith Sonnier and others. Her sculptures of the period were influenced by the formal idiom of Eva Hesse. Later she would compare these formative years in Manhattan with Paris during the 1920s. Anderson wrote art reviews, taught in schools, and exhibited at various galleries and museums. Her debut as a performance artist came in 1972 in Rochester, New York, with a symphony for car horns held in a park (*The Afternoon of Automotive Transmission*, 1972), a work reminiscent of Futurist manifestations of the 1920s.

Early on, Anderson began electronically manipulating musical instruments, such as her violin. She had learned the violin from a young age and won several awards. This string instrument, whose sound range comes closest to that of the female voice, soon became a surrogate for the artist's vocalisations. In 1974, at the Artists Space in New York, she did a performance called *As:If*, which she considers her first "mature" performance in the true sense of the word. Anderson appeared in a white trouser suit, wearing a crucifix made of dry sponges around her neck and skates frozen into ice blocks on her feet. For the first time, she alienated her voice by placing a loudspeaker in her mouth. Accompanied by slide projections of individual words ("roof:rof", "word:water"), she told stories about language and religion, or related childhood memories such as that of ducks frozen into the ice on a pond.

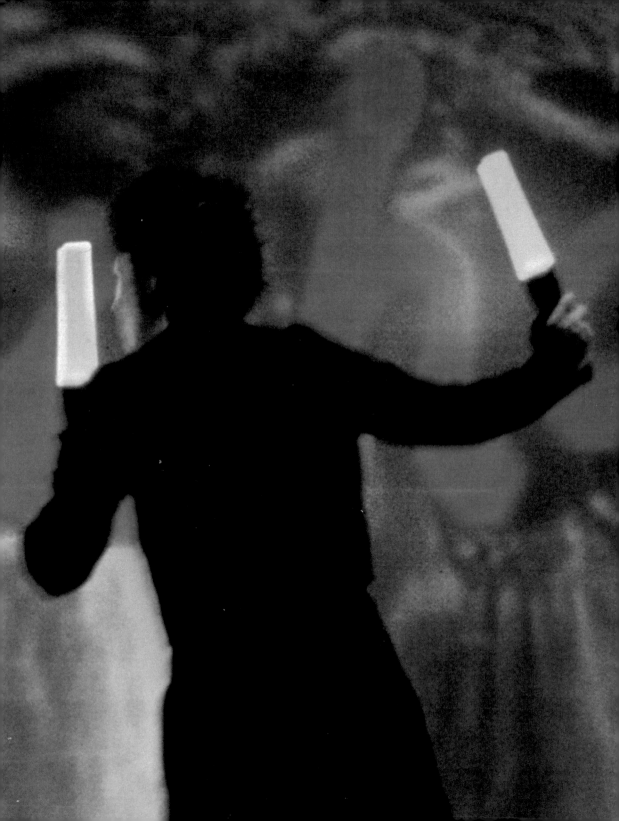

"My work is always about communicating."

1 Stories from the Nerve Bible, 1995

2 Empty Places, 1989/90
3 Laurie Anderson with **Talking Stick** in **Song and Stories from Moby Dick,** 1999
4 Home of the Brave, 1985
5 Laurie Anderson dancing "Drum Dance 2" in **Home of the Brave,** 1985

6 Preliminary sketch for **Video Bow,** 1992
7 Blood Fountain, 1994. Computer-generated image. Design for a monument at Columbus Circle in New York (NY), USA
8 Stories from the Nerve Bible, 1995

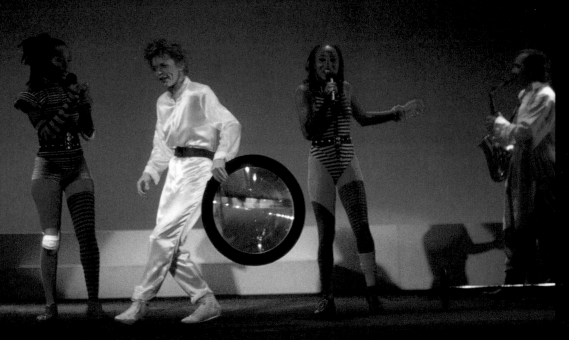

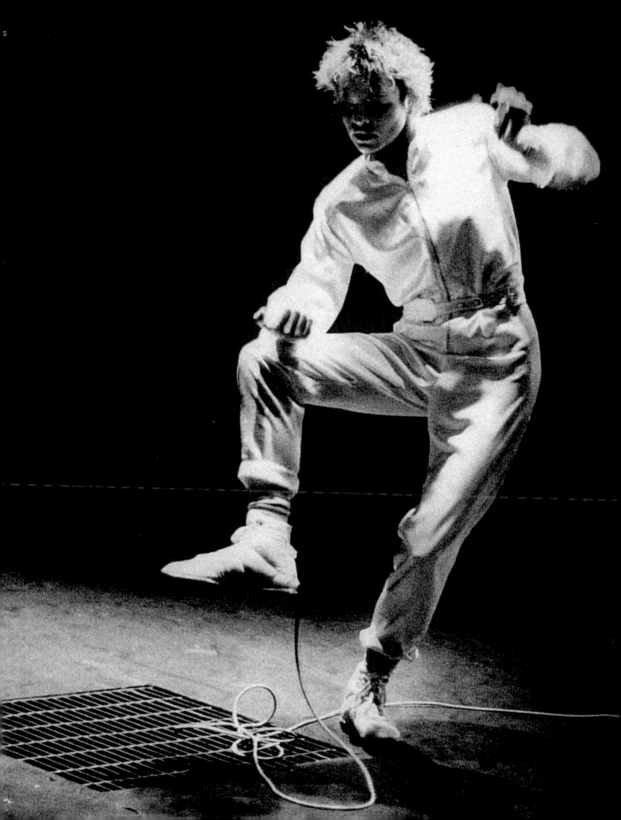

Stories from the Nerve Bible '93 sketch labels:

VIDEO BOW

LIPSTICK CAMERA

CABLE TO LIVE DECK

STORIES FROM THE NERVE BIBLE '93

Americans on the Move

In the mid-1970s' Anderson began looking for ways to have a surrogate perform in her place, as Vito Acconti or Dennis Oppenheim had demonstrated with tapes or dummies. In the performance *At the Shrink's*, 1975, held in New York's Holly Solomon Gallery, she presented a fake hologram, generated by a super-8 film – the first of numerous clones based on her own self. In 1976, Anderson presented a great number of performances and projects in Europe. As her song repertoire included universally familiar sounds and language fragments, she was able to communicate at least rudimentarily with audiences everywhere. After returning home, in 1978 Anderson travelled across the US, working, among other things, as a cotton picker. Her impressions of American society and politics were summed up in the multimedia performance *Americans on the Move, Part 1*, 1979, an amalgamation of the spoken word, music and projected imagery, held in The Kitchen, a New York club.

Anyone who went out in SoHo in the late 1970s would have probably gone to this club, where artists such as Robert Wilson, Philip Glass or Meredith Monk appeared, or later to the Mudd Club to hear Anderson's own trio, The Blue Horn File (with Peter Gordon and David van Tieghem). Over the years Anderson designed a series of innovative instruments, and she can justifiably be considered an early master of sampling. By attaching microphones to her body and distributing them around performance spaces, she transformed both into instruments, and she also used various objects to amplify sounds (as in *Talking Pillows*, 1977–97, and *Handphone Table*, 1978). Anderson has built violins of all kinds, from a "viophonograph", on which a record was played by the bow, through a neon violin with audible electronic resonance, to a digital violin, coupled with a synthesiser.

Home of the Brave

In the conservative 1980s of the Reagan administration, Anderson sought ways to convey political messages through the mass media. In 1981, the year MTV came into existence, her eight-minute "O Superman" video (art director: Perry Hobermann) was broadcast around the clock on the channel. There followed the eight-hour production *United States,* which Anderson termed a "talking opera". Containing songs, texts, images and found footage material from various films, it dealt, as the artist said, with motion, utopias and the passing of time in a technologically determined world. The success of "O Superman", a section of *United States, Part 2,* soon caused many on the avant-garde scene to accuse her of selling out to the establishment. Ten years on, her achievement would be described as crossover. At any rate, Anderson had acquired a new audience, and the SoHo art scene disintegrated as rents rose sky-high.

In 1982, Anderson issued a long-play record, *Big Science*, the following year the Institute of Contemporary Art in Philadelphia mounted a multimedia exhibition, "Laurie Anderson, Works from 1969 to 1983", which travelled through the United States and to Britain. Under the influence of the science-fiction craze sparked by George Orwell's novel *1984* and the impoverished language called Newspeak described there, the artist produced a homage to William S. Burrough's *Language is a Virus from Outer Space*. In 1984, *Mister Heartbreak* was performed, followed in 1985 by a documentation of the concert on film, *Home of the Brave*. The record *Strange Angels*, on which Anderson sang for the first time, was recorded in 1989, a stage version being called *Empty Places*. Finally, in 1992, the World Fair in Seville hosted the première of *Stories from the Nerve Bible*, a title referring to the 1991 Gulf War. For *Songs and Stories from Moby Dick*, 1999, based on the novel by Herman Melville, Anderson invented the "talking stick", which served simultaneously as a light, a harpoon, and a digital remote-controlled instrument. Apart from her performances, in recent years the artist has organised festivals, designed websites, taught at universities, and made videos. She lives with the musician Lou Reed. *Holger Liebs*

Laurie Anderson in Basle, 1977

Laurie Anderson, 1994

Janine Antoni

* 1964 in Freeport, Bahamas; lives and works in New York (NY), USA

Selected solo exhibitions: **1992** "Gnaw", Sandra Gering Gallery, New York (NY), USA / **1994** "Slumber", Anthony d'Offay Gallery, New York (NY), USA /
1995 "Slip of the Tongue", Centre of Contemporary Arts, Glasgow, Scotland / **1998** "Swoon", Whitney Museum of American Art, New York (NY), USA /
1999 "Imbed", Luhring Augustine Gallery, New York (NY), USA

Selected group exhibitions: **1993** Whitney Biennial, Whitney Museum of American Art, New York (NY), USA /
1994 "A Streetcar named Desire", Kunsthaus Zürich, Zurich, Switzerland / **1995** Johannesburg Biennial, Johannesburg, South Africa /
1997 "A Rrose is a Rrose is a Rrose", Solomon R. Guggenheim Museum, New York (NY), USA / **1999** "The American Century, Part II",
Whitney Museum of American Art, New York (NY), USA

Sublime self-irony

Janine Antoni is a narrator of myths, who draws with her eyelashes or weaves into materials the computer recordings of her brain activity while asleep, who lends her pictures and installations an element of comedy. Her works confront the viewer with a mixture of elaborately-spun epic and mirthful irony.

Thus arises an art in which, for example, the sacred architecture of the Temple of Delphi is made the starting point for a private experiment, begun by Antoni in 1996 and only concluded in 1999. The experiment consists of continuously rubbing together two pieces of limestone. On a trip to Greece, Janine Antoni was fascinated by the precision with which the stones of the ancient temple walls fitted together. Their almost seamless joins were created by a process of abrasion, whereby neighbouring stones were rubbed together until their two surfaces became as one. Antoni's project *and* arose out of the imitation of this process. Two monumental 400-kilogram blocks of limestone were drilled through the middle and mounted on a vertical steel axle. A crossbar provided the drive which transformed the stones into a mill. The artist ground the stones against each other for up to five hours a day, and thereby balanced out their unevenness in a fashion as imperceptible as it was asymmetrical. Instead of smooth surfaces, bulges and indentations carefully moulded themselves to each other. In this way, an unchangeable form was created, monumental, a natural given, which nevertheless – thanks to its function-al axle and banal drive shaft – remained identifiable in the gallery as an artificial piece of milling.

You don't spend years grinding away at stones out of mere irony. Janine Antoni might even be called the woman upon whom anti-irony has pinned its hopes. After the satirical tactics of 1980s art, which frequently meant something other than what one saw so as to dupe the all-swallowing art world, it was noted that what was astonishing about Antoni's work was its unswerving refusal to intro-duce an element of irony into the complex tableau. The subtle narrative manner with which she brought an abandoned and condemned

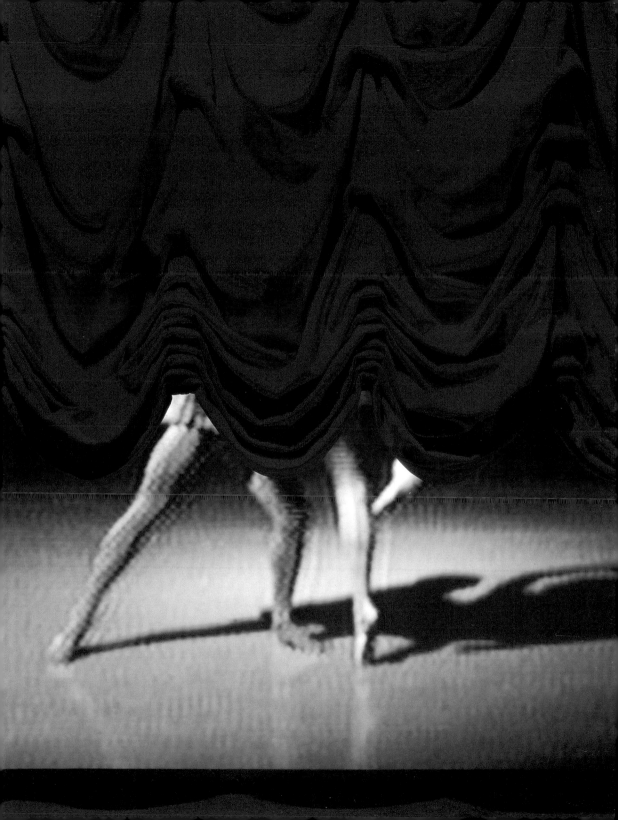

"I'm interested in everyday body rituals and converting the most basic sort of activities – eating, bathing, mopping – into sculptural processes."

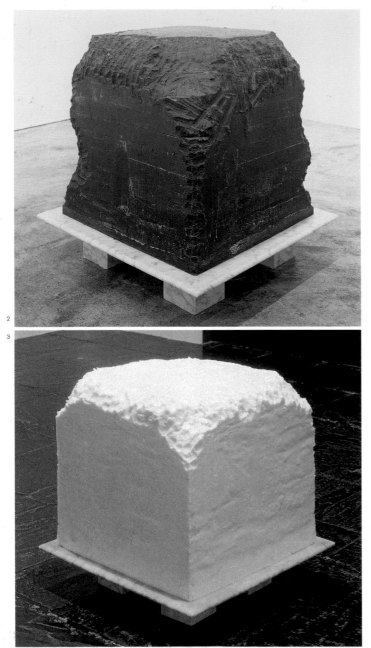

2

3

1 **Swoon,** 1997. Installation view, Capp Street Project

2 **Chocolate Gnaw,** 1992. Chocolate (600 lb. before biting), gnawed by the artist, 61 x 61 x 61 cm

3 **Lard Gnaw,** 1992. Lard (600 lb. before biting), gnawed at by the artist, 61 x 61 x 61 cm

4 **Lipstick Display,** 1992. Praline trays: chocolate. Lipstick, lard, pigment, beeswax

5 **and,** 1997–1999. Two 400-kilogram blocks of limestone, mounted on a vertical steel axle, c. 160 x 120 cm, axle 3 m

6 **Loving Care,** 1992. Loving Care hair dye, natural black. Performance "I soaked my hair in dye and mopped the floor with it", Anthony d'Offay Gallery, London, England

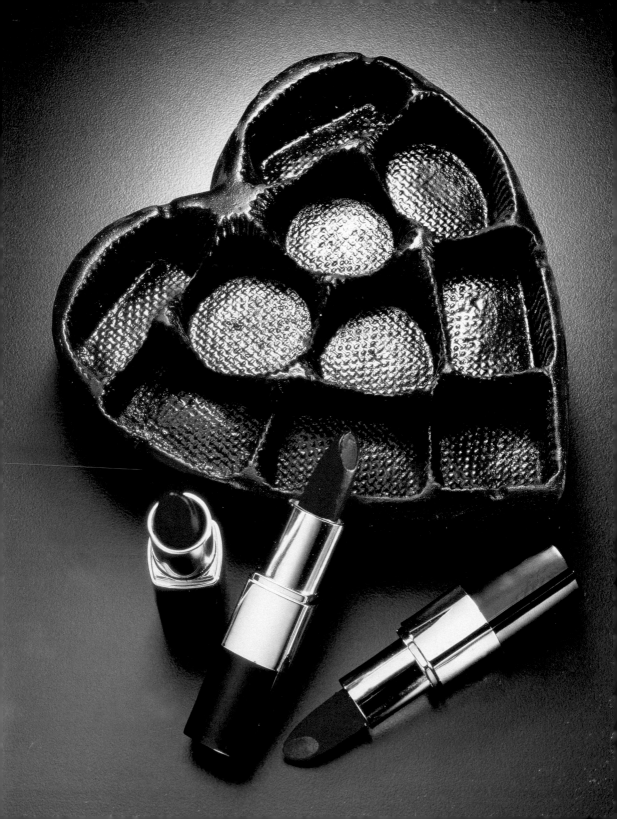

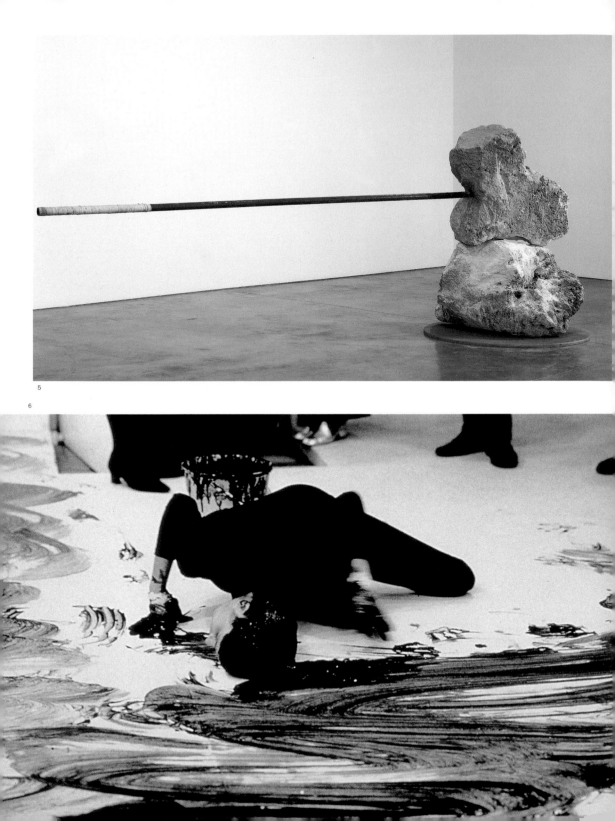

5

6

apartment back to its original state (*Beatrice Thomas,* 1996) in order to restore one of its rooms archeologically and thereby reconstruct the traces of its female occupant, and her selective presentation of a scene from *Swan Lake*, in which the dancers were obscured by the theatre curtain in such a way that you could only see torsos dancing *(Swoon,* 1997), rightly created the impression that the sublime and the historical here being taken literally – before undergoing reinvention. *Loving Care*, 1992, Antoni's abstract painting of a gallery floor using her own hair, which she had dipped in dye, and *Butterfly Kisses*, 1992, a drawing which she created with blinks of her mascara-coated eyelashes, were events that were far too physical to be dismissed as gentle irony. In Antoni's hair painting, the forceful actions of Abstract Expressionist painting were not just cited, but were re-enacted in greater physical intimacy.

Subtle narration

Janine Antoni's work nevertheless puts itself in a perspective that is humorously ironic. The joke in this art is the "ironic *complicity* which the work establishes with the viewer" (Ewa Lajer-Burcharth). The public is troubled not by the irony of the artist, but something like the self-irony of the works themselves. Thus, while the crossbar in the limestone sculpture, for example, speaks of the effort that has gone into the work, it also interrupts the overall sense of artistic illusion, rather in the way a sculpture does still has a chisel sticking into it. Antoni's photographic Madonna picture *(Coddle,* 1998), in which the Virgin contemplatively cradles her own lower leg in her hands, not only reworks the images of womankind handed down by art history, but also plays with the height of fall of religious pathos. To cast her own nipples and areolae narcissistically as golden brooches *(Tender Buttons,* 1994), on which each papilla protrudes exactly to scale and the fine network of veins is clearly visible, could be something like ironic feminism: reverence for the body, a play upon its fragmentation, and a parody of the aura which art lends to the physically banal.

Epic diligence

The corrective to this play with comedy is hard work on an epic scale. In the creation of *Gnaw*, 1992, Janine Antoni chewed and gnawed to the limits of her physical ability. She modelled two 600-lb blocks – one of chocolate, the other of lard – as if she were carving a classical sculpture. Doggedly working her jaws to the point of exhaustion, she rounded off the edges until the blocks were transformed into gallery sculptures. The bites spat out were themselves turned into other objects. The fat was mixed with beeswax and pigments and made into lipsticks, which were put on display like fetishes in a store window. The chocolate was remoulded into heart-shaped praline trays, resembling in their brown colour the plastic trays in which confectionery is presented like jewellery. The cult of cosmetics, lard and food as compensation for frustration, food packaging and the artistic act of creation were linked in a cycle of recycling whose basis was the stamina with which the artist passed each ounce of material through her mouth. The stereotypical images of the female played out by and borne by the body are thereby placed under the spotlight. The artist's oeuvre combines itself, above all, into a narrative of small steps, a contemplation of stamina and intimacy, a vigorous reflection upon the demands of the large artistic form and its scale. With Janine Antoni, this scale is always the human body. Although mostly absent, it is nevertheless always in the picture, serving to anchor the pure ideas and concepts which, without body contact, have no scale of reference. *Gerrit Gohlke*

Vanessa Beecroft

* 1969 in Genoa, Italy; lives and works in New York (NY), USA

Selected solo exhibitions: **1994** Schipper & Krome, Cologne, Germany / **1995** Fondation Cartier pour l'art, Paris / **1996** Museum Ludwig, Köln / **1998** Solomon R. Guggenheim Museum, New York (NY), USA / **1999** Museum of Contemporary Art, Sydney, Australia

Selected group exhibitions: **1995** "Campo 95", Corderie dell'Arsenale, Venice, Italy / **1997** "Vanessa Beecroft, Diana Thater, Tracey Moffatt", Städtisches Museum Abteiberg, Mönchengladbach, Germany / **1998** "Wounds Between Democracy and Redemption in Contemporary Art", Moderna Museet, Stockholm, Sweden / **1999** "Heaven", Kunsthalle Düsseldorf, Düsseldorf, Germany / **2000** Sydney Biennial, Sydney, Australia

Waiting for beauty

Vanessa Beecroft "paints" individual and group portraits in three dimensions, with living girls and women. They occupy a certain room for a certain time, are dressed, usually scantily, by the artist, often wear wigs, and never make contact with the spectators. The result is a strangely cool, eerie atmosphere, making the viewer seem somehow just as out of place as the girls themselves, who hardly move and seem merely to be waiting for something. "I am interested in the interrelationship between the fact that the models are flesh-and-blood women and their function as a work of art or image", the artist explains. Beecroft's art is hard to categorise. Does it amount to performances or "living sculptures" like those of the British team Gilbert & George, or perhaps to a modern form of portraiture, to psychologically charged still lifes with living subjects? The question remains open.

In one of her early exhibitions, in 1994 at a Cologne gallery, Beecroft presented 30 young girls in a showroom to which the public had no access. The event was visible only through a small rectangular window frame that gave one the sense of peering through a peephole. The girls all had a similar, non-athletic figure, and were dressed merely in black shoes and knee stockings, grey underwear, and black or grey tops. This uniform costume, which produced a striking visual composition in space, was rounded off with yellow wigs, some with and some without braids. Some of the girls sat there seemingly pouting, others leant against the walls, still others walked slowly back and forth. None of them seemed seriously to expect anything to happen – instead of an action-filled period of time, there was merely and literally a boring duration. The title of this work spoke volumes: *A Blonde Dream*. As the event took place in a German gallery, the allusion to the cliché of "Aryan beauty" propagated during the Third Reich seemed abundantly clear.

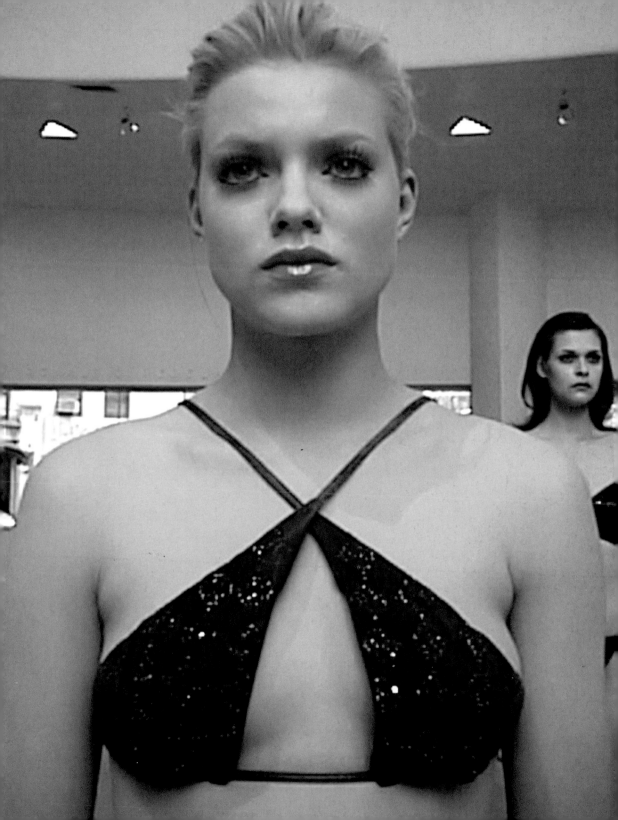

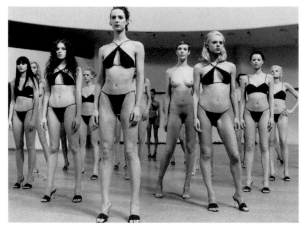
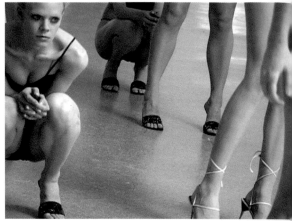
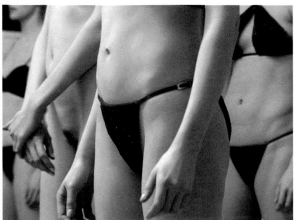
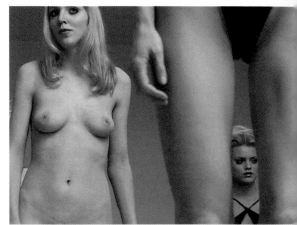
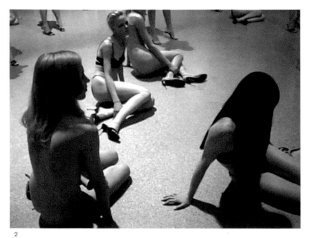
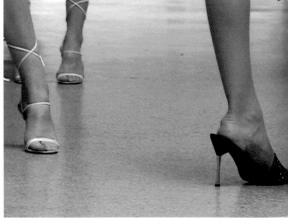

2

1 **Show,** 1998. Performance, Solomon R. Guggenheim Museum, New York (NY), USA
2 **Show,** 1998. Performance, Solomon R. Guggenheim Museum, New York (NY), USA
3 **Leipzig,** 1998. Performance, Galerie für zeitgenössische Kunst, Leipzig, Germany
4 **Royal Opening,** 1998. Performance, Moderna Museet, Stockholm, Sweden

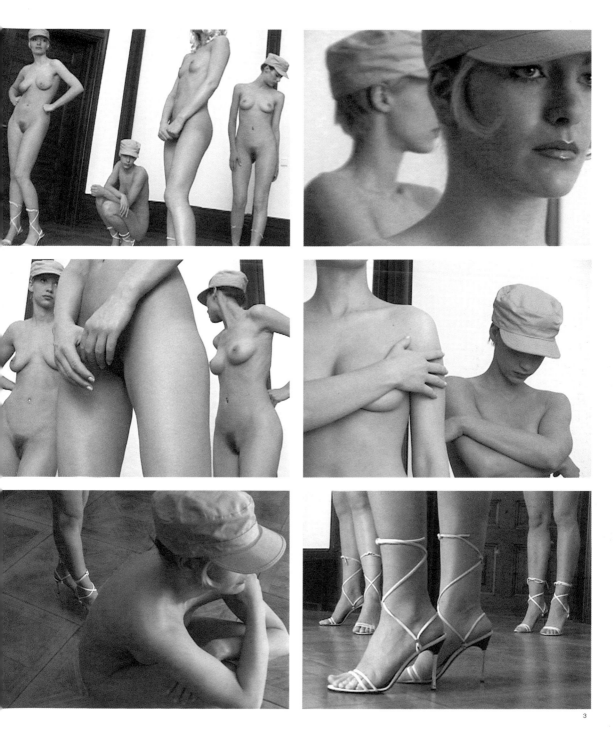

**"Nobody acts, nothing happens;
neither does anyone begin anything,
nor is anything finished."**

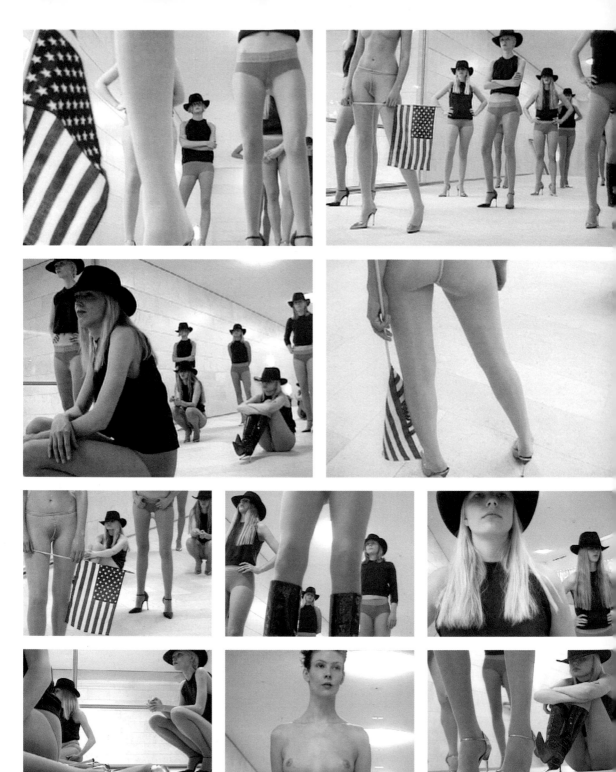

Born in the 1960s, Beecroft was inspired to her 30 provocative conjugations of the female figure not by personal experience, but by Roberto Rossellini's film *Germany in the Year Zero,* 1947. More precisely, by Edmund, the film's anti-hero, who in the ruins of post-war Berlin kills his father and then himself. What took place in the event was thus a closed circuit of various episodes of a narrative fiction. A media narration about a demise of morality was translated into a different media spectacle which, like the film, was composed of "real" people but which dispensed with a plot of any kind. Confronted with this very cool, well-nigh absurd translation, viewers were challenged to call up comparable visions from their visual memory, visions that might just as well have been recalled from movies as from "real life" experiences.

A blonde dream

A Blonde Dream is typical of the artist's staged installations. Again and again, Beecroft places models, actresses, even occasionally women met by chance on the street, in precisely defined visual spaces, quoting in the process from a range of cultural codes from cinema, fashion, literature or art. In *Play,* 1995, for instance, she referred explicitly to Samuel Beckett's 1963 stage play of that name. Beckett's characters were supplanted by three doubles of the artist, two seated next to each other on chairs, barefoot, wearing the same brown wig and black coat, while the third, dressed only in dark shoes, light-coloured underwear, and a red wig, circled around them with a suspicious look in her eye. A symbolic picture with far-reaching associations arose from this silent, largely motionless still life: the allusions ranged from the red hair of the socialist revolutionary Rosa Luxemburg to the naked legs and feet of countless depictions of the *Pietà*. It was intriguing to see the artist taking up the factor of perception, naturally a precondition of all visual art, and restating it in terms of the psychotic, self-referential, aimless and circular action of *Play*.

Diaries

Such works have been supplemented by sensitive drawings, for instance of enigmatic female heads such as *Lotte,* 1994, with her long mane of red hair. Books, too, are among the media employed by Beecroft. Early in her career she began recording important aspects of her aesthetic activity in a journal-like artist's book titled *Despair,* 1985–93. Here she not only described her eating habits, but made intimate confessions regarding her feelings of guilt and her relationship with her parents. This literary self-portrait was shown in Beecroft's first gallery exhibition in Milan, during a presentation of young girls discovered on the city streets and asked to be an "understanding" audience for the diary. Since all of the girls wore clothing that belonged to Beecroft, the readers and the subject of the book tended to merge into one. Both played roles; both were ready to identify with them, but also to distance themselves from them. The director of the tableau, for her part, stood simultaneously inside and outside the equally self-referential and extra-referential presentation.

Raimar Stange

Vanessa Beecroft

Louise Bourgeois

*** 1911 in Paris, France; lives and works in New York (NY), USA**

Selected solo exhibitions: **1945** "Paintings by Louis Bourgeois", Bertha Schaefer Gallery, New York (NY), USA /
1959 "Sculpture by Louise Bourgeois", Andrew D. White Art Museum, Cornell University, Ithaca (NY), USA /
1982/83 "Louise Bourgeois: Retrospective", The Museum of Modern Art, New York (NY), USA /
1996 "Louise Bourgeois. Der Ort des Gedächtnisses. Skulpturen, Environments, Zeichnungen 1946–1995",
Deichtorhallen Hamburg, Hamburg, Germany / **2000** Tate Modern, London, England

Selected group exhibitions: **1945** "Modern Drawings", The Museum of Modern Art, New York (NY), USA /
1983 Whitney Biennial, Whitney Museum of American Art, New York (NY), USA / **1989** "Magiciens de la Terre",
Musée national d'art moderne, Centre Georges Pompidou, Paris, France / **1992** documenta IX, Kassel, Germany /
1993 XLV Esposizione Internazionale d'Arte, la Biennale di Venezia, Venice, Italy

Selected bibliography: **1998** Marie-Laure Bernadac, Hans-Ulrich Obrist (eds.), *Louise Bourgeois, Destruction of the Father:
Reconstruction of the Father,* London

Spools, reels and visions

A narrow corridor leads into a polygonal room whose screen-like walls are made up of doors. Inside there is a dense conglomeration of large red and pale blue spools on mounts, spirally wound objects and body fragments of clear glass, two small suitcases, a petroleum lamp, and two bottles filled with coins. A red ladder leans against the wall and a drop-shaped object dangles from one of the spool mounts. One of the doors has a small window, behind which the word "private" can be read in shabby lettering. The atmospheric density of Louise Bourgeois' *Red Room (Child)*, 1994, is created by the obsessively enigmatic logic of its *objets trouvés* and artefacts, and by the informally intangible structures of the luminous red glass spools. *Red Room* contains many of the central motifs and metaphors that have been explored by Bourgeois for decades: the claustrophobic room reminiscent of a hiding place or inner body, surrealist, organ-like partial objects, a ladder that is too short to allow escape from the room, and the spools of yarn, recalling Bourgeois' childhood. The "private" sign suggests that this is a place of personal reminiscence, and that working through autobiographical elements and constellations is one of the central processes in her creative work. Bourgeois' oeuvre, in which mastery of a formal sculptural vocabulary is inextricably linked with a complex and coded content, has remained open to the projections of its critics, while at the same time constantly fuelling biographical interpretation by many written and verbal statements. Thus, the construction of memory is a central motive for her work.

According to her biography, Louise Bourgeois' family ran a workshop for the restoration of antique tapestries in the French town of Choisy-le-Roi. Recognising her talent for the task, Louise Bourgeois' parents entrusted her with drawing sketches of missing areas in the textiles and creating cartoons for their subsequent repair. Bourgeois went on to study mathematics at the Sorbonne. From the mid-1930s, she attended a number of art schools, eventually becoming a student of Fernand Léger. She married the American art historian Robert Goldwater and moved to New York in 1938, where she continued her artistic training until 1940 at the Art Students' League. She then worked as a painter. One of her first groups of work was *Femmes Maison*, female figures whose bodies consisted partly of a house, in reference to the social status of women and their allocation to domestic territory. Bourgeois also explored the same subject in

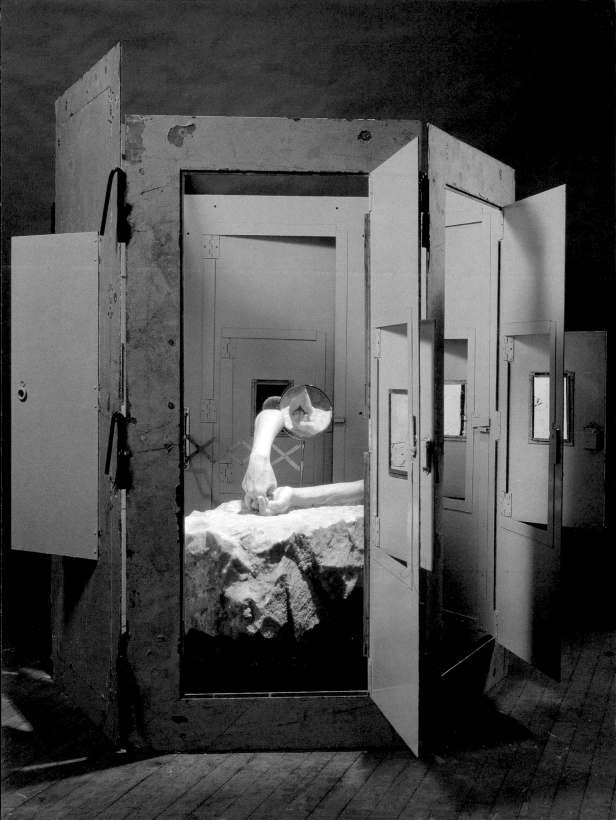

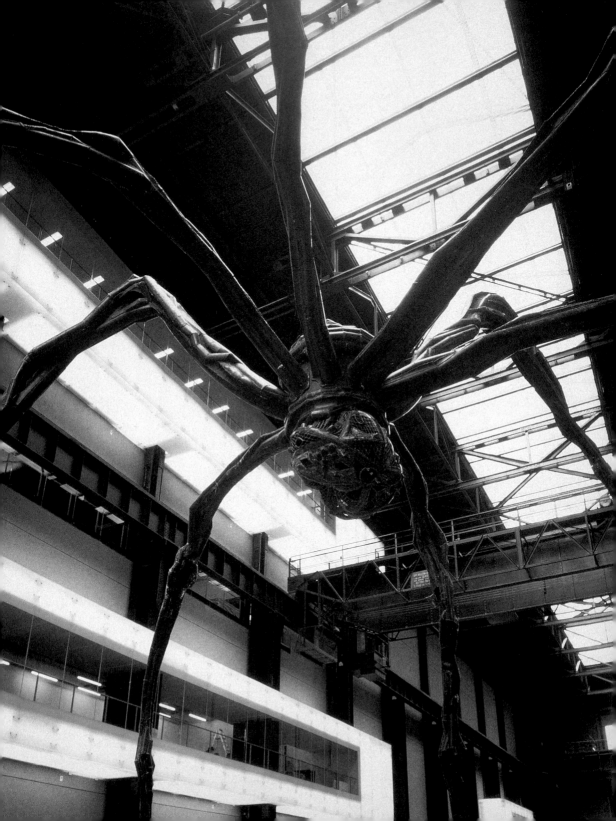

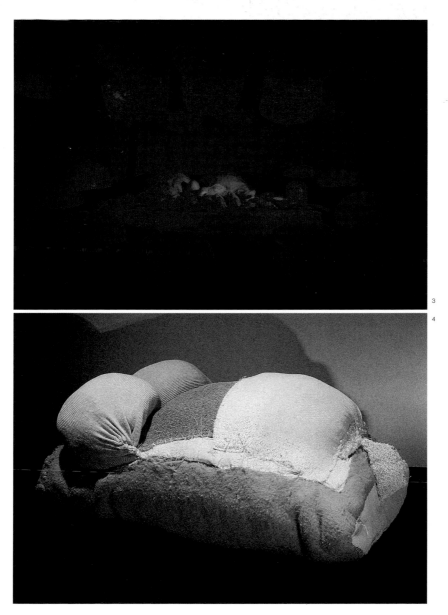

**"I've always had a fascination with the needle,
the magic power of the needle.
The needle is used to repair the damage.
It's a claim to forgiveness."**

1 **Cell (Hands and Mirror),** 1995. Marble, painted metal, mirror, 160 x 122 x 114 cm

2 **Maman,** 1999. Steel and marble, 9.27 x 8.92 x 10.24 m. Installation view, Tate Modern, London, England, 2000
3 **The Destruction of the Father,** 1974. Plaster, latex, wood, cloth, 2.38 x 3.62 x 2.71 m
4 **Torso,** 1996. Cloth, 30 x 64 x 38 cm

5 **Arch of Hysteria,** 2000. Various materials, 14 x 45 x 28 cm
6 **Red Room (Child),** 1964. Various materials, 2.11 x 3.53 x 2.74 m
7 **Cell (You Better Grow Up),** 1993. Steel, glass, marble, ceramic, wood, 2.11 x 2.08 x 2.12 cm

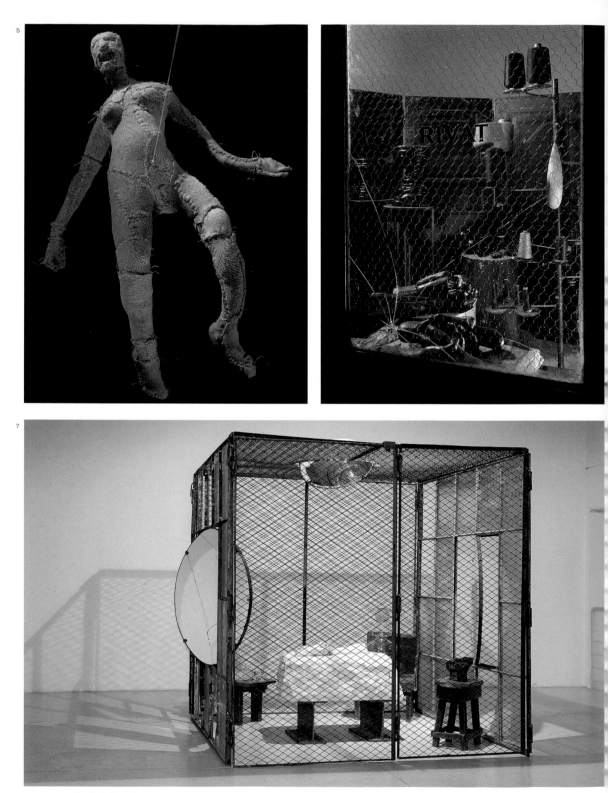

sculpture. From about the mid-1940s, she created her so-called *Personages,* pared-down stela-like figures reminiscent of totemic arte-facts from tribal cultures. In the 1950s, Bourgeois developed a series of anthropomorphic sculptures made up of similar elements mount-ed on a rod, featuring not only objects recalling Brancusi's sculpture, but also Minimalist serial principles such as those to be found in the early works of Carl Andre.

In the years to follow, Bourgeois experimented with unusual materials, such as latex, rubber, plaster and cement. In the early 1960s, she took her domestic theme a step further in her *Lairs* – sweeping, spiral, labyrinthine forms that generally open up towards a hollow inner space. Like her *Lairs*, her soft landscapes also follow principles of an organic and anti-formalist approach. An almost fleshy materiality makes such latex works as *Double Negative*, 1963, seem like visceral landscapes in which the interior appears to have been turned outwards. Spherical, mushroom-like forms grow out of fluid bases, defying unequivocal identification, but suggesting the many breasts of Artemis of Ephesus, or phalli. Like most of the sexualised forms in the work of Bourgeois, they are not clearly "male" or "female". Even *Fillette* (*Little Girl*), 1968, a large latex phallus with which Bourgeois struck a humorously provocative pose in Robert Mapplethorpe's 1982 portrait of her, hypertrophies the phallic form as well as the round form. When Lucy Lippard included some of the *Lairs* in her ground-breaking "Eccentric Abstraction" exhibition in 1966, Bourgeois' works finally took their place in the feminist discourse.

In 1974, Bourgeois created her sculpture *Destruction of the Father*, portraying a symbolic patricide set in a threatening land-scape with cocoon-like or egg-shaped protrusions and spherical forms that grow towards the spectator in a menacing way. The work has its roots in her childhood fantasy of devouring the unfaithful father, who cheated on Bourgeois' mother with his mistress.

"Fear is pain"

Towards the late 1970s, Bourgeois was able to consolidate her position within the New York art scene, increasingly gaining the recognition of a younger generation of artists. It was not until 1982, when she was 71 years old, that the New York Museum of Modern Art mounted a first major retrospective exhibition of her work, honouring her previously under-represented contribution to post-war Amer-ican art. Her international standing was finally confirmed by the first major retrospective exhibition of her work to be shown in Europe, at the Frankfurt Kunstverein in 1989, and consolidated by her participation in documenta IX at Kassel in 1992 and the Venice Biennale in 1993.

From the mid-1980s onwards, Bourgeois returned to the topics of memory and childhood conflict already present in *Personages* and *Destruction of the Father* when she created *Cells*, which are large rooms with encompassing mesh fences, enigmatic mirrors and furnishings. In Bourgeois' words: "Each *Cell* tells of fear. Fear is pain." In the *Cells*, objects function as representatives of absent persons, e. g. in the form of empty chairs or beds, whose unknown emptiness triggers memory. The *Cells,* with their connotations of fear, alien-ation and menacing sexuality, are iconographically closely related to the enormous *Spiders* which Bourgeois has produced in a number of variations in recent years. The potential of these works lies precisely in the tension between the autobiographical elements and a metaphorical, formally complex syntax that provides spectators with a projection screen for their own constructs of memory, thereby creating fantastic places of desire.

Ilka Becker

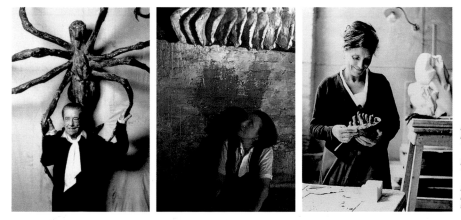

Louise Bourgeois in her studio in front of "Spider IV", 1996

Louise Bourgeois with "Germinal", 1967

Louise Bourgeois work-ing on "Destruction of the Father", 1974

Hanne Darboven

*** 1941 in Munich, Germany; lives and works in Hamburg, Germany, and New York (NY), USA**

Selected solo exhibitions: **1974** "Ein Monat, ein Jahr, ein Jahrhundert", Kunstmuseum Basel, Basle, Switzerland /
1979 "Bismarckzeit", Rheinisches Landesmuseum, Bonn, Germany / **1983** "Schreibzeit", Kunstverein in Hamburg, Hamburg, Germany /
1989/90 "Quartett '88", The Renaissance Society at the University of Chicago, Chicago (IL), USA; Portikus, Frankfurt am Main, Germany;
Neue Gesellschaft für Bildende Kunst, Berlin, Germany; Museum of Contemporary Art, Los Angeles (CA), USA /
1996 "Kulturgeschichte 1863–1983", Dia Center for the Arts, New York (NY), USA / **1997** "Kinder dieser Welt",
Staatsgalerie Stuttgart, Stuttgart, Germany

Selected group exhibitions: **1969/70** "Live in your head. When Attitudes Become Form", Kunsthalle Bern, Berne, Switzerland /
1970 "Conceptual Art. Arte Povera. Land Art", Galleria Civica d'Arte Moderna, Turin, Italy / **1972** documenta 5, Kassel, Germany /
1989 "Bilderstreit. Widerspruch, Einheit und Fragment in der Kunst seit 1960", Museum Ludwig in den Rheinhallen, Cologne, Germany /
1997 "Deep Storage", Haus der Kunst, Munich, Germany; Neue Nationalgalerie, Berlin, Germany

Selected bibliography: **1974** Hanne Darboven, *Das Sehen ist nämlich auch eine Kunst,* Brussels, Hamburg / **1976** Hanne Darboven,
New York Diary, New York (NY), USA / **1995** Hanne Darboven, *Briefe,* Stuttgart, Germany

Enumerated time

Hanne Darboven's artistic obsession is with numbers. After studying art, she left her birthplace, Munich, for New York in 1966. She began filling sheets of graph paper with geometric figures, usually variations of diagonal, linear configurations done in a predetermined sequence, noted on the margin of the sheet. In the late 1960s, this equally non-objective and concrete world of numbers and graphic notations came to the attention of critics and other artists. With Sol LeWitt, Carl Andre and Donald Judd, Darboven shared an interest in elemental structures and their visualisation. She owed her breakthrough as an artist, however, to a productive misunderstanding.

An exhibition titled "Working Drawings and Other Visible Things on Paper Not Necessarily Meant to be Viewed as Art", held in the Visual Art Gallery in 1968, rang in the birth of Minimal Art. Art historians Lucy Lippard and John Chandler analysed the break with the predominant trends of Abstract Expressionism and Pop Art in their essay *The Dematerialization of Art,* and brought Darboven's drawings into proximity with works of the conceptual artists around Sol LeWitt, John Cage and Robert Smithson.

Darboven herself has always denied any link with this movement. And although she is a friend of conceptual artists such as Joseph Kosuth and Lawrence Weiner, she is less concerned with the systematic realisation of an artistic idea than with the metamorphoses of a limited formal vocabulary. Like Piet Mondrian, Darboven painstakingly investigates the fundamental reciprocal relationship between figure and ground, but without transcending it. In addition, she employs, almost exclusively, a subjective handwriting which lends her activity an even stronger air of obsession. Her early works on graph paper, *Constructions,* 1967, were already based on a fundamental order that permitted a truly infinite number of permutations. Soon the artist's studio began to fill to the ceiling with entire stacks of these works.

From the numerical elucidation of graphic variations, it was only a step to the calendar sequence, which Darboven made the basis of her record-making system in 1968. She reduced the infinite universe of numbers to a cross-sum, calculated by means of a special

V, 88

am burgberg

1, 6, → 30, 6, 88 Arbeit

2, 5, 8 8 → 25

mommes au meinen vater Axel, gedankenstrich(+), VI, 88

am burgberg

1, 6, 8 8 → 23 heute

2, 6, 8 8 → 25

1, 7, → 31, 7, 8 8 heute

mommes au meinen vater Axel, gedankenstrich(+), VII, 88

am burgberg

1, 7, 8 8 → 24 heute

2, 7, 8 8 → 25

1, 8, → 31, 8, 8 8 Arbeit

mommes au meinen vater Axel, gedankenstrich(+), VIII, 88

am burgberg

1, 8, 8 8 → 25 heute

2, 8, 8 8 → 26

2, 9, 8 8

1, 9, 8 8 → 26 heute

1, 9, → 30, 9, 8 8 Arbeit

"In my work I try to expand and contract as far as possible between limits known and unknown."

1 **Homage to My Father,** 1988 (detail). Ballpoint pen on blue graph paper, 12 black-and-white photographs, 192 DIN-A-4

2 **Homage to My Father,** 1988. Ballpoint pen on blue graph paper, 12 black-and-white photographs, 192 DIN-A-4 frames

3 **Life, Living,** 1997/98 (detail). 2,782 works on paper, 2 dolls' houses, overall dimensions variable: each sheet and each photograph 30 x 20 cm

4 **Life, Living,** 1997/98. 2,782 works on paper, 8 photographs, 2 dolls' houses, overall dimensions variable: each sheet and each photograph 30 x 20 cm

5 **Weaver's Loom Work,** 1996 (detail). 10 booklets DIN-A-6 with each 2 black-and-white photographs (Ekaha A 6 lined, 32 pages, blue cover),
 Pancolor felt pen, non-fading, 344 DIN-A-4-frame, photocopies from a 10-year period, 1990–1999

6 **Weaver's Loom Work (Am Burgberg / my mother / my childhood / postum a higher / knitting Penelope),** 1996. 10 booklets DIN-A-6
 with each 2 black-and-white photos (Ekaha A 6 lined, 32 pages, blue cover), Pancolor felt pen, non-fading, 344 DIN-A-4-frame, photocopies from a 10-year period, 1990–1999

2

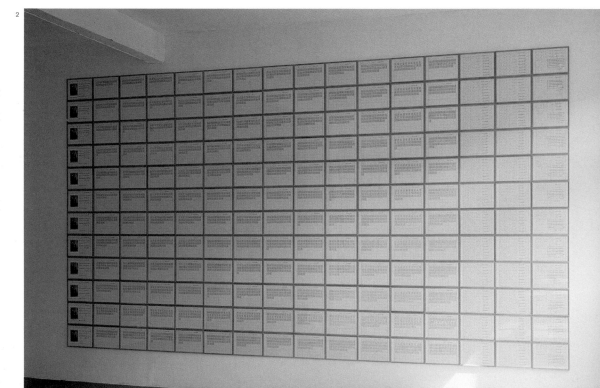

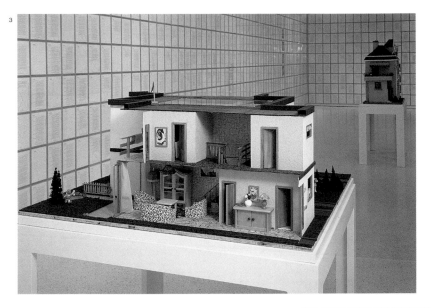

3

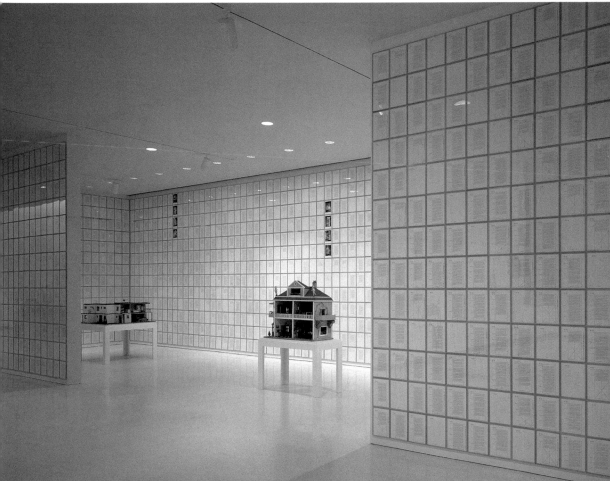

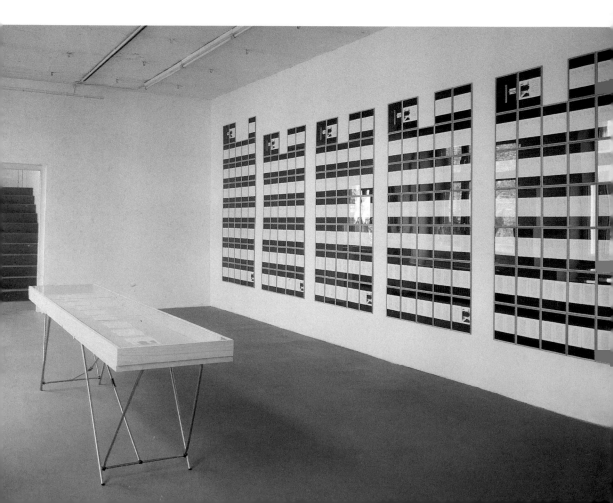

operation. While calculating long periods of time, Darboven realised that taking the cross-sum of a certain period gave a limited number of results, which oscillated between two poles. Using this system, for instance, all the days in a century could either be entered in 402 loose-leaf binders or, as a cross-sum index, on a single sheet. Darboven graphically represented these cross-sums in various ways: either by writing the number as many times as corresponded to its numerical value, noting it as a numeral including all preceding numerals, or by representing it by a corresponding number of identical small boxes.

Writing Time

By systematically recording calendar dates or making careful hand copies of printed texts, Darboven drew attention to the flux of time, not only concretely but as a matter of subjective experience. Since the early 1970s she has employed both dictionary entries and literary material, copying there out, modifying there through her own notations, or translating it into wavelike script and combining the resulting images and objects into installations. For Darboven, letters and digits represent nothing but themselves. In exhibitions, her drawings and collages are distributed among various rooms, usually in a wall-filling all-over pattern. Identical frames serve to heighten the impression of a serial accumulation and the absolute equality in value of each piece. Also, her compulsive work of writing, as it were, consumes Darboven's lifetime, which is why she deletes the word "heute" (today) in the transcriptions collectively titled *Writing Time*. In addition, she has published diaries and letters which provide information ranging from individual experiences to epoch-making events. In 1980, she once more expanded her writing system to include the translation of numerical transcriptions into musical notations.

History for everyone

Subsequently, references to current events began to assume increasing importance in Darboven's work. For *Wende '80* (Transition '80), she used an interview with the current German Chancellor, Helmut Schmidt, and his challenger in that year's national election, Franz Josef Strauss, blacking out the latter's replies. A more comprehensive point of view was taken in *Cultural History 1863–1983*. Although visual documentation had already played a part in various earlier works, such as *Evolution Leibnitz* and *Evolution '86* (both 1986), in this piece Darboven integrated postcards, covers of *Der Spiegel* news magazine, pictures of film stars, pages from a catalogue on 1960s art designed by Wolf Vostell, and sheets from earlier works, such as texts and photographs copied from *Bismarck Time,* 1978. The principle of repetition now came full circle: by quoting herself, the artist confirmed the historicity of every insight, all recognition.

For the piece *Children of This World*, Darboven converted her studio in Hamburg-Harburg for years into a collector's shop. In 1990, she began gathering children's toys of every kind and origin, from rare collector's items to knickknacks and mass-produced articles – the entire universe of childhood fantasies. She consciously selected objects from mundane culture in order to illustrate history as a process that anyone could understand, since the longings of entire generations are precipitated by things of this kind. This time, Darboven recorded her calendar calculations in school notebooks and systematised the entries in the form of musical scores, photographs and coloured markings. Still, as the number and variety of the items made clear, our grasp of history can never be anything but fragmentary, and historiography, like Darboven's numerical calculations, depends on systematic constructs. *Petra Löffler*

Hanne Darboven in her studio; Invitation to the exhibition "Die geflügelte Erde – Requiem", Deichtorhallen Hamburg, Hamburg, Germany, 1991

Hanne Darboven in her studio; Invitation to the exhibition "Stone of Wisdom – Stein der Weisen – 1996", Sperone Westwater, New York (NY), 1998

Sonia Delaunay

*** Born 1885 in Gradisk, the Ukraine; ✝ 1979 in Paris, France**

Selected solo exhibitions: **1908** Galerie Notre-Dame-des-Champs, Paris, France / **1958** Kunsthalle Bielefeld, Bielefeld, Germany /
1962 Galerie Denise René, Paris, France / **1967** Musée National d'Art Moderne, Paris, France / **1985** "Robert et Sonia Delaunay",
Musée d'Art Moderne de la Ville de Paris, Paris, France / **1999** "Robert und Sonia Delaunay", Hamburger Kunsthalle, Hamburg, Germany

Selected group exhibitions: **1913** Erster deutscher Herbstsalon, Galerie der Sturm, Berlin, Germany /
1914 Salon des Indépendants, Paris, France / **1937** Exposition Internationale, Paris, France/ **1979** "Paris – Moscow",
Musée national d'art moderne, Centre Georges Pompidou, Paris, France

Selected bibliography: **1978** Sonia Delaunay, *Nous irons jusqu'au soleil*, Paris / Arthur A. Cohen (ed.): *The New Art of Colour.*
The Writings of Robert and Sonia Delaunay, New York (NY)

Between art and fashion

For a long time, Sonia Delaunay was seen chiefly as an applied artist, moreover one whose influence was as great as her success. In 1912, when colour and light – divorced from all objective reference – were at the heart of an aesthetic debate amongst the Parisian avant-garde, she was busy making everyday objects such as lampshades or curtains that were filled with *real* light. Together with her husband, artist Robert Delaunay, she evolved a novel form of abstract painting known as *simultanéisme*, which used luminous dynamic compositions consisting of geometrical blocks of colour that were intended to be registered simultaneously. This principle Sonia Delaunay transferred to other items such as books or clothing. For example, she transformed Blaise Cendrars' poem *La Prose du Transsibérien et de la Petite Jehanne de France*, 1913, into the first "simultaneous book", a two-metre, vertical leporello intended to be both read and viewed. From 1913, she designed "simultaneous" dresses and suits, and her surprising creations in all manner of materials, in designs using contrasting colours and geometrical shapes, were given an enthusiastic reception by eminent commentators such as the writer Guillaume Apollinaire. The clothes seemed to epitomise that synthesis of art and metropolitan life that the avant-garde of the day was seeking. When Sonia Delaunay went to tango evenings at the Bal Bullier, a Parisian dance hall, she wore a spectacular clinging dress of her own creation, which wrapped her in an abstract composition, and of this dress Cendrars wrote: "On her dress she wears a body." Robert Delaunay described her *simultanéiste* fashion as "living paintings".

Sonia Delaunay was born in 1885 in Gradisk in the Ukraine, and her original name was Sarah Stern. Her parents were factory workers, and when the girl was five years old they placed her in the care of a well-to-do relative, St. Petersburg art collector Heinrich Terk, who saw to it that she was properly educated. After briefly studying drawing at the Karlsruhe Academy of Art in Germany, she moved

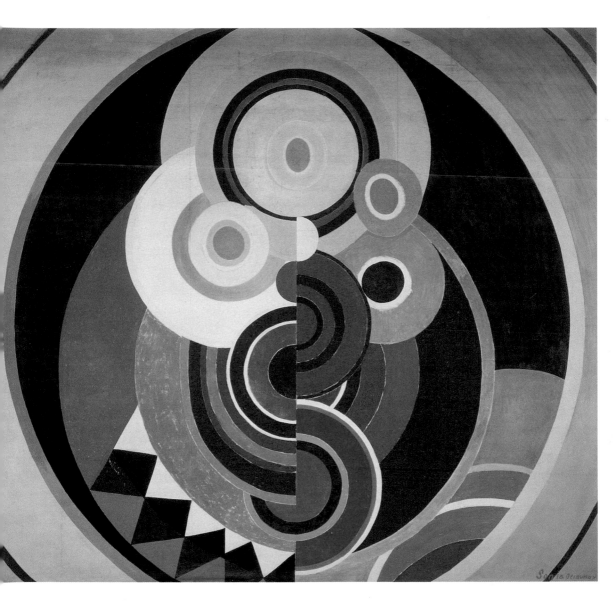

"I have had three lives: one for Robert, one for my son and grandsons, and a shorter one for myself. I have no regrets for not having been more concerned with myself. I really didn't have the time."

3

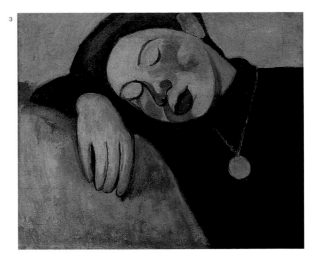

4

5

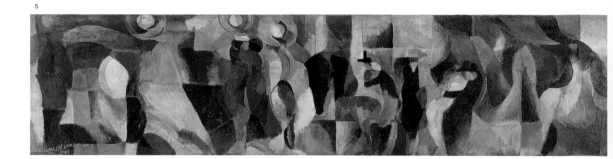

1 **Rhythme,** 1938. Oil on canvas, 536 x 595 cm

2 **Contrastes simultanés,** 1912. Oil on canvas, 46 x 55 cm

3 **Jeune fille endormie,** 1907. Oil on canvas, 46 x 55 cm
4 **Couverture,** 1911. Appliquéd fabric, 82 x 111 cm

5 **Le Bal Bullier,** 1913. Oil on mattress fabric, 97 x 390 cm
6 **Rhythme Couleur,** 1958. Oil on canvas, 100 x 143 cm

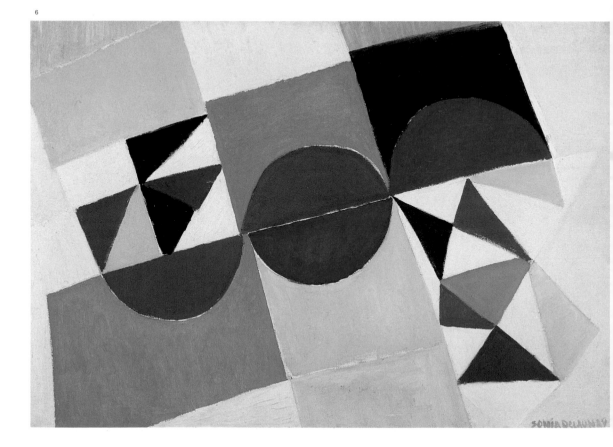

56 Sonia Delaunay

to Paris in 1905 and signed on at the Académie de la Palette. Her family, however, thought that a professional career in the arts was not appropriate to her station in life, and to avoid returning to Russia as they demanded, she in 1909 married a friend, the art dealer and collector Wilhelm Uhde. The previous year she had had her first solo show of figurative paintings at Uhde's Paris gallery, where the work she exhibited reflected her interest in van Gogh, Gauguin, Matisse, and German Expressionism, and was well received by the press. It was through the gallery that, in 1908, she met fellow artist Robert Delaunay, whom, after divorcing Uhde, she married in 1910. It was the beginning of a creative partnership that was to last 30 years, a partnership founded on shared aesthetic ideas and intense debate and mutual influence, and on projects that the two brought to fruition together. It was Sonia, indeed, who largely saw to their financial security, which meant that her own work as a painter was shelved until Robert Delaunay died in 1941. This division of labour had long-term implications, and to this day there are reference works with an entry for Robert Delaunay but none for Sonia.

Despite her successful debut as a painter, in 1909 she turned to the applied arts. Her first abstract work was created in 1911, the year of the birth of her son Charles, when she made a patchwork blanket for the infant's cot, combining features of Cubist painting with reminiscences of Russian folk art. Meanwhile Sonia and Robert Delaunay were pursuing their studies in colour theory and their experiments in painting, and, in 1912, Sonia completed her first abstract painting, *Contrastes simultanés*, which suggests a landscape in sunlight. At the same time, Robert was at work on his series of *Formes Circulaires, Soleil*. The Russian Revolution of 1917 signalled a turning point, since Sonia no longer had her rent income, which had hitherto been the foundation of their financial security, and it was now that she decided to extend her work in applied art and put it on a commercial basis. In addition to designing costumes for Diaghilev's Russian Ballet and for Tristan Tzara's play *Le Cœur à Gaz*, 1923, she worked for industry, creating the interior of a Citroën car or a collection of fabrics for a Lyons textile manufacturer. In 1925, to coincide with the Exposition des Arts Décoratifs in Paris, she opened the Boutique Simultané, for fashion and accessories, with fashion designer Jacques Heim. The shop numbered among its customers stars of the fashion and film worlds, such as Coco Chanel and Greta Garbo.

Late recognition as an artist

In the early 1930s, Sonia Delaunay returned to abstract painting, not least because the depression had forced her to close the boutique in 1929, and in 1932 she became a member of the Abstraction-Création group of artists. However, it was not until the 1950s that she was accorded her first retrospective exhibitions in museums (widely seen as a yardstick of recognition) and began reaping the first of many official honours. Stanley Baron, author of a biography of Sonia Delaunay, believes that the tardiness of this institutional recognition was related to the conventional distinction between high art and the more everyday, applied variety, which was seen as a lower product altogether. Nevertheless, two decades after her death in 1979, we can now see that Sonia Delaunay's work and approach are coming into their own: in the late 1990s, many a fashion designer took to quoting the ideas characteristic of Sonia Delaunay's designs, while at museums the relations between fashion and art have been the subject of a number of exhibitions in recent years.

Barbara Hess

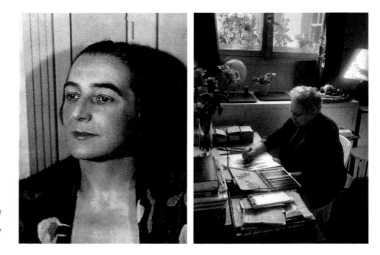

Sonia Delaunay, 1932

Sonia Delaunay in her
Paris studio

Rineke Dijkstra

✳ 1959 in Sittard, The Netherlands; lives and works in Amsterdam, The Netherlands

Selected solo exhibitions: **1988** "Paradiso Portretten", de Moor, Amsterdam, The Netherlands /
1997 "Location", The Photographer's Gallery, London, England / **1998** "Menschenbilder", Museum Folkwang, Essen, Germany;
Museum Boijmans Van Beunigen, Rotterdam, The Netherlands / **2001** The Art Institute of Chicago, Chicago (IL), USA

Selected group exhibitions: **1993** Foto Festival Naarden, Naarden, The Netherlands / **1996** "Prospekt '96", Schirn Kunsthalle,
Frankfurt am Main, Germany / **1997** XLVII Esposizione Internazionale d'Arte, la Biennale di Venezia, Venice, Italy /
1998 São Paulo Biennial, São Paulo, Brazil / **2000** "how you look at it", Sprengel Museum Hannover, Hanover, Germany

Identity and gaze

A young girl stands on the beach. Her heels are pressed close together on the wet sand. Behind her is the sea, and above her the infinite blue of the sky. The girl's orange bikini emphasises her well-developed figure as she presses her long blonde hair to her left shoulder, while her right hand with rings on three fingers rests loosely on her left thigh. She looks at the camera with a certain shyness and searching dreaminess, expressing at the same time a self-confidence in her stately appearance. From 1992 to 1996, Rineke Dijkstra took portraits of children and pubescent youngsters on various beaches, e. g. in Holland, the USA or the Ukraine. Sometimes they stand alone, sometimes in groups of two or three. Otherwise the decidedly conceptual approach of these "beach portraits" is always the same: Dijkstra photographs the children and youngsters wherever she comes across them. Nothing is staged. Instead, the subjects look direct-ly and naturally at the camera. She shoots them slightly from below, always in daylight and yet with flash. The youngsters therefore stand out in the photos, sharply outlined against the sea. This very preciseness is in stark contradiction to the aura of uncertainty, even vulner-ability evinced by the subjects. Fully aware of the conventions of portrait photography, the subjects cast around for the right expression and personal pose they would like to present to the photographer or later viewers of the photo. The "beach photos" are thus a sensitive testimony to their search for self and self-presentation. Somewhere in the interplay of the carefree and the cliché, the individuality and generality, identity makes an appearance at an artistic level.

The "beach portrait" series soon made Dijkstra well-known in the late 1990s. The emotional, perhaps even latently dramatic qual-ity of the pictures, despite the minimal outlay on intervention and staging, was the formula for success. Nonetheless, the question arose as to whether she was just acting as a documentary photographer. Justly, because the question illuminates the core of her aesthetic phil-osophy. "As soon as you take an interest, fiction comes into play", said the French film director Jean-Luc Godard, defining the difference between document and art. The "interest" was one of "relationships and connections" In this context, Godard was referring mainly to the

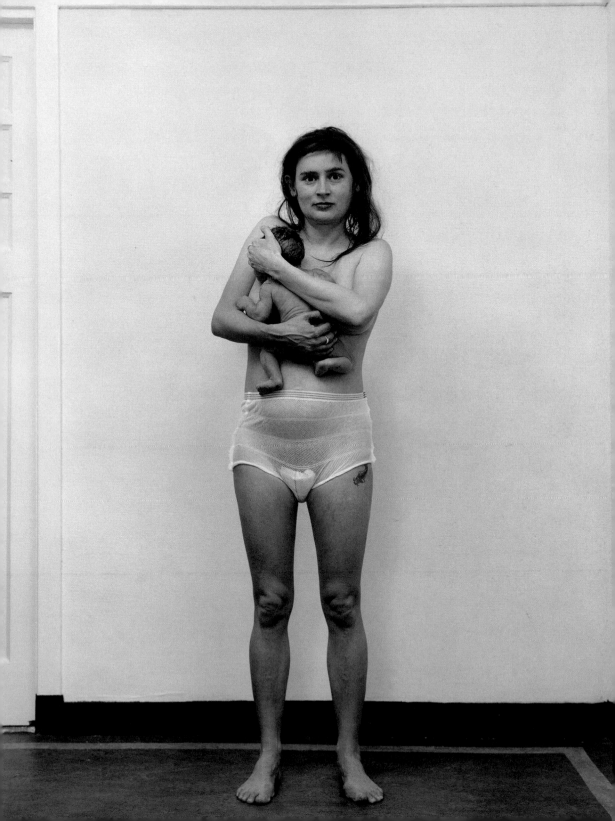

"I don't take photos of people who fancy themselves. They can't surprise me."

2

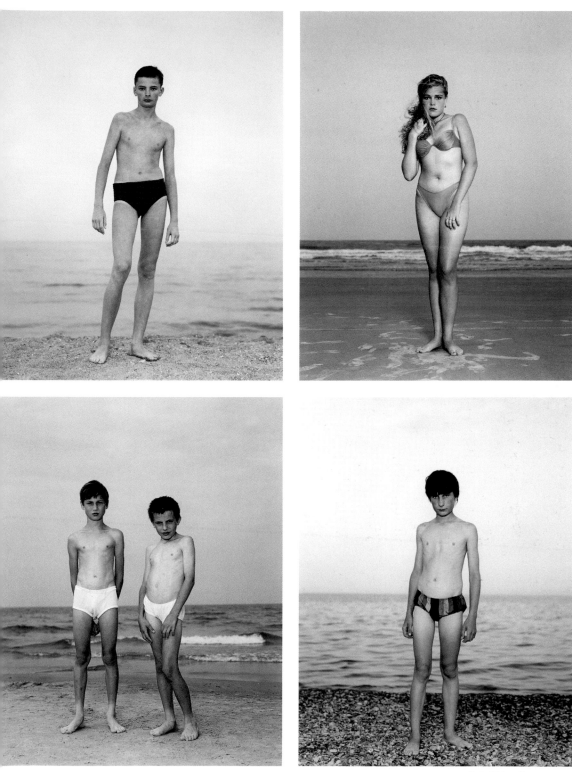

5

7

8

9

relationship of the individual with himself and with objectivity, i.e. the socially communicated essence. In this respect, fiction goes beyond the documentary. "Fiction is in fact the expression of documentation. The documentary is the impression", according to Godard. It is precisely this expression of the relationships between subjectivity and essence that recurs in Dijkstra's portraits. For example, during a stay in Portugal, she photographed bullfighters just at the moment of leaving the arena. The strain still shows on their faces, but exhaustion and uncertainty about what has just happened is also visible. "Universal experiences", as Dijkstra calls them, such as danger and death, or the relationship between human mastery and animal subjugation, is what these pictures are about. In *Villa Franca, Portugal, 8 May 1994*, for example, bloodstains on the white shirt collar and rents in the matadors' costumes bear witness to a fight successfully weathered.

Contradictory emotions

The photos that Dijkstra took of women who have just given birth are also about existential matters. Once again, the photos are taken with a plate camera and flash. Birth instead of death, women instead of men are now the agenda. The series forms thus a kind of counterpoint to Dijkstra's bullfighter series. In *Julie, Den Haag, February 29, 1994* we see a young mother holding a baby only a few minutes old. Proud, at once both a little astonished and imperious, the woman stands in an anonymous corridor looking at the camera. Instead of an unambiguous emotional state, we are once more presented with a fascinating mixture of contradictory emotions expressed in the pictures. Again, the titles of the pictures identify the place and time of the photos, but this time the subject's first name is included. The existential thus becomes concrete and is set in a precisely identifiable context. Or is it? The fact is, the sober hospital setting gives us no idea whether Julie is, for example, hard up or well-off. Even so, the viewer looks in vain for supposed "eternal human truths" here.

Model and self-presentation

In her first video work, *The Buzzclub, Liverpool, UK/ Mysteryworld, Zaandam, NL (1996–97)*, Dijkstra concentrated wholly on the relationship between individual self-perception and social moulding. For over two years she filmed young people who regularly visited two discotheques, one in England, one in Holland. Once again, Dijkstra's subjects stand in front of a plain background, while her gaze is directed at the disco visitors arriving singly or in pairs. To a certain extent, the artist has transferred the white cube of the art gallery to the pleasure temple of youth. And vice versa – suddenly two teenagers are seen canoodling on the video screen in the museum, dance music is heard, and art lovers are confronted with the current club scene instead of the codes of art history. Sometimes the subjects stand nonchalantly holding a drink, sometimes they chew gum in embarrassment, then perform a few cheeky dance steps in front of the camera. The protagonists of this video installation trot out more or less all the 'Saturday night fever' rituals – and yet there is always a gap between the image they would like to convey and how they actually present themselves. The teenagers have not yet found their identities. Their egos still appear to contradict the standard values of the rules dictated by the discotheque environment. On this point, Dijkstra once quoted the American photographer Diane Arbus: "This is to do with what I always call the discrepancy between intention and effect."

Raimar Stange

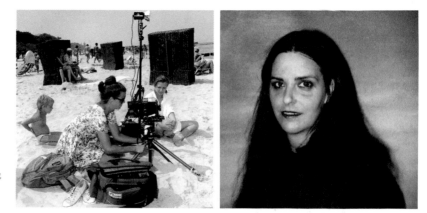

Rineke Dijkstra on Kolobrzeg beach, Poland, 1992

Rineke Dijkstra

Marlene Dumas

*** 1953 in Cape Town, South Africa; lives and works in Amsterdam, The Netherlands**

Selected solo exhibitions: **1992** "Miss Interpreted", Stedelijk Van Abbemuseum, Eindhoven, The Netherlands; Institute of Contemporary Art, Philadelphia (PA), USA / **1995/96** "Models", Salzburger Kunstverein, Salzburg, Austria; Portikus, Frankfurt am Main, Germany; Neue Gesellschaft für bildende Kunst, Berlin, Germany / **1996** "Marlene Dumas", Tate Gallery, London / **1998** "Fantasma", Fundacão Calouste Gulbenkian – Centro d'Arte Moderna, Lisbon, Portugal / **2000** "M D", Muhka, Antwerp, Belgium; Camden Arts Centre, London; Henie Onstad Art Center, Oslo, Norway

Selected group exhibitions: **1982** documenta 7, Kassel, Germany / **1992** documenta IX, Kassel, Germany / **1995** "Africus", Johannesburg Biennial, Johannesburg, South Africa / XLVI Esposizione Internazionale d'Arte, la Biennale di Venezia, Dutch Pavilion, Venice, Italy / **2000** Sydney Biennial, Sydney, Australia

Selected Bibliography: **1999** Marlene Dumas, *The Phaidon Book*, London

Identity as interpretation

Marlene Dumas grew up in South Africa during the 1950s and 1960s. As a "white African" she soon experienced the fate of being a stranger in her own land. The apartheid regime propagated a society segregated by race and dominated by whites. To belong to a minority and to possess power over the majority induced a sense of guilt in Dumas, which she carried with her when she went to Holland to study art in Amsterdam in the mid-1970s. This was where the young artist's international career began, initially with drawings, collages and object montages, then, in 1983, with the drawings and oil paintings for which Dumas is best known today. She also rapidly made a name for herself as an intelligent, independent-minded writer on aesthetics.

Dumas' emotional painting, usually done with glazes, frequently relies on photographs she has discovered or taken, as well as on motifs from the history of art and literature. The titles as well as words and phrases introduced into the pictures – almost always human faces, nude figures, or groups of people – contribute to suspenseful layers of meaning. The result of this artistic strategy is not an expressionism that would suggest "profound authenticity" to the viewer, but it does convey a form of reflected feeling, of a broken if content-rich sensuousness. Detachment and intensity remain in balance, and the gestural, action-emphasising character of the painting process does not detract from the almost conceptual air of Dumas' imagery.

This is an art on a continual search for the meaning and possibility of personal identity, which both emotionally appeals to and intellectually challenges the viewer. The relationship with the viewer is always taken into consideration. Dumas frequently reflects on this reciprocal relationship in her writings as well.

As mentioned, what it means to have a split identity, both vulnerable and powerful, was something the artist experienced during her early socialisation in South Africa. The dilemma was deepened by the fact that she was not only white but female. From the beginning, Dumas has defined her feelings and existential self-relationship both from the outside and from an inward, self-determined interpretation. This is why her paintings rest on a dual foundation: the externally determined view represented by the photographs and other cultural manifestations, and the painting process used to suffuse this view with personal meaning. This is seen to good effect in *Snow*

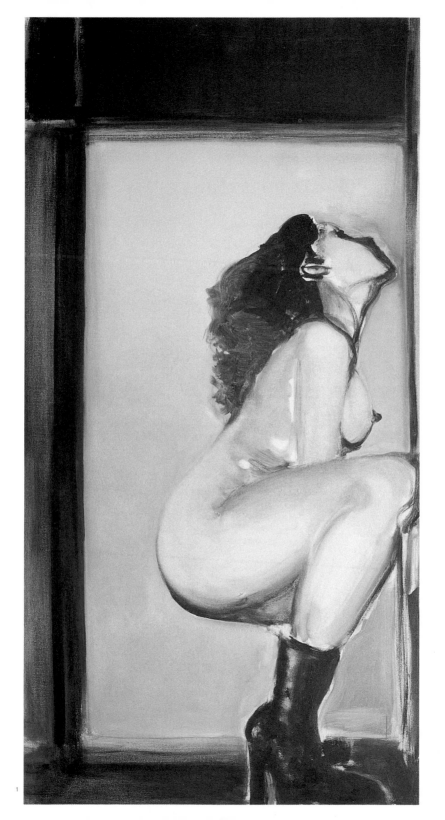

"Even when I make a picture of a living being, I always create only an image, a thing, and not a living being."

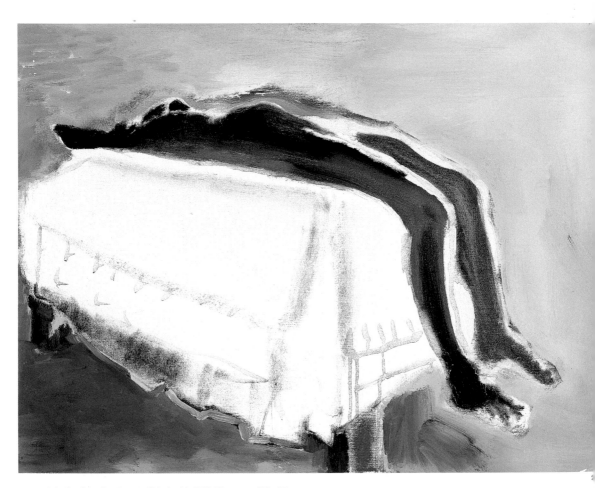

1 **Leather Boots** from the series **Strippinggirls**, 2000. Oil on canvas, 200 x 100 cm

2 **Waiting (for Meaning)**, 1988. Oil on canvas, 50 x 70 cm

3 **Cleaning the Pole** from the series **Strippinggirls**, 2000. Oil on canvas, 230 x 60 cm

4 **Cracking the Whip** from the series **Strippinggirls**, 2000. Oil on canvas, 230 x 60 cm

5 **Caressing the Pole** from the series **Strippinggirls**, 2000. Oil on canvas, 230 x 60 cm

6 **Young Boys (Pale Skin)**, 1996. Mixed media on paper, 125 x 70 cm

7 **The Painter**, 1994. Oil on canvas, 200 x 100 cm

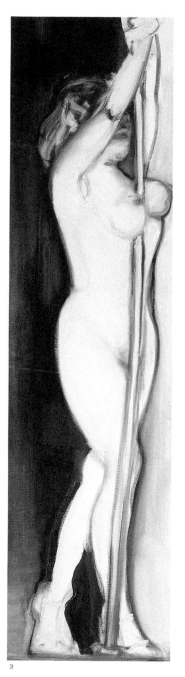

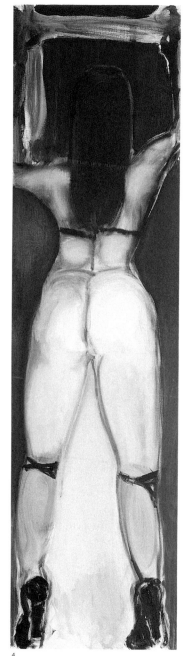

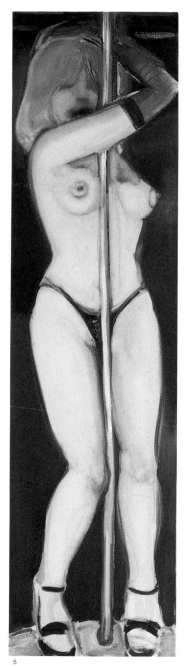

3

4

5

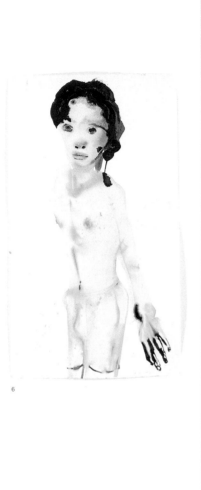

6

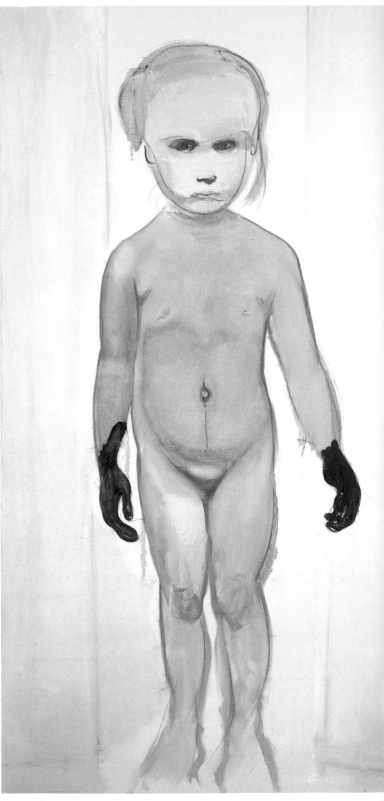

7

White and the Broken Arm, 1988. Snow White, a metaphor for the "white negress", lies naked and apparently helplessly exposed to the stare of men with childish faces. In her bent, evidently broken arm she holds a camera, and the Polaroids she has just taken lie strewn over the floor. The images on the photos are not recognisable, since they lie face downward.

In this image, several stories – and this is typical of the artist's approach – are simultaneously interwoven, preventing any hard-and-fast interpretation. First there is the fairy-tale reference to Snow White and the Seven Dwarfs, the story of the lovely maiden in a glass coffin who has come back to life. The camera and photos expand this narration to include a self-portrait of the artist. The figure's pose and the sombre, as it were icy colours have reminded some commentators of the dead Christ, who has taken the sins of mankind upon himself. His hoped-for resurrection provides a link with the Snow White tale. The voyeurs looming in the background, finally, recall Henry Füssli's painting *The Nightmare,* 1781, in which a swooning woman is watched by a gnome. These figures bring a similar sense of latent threat into play. Covert or overt references to apartheid are found in many other works as well. One is a female nude entitled *The Guilt of the Privileged,* 1988, in which Dumas apparently admits to her sense of guilt, presenting herself as a sexual object. Another is *The White Disease,* 1985, an oppressive image of a bloated white face.

Mental confusions

Yet Dumas' themes evince more aspects than these. The range extends from "childhood and motherhood" – as in the four-painting sequence *The First People I-IV,* 1991 – to religious issues, as in the series *Mary Magdalene,* 1995. Pornography and sexuality are also given critical, if sometimes lustful readings. The bright red mouth of *Girl with Lipstick,* 1992, or the blonde with the temptingly rolled-down stocking in *Miss January,* 1997, for instance, expose women to the gaze of the viewer, whose voyeurism is simultaneously satisfied and unmasked. Men, naturally, are also represented in Dumas' imagery, as in *The Schoolboys,* 1987, a portrait of adolescents in their school uniforms.

Whatever subject Dumas addresses, she invariably avoids a merely superficial art for art's sake. Instead, she stages sensuous and seductive images rife with meaning and open to multiple interpretations. "Mental confusions", as Dumas herself says, are the most positive reaction we can expect to have.

Raimar Stange

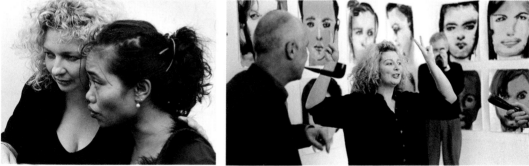

Marlene Dumas and Lisa Sulisliawati, 1998

Marlene Dumas in the Kasseler Kunsterverein, 1998

Marlene Dumas at her exhibition at the Portikus, Frankfurt, 1995

"Three generations: I (in my forties), my mother (in her seventies) and my daughter Helena (almost ten years old)," 1990s

Tracey Emin

✳ 1963 in London, England; lives and works in London

Selected solo exhibitions: **1994** White Columns, New York (NY), USA / **1996** Habitat, London / "Exorcism of the Last Painting I Ever Made",
Galleri Andreas Brändström, Stockholm, Sweden / **1998** Gesellschaft für aktuelle Kunst, Bremen, Germany /
1999 "The Turner Prize 1999", Tate Gallery, London, England

Selected group exhibitions: **1994** "Karaoke & Football", Portikus, Frankfurt am Main, Germany / **1995** "Brilliant", Walker Art Center,
Minneapolis (MN), USA / **1997** "Sensation", The Royal Academy of Arts, London, England / "Time out", Kunsthalle Nürnberg, Nuremberg, Germany /
1998 "Emotion", Deichtorhallen Hamburg, Hamburg, Germany

Selected bibliography: **1994** *Exploration of the Soul*

The tyranny of intimacy

More legends have probably arisen around Tracey Emin than around any other artist who came on the scene in the 1990s under the label of Young British Art (YBA). Stories about her dropping out of school, doing dodgy jobs, having a wild sex life and all the attendant traumas – such as losing her virginity at 13, in what was actually a rape – appeared everywhere not just in the art journals. Readers and viewers were made privy to stillbirths, alcohol abuse, and, not least, to scandalous live appearances on TV. Such stories of lust and pain were nourished by Emin's art itself, a merciless exploitation of her own biography, whose apparently exhibitionistic directness can seem truly shocking. The viewer inadvertently becomes a voyeur who can satisfy his need for sensationalism and human interest in a way otherwise provided only by the mass media. But he can also gain something from Emin these media do not offer, since a closer look at her art reveals a poetic and precise, evidently authentic world, which is capable of throwing one back on one's own life and problems. The individual and the universal, the intimate and the public, are continually interwoven in Emin's work.

Within this force field, she manages to engender a compelling discourse on affects and desires which spirits the viewer and his longings back into the otherwise dry, academic, "objectified" art world. This is precisely where the political aspect of Emin's art lies.

The way in which moments from her own biography are interlinked with collective experience, recollection, and current concerns is clearly seen in *Everyone I Have Ever Slept With From 1963–1995,* a work of 1995. The inside walls of a small igloo tent were covered

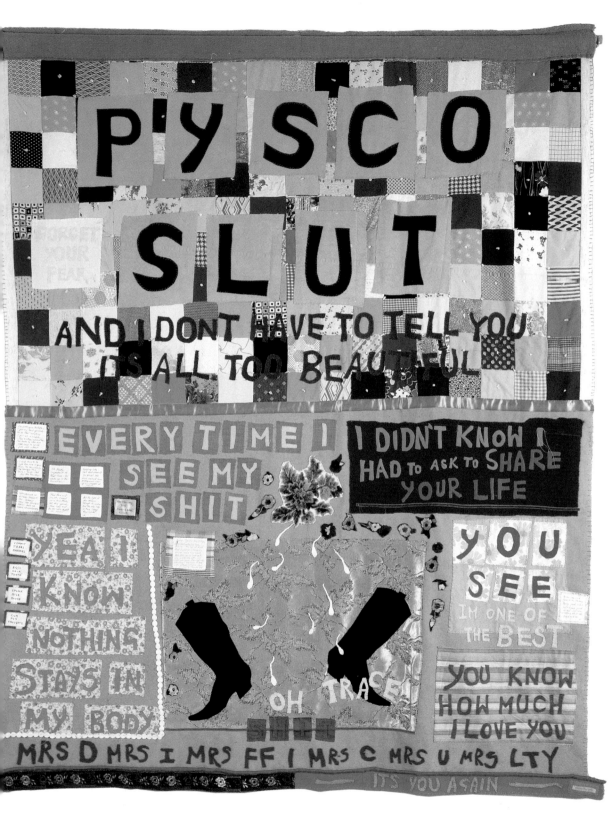

1 **Pysco Slut,** 1999. Appliquéd blanket, 244 x 193 cm

2 **Installation view,** 1999. "The Turner Prize 1999", Tate Gallery, London, England
3 **I've got it all,** 2000. Ink-jet print, 122 x 91 cm
4 **Blinding,** 2000. Neon, 120 x 150 x 8 cm
5 **Beautiful Child,** 1999. Mono screenprint, 65 x 81 cm

6 **Outside Myself (Monument Valley),** 1994. Colour photograph, 65 x 81 cm
7 **There Is A Lot Of Money In Chairs,** 1994. Appliquéd armchair, 69 x 54 x 50 cm
8 **Everyone I Have Ever Slept With 1963–1995,** 1995. Appliquéd tent, mattress and light, 122 x 245 x 215 cm

"For me, being an artist isn't just about making nice things or people patting you on your back; it's some kind of communication, a message."

2

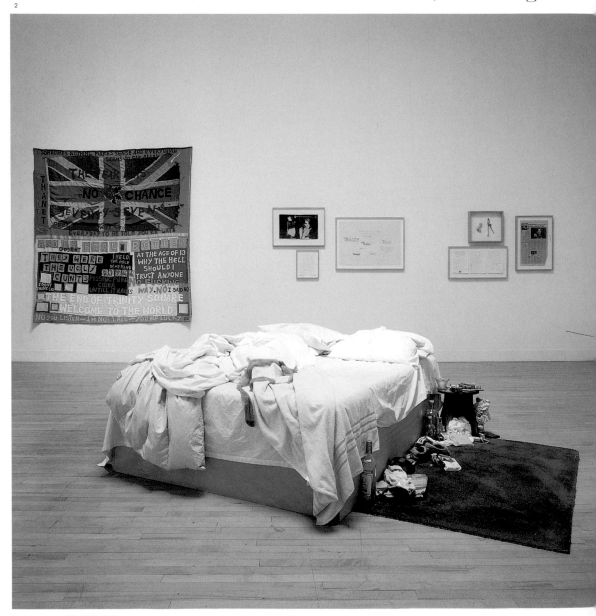

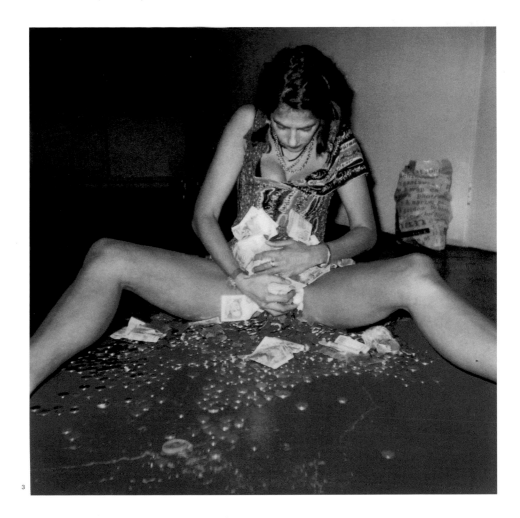

3

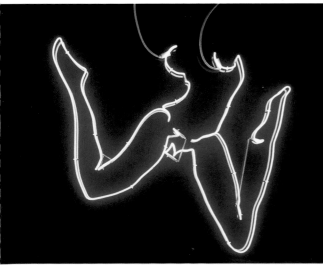

4

5

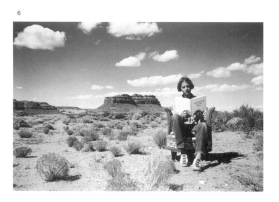

6

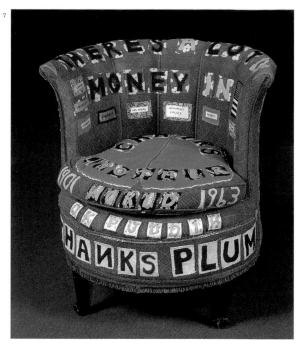

7

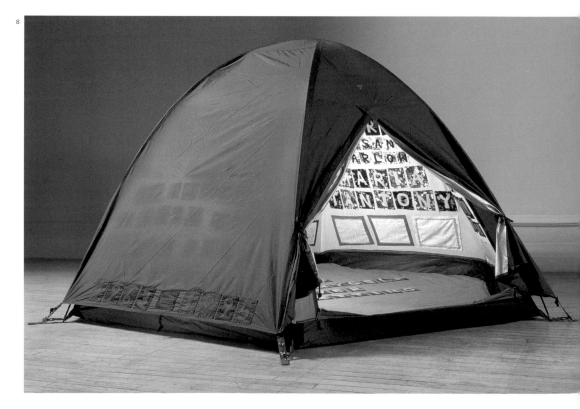

8

with varicoloured, cut-out letters spelling out the names of all those who shared a bed with the artist during that time period. These included early boyfriends and girlfriends, family members, her twin brother, and of course subsequent lovers. Not to forget her own name: *With myself always myself never forgetting*. Intimate moments were recalled, scenes of a kind almost everyone has experienced in a tent. In addition, the tent called up associations with prenatal security, the joys of teenage holidays, as well as with a nomadic restlessness and a despairing drive.

Documentary authenticity as fiction

The written word appears frequently in Emin's art: sentimental embroideries and "handwritten" neon tubes – as in the frigid, light-blue illumination of *Fantastic to Feel Beautiful Again,* 1997 – notations on walls, drawings and paintings, even entire books. In her *Exploration of the Soul,* 1994, Emin recorded her chequered life story from her conception to loss of virginity. Yet despite all its seeming authenticity, this retrospective recollecting view proves to be fiction, a kind of literary self-investigation which could hardly be more narcissistic, but which for that very reason hovers between a frank confession and an aesthetic *mise en scène*. On a trip through America by car, Emin read from her book at various venues, seated in an overstuffed easy chair that was covered with diverse embroideries (*There Is A Lot of Money in Chairs*, 1994). The readings were accompanied by tape recordings and live commentaries. The photo work *Monument Valley (Grand Scale)*, 1995, shows the artist at one such "session". It is a good example of the way the various corresponding levels in her work enter the type of dialogue she intends to initiate in the viewer's mind.

Alternative art presentations

The effect of Emin's art is craftily augmented by the artist's personal presence, as in the installation *Exorcism Of The Last Painting I Ever Made,* 1988. This reconstruction of her own studio in the museum context included laundry hanging on a line, paintings leaning against the walls, an unmade bed, empty cigarette packets, diverse mundane objects, and drawings and painting utensils chaotically scattered over the floor. A video showed the artist, naked, presenting a painting performance. During the vernissage, Emin was there in her simulated atelier, charging the work with her immediate presence and thereby making it "corporeal" and "vital" in the truest sense of the words. Yet as the title of the installation indicated, the spiritual aspect of her work is essential to Emin.

In 1995, the artist established her own Tracey Emin Museum in London. In the private atmosphere of a rented flat on Waterloo Road, a great variety of works were presented, including the autobiographical video *Why I Didn't Become a Dancer,* 1995. The museum, as it were the quintessence of her career displayed in surroundings combining museum with gallery, apartment with souvenir or clothing store, represents an alternative to familiar modes of art presentation. A powerful form of communication that transcends hidebound rituals to address the viewer dynamically and directly through personal confession – as does Emin's oeuvre as a whole. *Raimar Stange*

Tracey Emin

VALIE EXPORT

* 1940 in Linz, Austria; lives and works in Vienna, Austria, and Cologne, Germany

Selected solo exhibitions: **1980** "Körperkonfigurationen 1972–1976", Galerie Krinzinger, Innsbruck, Austria / "Video Pojekte, Fotografien", Stedelijk Museum, Amsterdam (with Ulrike Rosenbach) / **1990** "Gläserne Papiere", EA Generali Foundation, Vienna, Austria / **1997** "Split:Reality VALIE EXPORT", Museum Moderner Kunst, Stiftung Ludwig Wien, Vienna, Austria / **2000** Ob/De+Con(Struction)", Goldie Paley Gallery and Levy Gallery for the Arts in Philadelphia at Moore College of Art and Design, Philadelphia (PA), USA

Selected group exhibitions: **1974** "Projekt 74", Kölnischer Kunstverein, Cologne, Germany / **1979** "Im Namen des Volkes", Wilhelm Lehmbruck Museum, Duisburg, Germany / **1996** "L'Avant-garde Autrichienne au Cinéma 1955–1993", Musée national d'art moderne, Centre Georges Pompidou, Paris, France / **1997** "Photography after Photography", Institute of Contemporary Arts, London, England / **1999** "Out of Actions: Between Performance and the Object, 1949–1979", Museum of Contemporary Art, Los Angeles (CA), USA

Selected bibliography: **1992** VALIE EXPORT, *Das Reale und sein Double: DER KÖRPER* / **1997** C. Braun (ed.), *Split: Reality Valerie Export*, Vienna, Austria / **1998** *Bilder der Berührungen* (CD-Rom)

Always and everywhere

"Export means always and everywhere," declared VALIE EXPORT in a 1996 interview. "It means exporting myself. I did not want to use either my father's name or that of my husband. I wanted to find a name of my own." A black-and-white photograph titled *Smart Export/Selbstportrait* (Smart Export/Self-Portrait, 1967/70) shows the artist in the style of the youth's protest movement of the late 1960s: a cigarette in the corner of her mouth, she is offering us a SMART EXPORT cigarette pack whose packaging is emblazoned with the artist's name and portrait: "VALIE EXPORT—semper et ubique—immer und überall" (i.e. always and everywhere). The artist wanted her adopted name to be "written only in capitals", giving it not only the impact of a manifesto, but also the quality of a logo. Coupled with the legend "MADE IN AUSTRIA", the name conveyed the idea that the production of art is also the production of a commodity, and linked that idea to the issue of how women are constructed as commodities both within and outside the art world.

VALIE EXPORT's work of the 1960s grew out of the Vienna Actionism background, but also insisted on its own discrete identity. Like the Vienna Actionist artists Hermann Nitsch, Günter Brus, Otto Mühl or Rudolf Schwarzkogler, Export often used the body (her own) as the subject and the point of departure for her work; and, again like the Actionists, she sought to transcend the boundaries imposed by taboos and so confront a sated middle-class public that had returned all too swiftly to a "normal" life after the Second World War. Nevertheless, VALIE EXPORT's actions and performances, photographs and films differed in two respects from those of Vienna Actionism. Firstly, they were emphatically feminist, deconstructing images of women established by a male-dominated society. Thus Export defined her self-inflicted injuries – as in the film … *Remote … Remote*, 1973, in which she worries at her fingertips with scissors till they bleed – not as the expression of an individual masochistic impulse, but rather, in her view, as "signs of history, revealed in actions involving the body" (cf Export in the 1979 essay "Feminist Actionism"). Similarly, the garter she had tattooed on her left upper thigh in *Body Sign Action*, 1970, was meant as a "sign of past enslavement". Secondly, however, Export's artistic output was intended from the outset as a critique of the media. She never saw photography, film or video as neutral and documentary. In her text *Mediale Anagramme* (Media Anagrams), 1990, she described her work as "notebooks in which the 'pages', notes, images, are repeatedly being shifted to

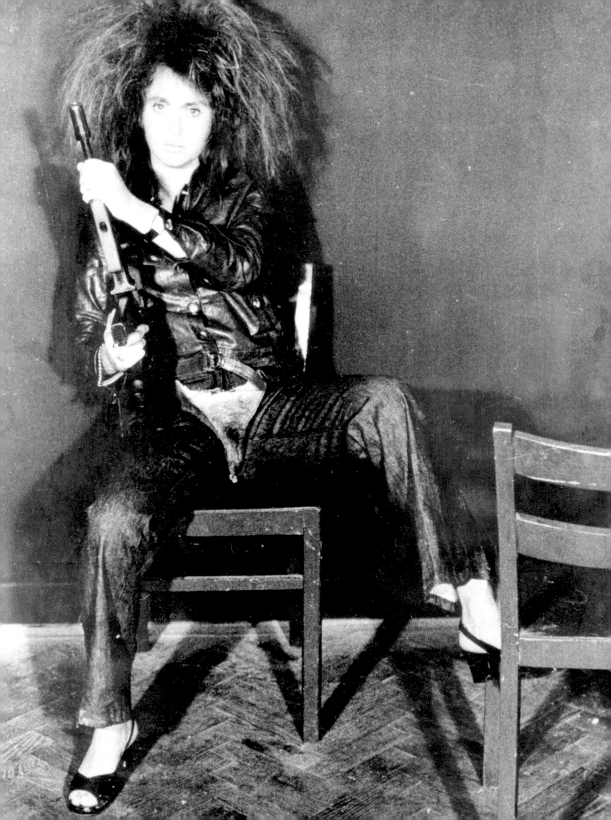

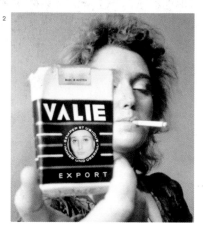

2

1 **Aktionshose: Genitalpanik**, 1969/1980. Black-and-white photograph, 176 x 127 cm
2 **Smart-Export, Selbstporträt**, 1967/1970. Black-and-white photograph, 61 x 41 cm
3 **Body Sign Action**, 1970. Body action, (total art), concept sheet, pencil, coloured pencil, colour photograph on paper, 43 x 41 cm
4 **Body Sign**, 1971. Body action, (total art), black-and-white photograph, 30 x 24 cm
5 **Erwartung**, 1976. Photo-object, 85 x 155 x 124 cm
6 **Tapp- und Tastkino**, 1968. Tap-and-touch cinema, street cinema, mobile cinema, genuine women's cinema, body action, social action
7 **Der Schrei**, 1994. Laser-video-text and voice installation. Installation view, Neuer Aachener Kunstverein, Aachen, Germany, 1998
8 **Adjungierte Dislokationen**, 1973. Expanded cinema

"If women abandon their husbands and children, and society tolerates their action both legally and socially, as it does in the case of a man; if women achieve all of this – then they will develop an equally copious creativity."

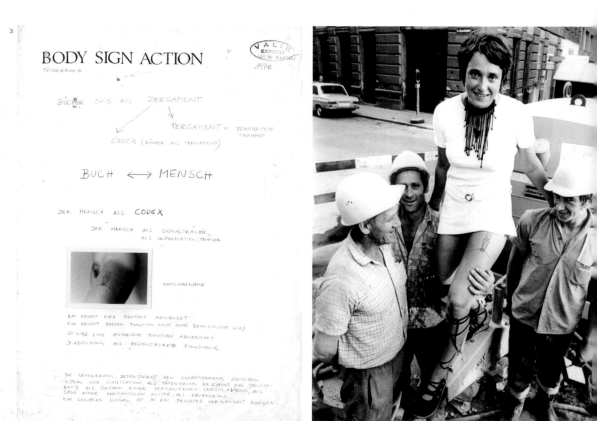

3

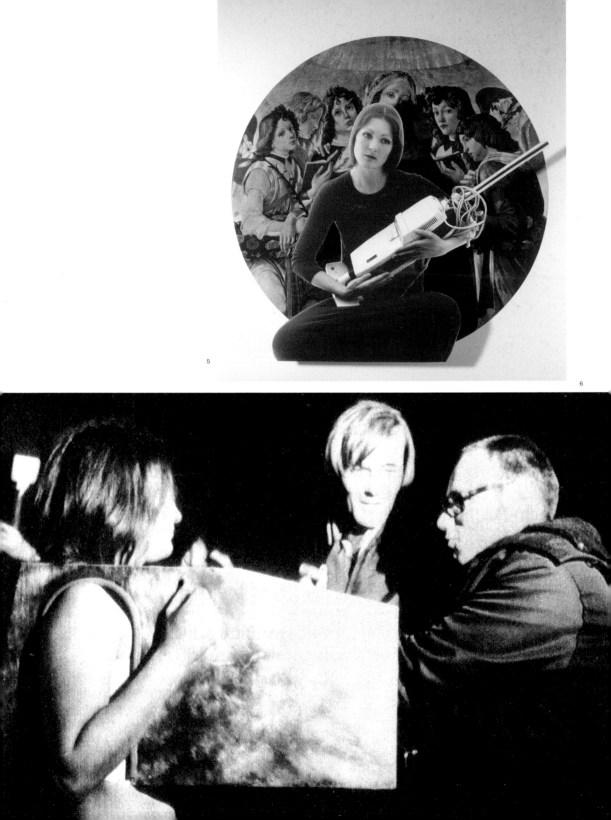

different relations, and new meanings make a new context possible. The medium alone is not the message, or, to put it differently, the medium is not only ONE message." The anagrammatical principle of re-ordering existing elements so as to produce ever new meanings has also been characteristic of Export's use of the digital media since the late 80s, as in her CD-ROM *Bilder der Berührungen* (Images of Contact), 1998, which offers not merely a comprehensive audiovisual archive of her work of three decades, but also, through the interactive side, the option of shifts in the order and mode of viewing.

Tapp- und Tastkino

Ever since the 1960s, Export has repeatedly aimed to reveal and dismantle the patriarchal regime of vision and power structures that underpin images of "femininity". Thus in her famous *Tapp- und Tastkino*, 1968, she undermined the cinema's use of the female body for a heterosexual male audience. Export strapped a box with two curtained openings onto her chest and went out in the streets, while her partner of the time, Peter Weibel, speaking through a megaphone, invited passers-by to feel Export's bared breasts through the drapes. It was VALIE EXPORT's way of transforming the voyeuristic situation of the cinema into an "expanded cinema" – substituting for a male-defined cinema image of "femininity" her own real body, and returning the gaze of those who looked at her, thus making them in turn objects to be stared at. No less radical was her performance *Aktionshose:Genitalpanik* (Action Trousers:Genital Panic), 1969: wearing a pair of trousers with the crotch cut out, and armed with a machine-gun, Export strode down the rows of a Munich porn cinema amongst would-be viewers who had been expecting screen images of genitals. Threatened both physically and psychologically by the weapon and by the "ontological leap" (as the title of a 1974 photographic series later had it) from pornographic image to real female genitals, the audience left the cinema.

Image and reality

By superimposing or layering different representations of the same subject, Export makes visible not only the constructed nature of images but also the potential to change them. She also points out the mutual influence and interpenetration of image and reality. A good example of this strategy is a series of posed photographs showing women with domestic objects in the postures of Renaissance madonnas. Thus in *Die Putzfrau (Fotoobjekt nach Tizian)* (The Cleaning Woman, photo after Titian, 1976), two contradictory stereotypes, one an idealised cliché from high culture and the other a pejorative cliché of everyday culture, are superimposed. One option for the deconstruction of received cultural gender identities and socially defined roles (such as that of motherhood) is the technological extension or relocation of biological bodily functions. With one eye on Sigmund Freud, who saw humankind as the "prosthetic god", Export's installation *Fragmente der Bilder einer Berührung*, 1994, spotlights the technologies of reproduction, which (whatever the justified criticisms) can also be a contribution to "liberation from the burden of the body" (in Export's phrase): lit light bulbs were lowered gradually and immersed in glass vessels containing milk, oil or water, and then withdrawn. The technical procedure evoked associations with an a-physical sexual act, and thus the ambivalent vision of a liberation from the body – which for VALIE EXPORT is equivalent to transcending the reality principle.

Barbara Hess

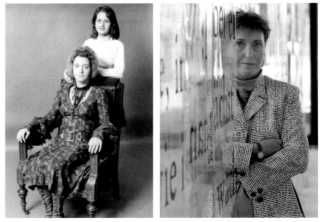

VALIE EXPORT with her
daughter Perdita, 1970

VALIE EXPORT at the opening
of her retrospective at the 20er
Hause (20s House) in Vienna,
1997

Sylvie Fleury

*** 1961 in Geneva, Switzerland; lives and works in Geneva**

Selected solo exhibitions: **1994** "Espace", Le Consortium, Dijon, France / **1996** "First Spaceship on Venus", Musée d'Art Moderne et Contemporain, Geneva, Switzerland / **1998** "Hot Heels", Migros Museum, Museum für Gegenwartskunst, Zurich, Switzerland / **1999** Villa Merkel, Galerie der Stadt Esslingen, Esslingen, Germany / **2000** "John Armleder & Sylvie Fleury", Kunstmuseum St. Gallen, St. Gallen, Switzerland

Selected group exhibitions: **1993** "Post Human", Deichtorhallen Hamburg, Hamburg, Germany / **1993** "Aperto", XLVI Esposizione Internazionale d'Arte, la Biennale di Venezia, Venice, Italy / **1998** Biennale de São Paulo, São Paulo, Brazil / **1999** "Heaven", Tate Gallery, Liverpool, England / **2000** "Human Being and Gender", Korea Biennial, Seoul, Korea

The world as a shopping basket

Sylvie Fleury made her name in the early 1990s with her *Shopping bags*, arrangements of designer brand-name bags looking as if they had simply been left on the gallery floor after a shopping spree. The content was covered with fine fabrics, making the bags seem even more enigmatic, and more attractive. Fleury's hallmark was to transfer women's luxury consumer goods, as ready-mades, into the art context – everything from black-and-gold Chanel cosmetics packages in *Coco*, 1990, to photographic enlargements of the covers of glitzy fashion mags, to a spacious installation with a soft-pile carpet, stylish seating and countless designer shoes and shoeboxes. Critic Eric Troncy described her as "an artist who creates her works on a credit card", and, much as in the case of Andy Warhol, the issue of whether her art was intended to be critical of its subject matter or affirmative was much debated. Many of her works seem to confirm the cliché that fashion and decor are among the favourite interests of women, and even Fleury's projection of herself as a "fashion victim" and her statements show that she herself is an enthusiastic consumer of the commodities that appear in her work.

It can surely be no coincidence that Fleury's first work dates from a time when capitalism saw itself as the triumphant social and economic model. In 1993, she noted in an interview: "The system has collapsed, as it has in other areas, and I believe we are now at liberty to rummage about in the free world as we might in a basket of goods." The 'basket of goods' Fleury has rummaged in contains not only a substantial range of pretty exclusive products aimed at female consumers, but also the art movements of the 20th century – largely

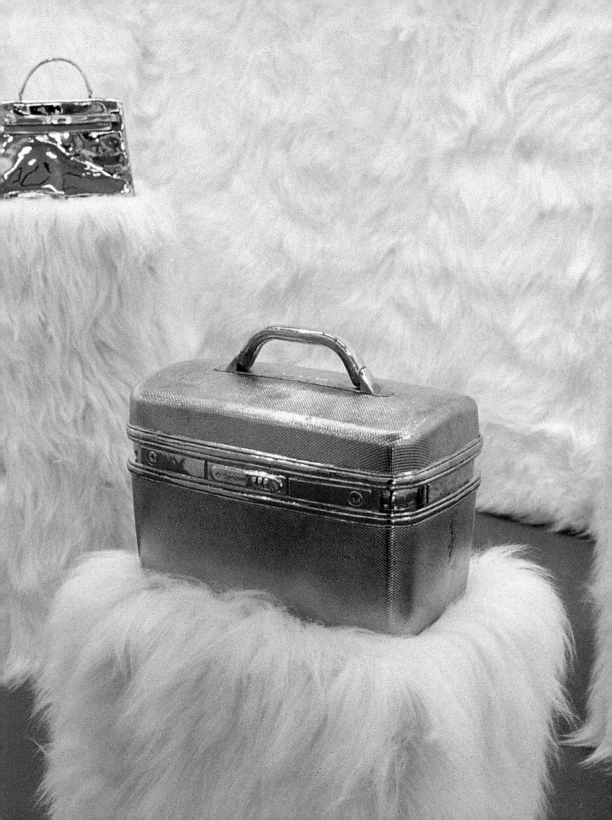

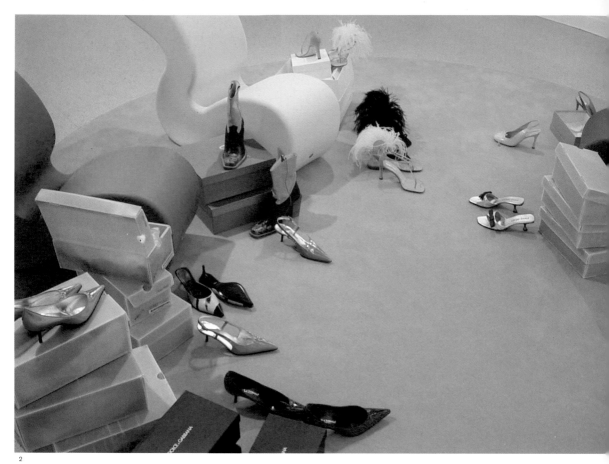

2

"Every satisfied desire arouses the desire for more."

6

7

1 **Cuddly Wall, Kelly Bag, Vanity Case,** 1998. Synthetic fur, bronze, 27 x 18 x 18 cm, 32 x 38 x 20 cm

2 **Untitled,** 2000. Carpet, "Phantom" chairs by Verner Panton, shoes, shoeboxes. Installation view, Art 31, Basle, Switzerland

3 **Car Magazine Covers,** 1999. Photograph on Alucobond, nine parts, dimensions variable

4 **First Spaceships on Venus,** 1996. Fibreglass, loudspeakers, CDs, each 350 x 130 x 130 cm

5 **Skin Crime No. 318,** 1997. Car, sprayed car wrecks, 390 x 190 x 50 cm

6 **Patrick and Josef,** 1996. Shoes by Patrick Cox on an image by Josef Albers, 100 x 100 x 30 cm

7 **Dog Toy 3 (Crazy Bird),** 2000. Styrofoam, paint, 260 x 210 x 180 cm

8 **A 011/355,** 1999. Asphalt surface and white neon lettering. Installation view "FASTER! BIGGER! BETTER!", Mehdi Chouakri, Berlin

8

fashioned by male artists – and especially of the 1960s. She adjusts the standards of western high culture by re-encoding that culture's versions of familiar recent artworks and giving them a feminine angle. Thus, for instance, her sculptures made of Slim Fast cartons allude to Andy Warhol's famous *Brillo Boxes*, 1964, while the diet product simultaneously prompts associations with female ideals of slenderness and so of self-starvation rituals. Often Fleury deploys the products, fabric designs and fashionable colours of a given season, as in her mural paintings or missiles in lipstick colours, or uses soft materials that appeal to the sense of touch. Her subversive irony is brought to bear not only on individual heroes of art, but also on canonical forms of artistic presentation, as in the white cube – the white and seemingly neutral and rational modernist exhibition space that Fleury lined entirely with synthetic fur in her 1998 installation *Cuddly Wall*, thus transforming it into a sensuous and mildly claustrophobic white cave, in which chrome-plated bronze sculptures by the artist's avowed design favourites were on display as museum icons: the Hermès Kelly bag, the Chanel No. 5 flacon, or an Evian mineral-water bottle.

It would be possible to argue that Sylvie Fleury pays uncritical homage to the commodities she fetishizes, unreflectingly identifying with the dictates of fashion (including fashions in art) and of the images of women propagated in public arenas. To this, art theorist Peter Weibel has countered that Fleury is recalling those utopian hopes and wishes for fulfilment in life that popular culture, in however distorted a form, promises to fulfil. Weibel points out that while there are countless works of art that legitimise male pleasures, there are hardly any that celebrate the indulgences of women in like manner. One might, moreover, argue that, while Fleury never denies that luxury holds a fascination for her, her work is not blind to the destructive aspects of beautiful illusions. Thus, in one of her mural paintings that uses quotations from glossy magazines, one of the quotes reads "Suffering in Silence – Women and Self-Mutilation". Similarly, the immaculate pink spray-jobs in her *Skin Crime* series, 1997, cannot distract from the fact that these crushed cars (in allusion to work by Pop artist John Chamberlain) are write-offs. A 1999 Fleury exhibition catalogue feature video stills of accidents in motor races.

Within the last male citadel

Motor racing is one of the last male citadels in popular culture. In designing her *Formula One Dress*, 1999, Fleury drew upon the clothing worn by Mika Häkkinen, 1998 formula one world champion, and then had herself photographed – to striking effect – alongside the motorsport idol. It is a field that affords potential for a more aggressive, deliberately trashy aesthetic. Fleury's installation *She Devils on Wheels Headquarters*, 1997, delivers the offices of an all-women motor club as promised in the title, complete with various borrowings from the covers of Playgirl magazine. A sign reading "Race in Progress" provides a gloss on the apparently unfinished provisional quality of the installation, but it might equally well be read as a glance at the competitive nature of relations between the sexes – or a reminder that the race for equal rights and opportunities is still being run.

Barbara Hess

Mika Häkkinen and alongside Sylvie Fleury in a Formula 1 dress that she designed in cooperation with Hugo Boss, 1999

Katharina Fritsch

*** 1956 in Essen, Germany; lives and works in Düsseldorf, Germany**

Selected solo exhibitions: **1988** Kunsthalle Basel, Basle, Switzerland / **1993** Dia Center for the Arts, New York (NY), USA /
1996 San Francisco Museum of Modern Art, San Francisco (CA), USA / **1997** Museum für Gegenwartskunst, Basle, Switzerland /
1999 "Damenwahl", Kunsthalle Düsseldorf, Düsseldorf, Germany (with Alexej Koschkarow)

Selected group exhibitions: **1982** "Möbel perdu", Museum für Kunst und Gewerbe, Hamburg, Germany / **1987** "Skulptur. Projekte in Münster",
Westfälisches Landesmuseum für Kunst und Kulturgeschichte, Münster, Germany / **1988** Sydney Biennial, Sydney, Australia /
1995 XLVI Esposizione Internazionale d'Arte, la Biennale di Venezia, German Pavilion, Venice, Italy (with Martin Honert and Thomas Ruff) /
1997 "Die Epoche der Moderne. Kunst im 20. Jahrhundert", Martin-Gropius-Bau, Berlin, Germany

Smoothness and essence

As the story goes, in 1987, Katharina Fritsch waited for weeks for the right rain, the kind of rain that would produce a very particular rain sound at a precise point in a specially chosen park. A sound expert was required for this, and in the middle of the night, right there under a rhododendron bush, it was possible to make the recording which later, when the small vinyl record was finally produced, was taken by many to be a commercial studio sound. That all the effort taken was still unavoidable has nothing to do with the artist having a keener sense of hearing than her audience. It has to do with the fact that in her works she pursues two objectives at one and the same time: the production of archetypal forms, and the stringent exclusion of the colourful arbitrariness of all the commonplace items, objects and articles with which industry floods the market. Katharina Fritsch has herself repeatedly constructed shop counters and "goods stands", on which figures and objects are displayed as in an especially meticulously decorated department store. Yet her sculptures and small object-like sculptural components are not copies of found mass-produced items, but are smoothed, adapted, idealised artefacts. And the audience never really knows if these large and small ideal objects made to their very own scale are derivations of reality, summaries, as it were, of all available or remembered objects, or simulations of a distant primordial image from which all the everyday items surrounding us may have surged forth.

One thing is certain, and that is that these sculptures are as compelling as three-dimensional pictograms. Their lack of technical blemishes has often been lauded as "perfection", and yet this suggests not so much an unsurpassable individual form, as the smooth purity of an unreal recurrent dream fantasy, in which all the figures play their memorable role, though none has an individual face. Her *Tischgesellschaft*, 1988, for example, consists of 32 male figures sitting at a long table covered by a red-and-white patterned tablecloth. The men's hands and faces have a whitish hue but no particularly obvious marks that might distinguish them. Their hands are spread out

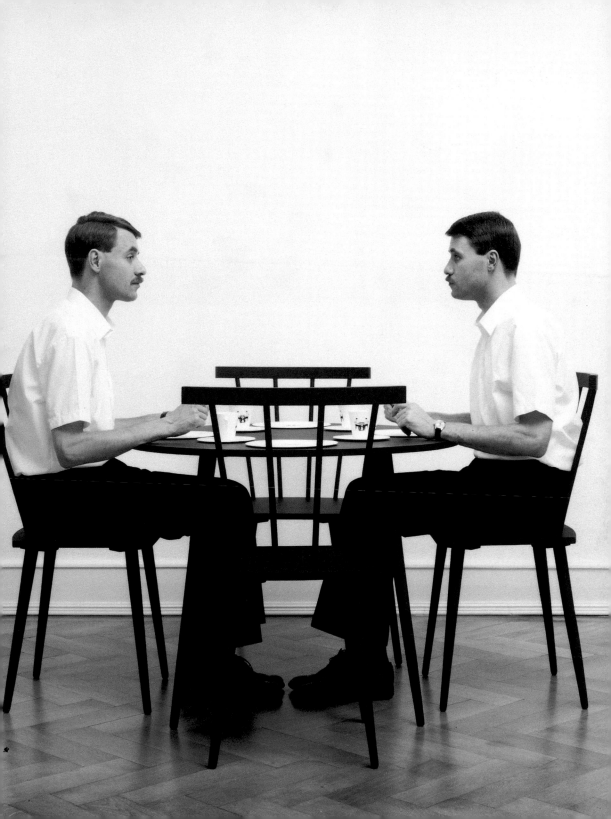

"Irritation is made possible in the first place by formal clarity and precise scale. I could almost demonstrate this scientifically."

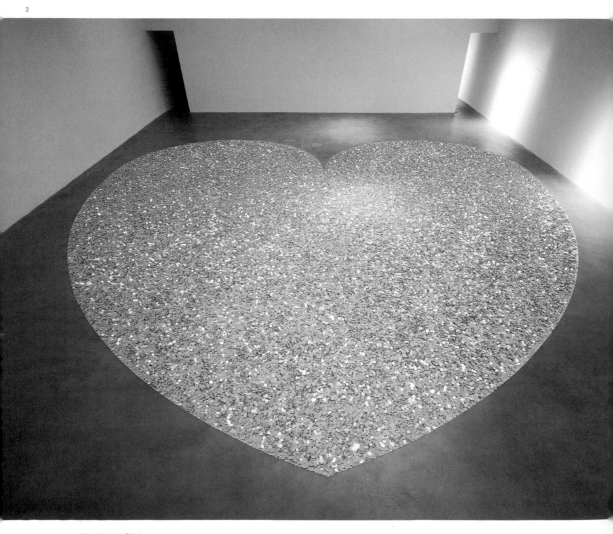

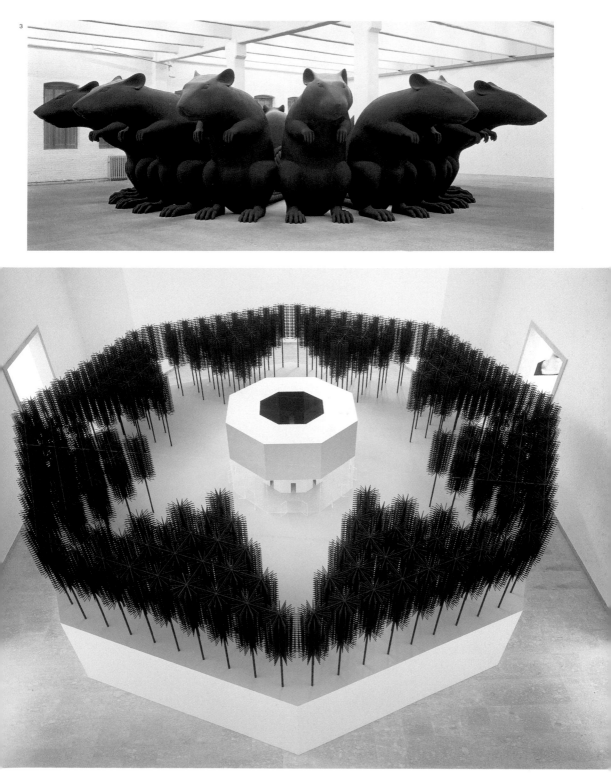

1 **Tisch mit eineiigen Zwillingen (Herr Wiegmann und Herr Wiegmann),** 1985. Wood, paint, synthetic material, 150 (h) cm, diameter 150 cm

2 **Herz mit Geld,** 1999/2000. Synthetic material, aluminium, paint, 400 x 400 cm

3 **Rattenkönig (Rat King),** 1993. Dia Center for the Arts, New York (NY), USA, 1993/94

4 **Museum (Modell 1: 10),** 1995. Wood, aluminium, Plexiglas, foil, paint, 3.3 x 10.4 x 10.4 m. Installation view, XLVI Esposizione Internazionale d'Arte, la Biennale di Venezia, German Pavilion, Venice, Italy

5 **Totenkopf,** 1997/98. Plastic material, paint, 20 x 16 x 25 cm

6 **Tischgesellschaft,** 1988. Polyester, wood, cotton, paint, 1.40 x 16 x 1.75 m

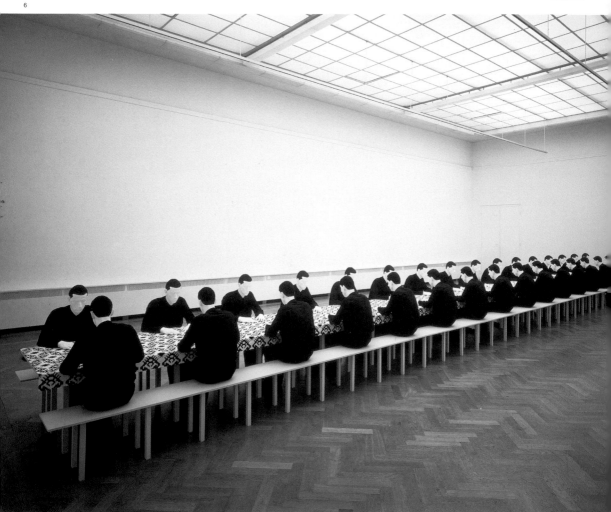

flat on the table, their hairstyles resemble that of typical window-display models. 16 figures on either side of the table in a rigid pose, monotonous, deep in thought, an alignment of bodies so symmetrical that its distant central perspectival vanishing point at the end of the table somewhere behind the museum wall becomes the engrossing centre of the work. The 32 figures are replicas commissioned and precisely crafted according to a prototype. These are not copies of a product, but a replicated image of an experience. "The point of departure was a person", says Katharina Fritsch. The concrete pose, the physical appearance became her primal image. It was the "point of departure for this psychedelic vision of replicated man at a table". The finished work, of which the tablecloth is an enlargement to scale of the patterned tablecloth commonly found in Swiss pubs, is the perspectival replication, alignment and smoothing of a memory which, freed of all detail, can become a picture that extends into space.

Perfection

The irritating quality of these sculptures could be described as the opposite of photography. Whereas in photography the striking detail, the clearly recognisable eye-catching feature is what constitutes the peculiarity of the shot and forms the basis of its credibility, in Katharina Fritsch's works the dominating feature is an unsettling emptiness. For this reason, the overwhelming and much-cited impression is one of "perfection". Her powerful, spatially dominant sculpture *Rattenkönig* (Rat King), 1993/94, is the product of a very ordinary experience, half repulsive, half fascinating, which she had in a large city, more precisely, at the back door of a New York art institution. The artist found herself in front of a rat hole, and thus the idea was born for a ring of huge rats geometrically linked to form a crown and awakening associations with the legends and stories of a circular tangle of knotted rats' tails, a seat of infection, and a demonic throng. Whereas the kind of rat found on the shelves of toy shops presents an imitated physiognomy, that is to say, is a copy of a possible animal, the sexless, 2.8-metre-high creatures comprising the *Rattenkönig* installation resemble the immaterial simulations of computer design. In her early years, Katharina Fritsch was fascinated by the English Arts and Crafts movement, and she applies its ideology of enhancing everyday life by using perfect industrial and crafted products in her sculptures with their regular and series-like precision. Her design for an ideal museum for the Venice Biennale was a large soaring sculpture disguised as a proposal for architectural reform. This is industrial design turned upside down. Instead of the perfect sales article, there are myths, madonnas, legendary animals and household items pressed so long into a precise streamlined form until the exact opposite of that pleasing individuality that they achieve which a modern commodity offers its buyers. With infinite patience and meticulousness, the artist seeks the most suggestive scale and the most unquestionable colour. The "extreme isolation by which the things and themes are stripped of all chance aspects and dependencies" (Julian Heynen) and presented, is intended to uncover the "essence" of the objects. In the middle of a world of commodities striving for unlimited diversity, Katharina Fritsch strives for perfect craftsmanship as the source not of arbitrariness, but of an intuitive mythic accuracy. In the end, the trivial styling of each and every item comes face to face with fundamental primordial forms that are so vacuous and mask-like that on seeing them one is thoroughly shocked by the prospect of potentially perfect society. *Gerrit Gohlke*

Katharina Fritsch

Ellen Gallagher

⁂ 1965 in Providence (RI), USA; lives and works in New York (NY), USA

Selected solo exhibitions: **1996** Anthony d'Offay Gallery, London, England / **1998** Gagosian Gallery, New York (NY), USA /
1999 Mario Diacono Gallery, Boston (IA), USA; Galerie Max Hetzler, Berlin / **2001** "Blubber", Gagosian Gallery, New York (NY), USA

Selected group exhibitions: **1995** Whitney Biennial, Whitney Museum of American Art, New York (NY) / **1997** "Projects", Irish Museum of Modern Art,
Dublin, Ireland / "T-Race", Randolph Street Gallery, Chicago (IL), USA / **2000** "New Acquisitions", Solomon R. Guggenheim Museum, New York (NY), USA /
"Making Sense", Contemporary Museum, Baltimore (MD), USA

Black is black?

The black painter Ellen Gallagher was born the daughter of an Irish-American mother and an African-American father. The two did not marry, and Ellen Gallagher grew up with her mother, who sent her to reputable private schools. Like many Americans, Gallagher was made aware from her earliest years of being "coloured", something which in America is always accompanied by a latent racism. She later studied art in Boston and Skowhegan, Maine. Her paintings quickly caught the attention of the American art scene, and women artists such as Kiki Smith and Nan Goldin began to champion her work. In 1995 Ellen Gallagher was invited to show at the Whitney Bienial in New York.

Many of the characteristic elements of Ellen Gallagher's art are already present in the painting *Host* of 1996. In varying concentrations on countless lengths of lined paper, the artist draws banana-shaped and circular-like elements – eyes and mouths which Gallagher has taken from pictures of American minstrels from the 19th century. These minstrels were travelling entertainers who, with blackened faces and in appropriate costume, performed the songs and dances of the African-Americans and parodied the circumstances of black people. In the upper part of the picture, the forms combine to suggest faces. In their manic accumulation, these stereotype forms and fragments are dismantled piece by piece and thereby woven into a new rhythmical structure. The stereotyped "portraits" of minstrels continue to remain an important source for Ellen Gallagher's "own" aesthetic vocabulary. Her pictures are always a critical commentary on the situation of blacks in the USA, although they never possess the aggressiveness of Protest Art. Instead, her works evade a clear message and precisely in this way illuminate the problem of racism not just in North America. The African-American population and other ethnic minorities in the USA are frequently exposed to discrimination; equal opportunity exists only on paper. Violent treatment from the

"I try to turn something meaningless into a meaningful thing."

1 **Untitled, Preserve,** 2001. Oil, pencil and plasticine on magazine page, 33 x 25 cm

2 **Untitled,** 2000. Oil, pencil and plasticine on paper, 50 x 38 cm

3 **Untitled,** 1999. Mixed media on paper, 40 x 37 cm

4 **bling bling,** 2001. Rubber, paper and enamel on linen, 244 x 305 cm

5 **Untitled,** 1999. Watercolour, pencil and oil on paper, 54 x 69 cm

6 **Host,** 1996. Oil, pencil and paper on canvas, 175 x 127 cm

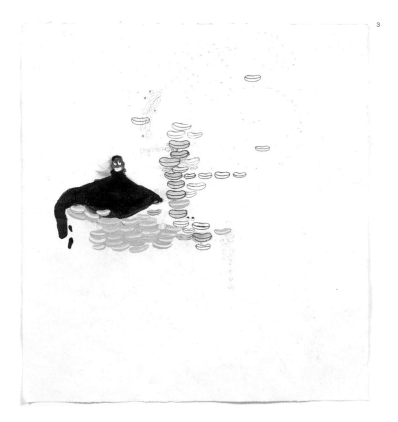

police, restricted access to education and considerably poorer prospects of a professional career are part of everyday life for black communities in America. Opportunities for success are offered only by sport and entertainment, where blacks play a major role – as in light athletics and basketball, and in jazz, soul and hip-hop in the music business – and occasionally in the field of art, whereby blacks' supposed "naturalness" becomes a quality which – parodying their own origins as the minstrels did – they exploit. It is possible, on the other hand, for blacks to achieve recognition and prosperity in other spheres of society if they identify with the culture of the white majority, who – like Ellen Gallagher – belong to the "better educated people". It is a solution, of course, which requires them to deny their own culture and tradition. In precisely this situation, Ellen Gallagher says: "I am interested in the life that people lead under these brutal constraints."

In *Purgatorium 2000*, the artist again uses the cliché of a minstrel's lips, cleanly arranged in varying sizes and in geometric blocks on lined writing paper – as if wanting to learn how to knuckle down stoically and industriously within a pre-existing social system. Her art is often compared with the Minimal Art of such as Agnes Martin, as both seem to be dominated by a fastidious, almost mathematical order. But, as so often, first impressions are deceptive. Ellen Gallagher abides by the rules so rigidly that their absurdity and arbitrariness are rapidly revealed, while at the same time small deviations and errors are constantly recurring within these redundant rows. "Viruses" creep into their seemingly endlessly repeating patterns, poisoning the entire superficial matrix. In other works, such as *ly*, 2000, the artist takes up the image of the virus by arranging the ink lips, like tiny microbes under the microscope, into a biomorphic hieroglyph. The issue of racism and its history is suddenly being deliberated at the level of natural science – naturally recalling the current debate surrounding genetic engineering. Thus Ellen Gallagher successfully passes from the microcosm of lips and viruses to the global macrocosm of (white-dominated) science, which is increasingly obliged to toe the line dictated by economic forces and which leaves ethical considerations out of the equation.

Between body and art

Another important aspect separates Ellen Gallagher's art from the much-cited purism of Minimal Art. The artist often chooses Okawara paper for her works, a material which "absorbs ink like the skin a tattoo", as she herself has described it. Ellen Gallagher's pictures thereby convey the impression of dwelling halfway between body and art, and thus avoid mere academic abstraction. The emphasis upon the physical, like the reference to skin and tattooing, is equally a play on racist categories such as skin colour and exoticism. This is clearest of all in the artist's black pictures, such as *Mohh Deep* of 1998: against a black ground, minstrels – or are they battling athletes? – are sketched in white strokes, more suggested than clearly depicted. Black and white present themselves in this work as unclearly overlaid – another characteristic of the tension in Ellen Gallagher's art, which captivates the viewer as subliminally as it does enduringly both through its form and its content.

Raimar Stange

Ellen Gallagher in her studio *Ellen Gallagher*

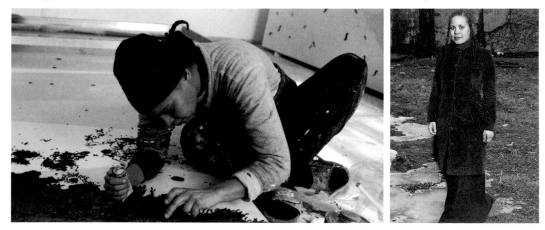

Isa Genzken

*** 1948 in Bad Oldesloe, Germany; lives and works in Berlin, Germany**

Selected solo exhibitions: **1989** Museum Boijmans Van Beunigen, Rotterdam, The Netherlands / **1992** "jeder braucht mindestens ein fenster", The Renaissance Society at the University of Chicago, Chicago (IL), USA / **1993** Städtische Galerie im Lenbachhaus, Munich, Germany / **2000** "Urlaub", Frankfurter Kunstverein, Frankfurt am Main, Germany; "Sie sind mein Glück", Kunstverein Braunschweig, Brunswick, Germany

Selected group exhibitions: **1988** Sydney Biennial, Sydney, Australia / **1992** documenta IX, Kassel, Germany / **1997** "Skulptur. Projekte in Münster 1997", Westfälisches Landesmuseum für Kunst und Kulturgeschichte, Münster, Germany / **1999** "Das XX. Jahrhundert. Ein Jahrhundert in Deutschland", Neue Nationalgalerie, Berlin, Germany / **2000** "Deutsche Kunst in Moskau", Central House of Artists, Expo Park, Moscow, Russia

The (im)possibility of communication

The sculpture shoots through the otherwise empty space like an arrow – a photo of Isa Genzken's 1979 installation at Krefeld's Museum Haus Lange conveys an idea of the spatial effect of the geometrical floor works that established her reputation. Her *Ellipsoids*, 1976–82, and *Hyperbolas*, 1979–83, extended horizontally up to 40 feet through space. They were designed on a computer, lacked a compositional centre of interest, and were difficult to take in at a glance. Much like the sculptures of American Minimal Art, these pieces aimed at a new definition of the object-space relationship and an activation of the viewer's role.

In 1976, while still a student at the Düsseldorf Art Academy (1973–77), Genzken showed at Galerie Konrad Fischer, a key venue for advanced German artists such as Sigmar Polke, Blinky Palermo and Gerhard Richter, but also for American Minimalists like Carl Andre and Sol LeWitt. Genzken's rapid rise – she participated in the groundbreaking "Westkunst" exhibition in 1981, and in documenta 7 as well as the Venice Biennale in 1982 – seemed to belie the widespread opinion that sculpture was a classically male domain. Yet as art critic Benjamin Buchloh noted in a 1992 essay, the prejudice remained: her sculptures were denounced as phallic exaggerations, an expression of female hysteria.

Genzken remained immune to such readings. At a time when the notion of artistic autonomy seemed to have been made obsolete by an increasing dematerialization of the art object and enthusiasm for the new media, she faced the issue of the meaning of sculpture, taking account of the critique of traditional definitions of sculpture in space and the specific conditions of its production and reception. The result was a characteristic dual thrust in Genzken's work, a concern with two seemingly contradictory but actually mutually supplementary strands. The first, in addition to sculptures, included photography, video, film, collage and collage books, as well as an ongoing involvement with the classical themes of sculpture – the ordering of masses and volumes, the interplay of construction, surface character, and material, and the relationship between object, space and viewer. The other strand was characterised by an inclusion of personal, social and institutional references in the work, as well as by inquiry into the possibility, or impossibility, of communication. An explicit factor in such works as the collage books *I Love New York – Crazy City*, 1995/96, in the *Hi-Fi Series*, 1979, the *Ear Series*, 1980, or the *World Receiver*, 1981/87, this dialectic was also implicitly present in the varying degrees of formal closure or openness in Genzken's sculptures.

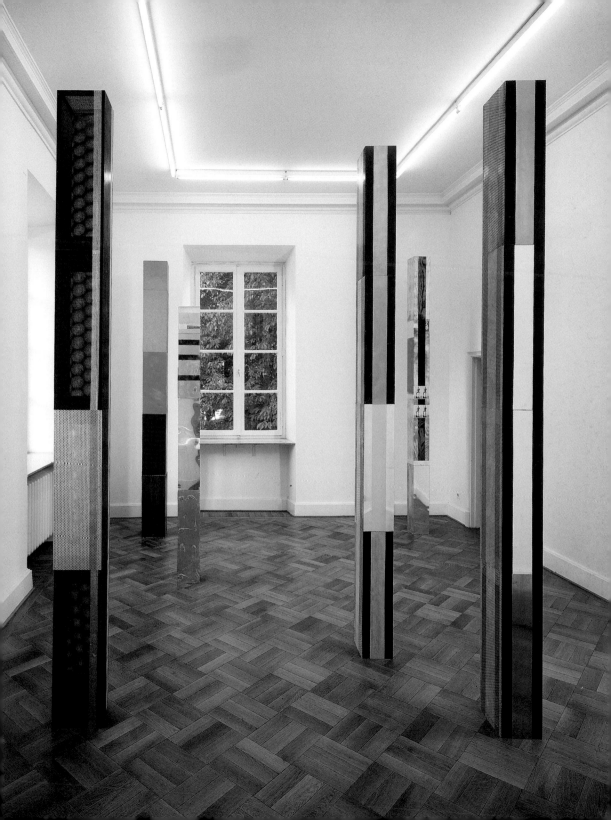

"When I go into a museum and come to a room with a lot of bad pictures, and then suddenly discover a picture that I stop in front of, I forget all the rest."

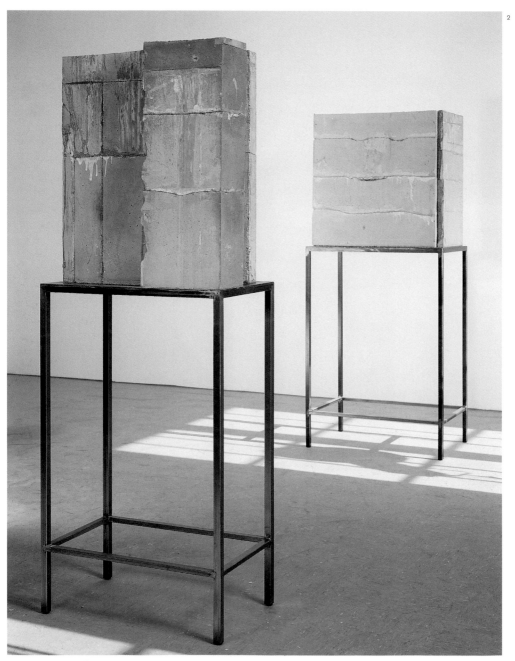

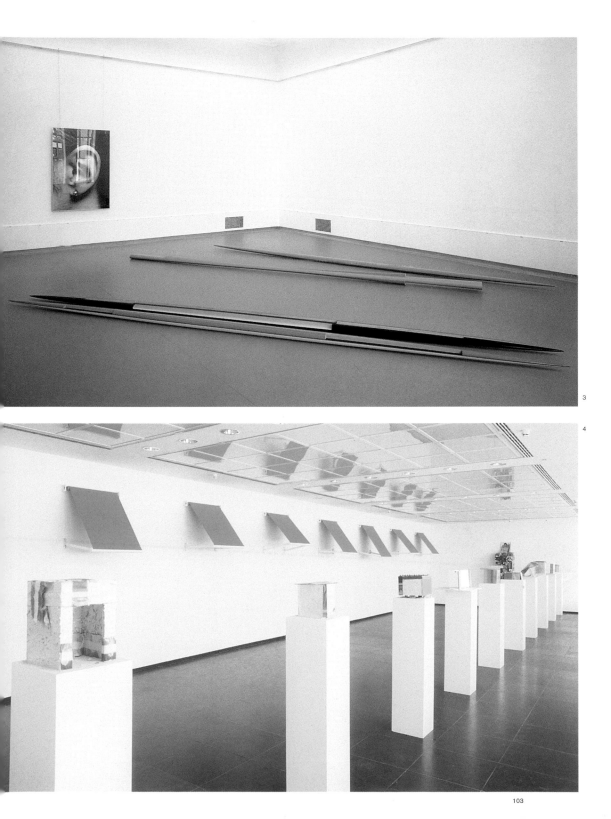

1 **Installation view "Sie sind mein Glück",** Kunstverein Braunschweig, Brunswick, Germany, 2000

2 **Guardini, Kuß,** 1987. Concrete on steel tubing

3 **Installation view,** 1989. Museum Boijmans Van Beuningen, Amsterdam, The Netherlands

4 **Installation view "Urlaub",** Frankfurter Kunstverein, Frankfurt am Main, Germany, 2000

5 **Camera,** 1990. Stainless steel, 5 m (h), 4 m (w). Rue de Canal, Brussels, Belgium

6 **Installation view,** Museum Boijmans Van Beuningen, Amsterdam, The Netherlands, 1989

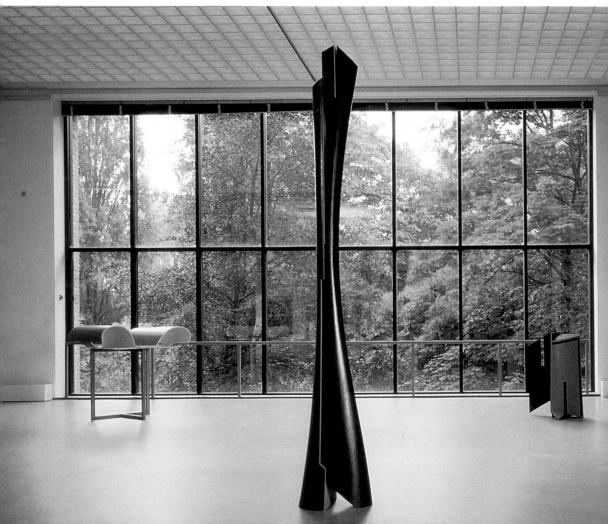

Wood, plaster, concrete

Accordingly, subsequent groups of works, developed partly in parallel and partly in sequence – be they the *Wood Sculptures*, 1976–85, the *Plaster Sculptures*, 1985–86, the *Concrete Sculptures*, 1986–92, the *Epoxy Resin Hoods* and *Lamps*, the assemblages of metal household appliances titled *Babies*, or the *Steles* of the 1990s – referred to various historical conceptions of sculpture. The floor works could be read as a critical continuation of Minimal Art. While rejecting its use of industrial methods to produce sculptures in series, Genzken insisted on the uniqueness of the sculptural object and, by choosing wood as the material, lent it an organic dimension. By contrast, the *Plaster* and *Concrete Sculptures* referred to the Constructivism of, say, El Lissitzky or Kasimir Malevich. Usually presented on floor or wall pedestals, the plaster sculptures – with titles such as *House*, 1985, or *New Building*, 1985 – consisted of irregular cast shapes that recalled architectural details and had an aspect of the unfinished and fragmentary, as if the artist were ironically denying the false promise of a reconciliation between architecture and sculpture. This refraction took even sharper form in the *Concrete Sculptures*. This ubiquitous urban material gained an astonishing lightness that was augmented by displaying the sculptures on long-legged steel tables. The structural possibilities of reinforced concrete also informed outdoor projects such as *ABC* (Münster, Germany, 1987), a twin arch of steel and concrete. The title called up associations with the nearby university library, but also with the ABC Group formed by El Lissitzky and Mart Stam in Basle in 1924, or with "ABC Art" as a derogatory term for Minimalism. In a way comparable to the concrete and epoxy *Windows*, which marked a permeable border between interior and exterior space and drew the eye to their surrounding spaces, *ABC* framed an excerpt of the urban environment.

Textiles and photographs

Genzken's play on an equilibrium of mass, volume and weight reached a preliminary culmination in her most recent work, *Beach Houses*, 2000. Constructed of cheap materials that, much like ready-mades, bore traces of earlier use and were only loosely assembled and held together in places with adhesive tape, these configurations had an aspect of extreme fragility. Similar in format to the plaster pieces, they too called up a range of associations with architectural references, if with a different focus – occasionally perhaps an allusion to one of Dan Graham's mirror pavilions, occasionally to deconstructivist architecture. The motif of the fragmentary returned also here, just as in the 36-part photo sequence *Yacht Holiday*, taken in 1993 on a voyage with the collector and industrialist Frieder Burda and the artist's then husband Gerhard Richter. As if taking an inventory, the camera captured details of the yacht – navigation instruments, portholes, deckchairs, lifeboat, etc. – without ever showing the ship as a whole. Only by mentally assembling the different points of view, could the viewer form a provisional image, subject to continual supplementation, expansion and change.

It is exactly this aspect of the transitory that Genzken has raised to an artistic principle, in the process creating a highly varied and continually surprising oeuvre.

Astrid Wege

Isa Genzken (invitation card for the exhibition "Isa Genzken – Atelier, 11 Fotos von Wolfgang Tillmans", Galerie Daniel Buchholz, Cologne, 1993

"Isa, Berlin", 1999

"Isa, dancing", 1995.

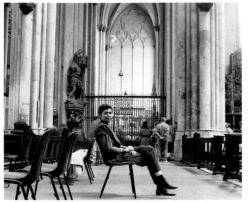

Nan Goldin



*** 1953 in Washington, DC, USA; lives and works in New York (NY), USA**

Selected solo exhibitions: **1986** "The Ballad of Sexual Dependency", Burden Gallery, Aperture Foundation, New York (NY), USA /
1992 "Fotoarbeiten 1972–1992", daadgalerie, Berlin, Germany / **1996/97** "I'll Be Your Mirror", Whitney Museum of American Art, New York (NY), USA /
1997 Kunstmuseum Wolfsburg, Wolfsburg, Germany; Fotomuseum Winterthur, Winterthur, Switzerland; Stedelijk Museum, Amsterdam,
The Netherlands; Kunsthalle Wien, Vienna, Austria / **1998** Yamaguchi Prefectural Museum of Art, Yamaguchi City, Japan

Selected group exhibitions: **1980** "The Indomitable Spirit: Photographers and Artists Respond in the Time of AIDS", International Center of Photography,
Midtown, New York (NY), USA; Los Angeles Municipal Art Gallery, Los Angeles (CA), USA / **1993** "Amerikanische Kunst im 20. Jahrhundert",
Martin-Gropius-Bau, Berlin, Germany / **1995** "fémininmasculin. Le sexe de l'art", Musée national d'art moderne, Centre Georges Pompidou, Paris, France /
Whitney Biennial, Whitney Museum of American Art, New York (NY), USA / **1996** "Sex and Crime: Von den Verhältnissen der Menschen",
Sprengel Museum Hannover, Hanover, Germany

Selected bibliography: **1986** *The Ballad of Sexual Dependency*, New York/Frankfurt am Main / **1993** *The Other Side*, Zürich/Berlin/New York;
Vakat, Cologne / **1994** *A Double Life*, Zurich/Berlin/New York / **1995** *Tokyo Love*, Tokyo (with Nobuyoshi Araki)

"I photograph directly from my life"

When Nan Goldin was given her first camera at the age of 16, she photographed her friends, herself and her immediate surroundings. The pictures she has taken since the late 1960s are not the product of detached observation, but of emotional bonding between the people they portray. The camera is her constant companion, the photographs her visual diary. Over a period of 30 years, her pictures have traced the story of her life and that of her friends. At the same time, they go beyond the scope of personal biography as an eye-witness account of certain groups and subcultures with which she has been involved. Although her photographs show drug addicts, alcoholics, homosexuals, transvestites and prostitutes, they are not so much a chronicle as an affectionate, warts-and-all homage to the kaleidoscope of life and death.

In 1965, Goldin's older sister committed suicide. The family was devastated. Her friends at Satay Community School in Lincoln, Massachusetts, became a kind of substitute family. She began to take photographs, as she says, so that she would not lose them, clinging to life in order to save her own life. Even in these first black-and-white photographs and Polaroids she developed the aesthetic of the snapshot, whose intimacy and immediacy is the hallmark of her later work. Her friends liked to be photographed by her. Fascinated by the world of fashion and cinema, they would strike poses and transfer them to their private surroundings. Among her friends were David Armstrong and Suzanne Fletcher, whom she photographed repeatedly in the following decades.

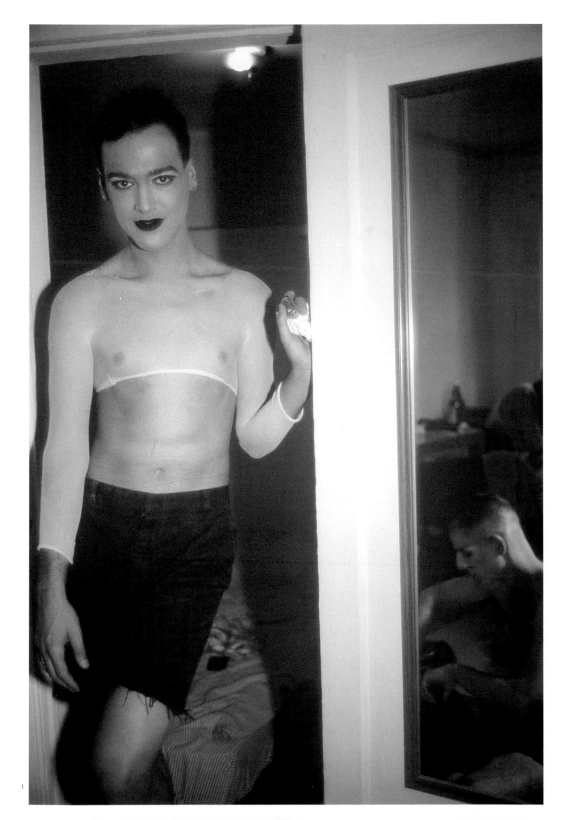

1

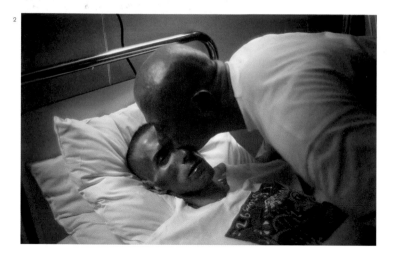

"Taking pictures is for me a way of touching someone – a form of tenderness."

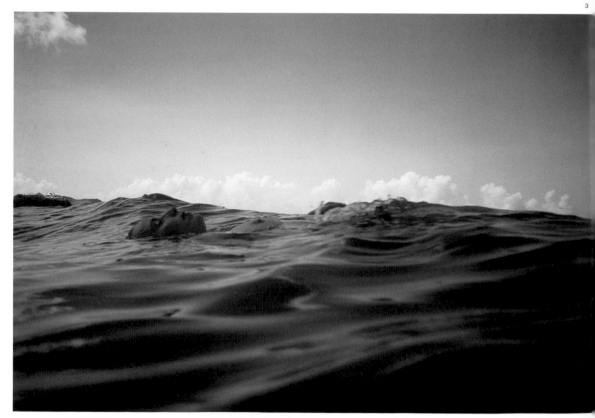

4

5

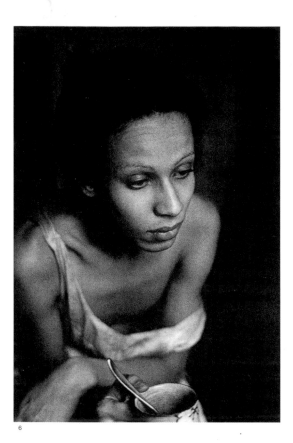

6

7

8

In the early 1970s, Goldin photographed the weekly beauty contest held at the Boston transvestite bar The Other Side. Influenced by the films of Andy Warhol and by Antonioni's *Blow Up*, she starting making super-8 films. In 1973, she began working in colour photography, for which she used artificial lighting. A year later, she met the photographer Lisette Model and began to study at the school of the Museum of Fine Arts in Boston. It was here that she used flash for the first time. Even the few outdoor shots from this period were taken using flash, which made the scenes appear cool and artificial. For her graduate work, she submitted slides, which she used for small private showings.

Intimacy goes public

In 1978, Goldin moved to New York and was soon at home in Manhattan's nightlife, working, like many artists (including Kiki Smith), as a barmaid at the Tin Pan Alley Bar, and presenting her slide shows, which she constantly changed, expanded and backed with music from 1980 onwards. On the basis of individual photos, she developed a fragmentary sequence of images based on narrative film sequences. The slide show, now encompassing more than 700 slides, is still being shown in constantly changing order with ever new motifs. In 1981, Goldin gave her slide show the title *The Ballad of Sexual Dependency* – a title she had taken from a song in Bertolt Brecht and Kurt Weill's *Threepenny Opera* – and in 1984 she published it in book form under the same title. *The Ballad* shows naked couples in bed, men making love or masturbating, empty rooms, broken bodies, women and men in bars, bedrooms, bathrooms or cars, and, time and again, women in front of the mirror. It is the empathy reflected in these images that lends them their undeniable lyricism. The motif of a woman gazing at her reflection in a mirror was a popular theme in classical painting, and is a recurrent motif in Nan Goldin's oeuvre. Even the title of her 1995 film *I'll Be Your Mirror* – featuring interviews with HIV positive friends – not only recalls her favoured theme, but can also be regarded as symbolising her work as a photographer. Her photographs, at the same time, are mirror images of her friends, her life and her means of self-assertion. When Goldin was beaten up by her lover in 1984, she photographed her own face in *Nan one month after being battered*.

Living and dying in the age of AIDS

Nan Goldin's slide shows are screened at film festivals world-wide. In Europe, she met Siobhan Liddell, and realised a number of portraits of her between 1986 and 1994. After drug-withdrawal therapy in 1988, she created many self-portraits and began to take photographs in daylight for the first time. AIDS became a focus of her work, and she photographed AIDS victims up to their deaths. In 1991, she was awarded a German Academic Exchange Service (DAAD) stipend to work in Berlin, where she lived until 1994. In Berlin, she made friends with the homosexual Alf Bold from the International Forum of Young Film and followed his progress, taking photographs of him as he went through the final stages of AIDS. In 1993, she published *The Other Side 1972–1992*, which was a compilation of her photographs of homosexuals and drag queens. That same year, she met the photographer Nobuyoshi Araki in Tokyo and carved out a niche for herself in that city, too.

Ulrike Lehmann

Self-portrait: "Nan one month after being battered", 1984 Nan Goldin

Natalia Goncharova

*** 1881 in Nagayevo, Russia; ✝ 1962 in Paris, France**

Selected solo exhibitions: **1910** Gesellschaft für freie Ästhetik, Moscow, Russia / **1914** "Exposition Goncharova et Larionow",
Galerie Paul Guillaume, Paris, France (with Michail Larionov) / **1922** "Larionov and Goncharova", Kongore Galleries, New York (NY), USA (with Michail
Larionov) / **1961** "Larionov and Goncharova. A Retrospective Exhibition of Paintings and Designs for the Theatre, Arts Council", Leeds, Bristol,
London, England / **1963** "Goncharova – Larionov", Musée d'Art Moderne de la Ville de Paris, Paris (with Michail Larionov)

Selected group exhibitions: **1906** "Exposition de l'art russe", Salon d'Automne, Paris, France / **1908–1910** "Zolotoje runo" (The Golden Fleece), Moscow,
Russia / **1912** "Der Blaue Reiter", Munich, Germany / **1936** "Cubism and Abstract Art", The Museum of Modern Art, New York (NY), USA /
1999/2000 "Amazons of the Avantgarde", Deutsche Guggenheim, Berlin, Germany; Royal Academy of Arts, London, England;
Peggy Guggenheim Collection, Venice, Italy; Solomon R. Guggenheim Museum, New York (NY), USA

Ex oriente lux!

Natalia Goncharova's diverse oeuvre was marked by frequent changes of style that reflected most every facet of the various avant-garde movements of the early 20th century. Like many other Russian artists of the period – above all, Michail Larionov, her lifelong companion – Goncharova combined modernism with elements of traditional Russian folk art and icon painting. Her *Still Life with Tiger Skin,* 1908, is a case in point. Standing on the tiger skin are two panels, one showing a scene from Japanese Kabuki theatre, the other an antique sarcophagus relief, facing each other as equally important sources of her art.

Goncharova came from a respected and prosperous family of architects. As a girl she spent a great deal of time at her grand-mother's country estate. This was the source of her interest in peasant costumes and customs, hand-crafted useful objects such as wooden trays and shop signs, and the popular legends that tell of the rootedness of the Russian people in nature. After graduating from school in Moscow, Goncharova decided to attend university – by no means a common thing for women at that time. After hearing lectures in history, botany, zoology and medicine, she transferred in 1901 to the Moscow School of Painting, Sculpture and Architecture, where she took courses in sculpture with Pavel Troubetskoi. After meeting Michail Larionov, she switched to painting, focusing on the way objects reflect light or on colour harmonies, and portraying herself in a series of different costumes.

The first decade of the 20th century brought forth a spate of new artistic movements, and not only in Russia. As early as 1906 Goncharova was invited to contribute to the Russian section at the Salon d'Automne in Paris, which was curated by Serge Diaghilev. By way of compensation, Goncharova and Larionov organised three exhibitions of contemporary French art, beginning in 1908. Held under the auspices of the influential art journal *Zolotoje runo* (The Golden Fleece), these shows brought works by Gauguin, van Gogh, Cézanne, Matisse, and the Fauves to Russia for the first time. Goncharova was especially intrigued by Gauguin's ornamental treatment of figure groups.

Over the following years, an involvement with icon painting and Oriental art led to a simplified, heavily contoured or Cubistically facetted style of depicting figures and interiors which was no longer beholding to French influences. Also, like Kasimir Malevich at the same period, Goncharova turned to subjects from peasant life, producing paintings such as *Potato Harvest* and *Garden in Springtime,* 1908/09. Yet when her work was shown in 1910 at the Association for Free Aesthetics, it spanked off a scandal. Two nudes and *The God of Fertility* were even declared pornographic and confiscated by the police. Her religious pictures were accused of blasphemy. This case reflects what Jane A. Sharp has called the "hybrid nature of Russian modernism," a trait that not only art lovers found hard to digest. Also represented at the show were Alexandra Exter, Lyubov Popova, and Olga Rosanova, in the first public appearance of self-confident women artists whose work would have a great influence on the avant-garde developments of the period.

Undaunted by criticism, Goncharova and Larionov organised further exhibitions and founded an influential artists' group called the Jack of Diamonds. At the culmination of their Futurist phase, in 1913, Goncharova played a role in the film *Drama in the Futurist*

"Decorative painting? Poetic poetry.
Musical music. Nonsense. All painting is decorative,
if it adorns, beautifies."

1 **Portrait de Larionov,** 1913. Oil on canvas,
105 x 78 cm

2 **Nature morte à la peau de tigre,** 1908.
Oil on canvas 140 x 137 cm

3 **Le Givre,** 1911. Oil on canvas, 101 x 132 cm

4 **Les Faucheurs,** 1907. Oil on canvas, 98 x 118 cm

5 **Danseuse debout, les bras levés, avec une
ceinture violette,** 1932. Watercolour on paper,
31 x 20 cm. Costume design from the ballet
Le temps de tatares

6 **Rosalka (Nymph aquatique),** 1908. Oil on can-
vas, 100 x 74 cm

7 **Paysan russe dans un costume de fête,** 1914.
Watercolour on paper, 26 x 35 cm. Costume design
from the ballet *Le coq d'or*

3

4

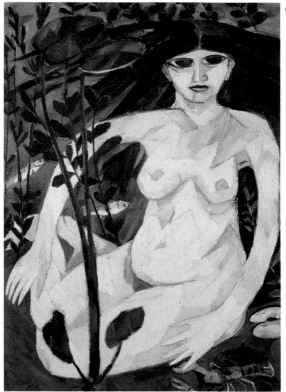

6

5

7

Cabinet No. 13. Concurrently she showed Rayonist works at an exhibition titled "The Target." Apart from a continuing interest in primitive folk art, Goncharova increasingly concentrated on developing a style that would conform to modern, industrial society. Like Larionov, she amalgamated elements of Cubism and Futurism, and worked in terms of his version of Rayonism. In paintings such as *The Weaver: Loom and Woman,* 1912–13, or *Electric Lamp,* 1913, objects from the realm of modern life and work were represented in a network of reflecting light rays. In *Portrait of Larionov,* also 1913, instead of extending light reflections from objects into space, Goncharova evoked the emanations of a strong personality. Also, she merged her own profile with Larionov's face to produce – as in a picture-puzzle – the double portrait of a couple kissing.

Increasing fame

By this time, Goncharova had become a highly respected artist. Her first solo show in Moscow, held in 1913 and also representing her first retrospective, comprised over 760 works. Numerous other works were concurrently on view in exhibitions at various art centres in the East and West. In 1914, Diaghilev, creative director of the *Ballets Russes,* invited the artist to come to Paris, to collaborate on his staging of a ballet based on Rimsky-Korsakov's opera *Le coq d'or.* Goncharova designed both the costumes and the sets, based on old Russian patterns, and came for the première on 21 May, 1914 – her first visit to Paris. The ballet was a dazzling success, and established the artist's fame as a stage and costume designer. But then the First World War intervened.

In 1916, Goncharova travelled with Diaghilev's troupe to Spain, and, in early 1917, to Rome, where she met Picasso. That same year she and Larionov, who had been wounded and discharged from the Russian army, managed to return to Paris. There followed a series of sets and costumes for ballet and theatre performances, including Stravinsky's *Les Noces,* 1923, in Paris and *The Firebird,* 1926, in London, although these were not nearly as successful as her 1914 debut. Besides continuing to produce book illustrations, Goncharova found fresh inspiration in Spanish folk art, which she had discovered during her 1916 travels with Diaghilev through Spain. The result was a series of stylised female figures in traditional costumes, *Spanish Women,* which was followed by a large-format depiction of *The Evangelists.* The naturalistic costume designs of this period stood in contrast to the geometrical reduction of Goncharova's free painting, such as a mahogany screen with the motif of *Spanish Women.*

Declining influence

Yet since she was interested neither in promoting the sale of her pictures nor in making appearances, like Larionov, on the Paris art scene, Goncharova's influence began to decline. A return to post-revolutionary Russia was out of the question for these emigrés for political reasons. Although both artists survived the war and German occupation relatively unscathed, the post-war years found them seldom leaving the seclusion of their Paris apartment. At this period Goncharova painted primarily in an abstract vein, including a series devoted to the first Russian satellite, *Sputnik.* It was not until 1954 that her work was rediscovered, in the context of a Diaghilev exhibition curated by Richard Buckle in Edinburgh and London. In 1961, a year before her death, the British Arts Council mounted a Goncharova and Larionov retrospective that included both paintings and theatre designs. *Petra Löffler*

Natalia Goncharova in front of her screen at "Les Espagnoles",
Paris 1920

Natalia Goncharova in
Rome, 1916

Natalia Goncharova, 1950

Barbara Hepworth

* 1903 in Wakefield, Yorkshire, England; ✝ 1975 in St Ives, Cornwall, England

Selected solo exhibitions: **1954** Whitechapel Art Gallery, London / **1962** "Sculpture 1952–1962", Whitechapel Art Gallery, London / **1994** "Barbara Hepworth, A Retrospective", Tate Gallery, Liverpool, touring to the Yale Center for British Art, New Haven, USA, February – April 1995 and the Art Gallery of Ontario, Canada, May – August 1995 / **1996** "Barbara Hepworth, Sculptures from the Estate", PaceWildenstein, New York (NY), USA

Selected bibliography: **1970** A. Adams (ed.), *Barbara Hepworth, A Pictorial Autobiography*, Bath

The exceptional case

Barbara Hepworth was asked in 1950 to represent Britain at the Venice Biennale, an outstanding achievement for any artist. Henry Moore had shown there two years previously and both she and Moore were part of an extraordinary group of British sculptors who would dominate the world stage in the immediate post-war years.

During her early years as a sculptor, Hepworth made representational work in stone of figures and animals, often exhibiting with her first husband, John Skeaping. In 1931, she met the painter, Ben Nicholson, whom she later married. Together they worked towards an art of complete abstraction, making close contact with artists in Paris, particularly Georges Braque, Constantin Brancusi and Piet Mondrian. An early abstract work from this period is *Three Forms*, 1935, which is also typical of her long-lasting fascination with multiple forms and their spatial relationships. From 1936–1939 Hepworth and Nicholson were at the centre of an important group of Modernist artists, resident in Hampstead, London, including Henry Moore, Naum Gabo and Piet Mondrian.

In 1939, when war broke out in Europe, Barbara Hepworth and Ben Nicholson moved to a small fishing port in Cornwall called St Ives. Artists had long been settling in St Ives, drawn there by large, relatively inexpensive studios, the dramatic Cornish landscape and the wonderful quality of light found on a peninsula. Hepworth fell in love with Cornwall and St Ives was to be her home for the rest of her life. Her work changed in response to her new environment and she became interested in the ancient standing stones found in the region, the sea and the dramatic landscape around her. All of these elements made their presence felt in her work almost straight away and her sculpture became less austere after her move from London.

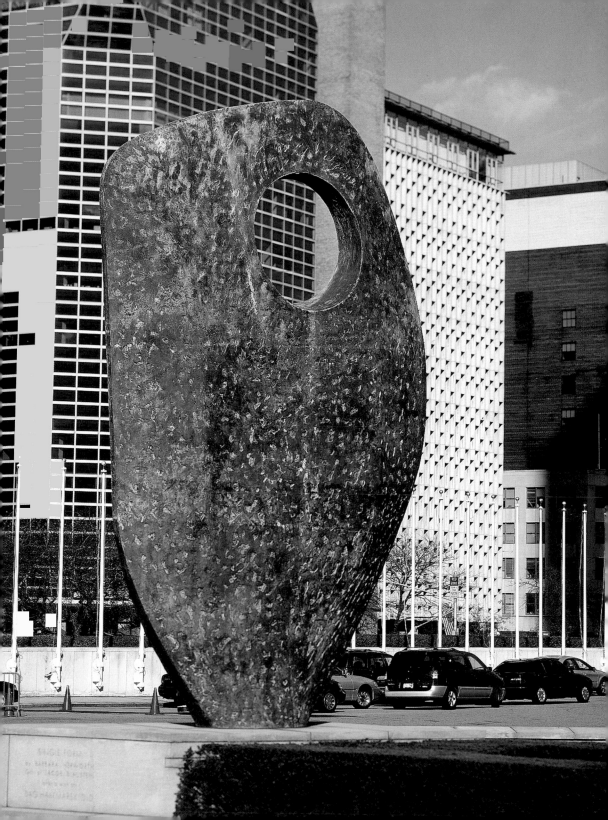

"The sculptor must search with passionate intensity for the underlying principle of the organisation of mass and tension – the meaning of gesture and the structure of rhythm."

1 **Single Form,** 1963. Bronze, (h) 6.40 m. Work commissioned by the Jacob and Hilda Blaustein
 Foundation for the United Nations, New York (NY), USA

2 **Conversation with Magic Stones,** 1973. Bronze. Figure I: (h) 269 cm; figure II: (h) 274 cm;
 stone I: (h) 80 cm; stone II: (h) 86 cm

3 **Spring,** 1966. Bronze, 85 x 57 x 53 cm

4 **Three Forms,** 1935. Serravezza marble, 20 x 53 x 34 cm

5 **Pierced Monolith with Colour,** 1965. Roman stone, inside painted blue, (h) 17cm

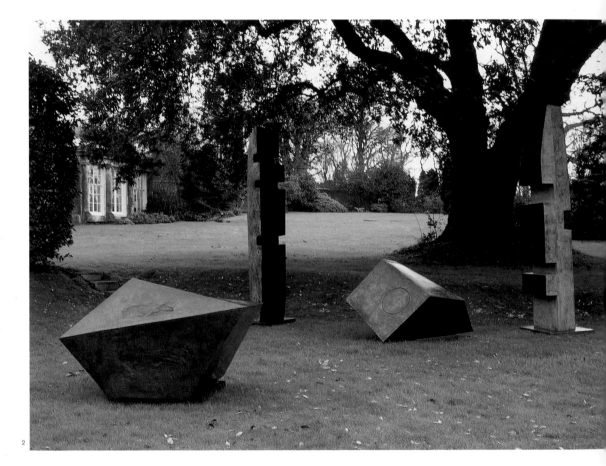

2

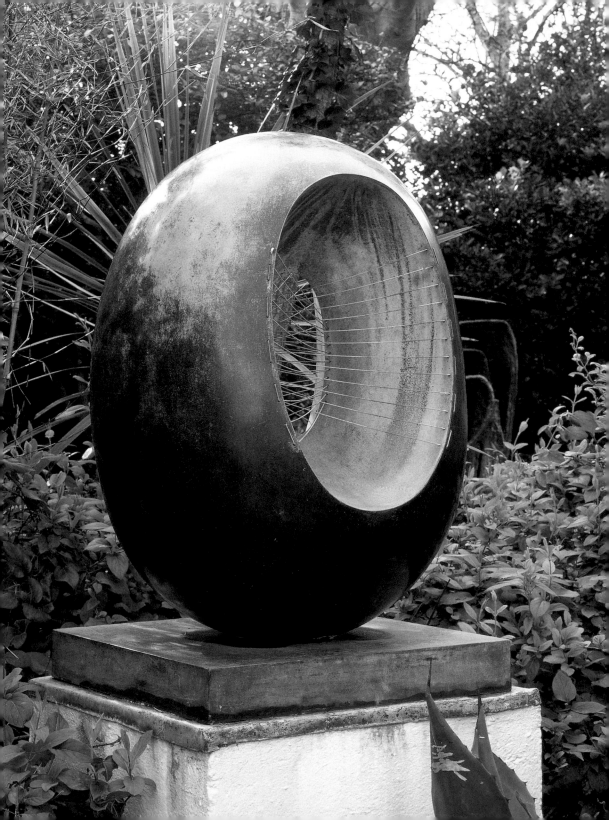

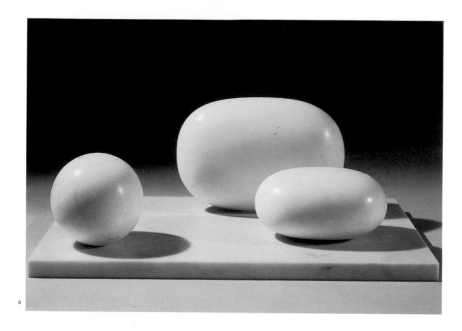

4

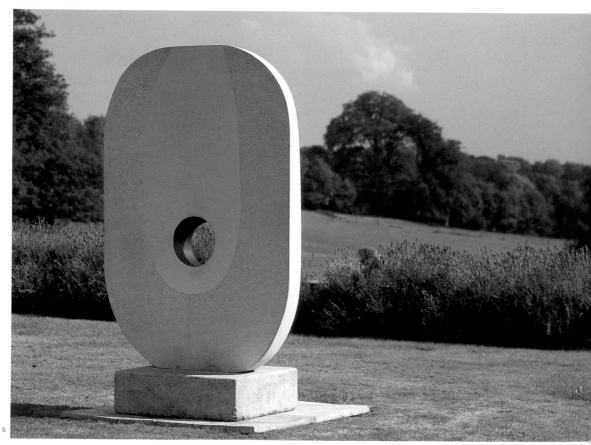

5

122 Barbara Hepworth

Hepworth's first love was carving and she made work in a wide variety of interesting materials, including woods such as walnut, teak and mahogany and stones such as marble and alabaster from Italy, as well as Cornish slate. Although she had experimented and made a few works in metal already, it was not until the 1950s that she began seriously to start exploring the potential of this material. In the mid-1950s she became interested in sheet metal, making constructed forms and, in 1956, she began to make bronze casts from her original carvings. *Spring*, 1966, is typical of this method of working and it was cast from an original elm carving Hepworth had made in the previous year. Casting enabled her sculpture to be shown out of doors and reach a much wider audience. It also allowed her to work on large-scale public commissions. Her most important public sculpture *Single Form*, 1963, stands outside the United Nations in New York. It was unveiled in 1964, as a memorial to Dag Hammarskjöld, the UN Secretary General, who had become a personal friend. After this commission and on her return to St Ives, Hepworth immediately went back to carving and completed *Pierced Monolith with Colour*, 1965. It was a personal piece and remained in her garden at St Ives until her death.

Barbara Hepworth received many honours and became a Dame of the British Empire in 1965. She also held many honorary degrees and served as a Trustee of the Tate Gallery from 1965–72. Like Henry Moore, Barbara Hepworth came from the North of England and she was always proud of her Yorkshire roots, despite her deep attachment to Cornwall. She was a small woman and totally dedicated to her art, much of which was very physically demanding. Hepworth had a very personal relationship with all the materials she used, carving everything herself and using assistants only for the bronzes and the largest works. As a result, her output is not huge compared to some of her contemporaries, but in terms of diversity of scale, form and material it is almost unrivalled. Her aim in life, in her own words, was to make "as many good sculptures as one can before one dies".

A Pictorial Autobiography

Despite an almost total immersion in her work as a sculptor, family life was vitally important to Hepworth. She had four children, a son from her first marriage to John Skeaping and triplets, a son and two girls, with Ben Nicholson. Her children played a central role in her life and, in 1970, she compiled and published *A Pictorial Autobiography* which contains many photographs of her children and grandchildren interspersed amongst images of her work, photos of Cornwall and the people and places that inspired and influenced her. It is a document that very much reflects how Hepworth saw herself and the world and explains how deeply entwined her art was with her life.

Hepworth died suddenly in a fire in her studio in 1975. Trewyn Studio in St Ives, where she had lived for almost 30 years, is now a museum run by the Tate Gallery. Her work can be found in all the most important museum collections in the world and she is particularly well represented in the collections of Leeds and Wakefield City Art Galleries, the Scottish National Gallery of Modern Art in Edinburgh, the Tate Gallery, London, the Rijksmuseum Kröller-Müller, Otterlo, the Netherlands and the Art Gallery of Ontario, Toronto, Canada. Today, Barbara Hepworth is regarded as one of the most important British sculptors.

Helen Simpson

Barbara Hepworth in St Ives, Cornwall, 1972

Barbara Hepworth in her Trewyn studio, St Ives, Cornwall, 1958

View of an exhibition of Hepworth's works at the Whitechapel Art Gallery, London, England, 1962

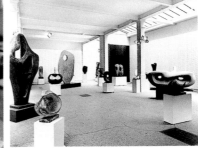

Eva Hesse

✱ 1936 in Hamburg, Germany; ✝ 1970 in New York (NY), USA

Selected solo exhibitions: **1965** Kunstverein für die Rheinlande und Westfalen, Düsseldorf, Germany / **1972** "Eva Hesse: A Memorial Exhibition", Solomon R. Guggenheim Museum, New York (NY), USA / **1979** "Eva Hesse: Sculpture", Whitechapel Art Gallery, London / **1982** "Eva Hesse: A Retrospective of the Drawings", Allen Art Memorial Museum, Oberlin (OH), USA / **1993** IVAM Centre Julio González, Valencia, Spain

Selected group exhibitions: **1961** "21ˢᵗ International Watercolor Biennial", Brooklyn Museum, Brooklyn, New York (NY), USA / **1968/69** "Annual Exhibition", Whitney Museum of American Art, New York (NY), USA / **1972** documenta 5, Kassel, Germany / **1981** "Westkunst: Zeitgenössische Kunst seit 1939", Museen der Stadt Köln, Cologne, Germany / **1993** "Amerikanische Kunst im 20. Jahrhundert", Martin-Gropius-Bau, Berlin

Selected bibliography: **1989** B. Barette (ed.), *Eva Hesse. Sculpture*, New York

An unknown quantity in art, an unknown quantity in life

Born in Germany, Eva Hesse grew up in New York, emerging as one of the most innovative and influential artists of the 1960s. In the brief period from 1965 to 1970 alone, her sculptural output numbered some 70 works. In this body of work she addressed and reinterpreted the paradigms of Pop Art and Minimalism, then the dominant movements in art — serial production, repetition, grids, the cube, the use of industrial materials and methods of production. The elusive impact of Eva Hesse's work partly derives from her use of soft, flexible, often translucent materials, either organic or seemingly so, such as fibreglass, resin, latex and rubber, synthetic tubing, and cord. They may be aesthetically appealing, indeed beautiful (a quality Eva Hesse was wary of), but they may equally suggest matter evacuated from the body. The reactions of those who visited her shows give a good indication of just how involved people felt with her work, both psychologically and physically. For instance, an early version of *Accession*, 1968, a galvanised steel cube open at the top, with innumerable short rubber tubes resembling hair on the inside, was wrecked when people tried to climb into it. Photographs show the artist herself interacting with her work: in one picture, she is seen stroking the inside of *Accession II*, 1968, while in another she is lying on a couch and her body is covered with tangled cord — a humorous self-display that, to judge by Hesse's smile, evidently alludes to the ritual of a psychoanalytical session.

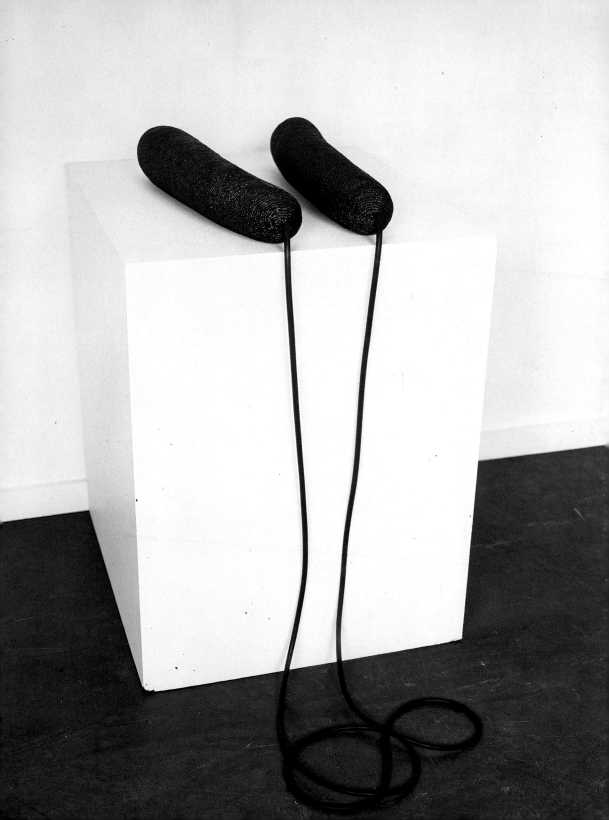

"I try my hand at the most absurd and extreme contrasts. That has always been more interesting for me than something normal with the right height and proportions."

1 **Ingeminate,** 1965. Enamel spray paint, papier mâché, cord on two balloons (each 59 x 11 x 11 cm) connected to each other by a tube (length 3.66 m)

2 **Hang Up,** 1966. Acrylic on cord and cloth, wood, steel, 183 x 213 x 198 cm

3 **Untitled,** 1963. Watercolour, gouache, Indian ink on paper, 57 x 57 cm

4 **Untitled,** 1965. Indian ink and coloured Indian ink on paper, 32 x 50 cm

5 **Repetition Nineteen III,** 1968. Fibreglass, polyester resin, 19 parts, each c. 50 cm (h), diameter c. 30 cm

6 **Accession III,** 1967/68. Fibreglass, plastic tubes, 80 x 80 x 80 cm

4

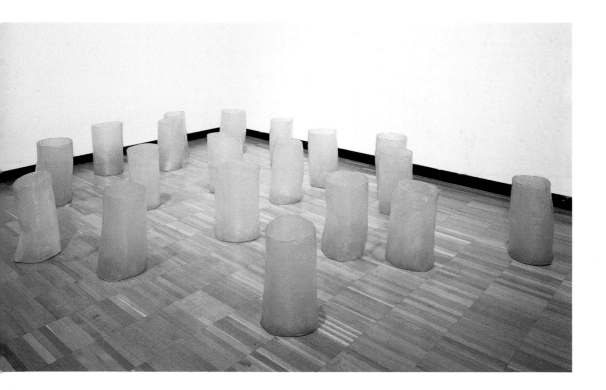

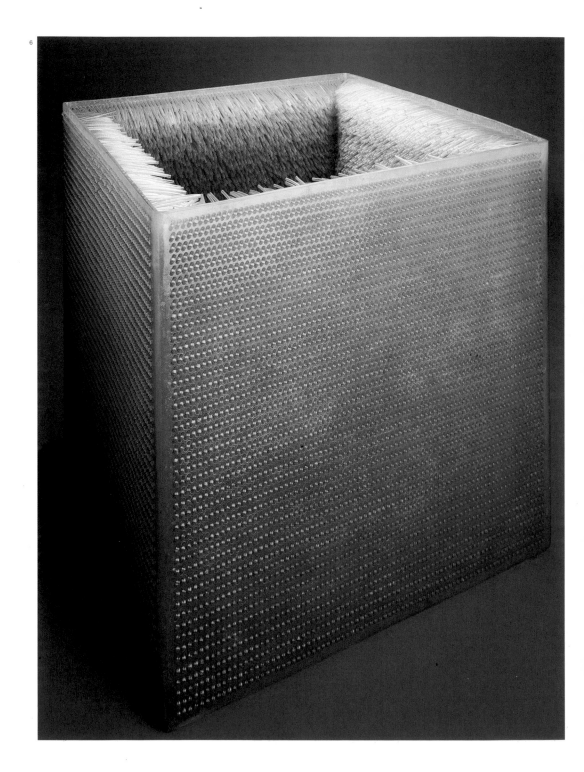

Eva Hesse saw herself as an artist from an early age. At 16 she was already writing to her father: "I am an artist. I guess I always feel and want to be a little different from most people. That is why we're called artists." She studied applied art from 1957 to 1959 at the Yale School of Art and Architecture, where German émigré Josef Albers was on the teaching staff. But while Bauhaus veteran Albers was all for strictly rational and systematic painting, Hesse's approach to the medium was more subjective, and coloured by Abstract Expressionism, as a number of self-portraits dating from around 1960 show. Willem de Kooning, Arshile Gorky and Jackson Pollock were among Hesse's major influences. But if she invariably felt painting to be a difficult, intractable affair, her output in drawing was all the more copious. The decisive breakthrough in her career – the change to three-dimensional work – did not occur while she was in the New York art milieu, however; it came in 1964–65 during a fourteen-month stay in Germany. The textile manufacturer Arnard Scheidt, an art collector, had invited Hesse's husband, American sculptor Tom Doyle, to use a factory building at Kettwig an der Ruhr as a studio. During that period, Hesse not only produced a large number of graphics surrealistically combining the mechanical and the organic, but also made 14 reliefs that were exhibited at the Kunsthalle in Düsseldorf in 1965. They were structured on rectangular fibreboard panels using plaster, papier mâché, and textiles such as cord or string, and then painted. A number had elements implying movement into the surrounding space, such as the violet cord in *Up the Down Road*, July 1965. The title is typical of the suggestive hint of paradox often found in Hesse's titles. It might be a pointer to a personal crisis recorded in Hesse's diaries, but equally it might register a fundamental unease at returning to the country which perpetrated the Holocaust, from which Hesse and her parents had fled in 1939.

Eva Hesse's return to New York in 1965 marked the beginning of her established phase as a sculptor. One of her most significant statements of the period was *Hang Up*, 1966, an outsize, empty frame structure wrapped in bandages, with a steel wire attachment or peg extending outward. In her last interview, given to Cindy Nemser in 1970, Hesse described *Hang Up* as one of her best works: "It was the first time where my idea of absurdity or extreme feeling came through." Like many of her later works, it is difficult to determine whether it is a picture or sculpture. The same is true of *Contingent*, 1969, eight cotton cloths steeped in latex and hung parallel, at right angles to the wall; or of *Right After*, 1969, an arrangement of fibreglass cords dipped in resin and hung from hooks in the ceiling. The title *Right After* refers to the making of this work after an operation for a brain tumour, which in fact killed her in May 1970.

The martyr of art

Eva Hesse's diaries, which were made public soon after her death, and the need of art criticism to have its martyr, led to an Eva Hesse myth. For a long time it was the tragic aspects of her life story – the suicide of her mother, the early death of her father, the failure of her marriage, and her own physical and mental state – that dominated interpretation of her work, which tended to be seen as the expression of specifically female experience. In 1994, though, Tom Doyle encapsulated a quite different political factor governing Eva Hesse's life and work in the following startling words: "The artist who had the most influence on Eva was Adolf Hitler." Recent studies, such as *Another Hesse* by American critic Anne M. Wagner (from which Doyle's quotation has been taken), give a more balanced account of the complex artistic, social and historical influences, relations and meanings of Hesse's work.

Barbara Hess

Eva Hesse in her studio in the Bowery, New York (NY)

Eva Hesse with her work "Right After", 1969 (detail)

Eva Hesse and Josef Albers

Hannah Höch

* 1889 in Gotha, Germany; † 1978 in Heiligensee, Berlin, Germany

Selected solo exhibitions: **1946** Galerie Rosen, Berlin, Germany / **1971** "Hannah Höch. Collagen aus den Jahren 1916–1971",
Akademie der Künste, Berlin, Germany / **1976** Musée d'Art Moderne de la Ville de Paris, Paris, France / **1989** "Hannah Höch 1889–1987",
Berlinische Galerie, Martin-Gropius-Bau, Berlin, Germany / **1996** "The Photomontages of Hannah Höch", Walker Art Center, Minneapolis (MN), USA /
2000/01 "Hannah Höch, Collagen", ifa-Galerie, Bonn, Germany

Selected group exhibitions: **1920** "Erste Internationale Dada-Messe", Kunsthandlung Dr. Otto Burchard, Berlin, Germany /
1929–1931 "Internationale Werkbund-Ausstellung, 'Film und Foto'", Stuttgart, Germany / **1958** "Dada – Dokumente einer Bewegung",
Kunstverein für die Rheinlande und Westfalen, Düsseldorf, Germany / **1988** "Stationen der Moderne", Berlinische Galerie, Berlin, Germany

Selected bibliography: **1989** Künstlerarchiv der Berlinischen Galerie Landesmuseum für Moderne Kunst, Photographie und Architektur (ed.),
Hannah Höch. Eine Lebenscollage, 1921–1945, Berlin/Ostfildern-Ruit, Germany

Hannah Höch triumphs!

"Dada triumphs!" This slogan was used by Hannah Höch, pioneer of photomontage and a member of the Berlin Dadaists from 1917 to 1922, in her famous collage *Schnitt mit dem Küchenmesser durch die letzte Weimarer Bierbauchkulturepoche Deutschlands* (Slash with the Kitchen Knife through the final Weimar Beer-Belly Cultural Epoch of Germany), 1919. The Dadaists' satirical declaration of victory was an attack on Europe's woeful social and political condition in after the First World War. They used the aesthetic weapons of collage and photomontage as an (anti-)artistic means of shocking the public and thus as a way of deconstructing a situation considered absurd.

Hannah Höch grew up in a middle-class home in the small town of Gotha in Thuringia, and, in 1912, began studies at the College of Applied Arts in Charlottenburg, Berlin. From Höch's point of view, this was a compromise: "All my dreams had been focused on the Academy, but I did not dare make known my wish to go there", she remarked later in her autobiographical *Lebensüberblick*, 1958, commenting on her true ambition to become a painter. The outbreak of the First World War in August 1914 (at which time she was in Cologne at the Werkbund exhibition) signalled the collapse of Höch's "hitherto well-tempered view of the world". In 1915 she returned to Berlin and entered the graphic art class taught by Emil Orlik at the State Museum of Applied Arts. That same year she embarked on a seven-year relationship that was to last seven years, with writer and artist Raoul Hausmann, through whom she was introduced to a number of artist's groups, among them the Expressionists (with their focal centre at Herwarth Walden's gallery and publishing house, Der Sturm), the Italian Futurists, and the Dadaist circle that was constituted in 1917, including Richard Hülsenbeck, Johannes Baader, George Grosz, John Heartfield and Wieland Herzfelde. Despite their anarchic-cum-revolutionary stance, the Berlin Dadaists were in fact something of a gentlemen's club with a patriarchal profile, in which the presence of women remained the exception. Höch was indeed the only woman artist included in the First International Dada Fair at Otto Burchard's Berlin gallery in 1920. Among the items she exhibited there was the photomontage *Schnitt mit dem Küchenmesser* (Slash with the Kitchen Knife…), which not only slashed Weimar's beer-belly culture, as the title promised, but also targeted the social situation of women: a map showed which European countries had given women the vote, while in her montage of men's and women's bodies Höch subverted unambiguous images of gender identity. The broader political statements made in the work are even clearer: at the bottom left, together with photographs of crowds and Höch's initials, are the heads of Dadaists and of Marx and Lenin, while at the top right, over the words "The Anti-Dadaist Movement", are portraits of Friedrich

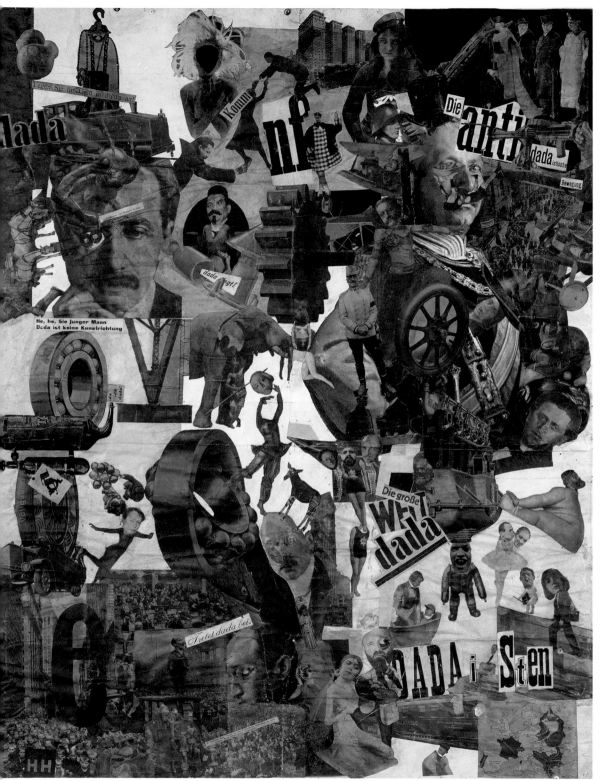

2

1 Schnitt mit dem Küchenmesser durch die letzte Weimarer
 Bierbauchkulturepoche Deutschlands, 1919. Collage, 114 x 90 cm
2 Entführung (aus einem ethnologischen Museum), 1925. Collage, 20 x 20
3 Meine Haussprüche, 1922. Collage on cardboard, 32 x 41 cm
4 Wenn die Düfte blühen, 1962. Collage, 21 x 23 cm
5 Frau und Saturn, 1922. Oil in canvas, 87 x 67 cm
6 Die Braut oder Pandora, 1927. Oil on canvas, 114 x 66 cm

3

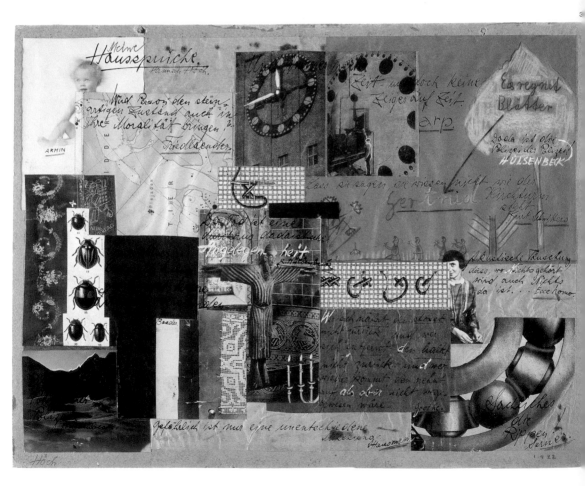

"I should like to erase the fixed boundaries that we self-assured humans like to draw around anything we can achieve."

5

6

A

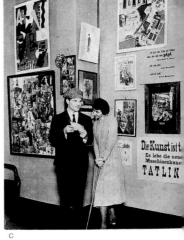

B

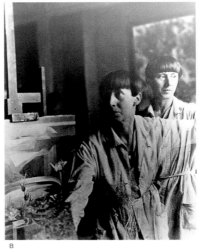

C

Ebert, Kaiser Wilhelm II, Field Marshal Hindenburg, and other military leaders. In the centre of the composition is Käthe Kollwitz, the first woman to be made a member of the Academy of Arts, in 1919; her portrait seems virtually suspended over the body of dancer Nidda Impekoven, who personifies the self-confident, financially independent New Woman of the 1920s. The material Höch used, both pictorial and textual, came in part from technical brochures or private photographs, but in the main was taken from illustrated magazines. This was a medium Höch was steeped in, not only in her work as an artist, but also in her professional work as a graphic designer for the publishing house Ullstein from 1916 to 1926. The montage *Meine Haussprüche* (My Domestic Mottoes), 1922, juxtaposed excerpts from handicraft patterns such as Höch was producing at the time with photographs of machine parts, portraits, children's drawings, and quotations from authors as various as Hülsenbeck, Baader and Hans Arp, Goethe and Nietzsche. This work was made at the time when the Berlin Dadaists went their separate ways, and Höch and Hausmann similarly separated – the names of Arp and Kurt Schwitters signalled her new artistic affinities.

In the post-Dada period, Höch continued to extend the potential of collage and photomontage, both formally and in terms of content. Her work in the 1920s included *Mischling* (Half-Breed), 1924, and series such as *Aus einem ethnographischen Museum* (From an Ethnographic Museum), 1925–29, which deconstructed clichéd images of ethnic and sexual identity and remade them in a ludic spirit. Though Höch remains primarily known to this day for her photomontages, she also produced a substantial and stylistically diverse body of work parallel to these: there are pictures in which the montage principle was imported into painting, for instance, and there are also surprising surreal tableaux, still lifes in the manner of the New Objectivity, and expressive portraits.

Surviving the Nazi era

In the 1930s, Höch found herself under mounting pressure from official arts policy in the Nazi Third Reich, a dilemma that found expression in various works. The (pre-Reich) collage *Dompteuse* (Trainer), 1930, not only expressed private conflict with her partner of many years' standing, the Dutch woman writer Til Brugman, but also (in the uniform-like clothing worn by the figure) articulated a sense of political menace. A number of her artist friends left the country after the Nazis came to power, but Höch, though lambasted as a "cultural Bolshevik" and banned from exhibiting, remained in Germany, in "inner emigration". In mortal danger, she created an archive of Dadaist work in her home on the outskirts of Berlin, and it was this that made the group's rediscovery after the Second World War feasible.

Although Hannah Höch began exhibitioning again in galleries in 1946, and was included in international Dada retrospectives, it was not until the major 1971 show of her work at the Academy of Art in Berlin that her achievement became an object of closer scrutiny and interest. Even so, Höch has time and again been reduced to her role as of Raoul Hausmann's partner, seen as a "fairy" (Eberhard Roters), "the Sleeping Beauty of Dada" (Heinz Ohff) or the "indispensable worker-ant" (Hans Richter) of the Dadaists. Not until the 1980s did feminist art history take a subtler, more careful view of Höch's complex and committed work. *Barbara Hess*

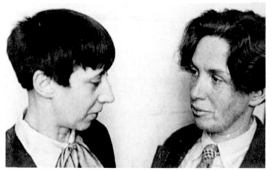

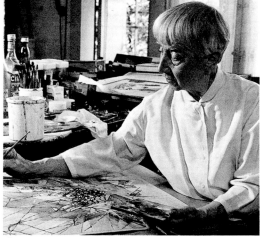

A Hannah Höch as a figurine with one of her Dada dolls, c. 1925
B Hannah Höch in her studio, c. 1930. Double exposure
C Hannah Höch and Raoul Hausmann before works of theirs at the First International Dada Fair, 1920
D Hannah Höch and her partner, the Dutch woman writer Til Brugman, c. 1930
E Hannah Höch working in her studio, c. 1970

Candida Höfer

*** 1944 in Eberswalde, Germany; lives and works in Cologne, Germany**

Selected solo exhibitions: **1982** "Öffentliche Innenräume 1979–82", Museum Folkwang, Essen, Germany /
1992 "Photographie II", Hamburger Kunsthalle, Hamburg, Germany / **1999** "Orte, Jahre", SK Stiftung Kultur, Cologne, Germany /
2000 The Museum of Contemporary Photography, Chicago (IL), USA; The Power Plant, Toronto, Canada

Selected group exhibitions: **1993** "Photographie in der deutschen Gegenwartskunst", Museum Ludwig, Cologne, Germany /
"Beyond Recognition", National Gallery of Australia, Canberra, Australia / **1999** "The Museum as Muse: Artists Reflect",
The Museum of Modern Art, New York (NY), USA / "Räume/Rooms", Kunsthaus Bregenz, Bregenz, Austria /
2000 "Rot Grau", Kunsthalle Basel, Basle, Switzerland

Found spaces

"What interests me about spaces is the mixture of different epochs, how different periods represent themselves", stated Candida Höfer in 1998, indicating a key theme of her work: the superimposition of various time levels that becomes evident in the stylistic discontinuities between architecture and interior decoration. Since 1979, Höfer has been photographing public and semi-public interiors – waiting rooms, hotel lobbies, spa facilities, banks, churches, theatres, university auditoriums, libraries, archives, museums and, since 1990, zoos. With a sure sense of the coexistence of the anachronistic, her images capture bizarre and occasionally paradoxical things when the history of a place and its current functions and uses collide. For instance, the modern radiators at the *Musée Antoine Wiertz Brussels I 1985* take on an almost sculptural character; our eye stumbles over a beverage vending machine in the Palladian *Teatro Olimpico Vicenza 1988* or the computer workplaces at the *Deutsche Bücherei Leipzig I 1997* reflect an innovative approach to information and knowledge.

Höfer's photographed interiors are places of transition, but also for the accumulation, storage and organisation of knowledge – locations of the cultural memory, designed for collective use. Yet they very seldom include actual human beings. Human presence is only indirectly sensed in the signs of use visible in the rooms, or in figurative representations in art, such as the mural in *Palacio de los Marqueses de Viana Córdoba 1993*.

The human figure was not absent from Höfer's work from the beginning. In 1972, she began an approximately six-year project called *Turks in Germany*, presented in 1975 in the form of slide projections in her first solo exhibition at the Galerie Konrad Fischer in Düsseldorf, and expanded in 1979 into a dual projection, *Turks in Germany and Turks in Turkey*. The photographs focused on people's relationship to their everyday, usually urban environment, in cities such as Ratingen, Cologne, Düsseldorf and Hamburg. Besides picnic scenes in parks, men sitting in tea rooms, and families at home in their flats, the series included many images of Turkish shopkeepers. Yet as she recalled in a 1989 interview, Höfer ultimately felt like an intruder into these people's private sphere, and hence has since avoided including persons in her photographs.

6

1 Wartesaal Köln III 1981. C-print, 38 x 38 cm

2 The Standard Los Angeles I 2000. C-print, 120 x 120 cm
3 Lycée Monod Enghien-les-Bains IV 1999. C-print, 120 x 120 cm
4 Festspielhaus Recklinghausen I 1997. C-print, 120 x 120 cm
5 Etablissement Thermal Enghien-les-Bains I 1999. C-print, 120 x 120 cm
6 Bibliothèque National de France Paris XXIV 1998. C-print, 60 x 75 cm

7 Zoologischer Garten Köln I 1992. C-print, 26 x 58 cm
8 Eckermannstraße Hamburg 1978. Gelatin silver print, 24 x 30 cm

"I photograph rooms the way they are."

Discovered locations

The interest in spatial structures already evident in this early work was further honed by Höfer's attendance of Bernd Becher's photography classes at the Düsseldorf Academy from 1976 to 1982. Yet, unlike the systematic documentary approach of Bernd and Hilla Becher, whose encyclopaedic "typologies" of industrial buildings strive for an utmost objectivity through homogeneous compositions, Höfer's camera positions – and thus the composition of the image space – are determined by the atmosphere of the specific interior. Similarly, her choice of motifs depends on personal preferences and chance opportunities. Still, Höfer does follow a consistent aesthetic principle: she photographs existing locations and situations largely without altering them, and works solely with the given light sources. Here, the principle of series and repetition becomes crucial. Elements that repeat themselves, like the window band and rows of lamps leading the eye into the background in *Abbey Mountain St. Benediktusberg Vaals II 1993,* the reading tables in *British Library London I,* 1994, the coat racks in *Mirabelle Palace Salzburg IV 1996,* or the minimalistic seating arrangements in the new *Bibliothèque Nationale de France Paris III 1998* articulate and lend rhythm to the pictorial space. They make visible the regulatory force of three-dimensional organisation and the architectural parameters that assign objects and persons their place within the overall structure.

Public places

Many of Höfer's photographs are devoted to libraries and museums, institutions in which Western notions of order in cultural history are categorised, administered, stored and displayed. The camera again and again captures situations illustrating the artificial nature of this system of order. In *Koninklijk Museum voor Schone Kunsten Antwerp II 1991* for instance, the eye is drawn to the scaffolding being used for renovation work in the farthest corner of the museum room; or, in *State Museum of Natural History and Prehistory Oldenburg I 1998,* we gaze into the depot with its countless stuffed birds closely packed on plain white cabinets. In *Museum of Ethnology Dresden IV 2000,* Höfer takes us into the museum workshop, where varicoloured pedestals form a random arrangement. These things, relatively unimportant apart from their purpose of displaying museum items, become display objects in their own right, pointing up the meaning-engendering aspect of the pedestal.

Höfer subtly employs this insight into the power of presentation in her own choice of formats and the arrangement of her exhibitions. For instance, the medium-format photographs of interiors in a trendy American hotel shown at Johnen & Schöttle in summer 2000 were hung not at eye-level but at waist-level, thus augmenting the suggestiveness of the images by emphasising the body axis and physically drawing the viewer into the image. The "placement of the exhibits" thus takes on dual meaning – as the object of aesthetic interest, as Höfer pointed out in 1989, and as a working principle.

Astrid Wege

Candida Höfer photographs in the Würzburger Residenz, 1980s
Candida Höfer, 2001
Candida Höfer with her assistant Ralph Müller taking photos in the Konsthal, Rotterdam, 2000

Nancy Holt

* 1938 in Worcester (MA), USA; lives and works in Galisteo (NM), USA

Selected solo exhibitions: **1972** Art Gallery, University of Montana, Missoula (MO), USA / **1977** "Young American Filmmakers' Series",
Whitney Museum of American Art, New York (NY), USA / **1979** Miami University Art Museum, Oxford (OH), USA / **1989** Montpellier Cultural Arts Center,
Laurel (MD), USA / **1993** John Weber Gallery, New York (NY), USA

Selected group exhibitions: **1977** Whitney Biennial, Whitney Museum of American Art, New York (NY), USA / **1981** "Summer Light",
The Museum of Modern Art, New York (NY), USA / **1989** "Making Their Mark", Cincinnati Art Museum, Cincinnati (OH), USA;
New Orleans Museum of Art, New Orleans (LA), USA; Denver Art Museum, Denver (CO), USA; Pennsylvania Academy of Fine Arts,
Philadelphia (PA), USA / **1998** Wiener Kunstverein, Vienna, Austria / **1999** "After Image: Drawing Through Process",
Museum of Contemporary Art, Los Angeles (CA), USA

Selected bibliography: **1993** Nancy Holt, "Ecological Aspects of My Work", in *Creative Solutions to Ecological Issues*, New York

Heaven and earth

Nancy Holt's *Sun Tunnels*, 1973–76, located in the salt flats of the Great Basin in northwestern Utah, is one of the icons of American Land Art. There is hardly a publication on this 1960s and 1970s movement that does not include photographs of sunlight being focused as if through a lens by the work's four concrete pipes or forming bright spots on their curved interiors.

Towards the end of the 1960s, a series of artists, including Michael Heizer, Walter de Maria, Dennis Oppenheim, and Holt's then husband Robert Smithson, left the constraints of galleries behind and set out to make aesthetic statements out of doors, often in the wide open spaces of the American West or at abandoned industrial sites. The landscape served them simultaneously as material for art and as a stage for occasionally huge-scale interventions which questioned and expanded conventional definitions of sculpture.

Holt, whose oeuvre includes films, videos, photographs and artist's books as well as sculptures, is one of the few and surely the best known of the women artists of this first generation of Land artists to have been repeatedly accused of an exploitive – that is, "male" – approach to the natural environment. Writing in *Art International* in 1978, for instance, Martha McWilliams Wright ironically sketched a heroic masculine picture of the "earthwork artist" who stands alone in the desert, flanked by bulldozer and dump truck, brandishing his fist in the face of the universe.

Even though this criticism of dominance over and monumentalisation of nature may have been justified in some cases, the overall picture of the artistic processes subsumed under the term Land Art is much more manifold. As regards Holt's *Sun Tunnels*, the notion of de-monumentalisation would seem more to the point. "I wanted to bring the vast space of the desert back down to human scale", Holt wrote in *Artforum* in 1977. "I had no desire to make a megalithic monument. The panoramic view of the landscape is too overwhelming to take in without visual reference points." *Sun Tunnels* on the one hand serves to limit and focus the viewer's gaze, and on the other projects our frame of reference far beyond the actual landscape itself. The size and placement of the holes drilled in the tunnel walls, though which sunlight and moonlight fall to produce changing patterns of light depending on the time of day and season, form stellar constellations. Oriented to the height of the sun at the solstices, the four pipes in the form of a cross constitute a universal timepiece.

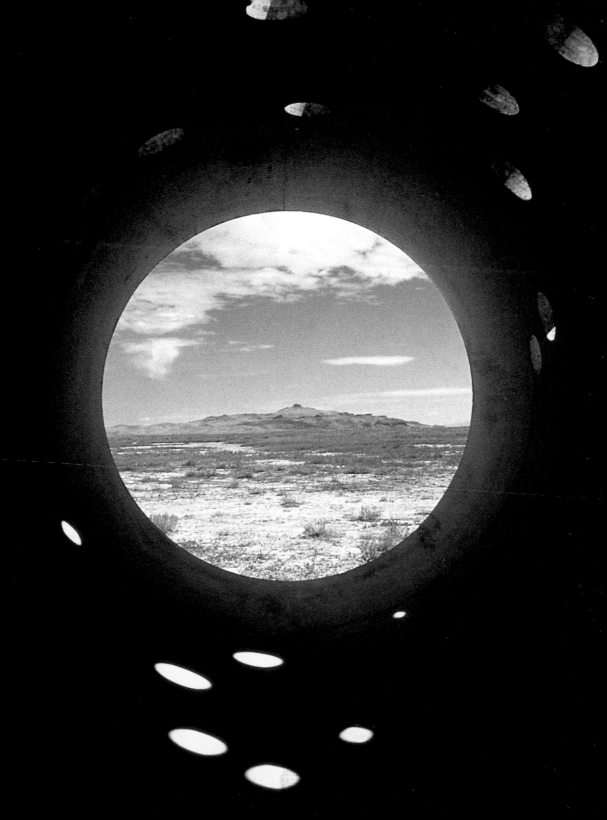

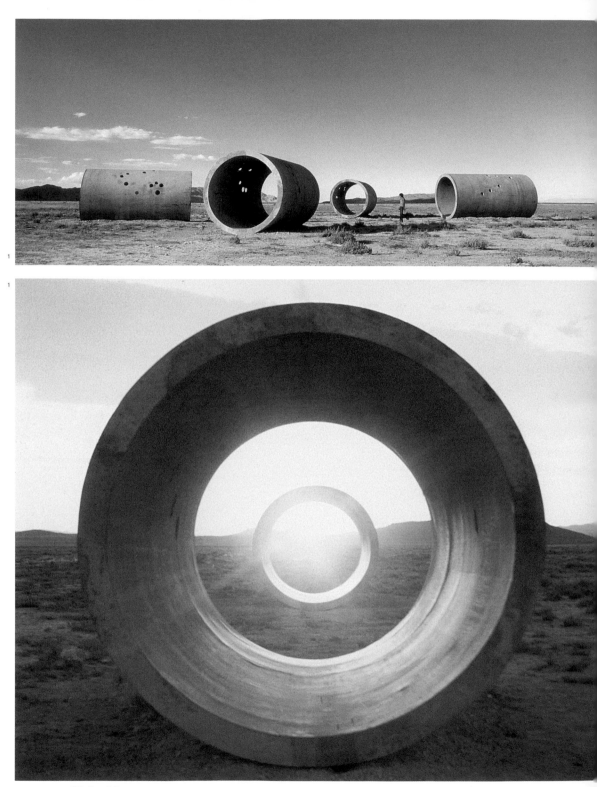

"Time is not just a mental concept or a mathematical abstraction in the salt desert of Utah's Great Basin. It can also take on a physical presence."

1 **Sun Tunnels,** 1973–76. Concrete. Great Basin Desert, Utah, USA

2 **Rock Rings,** 1977/78. (details). Stone masonry. Bellingham (WA), Washington, USA
3 **Up and Under,** 1998. (details). Sand, concrete, grass, water. Nokia, Finland

4 **Ventilation IV: Hampton Air,** 1992. Steel pipe, ventilators, air. Installation view, Guild Hall, East Hampton, New York (NY), USA
5 **Annual Ring,** 1980/81. Steel bars, marks solar noon summer solstice, 4.35 m (h), diameter 9 m. Saginaw, Michigan, USA
6 **Electrical System II,** 1982. Steel conduit, light bulbs. Installation view, Bellman Circuit, Toronto, Canada

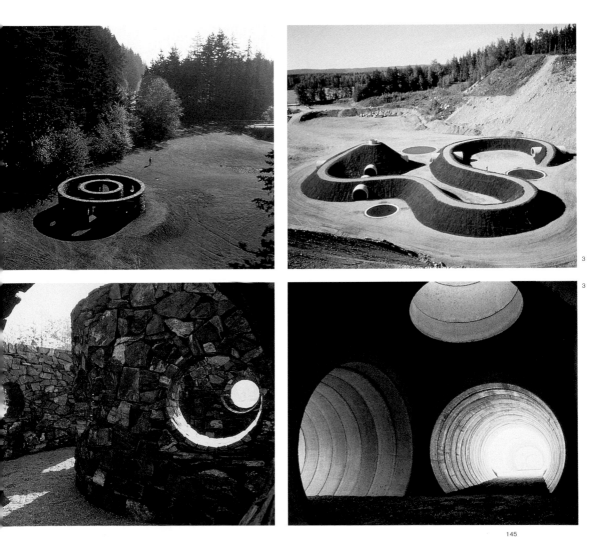

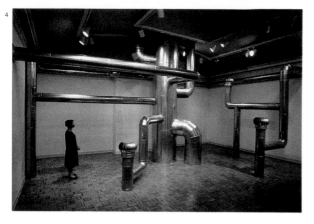

Natural wastelands

Sun Tunnels paradigmatically combines several essential aspects of Holt's approach: first, the relation of work to place, manifested, among other things, by choice of materials – natural rock, bricks, concrete, steel, soil, plants, water, etc.; second, an oscillation between physiological and psychological perceptions that gives us the sense of being drawn into and encompassed by the work; and third, an involvement with astronomy, which is not only the basis but a constituent part of many of Holt's works. Examples are the six water containers of various sizes in *Hydra's Head,* 1974, which reflected the constellation of Hydra; the configuration of *Rock Rings,* 1977/78, orientated to the position of the Pole Star; or *Annual Ring*, 1980/81, *Solar Rotary,* 1995, and *Solar Web,* 1984, conceived for Santa Monica Beach, all of which were astronomically precise instruments for measuring time. In *Annual Ring,* the rods of a grid form a dome, open at the top and with further open circles on the sides. The upper circle was calculated in such a way that the light cast by the sun when it reaches its zenith on the day of the summer solstice exactly fills the floor area of the cupola. The circles on the sides frame the sunrises and sunsets at the equinoxes, or the North Star. The midpoint of the stylised sun in *Solar Rotary*, 1995, is similarly oriented to the solar zenith. The cyclic progression of the universe, additionally symbolised by a meteorite at the sculpture's centre, is contrasted to the linear time structure of history. Five bronze plaques in the ground, illuminated by the sun on certain days at different hours, recall important events in the history of Florida – the sculpture is complete only in interaction with the sun's motion.

The deserts of civilisation

In executing her works, especially those of an urban and ecological character, Holt often collaborates with experts from other fields such as astrophysics, landscape architecture, and engineering. In *Dark Star Park,* 1979–84, she converted a vacant lot wedged between streets in Arlington, Virginia, into a city park. In *Catch Basin,* 1982, she constructed a basin and drainage system in St. James Park, Toronto, at exactly the point where water gathered after heavy rains. *Up and Under,* 1998, reflected a similar concern to reclaim an abandoned industrial site. In the lunar landscape of a sand quarry near the town of Nokia, Finland, Holt built a sinuous earth wall and planted it with grass. Punctuated by a system of seven concrete pipes pointing horizontally to the four points of the compass and one pipe pointing vertically into the sky, the work leads the eye to some detail in the surroundings or upwards, into the firmament. Like previous works, *Up and Under* sharpens our awareness of what is near by first drawing attention to what is distant.

If, in the 1970s, it was natural deserts which Holt wished to make accessible to people, now it is the deserts of civilisation. "I hope this project," said Holt of *Up and Under,* "will stimulate consideration of other unique ways to develop the numerous sand quarries and other industrially devastated areas in Finland and elsewhere, restoring them for public use while making them once again part of the ecosystem."

Astrid Wege

Nancy Holt at her "Sun Tunnels", 1999

Nancy Holt overseeing construction of "Up and Under", 1997

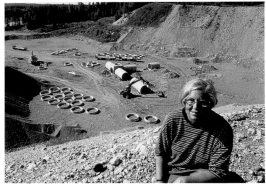

147

Jenny Holzer

* 1950 in Gallipolis (OH), USA; lives and works in Hoosick (NY), USA

Selected solo exhibitions: **1983** "Essays, Survival Series", Institute of Contemporary Arts, London **1989/90** "Laments 1988–1989", Dia Art Foundation, New York (NY), USA; Solomon R. Guggenheim Museum, New York (NY), USA / **1996** "Jenny Holzer: Lustmord", Contemporary Arts Museum, Houston (TX), USA; Kunstmuseum des Kantons Thurgau, Switzerland / **2001** "OH", Neue Nationalgalerie, Berlin, Germany

Selected group exhibitions: **1987** documenta 8, Kassel, Germany / **1990** "High & Low: Modern Art and Popular Culture", The Museum of Modern Art, New York (NY), USA; The Art Institute of Chicago, Chicago (IL), USA; San Francisco Museum of Modern Art, San Francisco (CA), USA / XLIV Esposizione Internazionale d'Arte, la Biennale di Venezia, United States Pavilion, Venice, Italy / **1995** "fémininmasculin. Le sexe de l'art", Musée national d'art moderne, Centre Georges Pompidou, Paris, France / **2000** "The American Century: Art and Culture 1900–2000", Whitney Museum of American Art, New York (NY), USA

Message en passant

Employing the medium of the word, Jenny Holzer gives expression to messages, statements, theses and antitheses on the subject of taboos, sex, violence, love, war and death. While she was a student, she was oriented towards abstract painting, but her aim was nonetheless to convey content and present her themes to the public eye. Initially, therefore, she wrote explicit texts on abstract pictures. In 1977, she moved to New York and has since concentrated on the medium of language. In the same year, she began her first series, called *Truisms*, printing one-liners in capitals on T-shirts and posters that she fly-posted throughout the city. Almost unnoticed, she attached her messages to telephone boxes, parking meters and house walls. The 40 to 60 sentences contained in each work were arranged alphabetically. They read like truisms or gawky statements about social conditions, politics, everyday life, violence and sexuality, and brought the reader up short, prompting him to reflect. The Anglo-American tradition of Speaker's Corner, the specifically American narrative tradition, and superficial *Reader's Digest*-style opinion-forming were as much Holzer's model as the conceptual art of Lawrence Weiner or Joseph Kossuth. But at first she did not feel she was an artist, seeing her activity instead as part of the agitprop tradition.

Between 1979 and 1982, Holzer created another series of posters. However, unlike *Truisms*, the texts of *Inflammatory Essays* were no longer a series of successive statements, but pamphlets or aphorisms – short structured texts consisting of just a few sentences inspired by the writings of Hitler, Lenin, Mao and Trotsky as well as other political figures and philosophers. In 1980, Holzer began a series of text panels made of bronze or some other metal whose inscriptions were executed in large lettering. She put up the panels besides the brass plates of doctor's surgeries or even gallery signs. This *Living Series*, up to 1982, was not so much in pursuit of 'great political ideas', but scattered everyday first-person messages and instructions, injunctions or advice aimed at an unspecified 'you'. Thanks to the inconspicuousness of the medium, noticed casually en passant, combined with the violence of the words, Holzer momentarily caught the attention of passers-by with her messages. She was exploiting advertising methods in the urban environment both to counter sanitised phraseology and put across her own message. At first, she made no use of artistic settings for this.

Her real breakthrough came in 1982, when she presented her sentences to the public in the form of constantly changing messages on an LED display in New York's Times Square. Borrowing from *Truisms*, one statement followed another, the best-remembered being "Protect me from what I want". Holzer used the display's ever-changing text to pile thesis on antithesis, thereby intensifying the provocative force. From now on, she worked in this advertising medium in a variety of places, such as football stadia, banks (interspersed with stock market news), and the forest of signs in Las Vegas. In such locations, she often sought the close proximity of ordinary advertising and neon signs to exploit the contrast with them.

"It's women who've been doing the most challenging art in the last decade. Psychologically seen, their work is much more extreme than men's."

1 **Various texts,** 1990. LED signs, each 385 x 14 x 10 cm. XLIV Esposizione Internazionale d'Arte, la Biennale di Venezia, United States Pavilion, Venice, Italy

2 **Lustmord,** 1993/94. Nine LED signs, c. 300 bones with rings, each LED display 452 x 25 x 11 cm. Installation view, National Gallery of Australia, Canberra, Australia

3 **Various texts,** 1990. LED sign, 160 m x 36 cm x 10 cm. Installation view, Solomon R. Guggenheim Museum, New York (NY), USA

4 **Various texts,** 1995. Four-sided hanging LED sign, 11.23 m x 45 cm x 45 cm. Installation view, Toyota Municipal Museum of Art, Toyota Aichi, Japan

5 **Various texts, Mother and Child,** 1990. Twelve LED signs, marble floor, LED displays 385 x 14 x 10 cm, floor 9.75 x 6.33 m. XLIV Esposizione Internazionale d'Arte, la Biennale di Venezia, United States Pavilion, Venice, Italy

6 **Kriegszustand, Leipzig Monument Project (Völkerschlachtdenkmal).** Laser projection. Outdoor installation, Galerie für Zeitgenössische Kunst Leipzig, Leipzig, Germany, 1996

7 **Arno,** 1996. Projection on the River Arno and Palazzo Bargagli, c. 60 x 34.5 m. Florence Biennial, Florence, Italy

8 **Lustmord,** 1993/94. Ink on skin, cibachrome print, 33 x 51 cm

2

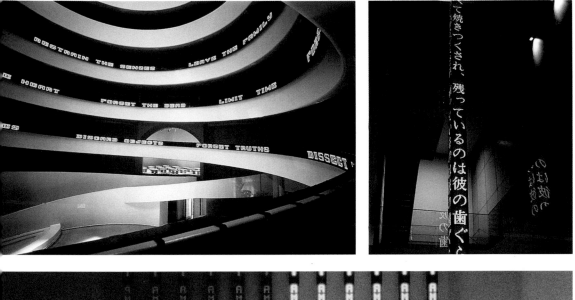

4

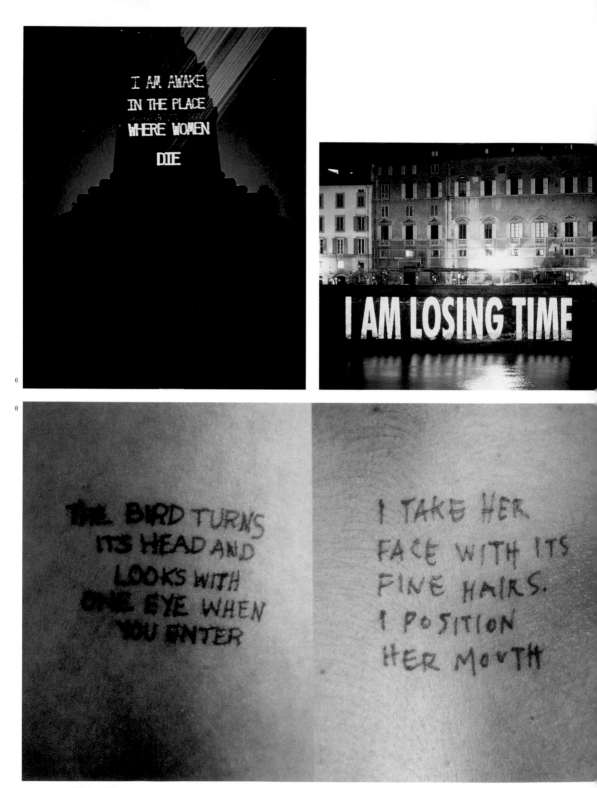

Survival messages

Between 1983 and 1985, Holzer worked on her *Survival Series*, which she presented on various combinations of LED monitors, small-format electronic displays, and photographic light tables. The contents of the new series were more complex than before, and the language more aggressive. In addition, the works' humanitarian assumptions and stance caused them to appeal to the reader, an example being: "Go where people sleep and see if they're safe." In such advertising vehicles, Holzer had found a medium that she could also exhibit in museums and galleries, although its effect here was much more muted than in the outside world.

Departing from the rapidly changing illuminated texts, in 1986 Holzer developed benches made of stone with texts carved into them, where exhibition visitors could sit down. She called these exhibition items inviting rest and contemplation *Under a Rock*, and they were later shown not just in exhibitions, but also in sculpture parks. The following year she did some sarcophagi made of granite, which were likewise inscribed. When she took part in documenta 8 in 1987, she used in her installation narrow coloured strips of light for the first time, whose letters ran individually from top to bottom or vice versa. In 1990, she hit the headlines at the Venice Biennale when – as a new mother – she was the USA's sole female artist, showing a work about the mother-child relationship, and her pavilion received the accolade of best national display.

Bloody news

In 1993, the year the Bosnian war was in full spate, Holzer had the message "Where women die, I am wide awake" printed in ink mixed with the blood of Bosnian women on the front cover of the magazine of the *Süddeutsche Zeitung*, which triggered public outrage. With this action and the photo series *Sex Murder*, 1993/94, where she wrote individual sentences on the women's skin, Holzer wanted to draw attention to the numerous rapes and sexual murders in Bosnia. Holzer is passionate about human rights and the rights of women.

In 1996, she used lasers to project location-specific texts on the battlefield memorial to the 1813 Battle of Leipzig. In the same year, she did the *Arno* project for the Florence Biennale: text images were beamed at night by xenon projection on embankment walls and nearby houses, and reflected in the river. Holzer always updates her range of media and works with the latest technologies, so that her response is appropriate and contemporary. She is thus already using three-dimensional LED displays, generating computer graphics for a cyberspace installation, and developing spots for the music channel MTV. But irrespective of the medium, her messages always pack an emotional punch, provoking the reader to stop and think.

Ulrike Lehmann

Jenny Holzer riding a pony with her mother

Jenny Holzer and her husband Mike Glier

Rebecca Horn

*** 1944 in Michelstadt, Germany, lives and works while simultaneously travelling**

Selected solo exhibitions: **1975** Kölnischer Kunstverein, Cologne, Germany / **1983** Centre d'Art Contemporain, Geneva, Switzerland; Kunsthaus Zürich, Zurich, Switzerland / **1984** Serpentine Gallery, London, England; Museum of Contemporary Art, Chicago (IL), USA / **1993** Solomon R. Guggenheim Museum, New York (NY), USA / **1997** "The Glance of Infinity", Kestner Gesellschaft, Hanover, Germany

Selected group exhibitions: **1972** documenta 5, Kassel, Germany / **1980** XXXIX Esposizione Internazionale d'Arte, la Biennale di Venezia, Venice, Italy / **1989** "Magiciens de la Terre", Musée national d'art moderne, Centre Georges Pompidou, Paris, France / **1992** documenta IX, Kassel, Germany / **1997** "Skulptur. Projekte in Münster 1997", Westfälisches Landesmuseum für Kunst und Kulturgeschichte, Münster, Germany / **2000** "Zeitwenden", Museum für Moderne Kunst Stiftung Ludwig, Vienna, Austria

A journey into the interior of the body

When Rebecca Horn was a young girl, her father told her fairy tales of witches, goblins and dragons, setting the scene of the action in their own vicinity, the Odenwald in Hesse. Since that time, Horn has suffered from great anxiety. Another key experience occurred during her schooldays: at junior school she had to take her turn, like all the other children, at leading prayers, but did not know how to do so. Her anxiety became so great that she lost control of her bladder, and consequently was punished. After being sent to boarding school, she ran away – accompanied by the fear that witches would pursue her. Subsequently she received private tuition from a blind professor in France. At her father's wish, she began reading economics and philosophy at college, but after six months began attending the Art School in Hamburg – at first secretly.

In 1967, Horn created her first sculptures, made of polyester and fibreglass. She seriously damaged her lungs while inhaling the polyester fumes produced during the work. While recuperating in a sanatorium, she searched for possibilities of communicating with others, despite her isolation. The result was a number of drawings and her first body sculptures made of cloth and bandages, borne by the wish to communicate via her body. Her ill health stood in the way of a career as an art teacher, so she decided to become an artist. Since then, her sculptures, performances, films, photos and installations have worked around a number of key episodes from her childhood, along with her anxieties, such as claustrophobia, fear of flying or her reluctance to wear gloves, and also contemporary biographical, political and historical events.

1970 saw the creation of Horn's *Der Überströmer* (The Overflower) – in which transparent tubes filled with red liquid were draped like a gown over the naked body of a man to look like an external circulatory system – and *Das Einhorn* (The Unicorn). In the latter piece, the artist had an oversized pointed wooden pole made and attached it like a horn to the head of a naked woman, who then performed a rehearsed "trance journey" through a backdrop of woods and fields. These works, which isolate their wearers and focus on mental and physical affliction, as well as on sensual and erotic experiences, were termed by Horn "personal art". This performance, which the artist filmed on cinefilm, led to her invitation, in 1972, to the documenta 5 at Kassel. Between 1968 and 1974, she developed sculptures that were tailored to people's bodies, such as *Die Bleistiftmaske* (Lead Pencil Mask), and *Handschuhfinger* (Glove Finger), both 1972, as well as mechanical fans made of feathers or fabric, which were tied onto and moved by people's bodies. These body sculptures were the protagonists in Horn's performances, which she documented in films, videos and photos. Akin to 1960s Body Art, but unlike Happenings, Horn's actions bore a resemblance to initiation rites. Performed without an audience, they were marked by an extreme perfectionism that left nothing to chance.

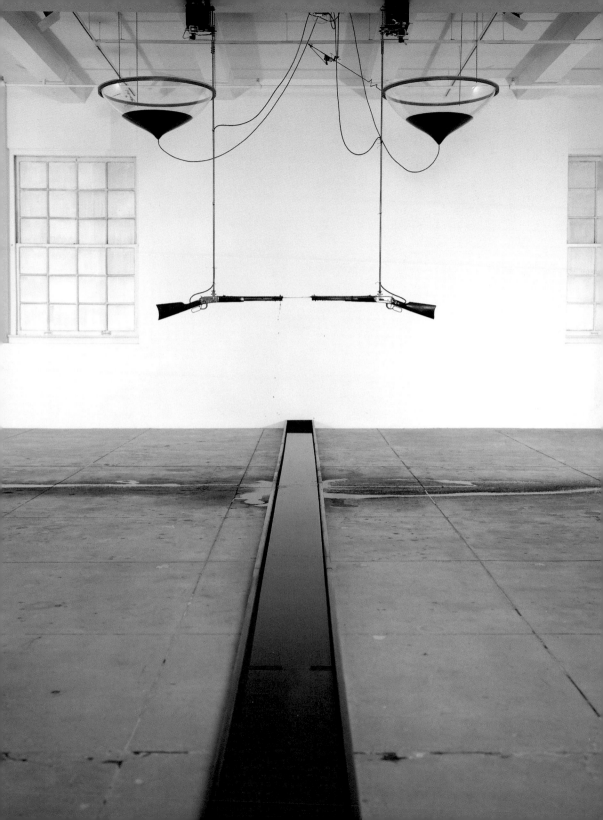

"What I am interested in is an object's soul, not its mechanical trappings."

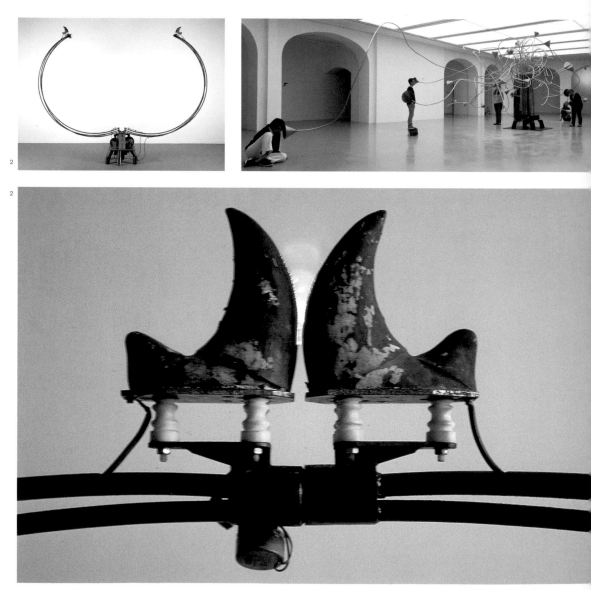

2

2

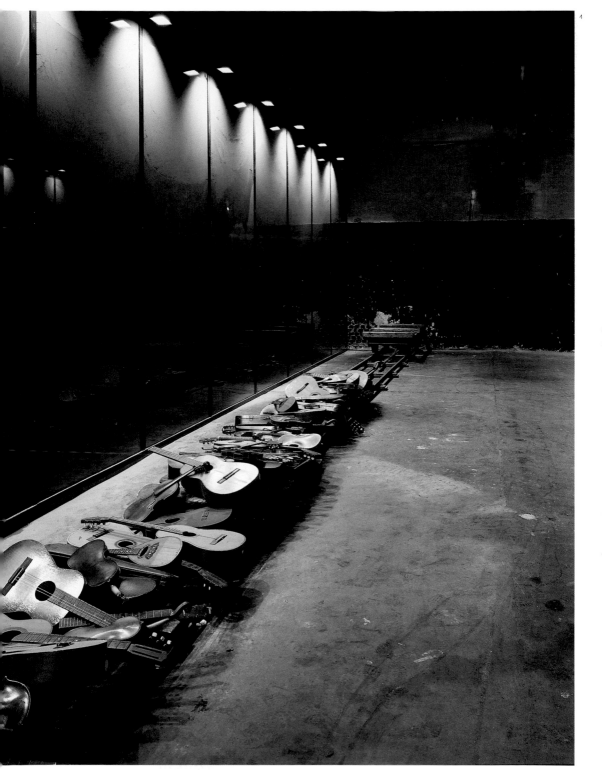

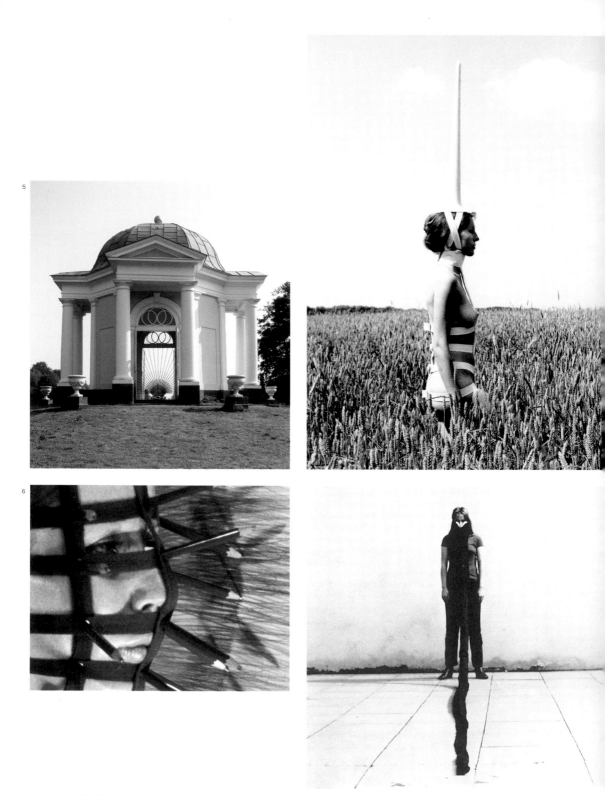

5

6

Her *Chinesische Verlobte* (Chinese Fiancée) of 1976 – a darkened room in which singing voices could be heard – heralded a new period in her work, in which Horn placed her performances in larger epic contexts as cinematic stories, leading her to become a film-maker. Her first film appeared in 1978, *Der Eintänzer* (The Taxi Dancer), in which a blind man (a reference to her blind professor) learns the tango, and a round mechanically-driven table likewise "dances". For this and further feature films, such as *La Ferdinanda*, 1981, and *Buster's Bedroom*, 1990, she created mechanical props and body sculptures, which play their parts on an equal footing with the actors, and have come to be included in important collections as artworks in their own right. Notable examples are the *Pfauenmaschine* (Peacock Machine), 1979/80, made with white feathers, the *Dialog der Silberschaukeln* (Dialogue between the Silver Swings), 1979, or the motor-driven wheelchair whose extended mechanical arm raised the whisky glass to Geraldine Chaplin's lips in the film *Buster's Bedroom*.

Mechanical sculptures

Time and again, feathers, tubes and funnels flowing with coloured liquids appear in Horn's work, but also alchemists' materials, such as mercury or salt, or sulphur and charcoal, as for instance in *Hybrid*, 1987. The central themes of these works are the flow of life, genesis, the passage of time and eventual decay, but also heaviness and lightness. Her mechanical sculptures and apparatuses made of everyday items – knives, scissors, suitcases, eggs, metal poles, a blind man's cane, feathers, violins or brushes – conjure up life, without actually being alive themselves. They visualise mechanisms and feelings deeply rooted in life, such as power, struggle, isolation, threats, as well as liberty and eroticism. Horn's poetic objects develop a life of their own, taking a resolute stand with regard to personal, historical and societal occurrences, as in *Chor der Heuschrecken* (Locust Chorus), 1991, about the Gulf War. Other examples include her no less impressive installation *Gegenläufiges Konzert* (Contrary Concert), 1987, set in the old kennels of Münster, in which the persistent beating of a small hammer summoned memories of the Nazis' torture methods and acts of violence; or her piece involving an entire schoolroom in Kassel during documenta IX, *Der Mond, das Kind, der anarchistische Fluss* (The Moon, the Child and the Anarchic River), 1992, in which school benches were hung from the ceiling and connected by lead tubes and funnels – a piece in which she worked through experiences from her junior school days.

Horn's other sculptures and installations similarly place familiar objects in unfamiliar contexts. They are brought into action and at the same time enter into a dialogue with other objects: brushes splash paint on the walls, violins play a concert on their own, a pair of scissors hangs just above an egg, knives stand erect and menacingly beneath brushes, tubes with coloured liquids snake through the room like the arteries in a body. Funnels drip, a stack of hospital beds stands in the middle of a room on rickety legs, and a piano suspended upside down from the ceiling from time to time allows its keys to hang out like so many tongues.

Even when the viewer is unfamiliar with what exactly has prompted Horn's works, her mysterious objects, machine sculptures and everyday utensils penetrate, with their collective archaic symbolism, deep into that person's consciousness, giving him or her a feeling of pensiveness and discomposure. Rebecca Horn's works, which are just as much inspired by Raymond Roussel's 1914 novel *Locus Solus* and by the "consciousness machines" described in it, as they are by Oscar Wilde, Marcel Duchamp and the Surrealists, impress us with their compelling imaginativeness, precision, and effective language and symbolism. *Ulrike Lehmann*

Rebecca Horn

Magdalena Jetelová

* 1946 in Semily, former Czechoslovakia; lives and works in Bergheim, near Cologne, Germany

Selected solo exhibitions: **1984** Galerie Walter Storms, Munich, Germany / **1987** "Project Room", The Museum of Modern Art, New York (NY), USA / **1988** Hamburger Kunsthalle, Hamburg, Germany / **1994** "Translocation", Kunstverein Hannover, Hanover, Germany / **1996** "Translocation II", Institut Mathildenhöhe, Darmstadt, Germany

Selected group exhibitions: **1983** "New Art", Tate Gallery, London, England / **1987** documenta 8, Kassel, Germany / **1993** "Mediale – Feuer, Erde, Wasser, Luft", Südliche Deichtorhalle, Hamburg, Germany / **1994** "Europa, Europa. Das Jahrhundert der Avantgarde in Mittel- und Osteuropa", Kunst- und Ausstellungshalle der Bundesrepublik Deutschland, Bonn, Germany / **1995** Zacheta National Gallery of Contemporary Art, Warsaw, Poland

Space and power

In 1968, the city of Prague experienced an incomparable spring which came to an abrupt violent end. Jetelová, at the time a young graduate of the Prague Art Academy, reacted sensitively and directly to the political events by enlarging everyday objects to monumental proportions. This was a simple gesture that shed light on the brutally simple mechanisms of power, ironically refracting them to give herself courage to face them. Jetelová's fearless voice made space for itself, and space empowers.

In 1987, she realised her first installation to consciously utilise space as a material of art. In *Table,* a wooden slab penetrated the masonry of the gallery wall. It hovered in space, a stable form suspended in weightlessness. The following year, Jetelová virtually dissolved a real exhibition space in the installation *Chair,* 1988. Consisting of four rough wooden blocks, a photograph of a forest, and the projection of a chair, the work showed various stages of an object's existence simultaneously, implying that simultaneity is capable of bringing down any wall, dissolving any space.

Around 1988 the artist began blackening walls with soot, a further attempt to open out space. Black negates space by transforming it, so to speak, into a black hole. Down to the late 1980s, Jetelová's sculptures, no matter how site-related they may have been, could figure as autonomous objects that could basically be shown in any space. Her concern with spatial conditions evinced certain parallels with the conceptual Land Art of a Robert Smithson, a Christo or a Walter de Maria. Yet in contrast to them, Jetelová was convinced that "everything is related to everything else", which led to her entropic form of conceptual art.

After 1989, her projects became increasingly complex. Her goal now became to transform spaces in such a way that an artistic reflection on history and architecture would emphasise their timeless and spaceless character. To achieve this, Jetelová attacked the limits of old existing structures by making harsh incursions and establishing surprising divisions. Then, with a laser, she placed accents, marked points of contact, axes, and special passages. Each of her complex projects generally had four basic phases, not necessarily presented at one particular site: investigation of an existing architectural structure, revelation of its intrinsic substances and potencies, incursion and appropriation by the artist, and a documentation of the process.

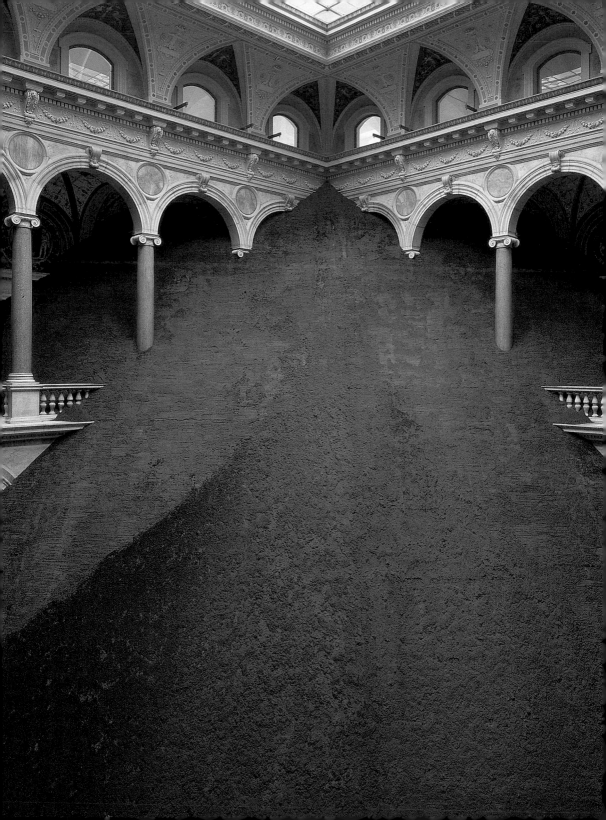

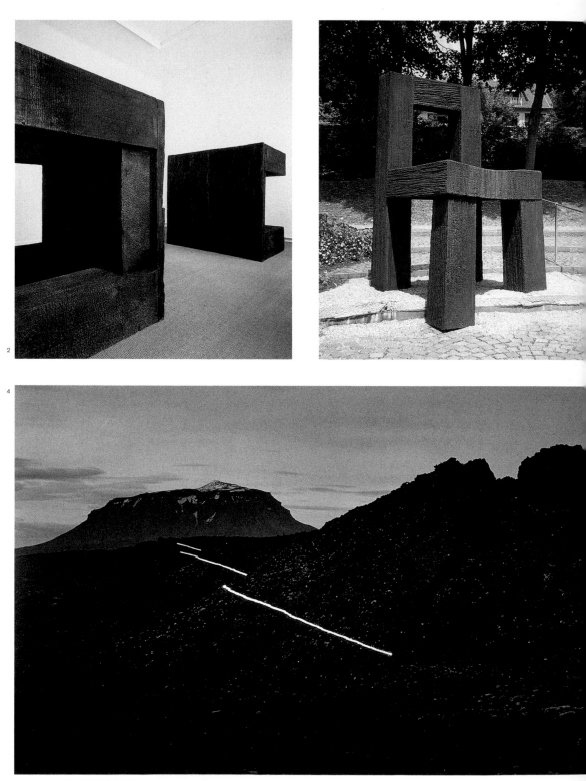

2

4

"I find it important to draw attention to thinking and doing as well as to what happens in between, to lightness and heaviness, to the energy that oscillates between these two poles, determining our thinking and living, to energy hidden everywhere."

1 **Domestizierung einer Pyramide,** 1992. Red quartz sand. Österreichisches Museum für Angewandte Kunst Wien, Vienna, Austria

2 **Tische,** 1989. Oak
3 **Stuhl,** undated. Cast steel. Würth Collection, Bad Mergentheim, Germany
4 **Island Projekt,** 1992. Laser
5 **Pyramide,** 1993. Lava stone. Installation view "Der Riß im Raum", Martin-Gropius-Bau, Berlin, Germany

6 **Time past and time present...,** 1990. Soot, laser. Installation view, Galerie Franck und Schulte, Berlin, Germany
7 **Atlantic Wall,** 1994. Laser. Jutland, Denmark

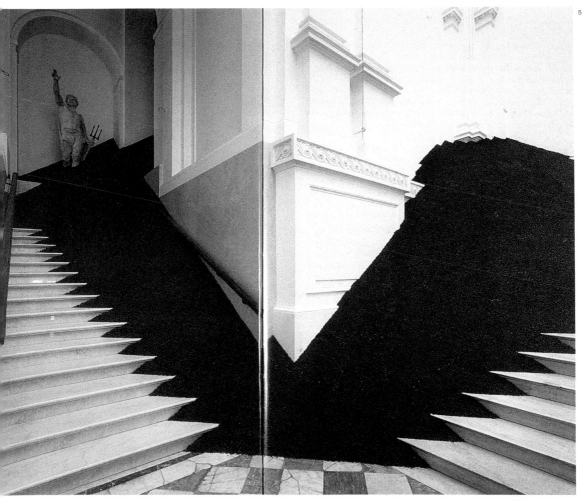

5

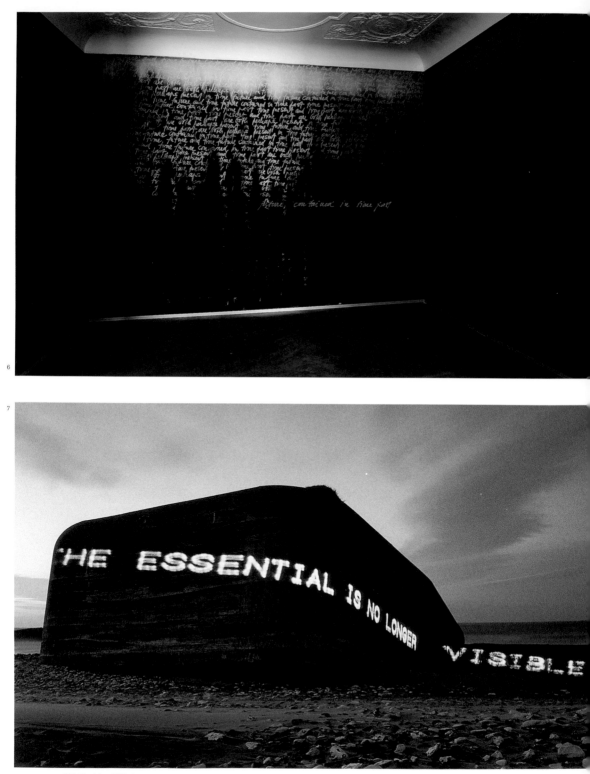

In 1992, in the rectangular vestibule of the Vienna Museum of Applied Art, Jetelová created *Domestication of a Pyramid*, a 15-m-high pyramid of red quartz sand. The choice of material was determined by the history and aura of the two-storey space, which was divided diagonally by the pyramid. The absurdity of the pile of sand subjected the Western cultural tradition – as reflected in the architectural design of the building, its arcades, colonnades and murals – to a harsh test. The elemental threatening presence of its mass and density, which made one wonder what it would be like to be buried under it, stood in contrast to the breadth of the space and the reflection of aesthetic and moral values in the building's Neo-Renaissance style. The superficially simple pyramid metamorphosed this ornate architecture into an absurd self-contradictory space. Jetelová succeeded in bringing together things that are separately perceived: past and present, space, time and history interpenetrated to form a new comprehensive image. The space was recreated by driving out the spirit of the past, rendering the space unusable, and thus defining it as a stage for fresh perception.

Places in motion

Jetelová confronts us with unfamiliar, striking perceptions of space and experiences of time. She manipulates sites, altering them in a way that makes us feel that the ground under our feet is no longer solid. Places can move – an unsettling feeling Jetelová has experienced in the oppressions and emigrations of her own biography. In this sense, her translocations and transformations of places represent an authentic linkage of life with art, artistic practice with the tactics of daily living. Jetelová's technique depends on the conditions of the given site. Analogously, her early sculptural pieces relied on a disproportion between object and surroundings to engender a paradoxical sense of space. Her evident adoption of certain aspects of Minimalism in the early 1980s distinguished Jetelová's approach from that of other Czech artists of the period. They helped her to liberate herself from social and political dependencies.

Imagined spaces

In 1985 Jetelová moved to Western Europe where, since 1986, she has been experimenting with light and, since 1987, with laser projections as ways of transforming spaces. She terms these projects "space drawings". The laser lends her work an additional dramatic, even magical effect. In the projections used in *Chair*, it produces the three-dimensional illusion of a sculpture of wood and light, invoking the ancient question of the nature of reality, the Platonic difference between imagination and thing.

When she employed lasers to project text sequences by Paul Virilio on fortified bunkers – Virilio's theme – in her project *Atlantic Wall*, 1995, Jetelová came very close to Plato's compelling image of reality as shadows cast on the walls of a cave. Her interest in the looming concrete structures of the German line of defence in the Second World War was to translate linear real time into a discontinuous time, into a context of interpretation beyond time, which would bring history and the present moment, memory and experience objectivity and subjectivity, into a complex whole. Jetelová works with us and our imagination to make time a concrete experience, by showing space to be subject to change, forever in flux. She engenders a new, holistic space-time experience, a space of immediate perception, artistically staged and aesthetically refined.

Frank Frangenberg

*Magdalena Jetelová's
studio, 1968*

Magdalena Jetelová

Frida Kahlo

* 1907 in Coyoacán, Mexico; ✝ 1954, in Coyoacán, Mexico

Selected solo exhibitions: **1939** Julien Levy Gallery, New York (NY), USA / **1953** Galerie Lola Alvarez Bravo, Mexico City, Mexico /
1991/92 "Die Welt der Frida Kahlo", Schirn Kunsthalle, Frankfurt am Main, Germany / **1994** "The Blue House", Museum of Fine Arts, Houston (TX), USA /
2000 "Frida Kahlo, Diego Rivera and Twentieth-Century Mexican Art", Museum of Contemporary Art, San Diego (CA), USA

Selected group exhibitions: **1939** "Mexique", Galerie Renou et Colle, Paris, France / **1940** Galería de Arte Mexicano, Mexico City, Mexico /
1943 "Mexican Art Today", Philadelphia Museum of Art, Philadelphia (PA), USA / **1968** "Dada, Surrealism and Their Heritage",
The Museum of Modern Art, New York (NY). USA / **1999** "Mirror Images", San Francisco Museum of Modern Art, San Francisco (CA), USA

Selected bibliography: **1995** Fuentes, C. (ed.), *The Diary of Frida Kahlo. An Intimate Self-Portrait,* New York (NY) / *Frida Kahlo: Gemaltes Tagebuch,* Munich,
Germany

"I never painted dreams"

Frida Kahlo found a universally comprehensible visual language somewhere between naivety, realism and surrealism. The internationally acclaimed oeuvre of this Mexican artist, born in 1907, comprises almost 200 works, most of them small-format self-portraits. These, like both her still life studies of fruit and her animal portrayals, are highly expressive and precisely detailed paintings. As often as not, her works bear harrowing witness to her own physical and mental suffering with a disturbing immediacy that makes them unforgettable.

As a child, Kahlo was confined to bed for nine months after contracting polio, which left her with a slightly malformed foot. At the age of 18, she was involved in a road accident, when the bus she was travelling on collided with a tram. She was impaled on a metal rod and suffered fractures of the spine, pelvis and legs. After a month in hospital, she had to wear a plaster corset for a further nine months. It was while she was in hospital that Kahlo began to draw and paint – first the accident and then herself. Her first self-portrait, dated 1926, shows her in a heroic pose. It was followed by many more, of which Frida Kahlo later said that she painted herself because she spent so much time alone and was the subject matter she knew best.

Her life was a constant struggle between life and death, a brutal fate that did not cause her to become resigned to her lot, but posed a keen challenge. Kahlo was bedridden for many months of her life, and in two drawings, *The Dream* or *Self-Portrait in a Dream I* and *II*, both 1932, as well as in her oil painting *The Dream* or *The Bed*, 1940, she presents herself lying in bed. It is a four-poster bed with a baldachin hovering in the clouds. On the baldachin lies a human skeleton, similar to the traditional Mexican figure of Judas, of which Kahlo owned some examples. The visual approach in Kahlo's picture goes beyond the level of the dream to enter the world of trauma.

Kahlo underwent repeated hospitalisation and operations. Within the space of a single year (1950), she had five toe amputations, various bone transplants and seven operations on her spine. After a leg amputation in 1953, she was confined to a wheelchair. In her short life of just 44 years, she had to come to terms with enormous physical suffering. Her self-portrait *The Broken Column*, 1944, is a harrowing image of Kahlo in a steel corset, with the fractured column symbolising her injured spine. Because of the accident, she was unable to bear a child. Her three miscarriages or abortions and her unfulfilled wish for children are addressed in such works as the lithograph *Frida and the Miscarriage*, 1932, and the oil painting *My Doll and I*, 1937.

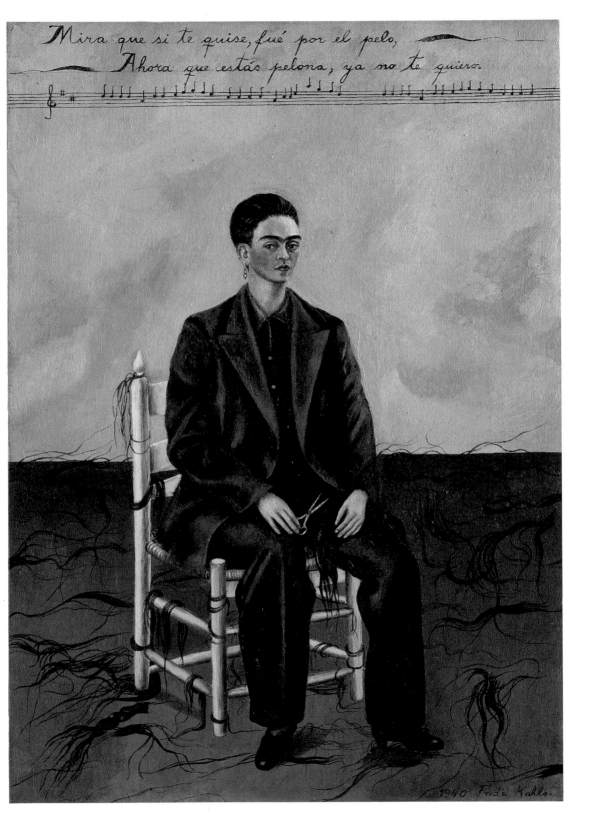

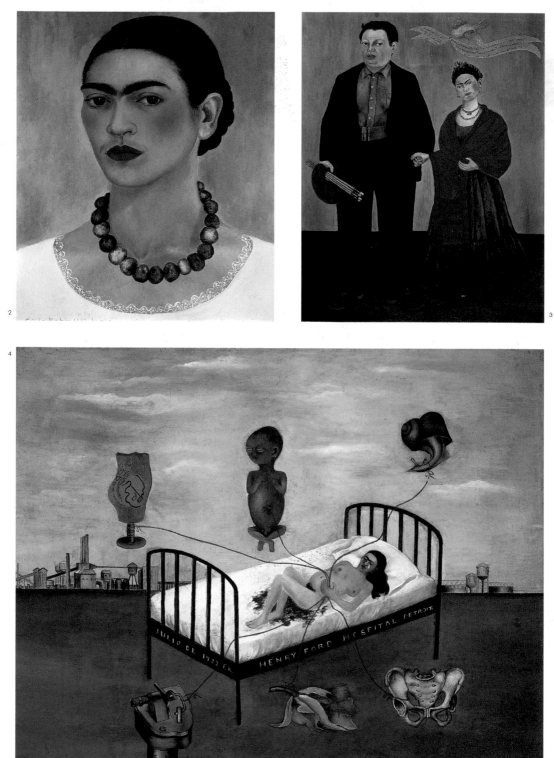

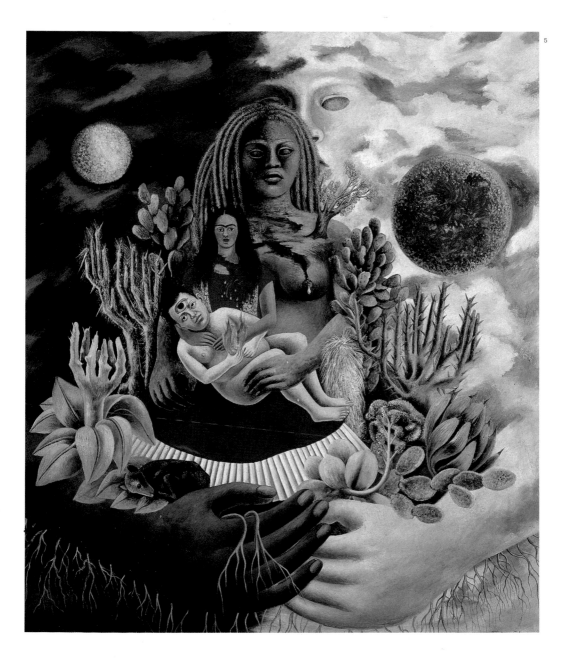

"My painting is not revolutionary.
Why should I delude myself that it is informed
by a fighting spirit."

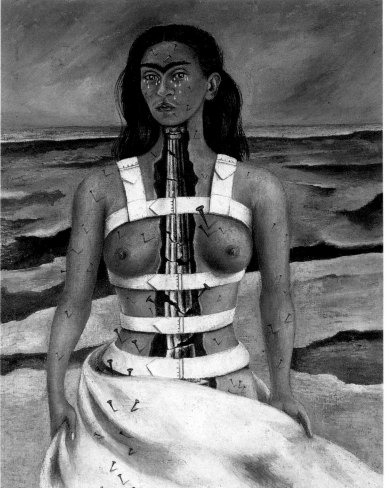

6

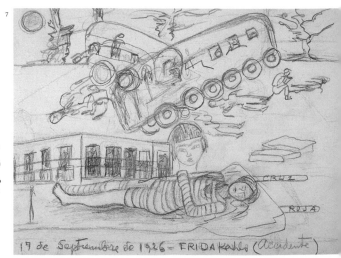

7

1 **Self-Portrait with Cropped Hair (Autorretrato con pelo cortado)**, 1940. Oil on canvas, 40 x 28 cm
2 **Self-Portrait with Necklace (Autorretrato con collar)**, 1933. Oil on metal, 35 x 28 cm
3 **Frida and Diego Rivera or Frida Kahlo and Diego Rivera (Frida y Diego Rivera o Frida Kahlo y Diego Rivera)**, 1931. Oil on canvas, 100 x 79 cm
4 **Henry Ford Hospital or the Flying Bed (Henry Ford Hospital o La cama volando)**, 1932. Oil on metal, 31 x 38 cm
5 **The Loving Embrace of the Universe, the Earth (Mexico), Myself, Diego and Mr Xólotl (El abrazo de amor de El universo, la tierra (México), Yo, Doiego y el señor Xólotl)**, 1949. Oil on canvas, 70 x 61 cm
6 **The Broken Column (La columna rota)**, 1944. Oil on canvas, mounted on hardboard, 40 x 31 cm
7 **Accident (Accidente)**, 1926. Pencil on paper, 20 x 27 cm

Art for life

In 1929, Frida Kahlo married Diego Rivera. Both were members of the Communist Party. Rivera, whose popularity in Mexico bordered on hero-worship, was an artist best known for the monumental wall paintings he created for the Communist regime. Between 1930 and 1934, Kahlo and Rivera lived in the USA, where Rivera had been commissioned to execute a number of works. For Kahlo, Rivera was an anchor and "the universe". One of her paintings is even entitled *The Loving Embrace of the Universe, the Earth (Mexico), Myself, Diego and Mr Xólotl*, 1949. Rivera was an unfaithful husband, whose affairs included a relationship with Frida's sister Cristina. They divorced in 1939, only to remarry at the end of 1940. Her physical sufferings were compounded by profound emotional pain. Yet, even though Frida Kahlo repeatedly confided her death wish to her diary and actually attempted suicide on more than one occasion, her painting did help her to come to terms with her situation and experiences. Her famous double portrait, *Two Fridas*, 1939, was created shortly after her separation from Rivera. The problem of double identity it explores was superseded a year later by a change of identity, addressed in *Self-Portrait with Cropped Hair*, 1940, created a year after the divorce. She is sitting on a chair, dressed in a suit, the scissors still in her hand.

Frida Kahlo was a self-taught painter who never had any academic training. Her works are painted in a realist and later increasingly surrealist style, and some of them are oriented towards aspects of traditional Mexican folk art, such as the little votive images painted on metal known as *retablos*.

"Happily I wait for the end"

Though Kahlo was in contact with the Paris Surrealists (especially André Breton) and many critics considered her to be one, she herself maintained "I didn't know I was a Surrealist until André Breton came to Mexico and told me so." Yet she did not accept the classification. "I never painted dreams. What I portrayed was my reality." Kahlo's paintings are inner images, realities created from within by outward reality. Even though her art explores her own biography, the spectator can understand and interpret the themes, forms, models and symbols it presents. The uncompromising candour and directness with which she addresses her personal fate in works that tangibly visualise her pain cannot fail to touch the viewer. Although the suffering they speak of is personal, each image stands as an example of a broader and more universal theme.

Ulrike Lehmann

Frida Kahlo during a stay in the USA, 1940s *Frida and Diego in the ABC-Hospital in Mexico, 1950*

Frida Kahlo's studio, which was designed and built by Diego Rivera in 1946

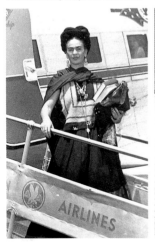 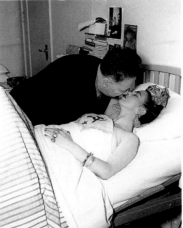 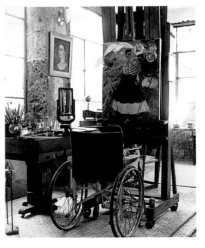

Toba Khedoori

*** 1964 in Sydney, Australia; lives and works in Los Angeles (CA), USA**

Selected solo exhibitions: **1995** Regen Projects, Los Angeles (CA), USA / **1996** David Zwirner Gallery, New York (NY), USA / **1997** "Directions", Hirshhorn Museum, Smithsonian Institution, Washington, D.C., USA / **1999** David Zwirner Gallery, New York (NY) / **2001** Museum of Contemporary Art, Los Angeles (CA)

Selected group exhibitions: **1995** Whitney Biennal, Whitney Museum of American Art, New York (NY), USA / **1996** "Some Recent Acquisitions", The Museum of Modern Art, New York (NY) / **1999** "Examining Pictures – Exhibiting Paintings", Whitechapel Art Gallery, London, England / **2000** "Open Ends", The Museum of Modern Art, New York (NY) / **2001** "Public Offering", Museum of Contemporary Art, Los Angeles (CA)

The Disorder of Order

Toba Khedoori has concentrated on a single medium to a degree rarely paralleled by other artists. That medium is drawing. The subjects she addresses, too, focus on a single theme – the existential aspect of life as a tangible orientation within a space that is at once closed and open, ordered and chaotic. She works on huge, long, white spreads of paper, generally measuring 3.50 m by 6 metres. She coats these large and clearly structured areas with transparent wax. Then, with great sensitivity and painstaking precision, but also deliberately leaving scope for error, she scores her drawings in the wax, inscribing them as it were, and then carefully colouring them. Once the work is finished, after about two months, the strips of paper are stapled vertically to the wall. As a rule, she hangs several works close together in a series reminiscent of a row of skyscrapers. Although the wall is completely covered by these strips, there is nothing wallpaper-like about them, for they are light and airy, and leave plenty of wall space exposed. A glance at the motifs chosen by Toba Khedoori reveals their aesthetic background: empty houses, overpasses, bridges, windows, doors and seats are rendered with almost manic precision. These are abandoned places, unused spaces for waiting and living, walking and crossing. Mobile factors such as trains and cranes are also represented, and these, too, have no people in them. Toba Khedoori does not completely cover the paper with these anonymous signs of time and space, but allows them instead to occupy a relatively small proportion of the area available. They seem rather lost, almost reticent, floating on the waxen transparency dulled only by the dust, hair and other impurities that have become embedded by chance in the wax. In the emptiness of the picture, the motifs themselves seem to dangle in the air. The loss of a consciously

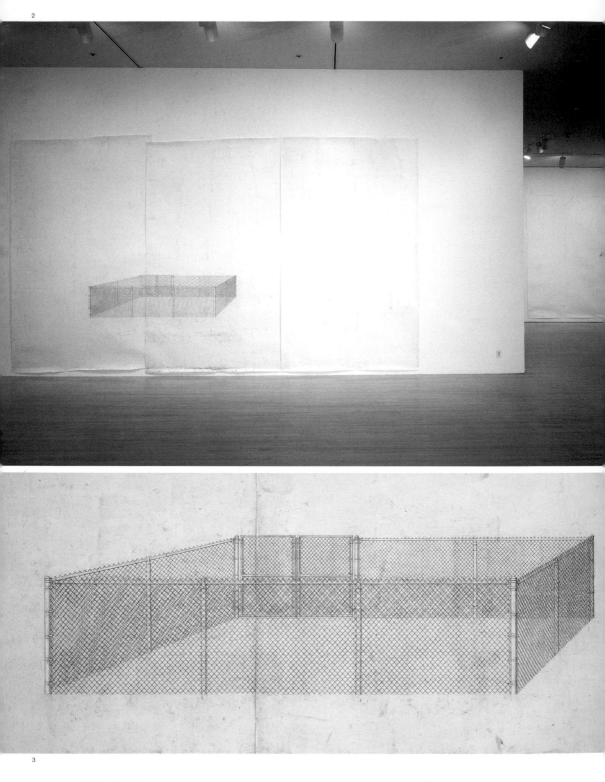

174 Toba Khedoori

4

"My materials and the size of my pictures stay pretty much the same; but within these parameters I try to change the objects."

1 **Untitled (Model),** 1998. Oil and wax on paper, 351 x 312 cm

2 **Installation view,** Museum of Contemporary Art, Los Angeles (CA), USA, 1997
3 **Untitled (Chain link fence),** 1996 (detail). Oil and wax on paper, 335 x 588 cm
4 **Untitled,** 1993. Oil and wax on paper, 335 x 610 cm
5 **Untitled (Cityscape),** 1998. Oil and wax on paper, 351 x 762 cm
6 **Untitled (Street),** 1999 (detail). Oil and wax on paper, 351 x 564 cm

5

ordered world view described by Georg Lukács in the early years of the 20th century as "transcendental homelessness" seems to pre-vail here. Yet, in the art of Toba Khedoori, Lukács' pessimism is only superficially evoked, for the artist balances out the apparent loss of being and orientation by an almost meditative immersion in her work in order to create serial orders within her drawings. For example, in *Untitled (Doors),* 1995, the rhythmic regularity of the doors of a row of houses recalls the repetitive structures of minimal music or con-crete art. The subtle differences between each door and each level, resulting from the creative process itself, confidently refute any notion of smooth perfection and mechanical repetition. The single rows of seating in her drawing *Untitled (Seats),* 1996, are shown on four jux-taposed strips of paper, of which only the two middle strips have drawings on them. No walls are in evidence here, let alone a cinema screen or stage. Khedoori has placed the rows of seats in the air, and they seem to emerge out of the infinite nothingness behind the picture plane. The rows are not straight and true, but slightly undulating. Obvious order and underlying chaos, constructive technique and creative nature go hand in hand, without hierarchy.

Drawn Architectures

In this respect, Toba Khedoori's drawn architectures, which invariably also present lyrical interior structures of the post-modern self, reflect a moment of orientation described by the Dutch architect Rem Koolhaas in his legendary book *S, M, L, XL* as follows: "In such a model of urban solid and metropolitan void, the desire for stability and the need for instability are no longer incompatible." Kool-haas, too, posits the contradiction of opposites that is to be found in the work of Toba Khedoori – solid and void, stability and instability, permanence and movement – and which lends the aesthetic process the strength it needs to survive. What we find on the paper strips of Toba Khedoori is not the Kafkaesque absurdity of nothingness, but an emptiness in search of fullness, an attitude to life that is as optimistic as it is contemplative, as determined as it is reticent.

In her more recent work, Toba Khedoori has chosen to take an even more monumental approach, not only in her chosen format, but also by rendering larger, more "confident" motifs that stretch right up to the edge of the picture in some cases. At the same time, the works are still more reduced, and sometimes almost abstract. For example, in *Three Rooms,* 1999, there are three stacked cubes, re-presenting the most basic form of room. Yet, once again, there are no people in them: demonstrative absence as an urgent indicator of the human condition. A negative dialectic unfurls, quietly firing the imagination of the keen observer, lending the work a dynamic and contemplative aspect at one and the same time. That, too, is typical of the drawings of Toba Khedoori. *Raimar Stange*

Toba Khedoori

Lee Krasner

* 1908 in Brooklyn (NY), USA; ✝ 1984 in New York (NY), USA

Selected solo exhibitions: **1951** Betty Parsons Gallery, New York (NY), USA / **1955** Stable Gallery, New York (NY), USA / **1958** Martha Jackson Gallery, New York (NY), USA / **1965/66** Whitechapel Art Gallery, London, England / **1973** Whitney Museum of American Art, New York (NY), USA

Selected group exhibitions: **1942** "French and American Painting", McIllen Inc., New York (NY), USA / **1945** "A Problem for Critics", Gallery 67, New York (NY), USA / **1946** "Artists: Man and Wife", Sidney Janis Gallery, New York (NY), USA / **1978** "Abstract Expressionism: The Formative Years", Herbert F. Johnson Museum of Art, Cornell University, Ithaca (NY), USA / **1981** "A Working Relationship", Grey Art Gallery and Study Centre, New York University, New York (NY), USA (with Jackson Pollock)

The action widow legend

Pollock – Krasner, Krasner – Pollock. Two artists, one marriage – and a cliché of art history that is far from doing justice to either of them. In Krasner's case, the oeuvre of her husband, Action Painter Jackson Pollock, who died in an automobile accident on 11 August 1956, long stood in the way of a serious evaluation of her own work. In 1972, in his book *Jackson Pollock: Energy Made Visible*, art critic B. H. Friedman coined a phrase to describe Krasner and other female survivors of the Abstract Expressionists – "action widows". This label impugned Krasner's supposed influence on the art market as administrator of her husband's estate, and suggested her artistic dependency on an idol of post-war American abstract art. And the label still sticks today, in so far as it would seem impossible to write about Krasner without writing about Pollock.

The Pollock legend already arose during his lifetime and was embellished after his death as fast as the prices of his paintings rose – the alcoholic maladjusted *artiste maudite*, "Jack the Dripper", uncrowned king of the New York School with his wild unleashed painting arm. This legend had a lasting influence on critical opinions of Krasner's work. Moreover, after Pollock's death there was a tendency to delete his wife and her painting from her husband's biography entirely. To do justice to Krasner's achievement, then, it will continue to be necessary to unravel the existential and artistic strands of their shared life. The question is not whether, but how, this should be done. There was not only a Krasner, painter and wife of Pollock, but also a painter Krasner *ante* Pollock and an artist Krasner *post* Pollock. As early as 1956, art critic Clement Greenberg stated – contrary to the conventional wisdom – that "even before their marriage her eye and judgement became important in his art, and continued to remain so."

Born into a New York family of immigrants from Odessa, Krasner was raised in the Orthodox Jewish tradition, growing up in Brooklyn. In 1922, she began to study art at Washington Irvine High School in Manhattan, discovered Russian literature, and read Nietzsche and Schopenhauer. Later she attended the Women's Art School at the Cooper Union and took courses at the Art Students League as well as at the National Academy of Design. Linked at this time with the White Russian emigré Igor Pantuhoff, she studied at the City College of New York, working part time as a waitress in a cocktail bar. She met the poet and critic Harold Rosenberg, soon to become a key interpreter of American post-war art, with whom she would share a lifelong friendship and intellectual involvement.

Influenced by Italian Pittura Metafisica, especially by Giorgio de Chirico, in the 1930s Krasner produced paintings such as *Gansevoort I*, 1934, and *Gansevoort II*, 1935. During her attendance at Hans Hofmann's School of Fine Arts (from 1937), she learned much

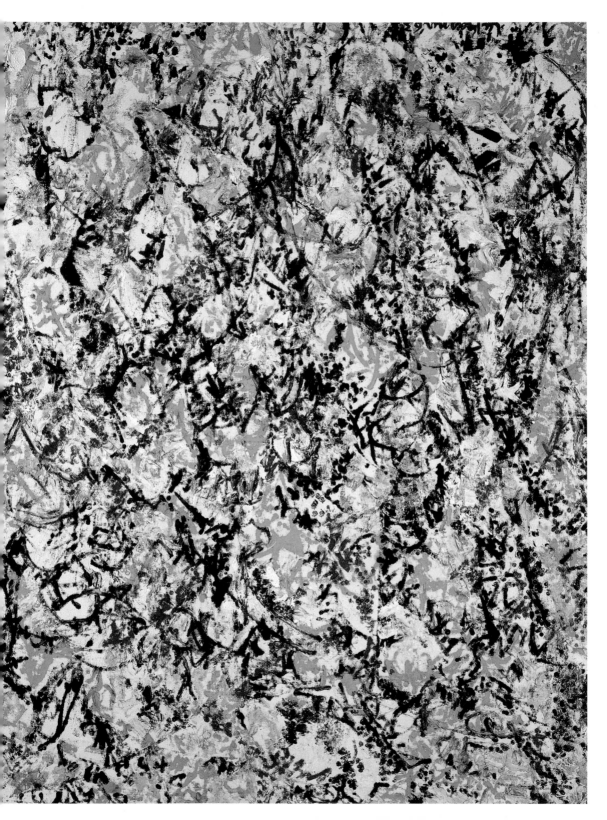

2

1 **Flowering Limb,** 1963. Oil on canvas, 147 x 116 cm

2 **Image Surfacing,** 1945/46. Oil on canvas, 69 x 55 cm
3 **Invocation,** 1970/71. Oil on canvas, 217 x 142 cm
4 **Vigil,** 1960. Oil on canvas, 225 x 178 cm

5 **Self-Portrait,** c. 1930. Oil on canvas, 77 x 64 cm
6 **Untitled,** 1949. Oil on canvas, 97 x 76 cm
7 **Sun Woman II,** 1957. Oil on canvas, 177 x 288 cm

"I merge what I call the organic with what I call the abstract."

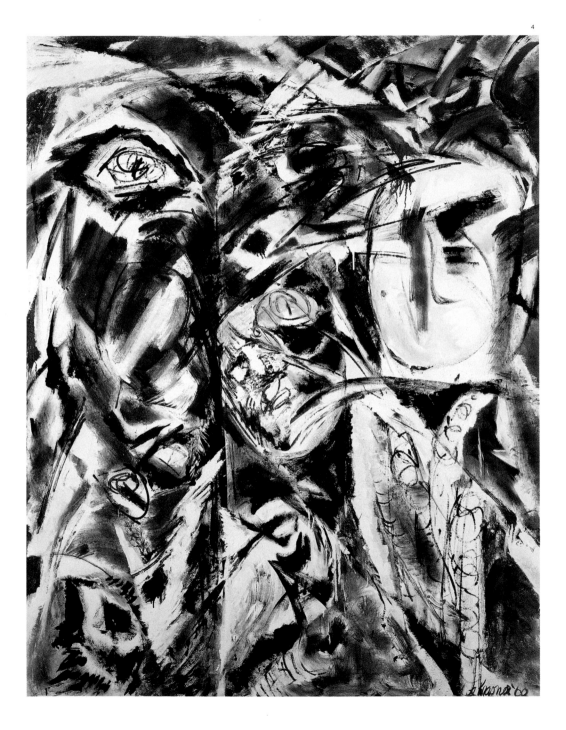

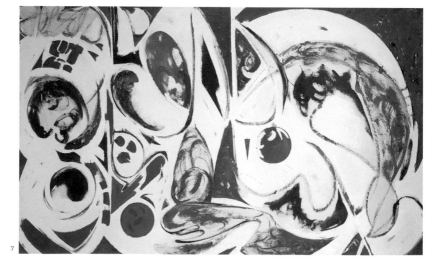

Lee Krasner

from the German artist about international modern avant-garde and abstract painting, including Matisse and Picasso (*Untitled [Still Life]*, 1938). In 1939, Krasner became a member of the advanced American Abstract Artists group, in which she championed Marxian ideas. The years 1934 to 1943 found her participating in the Works Progress Administration, which led to designs for murals in the Mexican tradition, and also – in 1941 – to some in an abstract idiom. It was also at the end of this year that her encounter with Pollock would have crucial consequences for the development of both. She had already met Pollock before, in 1936, yet at this point Krasner was still much better known than the young, aspiring 29-year-old artist, whom she visited in advance of a joint participation in the exhibition "French and American Painting" in New York (1942). In 1945, Pollock and Krasner were wed. Meanwhile she had introduced him to the New York art scene.

From artistic "black-out period" ...

Krasner once called the years from 1943 to 1946 her artistic "black-out period". Her paintings consisted of layers and layers of brushwork that resulted in grey, petrified-looking surfaces. Like the artist in Honoré de Balzac's story, "Le Chef d'Oeuvre Inconnu", 1831, Krasner was embroiled in a vain search for a balance between intuition and rationality as the basis for the perfect work of art. A more contextually oriented interpretation might find the reason for this crisis, during which Krasner worked as if obsessed, in the horrors of the Holocaust. In terms of art history, she took cues from Newman and Rothko and the tradition of the abstract sublime. By 1946 at the latest, mutual influences had become apparent in Pollock and Krasner's work. Pollock began his "drip paintings" and, in 1947–49, produced the "poured paintings", as Krasner executed her series of *Little Images,* 1946–49. *Abstract #2,* 1946–48, and *Painting No. 19,* 1947/48, translating Pollock's techniques of notation, sign-making, and paint-pouring into more formulaic, calligraphic and hieroglyphic terms. Krasner's painted continuums were more controlled and disciplined, perhaps reflecting her current concern with Surrealist *écriture automatique* and with linguistic systems such as Hebrew and Celtic. *Composition,* 1949, strongly recalled certain works by Paul Klee. Both Pollock and Krasner dispensed with references to reality, and also suppressed the direct trace of the artist's hand. Yet Krasner's approach was more detached, less reflective of the artist's personality and inward mental disquiet.

... her own pictorial rhetoric

Krasner's refusal to imitate Pollock, her attempt to develop her own pictorial rhetoric, became even clearer after Pollock's death, as Anne Wagner points out in her essay "Pollock's Absence, Krasner's Presence". Her paintings were now often built up in a circular manner, the colours muddy, with accents of white or bright magenta – nearly the opposite of the *Little Images.* From the well-nigh frightening *Prophecy,* started before Pollock's accident, through the volcanic *The Seasons,* 1957, *Birth,* 1956, and *Celebration,* 1957/1960, to the sombre *Gate,* 1959, in which Pollock's credo "I am Nature" was thought through and continued beyond his visions, there emerged a number of further major works as Krasner unceasingly questioned her approach and redefined her artistic identity. In 1981, she fell seriously ill. Krasner died three years later, after a career in art that had lasted 55 years.

Holger Liebs

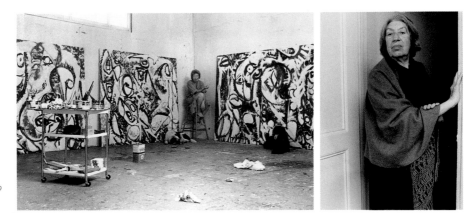

Lee Krasner in
her studio on East
Hampton, c. 1959/60

Lee Krasner

Barbara Kruger

*** 1945 in Newark (NJ), USA; lives and works in New York (NY) and Los Angeles (CA), USA**

Selected solo exhibitions: **1974** Artists Space, New York (NY), USA / **1983** "We Won't Play Nature to Your Culture", Institute of Contemporary Arts, London, England / **1990** Museum of Modern Art at Heide, Melbourne, Australia / **1996** Kölnischer Kunstverein, Cologne, Germany / **1999** Museum of Contemporary Art, Los Angeles (CA), USA

Selected group exhibitions: **1973** Whitney Biennial, Whitney Museum of American Art, New York (NY), USA / **1982** XL Esposizione Internazionale d'Arte, la Biennale di Venezia, Venice, Italy / documenta 7, Kassel, Germany / **1987** documenta 8, Kassel, Germany / **1998** "Read My Lips: Jenny Holzer, Barbara Kruger, Cindy Sherman", National Gallery of Australia, Canberra, Australia

Selected bibliography: **1993** Barbara Kruger, *Remote Control: Power, Cultures and the World of Appearances,* Cambridge (MA), USA / **1999** Barbara Kruger, *Thinking of You,* Cambridge (MA)/London

Who's talking?

"Why are we shown one picture and not another?" runs one of the slogans that have made the American artist Barbara Kruger known since the early 1980s. The provocative question addressed directly to the viewer indicates the subject areas that Kruger treats in her text + image combinations. She looks at the way violence, power and sexuality are produced and rendered visible by mass media images in our society. Kruger's position assumes a priori that our view of reality, ideas of normality, stable gender roles, and acceptance of everyday violence are constantly recreated and influenced by images and language. Her grainy black-and-white photos reproduce models which are in turn reproductions and mass-distributed. They chiefly involve 1940s and 1950s photo albums, prospectuses and user instructions which spread conservative social clichés and stereotypes in an especially succinct fashion. We find the established role models revived particularly in the Reagan era, when, for example, there was not just a repressive discussion of AIDS (the target of Kruger's *Visual AIDS Project,* 1992), but the achievements of the women's movement, especially women's right of disposal over their own bodies and their reproductive functions, were once more scrutinised. Kruger investigates the voices behind such pictures. Her appeals against the massive anti-abortion campaigns of these years are an example of her role as an activist, which takes the form of conspicuous slogans and a critical questioning of the way females are depicted in images, such as the declaration *Your Body is a - Battleground,* 1989.

That Kruger's striking works in public and institutional spaces, her billboards, wall installations, pictorial objects, books and even shopping bags borrow aesthetic strategies from advertising can be explained by her professional development. She grew up in Newark and, in 1964, began to study art at Syracuse University. From 1965, she attended courses at the Parsons School of Design, where her work was particularly influenced by the photographer Diane Arbus and the graphic designer and artist Marvin Israel, a former art director

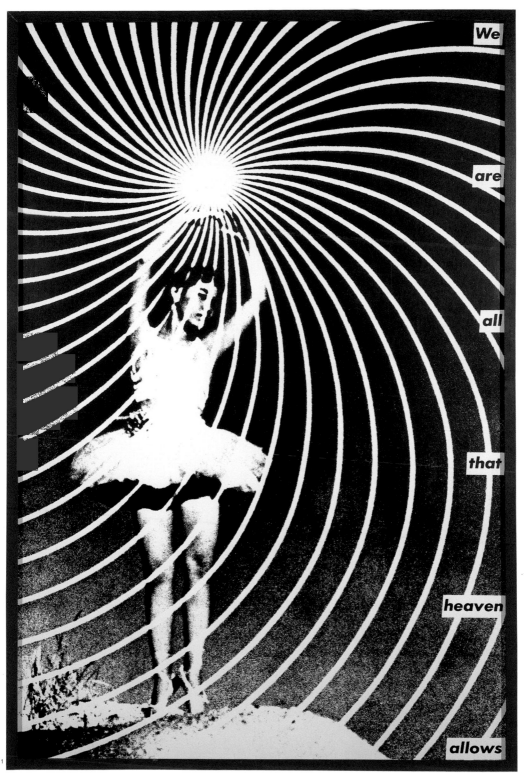

We

are

all

that

heaven

allows

2

"Making art is about objectifying your experience of the world, transforming the flow of moments into something visual, or textual, or musical. Art creates a kind of commentary."

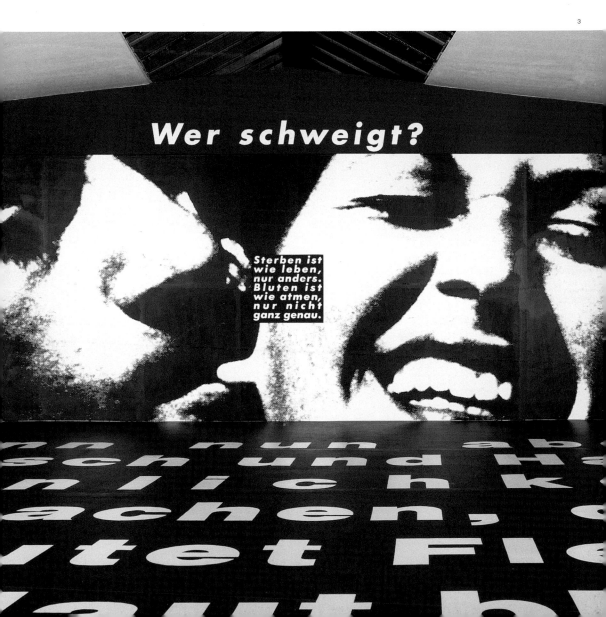

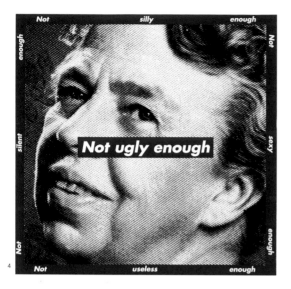

Not silly enough

enough

Not

Not

silent

sexy

Not ugly enough

Not

enough

Not useless enough

Man's best friend

of *Harper's Bazaar*. Her studies completed, she worked at an agency, then for the fashion periodical *Mademoiselle*. Kruger has been an active artist since 1969. When she moved into her loft in New York in 1970, she came into contact with feminist groups at local exhibitions. She was particularly impressed by the large textile wall-pieces of Magdalena Abakanowicz, who incorporates explicitly "female" production methods into her artistic practice, querying the traditional distinction between art and craft. During this phase, Kruger also began to write poetic texts of her own, presenting them at poetry readings at, for example, New York's Artists Space, where she had her first solo show in 1974. From 1975 to 1979, Kruger taught at universities and art institutes throughout the country, coming into contact with more recent art concepts and theories, which led her to reconsider her artistic identity and further develop her work. Her artistic production was also influenced by the arguments about the cultural and social determination of female identity, for example in the films of Chantal Akerman, in the work of Mary Kelly and Carol Squiers, or in the films of Sam Fuller and Yvonne Rainer. It is a theme developed in Barbara Kruger's work as a critic.

Artist and critic

In the late 1970s, Kruger began to write for *Artforum* and other publications, mainly about films, television and pop culture. In 1979, she showed her first collage-type pictures in New York's PS1. They consisted of photographed pictorial material intercut with text elements. Initially, individual words such as "nature" or "tradition" cropped up as well as linear elements alluding to, offsetting or commenting on semantic references in the photographic field. Imitating advertising strategies, she developed her own artistic trademark, a kind of corporate identity of black, white and red elements. The texts became more complex and were set in what became her favourite typeface in her work, Futura Bold Italic. The texts' instantly recognisable design and aggressive tone emphasise and reinforce the brutality and graphic force of the visual codes. They focus on the ideological structures of knowledge systems, the main topics being monitoring systems, medicine, representations of the body, sexual identity, emotions, work, power and the misuse of power. In her spatial installations, she uses walls, floors and ceilings as carriers of omnipresent, large-format images and texts, which often cover the entire room, excluding any possibility of "looking away".

"I shop, therefore I am"

In the 1980s, Kruger made a number of sorties into exterior locations, such as the façade of the Museum of Contemporary Art in Los Angeles (1989–1990) or an amphitheatre in front of the North Carolina Museum of Art, in Raleigh (1987–1996). She quit the institutional spaces of the art trade, establishing a presence in public spaces with large-scale billboards and poster campaigns – in 1996, city buses transported Kruger's posters through the streets of New York, each poster being a moving image with an outsize eye, emblazoned between the vehicle's rear lights, that screams "Don't be a jerk." A shopping bag designed by Kruger bears the slogan "I shop, therefore I am", In Kruger's anti-prestige projects, art itself is not excluded from consumption. An untitled work of 1985 places the slogan "When I hear the word culture, I take out my checkbook" diagonally across the picture of a ventriloquist's dummy. By 1994, Kruger was extending her media repertoire, using sound for the first time in an installation at the Mary Boone Gallery. In 1998, she combined her artistic work with her interest in the cinema, showing rear-screen projections at Deitch Projects. As with her context shifts of photographic material, she links her procedure with starting points that lie outside the artistic framework and integrates them in a strategy of alternating place and meanings.

Ilka Becker

Barbara Kruger

Louise Lawler

* 1947 in Bronxville (NY), USA; lives and works in New York (NY), USA

Selected solo exhibitions: **1984** "Home/Museum – Arranged for Living and Viewing", Matrix, The Wadsworth Atheneum, Hartford (CT), USA /
1987 "Enough. Projects: Louise Lawler", The Museum of Modern Art, New York (NY), USA / **1995** "A Spot on the Wall",
Münchener Kunstverein, Munich, Germany / **1997** "Monochrome", Hirshhorn Museum and Sculpture Garden, Washington, DC, USA /
2000 "More Pictures", Metro Pictures, New York (NY), USA

Selected group exhibitions: **1987** "Implosion: A Postmodern Perspective", Moderna Museet, Stockholm, Sweden /
1989 "A Forest of Signs: Art in the Crisis of Representation," Museum of Contemporary Art, Los Angeles (CA), USA /
1991 Whitney Biennial, Whitney Museum of American Art, New York (NY), USA / **1995** "The End(s) of the Museum", Fundació Antoni Tàpies,
Barcelona, Spain / "Passions Privées", Musée d'Art Moderne de la Ville de Paris, Paris, France / **2000** "ein/räumen", Hamburger Kunsthalle,
Hamburg, Germany

Selected bibliography: **1972** *Untitled*, New York (NY) (with Joanne Caring) / **1978** *Untitled, Red/Blue*, New York (NY); *Untitled, Black/White*,
New York (NY); *Enough/Projects Louise Lawler*, New York (NY)

Something about time
and space

"A painting that has been removed in space and time from the situation for which it was made," says Louise Lawler, "no longer
has the same references and functions. Whose work is it?" This is a question that has concerned the artist for over two decades. First
asked in 1978 at a group exhibition in New York's Artists Space, it runs like a leitmotif through her entire oeuvre. Lawler frequently quotes
the works of other artists in various topographical, social and economic contexts – galleries and museums, auction houses and private
as well as corporate art collections. Her photographs and cibachromes show such things as a Jackson Pollock drip painting hanging
behind a decorative planter (*Pollock and Tureen*, 1984/90), the juxtaposition of a Robert Delaunay and a Roy Lichtenstein in the TV
corner of a living room (*[Stevie Wonder] Livingroom Corner Arranged by Mr and Mrs Burton Tremaine, New York City*, 1984), or a small
sign beside Jasper John's *White Flag* at a Christie's auction (*Board of Directors*, 1989).

Lawler's compositions focus not on the artworks themselves, but on their surroundings. The exquisite art is frequently relegat-
ed to the margins or is only partly visible. Lawler traces the various stages in the evaluation of works of art, which – original, aesthetic
sign, and commodity in one – take on different meanings depending on their context, whether this is as a collector's item, a status sym-
bol, or a mark of good taste. As Helmut Draxler noted in his essay on Lawler's exhibition "A Spot on the Wall" (1995/96), her concern
is not to appropriate the art she quotes, but rather to define a "grammar of appropriation and financial utilisation".

The wall labels under Lawler's photographs often include the names of curators, museum staff and collectors. In *Untitled
(Dreams)*, 1992, she recorded the history of the changes of location and ownership of Ed Ruscha's *Dreams #1*, 1987, and Roy Lich-
tenstein's *Ball of Twine*, 1963, supplementing the provenance list with the terse statement: "This will mean more to some of you than
others." The signature as embodiment of authorship is shifted off-centre, and with it the notion that the artist is solely responsible for the
production of meaning. Yet even this explicit naming of the stations through which an art work passes, although it might seem to provide
transparency, includes a factor of exclusiveness. As Lawler's remark indicates, the web of social and financial considerations in which art
is entangled is more revealing to some eyes than to others.

2

3

"My pictures present information about the 'reception' of artworks."

1 **Marilyn,** 1999. Mixed media, 77 x 52 cm

2 **Painting and Sculpture,** 1998/99. 2 cibachromes, each 121 x 104 cm

3 **Hand on her back,** 1979. Cibachrome, 154 x 111 cm

4 **(Bunny) Sculpture and Painting,** 1999. Cibachrome, 121 x 168 cm

5 **Happy New Year,** 1991. Cibachrome, 107 x 138 cm

6 **Something About Time And Space But I'm Not Sure What It Is,** 1998.
12 cibachromes, 48 x 60 cm (6 pieces) and 61 x 75 cm (6 pieces). Installation view,
neugerriemschneider, Berlin, 2000

4

5

In the late 1970s and early 1980s, Lawler often adopted ephemeral approaches to focus on certain aspects of the supposedly secondary mechanisms of art presentation and marketing. For a group exhibition at the Artists Space in 1978, she designed a logo that was posted all over Lower Manhattan. In 1982, during a Los Angeles lecture by the art-market shooting-star of the moment, Julian Schnabel, Lawler distributed little books of matches bearing the title of the event, thus characterising it as a short-lived PR affair. The interweave of art and commerce was also the subject of a work done in collaboration with Allan McCollum, *For Presentation and Display: Ideal Settings,* 1984. The two artists made replicas of about 100 pedestals or stands of the kind commonly used to display art, and arranged them into a sculptural ensemble. Coloured spotlights suffused the installation with a seductive atmosphere. Conventional ways of presenting art, intended to lend it an aura of the exquisite and unique, were short-circuited with the persuasive strategies of advertising, and the gallery was transformed into a PR show.

Art and commerce

The culture of spectacle and its ubiquitous presence, as the American art historian Rosalind Krauss noted in an essay of 1996, is not only a condition of Lawler's work, but is inscribed into her production of art. Lawler's *Paperweights* – hemispherical glass objects presented like precious collector's items under Plexiglas domes – might be read as allusions to a peep show or to a camera lens. Viewers initially saw only their own faces and the surroundings distortedly reflected in the round glossy surface of the paperweights, but then detected a small opening, which revealed a view of miniature versions of the artist's "picture arrangements" on the bottom. Their perception merged with a reflection of the actual exhibition situation and its viewers, a model of the manifold reciprocal relationships that exist between artwork, context and viewer, manifested on a tiny scale.

I'm not sure what it is

A similarly complex interlinking of work and setting, artistic production and its appropriation or reception, was seen in Lawler's show "More Pictures", 2000. The extensive installation presented there, *Something About Time And Space But I'm Not Sure What It Is,* 1998, consisted of several variously coloured black-and-white photos of Andy Warhol's *Silver Clouds,* or more precisely, of their 1998 reinstallation at the D'Amelio Terras Gallery in New York.

In 1966, Warhol had set a number of helium-filled silver-foil pillows afloat in the Leo Castelli Gallery, a work whose ephemeral presence both radically and playfully undermined the concept of the original work of art and its permanence. Now, Lawler addressed the issue of the effect of repetition on such an event, and how it would change the meaning of the work. Her tactics were two-pronged. The photographs were affixed to the gallery ceiling at various angles and intervals in a way that simultaneously mimicked the floating pillows and yet solidly anchored them – just as, ultimately, the repetition of Warhol's event at D'Amelio Terras had contained a factor of fixation.

Seen in this light, *Something about Time* was also a statement about the public reception of art. In its oscillation between repetition and difference, reproduction and original object, there remained an underlying but provocative uncertainty in the viewer's mind as to what, indeed, this "something" consisted of.

Astrid Wege

Drawing by Roy Lichtenstein subsequently used by Louise Lawler as her portrait

Tamara de Lempicka

*** 1898 in Warsaw, Poland; ✝ 1980 in Cuernavaca, Mexico**

Glamour girl

By the time she was 25, Tamara de Lempicka had found her motto: "There are no miracles. There is only what you make yourself." The well-born Polish girl was determined never to be bored, and the best way to ensure this was by being glamorous. In the 1920s, no one embodied this phenomenon better than de Lempicka, who was perhaps the first woman artist to be a glamour star – as seen in her painting *Self-portrait (Tamara in a Green Bugatti),* 1925, which continues to grace schoolbooks and postcards to this day. "Style is the prime means of changing oneself and becoming what one would like to be." De Lempicka, childlike bride, emigrée, young mother, earned a fortune with her stylistically polished paintings, investing the money in countless huge hats and extravagant dresses.

She was portraitist of America's upper crust, depicting venal women and sensual girls in white and pink, and kings without a throne. Her studio apartment in Rue Méchain on Paris' Left Bank was furnished in Art Deco by Mallet-Stevens. It was the stage on which she both performed her life's role and created her art. Every detail was carefully worked out, down to her initials on the chairs. Her wardrobe, her parties, her social life were legendary. She loved the society world as much as the art world. Yet she was interested only in people she called the best – the wealthy, the powerful, the *arrivistes*. Everyone else, the bourgeois and the mediocre, she shunned.

Tamara de Lempicka was born as Tamara Gorska into an upper middle-class milieu in Warsaw in 1898. In St. Petersburg, in 1916, she married Tadeusz Lempicki, a lawyer and man-about-town. During the Russian Revolution, the couple fled by way of Finland to Copenhagen, and finally to Paris. Here Tamara had her only child, a daughter, Kizette. It was in the French capital that she decided to take up art. In 1918, she began studying painting with Maurice Denis and André Lhote. Denis, a member of the pre-war artists group the Nabis, to which Gauguin had also belonged, taught de Lempicka to simplify colours and forms, and to contour motifs sharply – and also how to give colours that enamel-like gloss that was to become so characteristic of her. Lhote, a co-founder of Neo-Cubism, demonstrated how decorativeness could be combined with features of the avant-garde experiments of a Georges Braque or a Juan Gris. Cubism subjected the human figure to a geometrical disassembly, reducing the anatomy to cubes, cones and spheres.

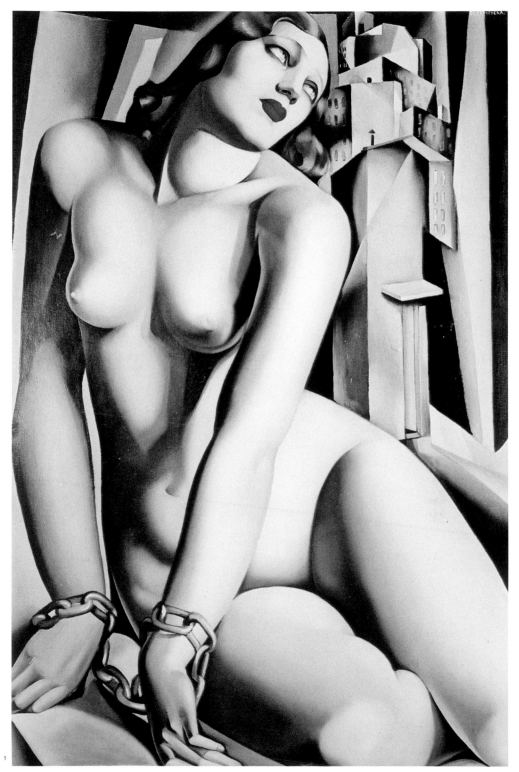

"My aim: never copy.
Create a new style, light, brilliant colours,
and sense the elegance in your models."

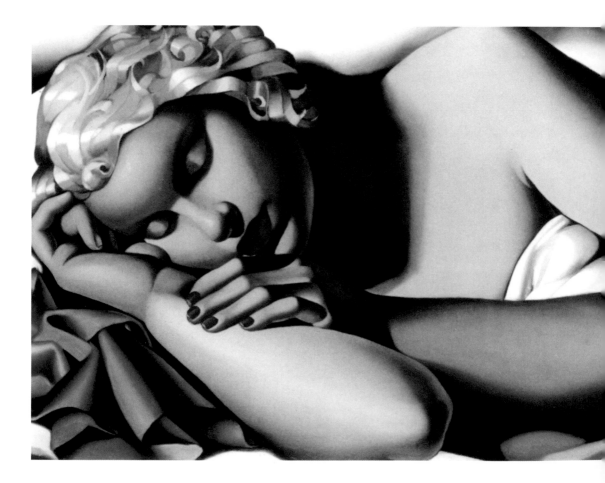

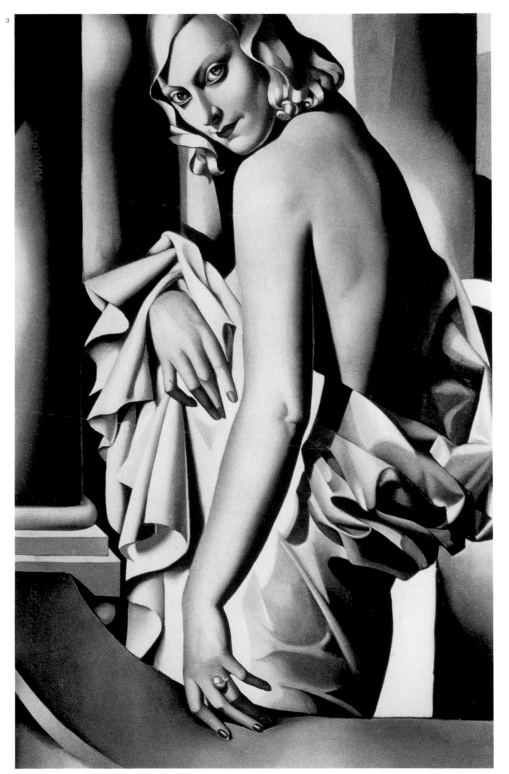

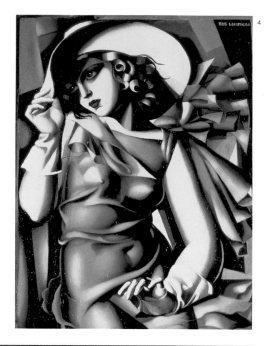

1 **Andromède,** 1929. Oil on canvas, 99 x 65 cm

2 **Dormeuse,** 1935. Oil on canvas, 33 x 42 cm

3 **Portrait de Marjorie Ferry,** 1932. Oil on canvas, 99 x 65 cm

4 **Jeune fille en vert,** 1927. Oil on canvas, 53 x 39 cm

5 **Les deux amies,** 1923. Oil on canvas, 130 x 160 cm

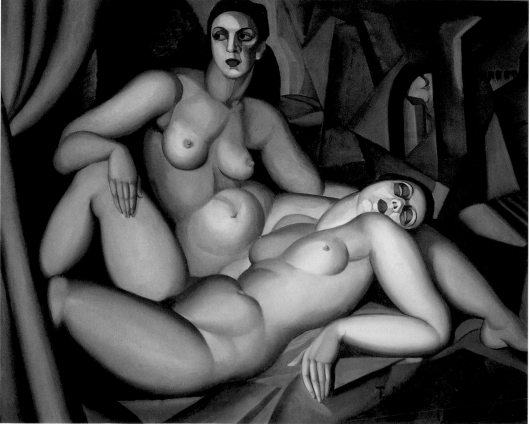

Yet de Lempicka's subject matter differed from that of other fashionable Art Deco painters. She depicted friends and acquaintances, experimented with contrasting planes and bright highlights. She became a detached portraitist with a rather condescending gaze, developed a sensuously decadent style that favoured strong hues. Some works achieved the quality of sensitive caricatures that perfectly recorded the spirit of the age. With a highly becoming arrogance, she caught the tics and revealing gestures of her sitters on canvas. Her glamour was, as we would now say, "cool", and so were her pictures. "A painting must be clear and clean. I was the first woman to paint clearly and cleanly – and that was the reason for my success."

Consorting with the rich and beautiful

The 1920s witnessed de Lempicka's rapid rise to fame. In 1923, she began exhibiting her work in the grand Salons. The Galerie Colette Weill gave the artist her first solo show, which attracted attention. Then came her first significant award, for a portrait of her daughter, *Kizette on the Balcony*, 1927. This was the breakthrough de Lempicka had so desired. Before the year was out, she was divorced from Tadeusz Lempicki. In 1928, she began depicting the European and American elite. After portraying the Hungarian baron, landowner, and art collector Raoul Kuffner, she married him in 1933 – life and art were intimately interwoven for de Lempicka. In the early 1930s, her fame reached an apex, and museums began to acquire her work. In view of the growing fascist threat, she convinced her husband to sell a considerable portion of his real estate in 1938. De Lempicka, the *grande dame* of Art Deco, left Europe with Baron Kuffner in 1939, for the United States. "The baroness with a brush" soon became the favourite portraitist of Hollywood stars.

Down with ugliness

De Lempicka detested the Existentialist philosophy that prevailed in post-war France. She had no good word to say about contemporary painting, avoided the "cult of ugliness" she thought had prevailed. Yet wanting to find new modes of expression, she turned, if without true enthusiasm, to abstract, non-objective painting. One of her last shows took place in New York in 1962, the year her husband died of a heart attack. De Lempicka, perpetual nomad, sold all her possessions, fled New York, went on three trips around the world, then settled for a time in Houston, Texas, where her daughter Kizette and her family lived. In 1978, she then moved to Cuernavaca, Mexico, where she befriended the sculptor Victor Contreras, 40 years her junior. At the time, Cuernavaca was a favourite refuge of wealthy Americans and the cosmopolitan jet-set. Their lavish and decadent lifestyle attracted Baroness de Lempicka, confirming her own love of extravagance. She returned to the painting style that had made her famous 40 years before. Tamara de Lempicka died in Cuernavaca in 1980. Judging by what we can see in her best pictures, hers must have been a wonderfully exciting life.

Frank Frangenberg

Tamara de Lempicka painting the portrait of her husband,
Tadeusz de Lempicki, 1928

Tamara de Lempicka, 1930s

Tamara de Lempicka

Sherrie Levine

*** 1947 in Hazleton (PA), USA; lives and works in New York (NY), USA**

Selected solo exhibitions: **1977** 3 Mercer Street, New York (NY), USA / **1988** Hirshhorn Museum and Sculpture Garden, Washington, DC, USA / **1991/92** Kunsthalle Zürich, Zurich, Switzerland; Westfälisches Landesmuseum, Münster, Germany; Rooseum-Center for Contemporary Art, Malmö, Sweden; Hôtel des Arts, Paris, France / **1993/94** "Sherrie Levine. Newborn", Philadelphia Museum of Art, Philadelphia (PA), USA; Portikus, Frankfurt am Main, Germany / **1997/98** "Sherrie Levine", Städtisches Museum Leverkusen Schloss Morsbroich, Leverkusen, Germany; Musée d'Art Moderne et Contemporain, Geneva, Switzerland

Selected group exhibitions: **1977** "Pictures", Artists Space, New York (NY), USA / **1986** "EUROPA/AMERIKA. Die Geschichte einer künstlerischen Faszination seit 1940", Museum Ludwig, Cologne, Germany / **1989** "A Forest of Signs. Art in the Crisis of Representation", Museum of Contemporary Art, Los Angeles (CA), USA / **1994** "Duchamp's Leg", Walker Art Center, Minneapolis (MN), USA / **1999** "The Museum as Muse: Artists Reflect", The Museum of Modern Art, New York (NY), USA

Originality according to Sherrie Levine

The work of Sherrie Levine exemplifies the post-modern sense of working in a period when the epoch-making achievements of modern art – such as the monochrome panel in painting, or the ready-made in sculpture – are already matters of recorded fact. Levine did not participate in the making of the modern canonical masterpieces, but she did observe the process, and, in 1980, described the situation she had found herself in by adapting a Freudian passage from Alberto Moravia's *The Wardrobe*: "Since the door was only half closed, I got a jumbled view of my mother and my father on the bed, one on top of the other. Mortified, hurt, horror-struck, I had the hateful sensation of having placed myself blindly and completely in unworthy hands. Instinctively and without effort, I divided myself, so to speak, into two persons, of whom one, the real, the genuine one, continued on her own account, while the other, a successful imitation of the first, was delegated to have relations with the world. My first self remains at a distance, impassive, ironical, and watching."

Levine established that the relationship of present-day artists to those of the past was a suppressed oedipal one, and the artistic idiom available to her as a woman was one that had been evolved by men, shaped by male desires and wishes. Levine defined her own position by giving clear expression to that fraught situation. Her professional life was begun with the *Shoe Sale* project: in 1977, at the 3 Mercer Street store (a New York art space), Levine sold 35 pairs of identical black children's shoes, fastened by the laces and looking like phallic miniature versions of men's shoes. *Shoe Sale* focused on the issues central to Levine's sphere of interests: the fetishist

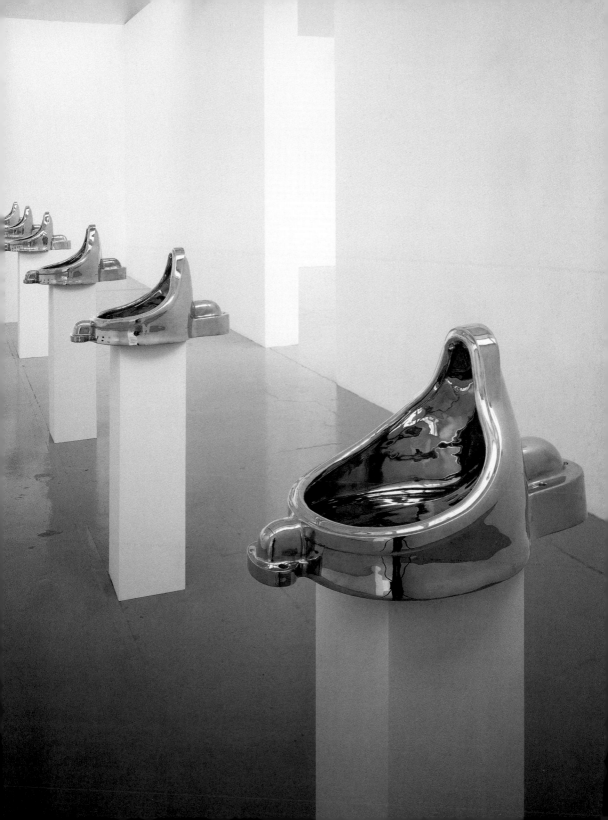

"Like Brancusi, I am interested in the corporeal and the sensuous, but also in the unforeseeable and the unstable. I like the aura of the accidental, just as I like repetition because it includes an endless sequence of substitutes and missed encounters."

1 **Fountains, after Duchamp,** 1991. Bronze. Installation view, Kunsthalle Zürich, Zurich, Switzerland
2 **Bachelors,** 1989. 6 parts, cast glass. Installation view, Mary Boone Gallery, New York (NY), USA
3 **After Walker Evans #3,** 1981. Black-and-white photograph, 25 x 20 cm
4 **Large Crate Tables,** 1993 (detail). 6 tables, untreated ash, each 81 x 61 x 64 cm
5 **Hobbyhorse,** 1996. 9 parts, aluminium, wooden pedestals, each 69 x 89 x 48 cm. Installation view, Städtisches Museum Schloss Morsbroich, Leverkusen, Germany, 1996

4

as well as commodity character of art objects, the question of the original and of originality, the nature of the unique one-off article and of the series. While the children's shoes were evidently male-encoded, in a three-part series of collages that followed, 1978/79, Levine subverted clear categories: from magazine photographs of women she cut out the silhouettes of three American presidents (Lincoln, Washington and Kennedy), so that the images could no longer be grasped independently of each other, but exerted a mutual influence. In 1981, Levine took the appropriation of existing images to *reductio ad absurdum* when she began photographing iconic works of photography, such as Edward Weston's photographs of his son Neil, or plant pictures by Karl Blossfeldt. The prints were given titles such as *After Edward Weston* or *After Karl Blossfeldt*, from the originators of the images. What makes Levine's act of appropriation so fascinating is the high degree of ambivalence that results: is she performing a kind of homage, a gesture of enthusiastic identification, or is this a form of ironic devaluation, of eradication, even of patricide? Are Levine's re-photographed images, being the work of a woman, perceived and interpreted differently from photographs by male artists? And to what extent are the latter in any case influenced by other images? Whatever the answers, in the early 1980s, Levine's deft strategy of establishing multi-layered images in a literal and a metaphoric sense was seen by part of the public as a startling breach of taboo. Some confessed that they shied away from close scrutiny of the photographs themselves, preferring to give their attention to those features which were unambiguously of Levine's authorship, such as the passe-partout, frame and title.

In the course of the 1980s, Levine extended her ready-made approach to media in which the principle of reproducibility was not already inherent. Thus the new objects of her attentions included drawings by Matisse, watercolours by Kandinsky, and paintings by Kirchner, Mondrian and Monet. She has invariably worked from catalogue reproductions (with whatever slight variations on the original this might already imply) rather than from the originals. Sometimes the reproduction is photographic, while at other times the colour values are worked out by computer and then applied onto wood panels by restoration experts. The notion of the unique original is undermined by the minimalist surrealism of some of the images – thus, for instance, Levine's recent *Monochromes*, 2000, consists of groups of twelve identical black, white or pink panels. Nevertheless, a hankering after the aura of the original can still be detected in Sherrie Levine's work, as in her *Crystal Bachelors*, 1989, her first sculptures. From Marcel Duchamp's hermetic masterpiece *Big Glass*, definitively left unfinished in 1923, Levine isolated the two-dimensional "Moules Mâlic" (malic moulds), elaborating six of them into glass creations that were displayed in showcases like sculptures in their own right – or Freudian totem objects, or commodities.

Critical appropriation

In the early 1980s, Sherrie Levine was seen as the foremost representative of Appropriation Art, a concept that involved the critical appropriation of images that already existed in high and mass culture. Discussion of her work focused on her demystification of male cult figures in the modern era, and her deconstruction of concepts such as "author", "original" or "originality". In the meantime, her work has come to be seen as a ludic and self-ironic form of imaginative venture. The playfulness is certainly to the fore in a series of mahogany panels dating from 1988, for which Levine re-used Krazy Kat and Ignatz Mouse, two characters in the work of cartoonist George Herriman: Krazy Kat is in love with Ignatz Mouse, who tries to get rid of his admirer by throwing a brick at her head. This act of rejection is paradoxically taken by Krazy Kat as a sign of affection – and she feels vindicated in playing out an obsessive relationship which owes its dynamics purely to a fundamental misunderstanding.

Barbara Hess

Sherrie Levine

Agnes Martin

✳ 1912 in Maklin, Saskatchewan, Canada; ✝ 2004 in Taos (NM), USA

Selected solo exhibitions: **1958** Betty Parsons Gallery, New York (NY), USA / **1962** Robert Elkon Gallery, New York (NY) /
1975 Pace Gallery, New York / **1991** "Paintings and Drawings", Stedelijk Museum, Amsterdam, The Netherlands /
2000 "Lovely Life: The Recent Work of Agnes Martin", Whitney Museum of American Art, New York (NY)

Selected group exhibitions: **1972** documenta 5, Kassel / 1977 documenta 7, Kassel / **1990** "Künstlerinnen des 20. Jahrhunderts",
Museum Wiesbaden, Wiesbaden / **1993** "Der zerbrochene Spiegel: Positionen zur Malerei", Museumsquartier Messepalast und Kunsthalle,
Wien; Deichtorhallen Hamburg, Hamburg / **1997** "Future, Present, Past", XLVII Esposizione Internazionale d'Arte, la Biennale di Venezia,
Venice, Italy

Selected bibliography: **1992** Dieter Schwarz (ed.), *Agnes Martin: Writings/Schriften,* Winterthur, Switzerland

The melancholy of perfection

The notion that the true purpose of art was to visualise the invisible, which was part of Romantic thinking, gained new currency with the emergence of the early 20th-century avant-garde. Caspar David Friedrich's postulate that the artist must close his physical eye in order to capture an image in the mind's eye, for instance, reappeared in the Blue Rider group's proclamation of an "epoch of great spirituality". Longing to redeem the human condition, modern artists sought in abstraction and amorphousness the visual promise of a coming spiritual Golden Age. This claim to the absoluteness of art continued to reverberate even in American Abstract Expressionist painting – including that of Agnes Martin, who long stood in the shadow of such contemporaries as Jackson Pollock, Ad Reinhardt or Mark Tobey, despite the fact that she had developed an independent style by the early 1960s.

Martin, who lives in New Mexico as Georgia O'Keeffe once did, is one of the great hermits among contemporary women artists. It is a paradox of 20th-century art history that exactly those artists who have attempted to keep themselves and their work out of the modernist discourse have come to be seen as its most typical representatives. The extreme individualism and genius displayed especially by the Abstract Expressionists does chime well with a voluntary splendid isolation. Yet Martin, whose life and work are of a remarkable consistency, has adopted neither the magisterial attitude nor the theoretical considerations of her male counterparts. With rare radical-ness, she has demanded discipline, rigor and perfection of her art – a perfection that art, like life, can of course never achieve, but can at most approach as an ideal. What she strove to awaken, as Martin once said, was an "awareness of perfection in your mind".

Agnes Martin was born in 1912, the second youngest of four children to a Canadian wheat farmer and his wife. After her father's death, she lived for a time with her grandfather, who let the children grow up with a great degree of freedom. In 1931, Martin left Canada for Washington to study education, and in 1941, now a practising teacher, she went to New York to take courses in art and art educa-tion at Columbia University. In 1947, a summer academy programme took her to Taos, New Mexico, where she has resided – when not in Manhattan – since the mid-1950s, becoming an American citizen in 1950. Her works of the 1940s were figurative, being based on Indian motifs, floral arrangements and landscapes. Showing the influence of Georges Rouault among others, these works were later for the most part destroyed by the artist because she considered them immature.

From 1957 onwards, Martin lived and worked in a studio in the Coenties Slip area of Downtown Manhattan. Although artists such as Elsworth Kelly or Robert Indiana regularly met at the nearby Cedar Bar, and James Rosenquist, Jasper Johns and Robert

2

"My pictures have neither subject nor space nor lines nor anything else – no forms. They are light, and are about fusion and formlessness, about dissolving form."

4

1 **Untitled #4,** 1999. Acrylic and graphite on linen, 31 x 31 cm

2 **Untitled #9,** 1980. Acrylic and pencil on canvas, 183 x 183 cm

3 **Untitled #12,** 1997. Acrylic and graphite on canvas, 152 x 152 cm

4 **Night Sea,** 1963. Oil on canvas with gold foil, 183 x 183 cm

Rauschenberg lived literally around the corner, Martin rarely sought contact with the local artistic scene. She was, however, a close friend of Kelly and Ad Reinhardt, and Barnett Newman used to install her shows. At this period, Martin developed her characteristically gritty visual idiom, a repetition of form that verged on formlessness, generally varying the basic geometric pattern of intersecting horizontal and vertical lines. The usually square formats evinced lines drawn in parallel, interwoven into grids, or series of small triangles or arcs arranged in pattern-like structures. Occasionally, small nail heads would be used to form a line of dots paralleling a pencil line.

Since 1958, the date of Martin's first solo show at the Betty Parsons Gallery, there has been, strictly speaking, no development in her work, but rather variations on a given theme, which were accompanied by an ever-increasing reduction of pictorial elements. In the beginning, the canvases were grounded in colours, but these were supplanted by white from 1964 to 1967. Prior to 1964, the grids were framed by a white band, while later they extended to the edges of the canvas. The lines were sometimes drawn sharply, sometimes diffusely. Martin employed pencil, ink, watercolour, oil or acrylic. The grid textures were frequently so fine that, when seen from a distance, they almost disappeared and merged with the painting ground. Since 1977, Martin has limited herself almost exclusively to horizontal lines – zero axes, as it were – and the canvas format (183 x 183 cm) has likewise remained unchanged. Dark shadowed gaps now appeared between metal frame and canvas. In her works on paper, this thin black edging line was drawn in ink. The titles often mentioned the predominant colour (*Blue Flower*, 1962; *Pale Grey*, 1966), or contained objective references (*Whispering*, 1963; *Grey Geese Descending*, 1985).

Reduction of form

Martin's non-figurative works have been compared to Minimal Art but, despite the similarities, they actually suggest closer ties with Abstract Expressionism. While their all-over textures recall Pollock, their serial sequences bring Mark Tobey to mind. The radical formal reduction of Martin's compositions, her attempt to achieve equilibrium and neutrality beyond the individual touch of the artist's hand, but, above all, her use of the square format, recall Ad Reinhardt, whereas her charging of the grid structures with spiritual meaning is reminiscent of the meditative voids of the "zips" in Barnett Newman's paintings. What is crucial for Martin is the idea of perfection, manifested in a precisely determined number of lines based on ancient laws of harmony, and also found in Taoist thought, with which art historian Thomas McEvilley has compared Martin's statements about her work.

Beyond individuality

Reinhardt died in 1967, and at the same time Martin's New York loft was condemned. She left the city, travelled for a year and a half, and finally settled in total isolation in New Mexico. She built a studio with her own hands, and began working again in 1974. She made the film *Gabriel*, whose images of idyllic landscapes, according to the artist, reflected beauty, innocence and happiness, but whose emphasis was actually on the difference between nature and ideas. In paintings of recent years, Martin has limited herself to variations of grey and white, applied either in fine linear sheaves or in heavier bands. These works, darker and denser than earlier ones, she calls – perhaps in homage to Reinhardt – *Black Paintings*. Although far from being "last paintings" like Reinhardt's, they do aim at complete objectivity, achieved by means of a weightless, endless linear pattern entirely divorced from natural observation or reference.

Holger Liebs

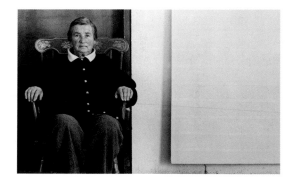

Agnes Martin,
New Mexico, 1992

Tracey Moffatt

* 1960 in Brisbane, Australia; lives and works in Sydney, Australia, and New York (NY), USA

Selected solo exhibitions: **1989** "Something More", Australian Centre of Photography, Sydney, Australia /
1993 Centre for Contemporary Arts, Glasgow, Scotland / **1997** Dia Center for the Arts, New York (NY), USA / **1998** "Free Falling",
The Renaissance Society at the University of Chicago, Chicago (IL), USA / **1999** "Laudanum", Ulmer Museum, Ulm, Germany;
Neuer Berliner Kunstverein, Berlin, Germany; Kunstverein Freiburg, Freiburg, Germany

Selected group exhibitions: **1993** "The Boundary Rider"; Sydney Biennial, Sydney, Australia / **1995** XLVII Esposizione Internazionale d'Arte,
la Biennale di Venezia, Venice, Italy / **1996** Biennale de São Paulo, São Paulo, Brazil / **1999** "Wohin kein Auge reicht",
Deichtorhallen, Hamburg, Germany / **2000** "Photography Now", Contemporary Arts Center, New Orleans (LA), USA

Between reality and fiction

Tracey Moffatt is an Australian photography and film artist who grew up as a half Aborigine with white adoptive parents in a working-class milieu. Until 1982, she studied Visual Communication at Queensland College of Art in Brisbane. It was not long before her work began to address her ethnic origins and the social situation of her formative years. Her first film, *Nice Coloured Girls*, which she made in 1987, looks at young Aborigine women in the city. By blending in historical paintings and using documentary material – including the story of her own grandmother and the arrival of white settlers in the Bay of Sydney – Moffatt explores the history of the Aborigines and the colonisation of their Australian homeland. In her most famous film *Night Cries: A Rural Tragedy*, 1989, Moffatt deals with her experience as an adopted child under the official Australian programme of forced adoption of Aboriginal children. In harrowing scenes of enormous emotional density and psychological depth, the film shows the tragedy of a black girl's hate-filled love for her terminally ill adoptive mother. Three ghost stories from her childhood are the theme of her first 90-minute feature film *Bedevil*, 1993, screened at the Cannes Film Festival in 1993, in which she explores typical Aborigine problems of dual identity and criminality, woven together in surreal images and dreamlike myths of the Aboriginal with the primordial link between man and nature.

In her films and photographic series, Moffatt combines historical facts and the present day, addressing the difficult relationship between black Aborigines and white colonial settlers, and visualising her own dream images in a distinctive merging of reality and fiction, documentation and narrative. Whereas her films occasionally include photographic sequences in which the plot itself seems to develop only slowly, the staged individual images of her various photo series appear like film stills, between which a story seems to develop.

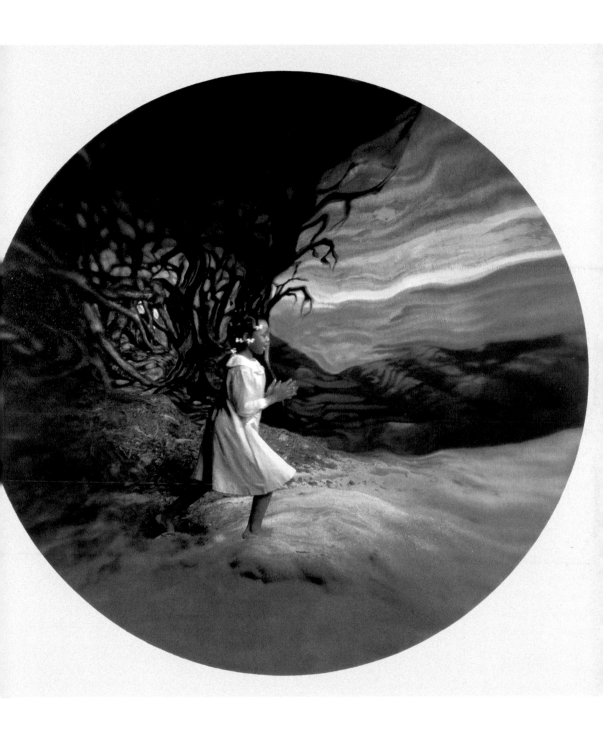

2

"I think my works receive attention because I endeavour to create not just something 'Aboriginal-Australian', but something 'universal'."

1 **Invocations (10)**, 2000. Photographic silkscreen with ultraviolet paint on structured Somerset satin paper, 107 x 99 cm

2 **Laudanum (2)**, 1998. Photogravure, 76 x 58 cm

3 **Something More**, 1989. Series of 6 cibachromes and 3 black-and-white photographs, each 99 x 130 cm. Clockwise from top left: **Something More 1, 3, 5, 7, 8**, 1989. Cibachrome, each 99 x 130 cm

4 **Up in the Sky**, 1997. Offset prints on paper, each 78 x 102 cm. Clockwise from top left: **Up in the Sky 1, 8, 9, 13, 14, 23**, 1997.

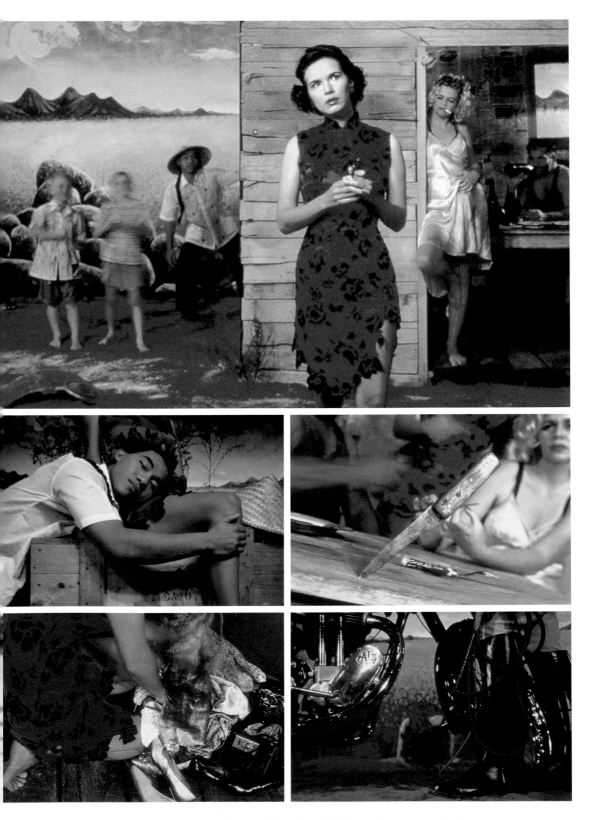

4

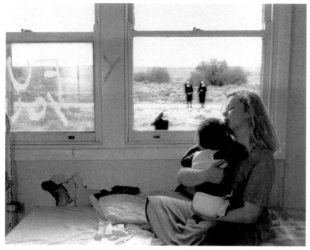

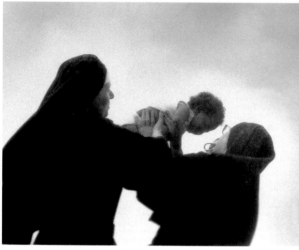

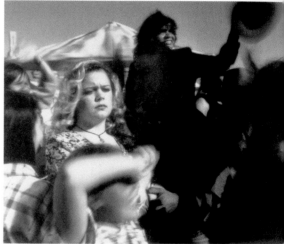

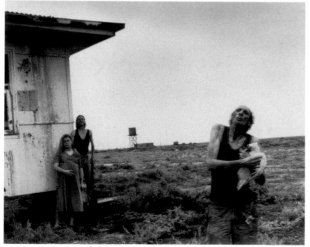

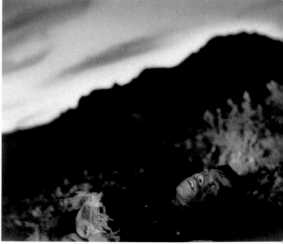

Her 1989 photo series *Something More* catapulted her to international fame. In these six colour and three black-and-white photos of strikingly simple composition, the main protagonist is always a woman in a red dress with a black rose pattern, whose relationship to the other persons remains enigmatic. Out-of-focus shots, cropped decontextualised details, and a shift between real background and painted backdrop defy unequivocal interpretation. The story remains fragmentary, yet at the same time these are emotionally emphatic images that blend reality and fiction with a striking visual approach.

Image-maker

Moffatt, who describes herself as an image-maker, makes references to American feature films, television and theatre as well as to comics, art history and the world of advertising in a very personal blend that blurs the boundaries between high and low culture. Each series of photographs is distinct. Her skilful handling of styles, methods and media make it difficult to classify her work. Her six-part photo series *Pet Thang*, 1991, features a naked woman with eyes closed in a dream-like rapport with a woolly sheep. Set against a black ground, their bodies radiate in a cold and unreal green or magenta. The series of nine offset prints *Scarred for Life*, 1994, shows different people, alone or with others, in snapshot-style images with captions that tell of violence, sexuality, power and trauma. The way the images are dated from 1956 to 1977 gives them a pretend documentary character, as does the layout, which is reminiscent of the layout of the US magazine *Life* in the 1960s.

The loss of narrative

In *Guapa*, Moffatt turns her attention to the tough roller-skating world of the Roller Derby Queens. The bodies of the young women, both black and white, seem to float against the white background. This ten-part series, shot in the studio in 1995, is more cohesive than her other series and appears as a choreography of sporting rivalry and aggression somewhere between dream and reality. The 25 offset prints in Moffatt's hitherto biggest series *Up in the Sky*, 1997, recall film stills between which a multifaceted plot unfolds with repetitions but no linear structure. *Laudanum*, 1998, comprises 19 photogravures in the style of historic photographs illustrating the power-based relationship of a white woman and her black servant, oscillating between eroticism and violence. The 13 images of different sizes that make up *Invocations*, 2000, printed with ultraviolet ink, have distinctly painterly traits, citing Symbolism, Goya, Hitchcock and even Disney. In *Video Artists*, 2000, Moffatt aligns different film scenes with artists, culminating in the destruction of the artworks.

Tracey Moffatt always uses actors as her models. Sometimes she herself also stands in front of the camera. The photo sequences, oriented towards films and literature, simulate a plot or story, and while they may trigger any number of associations in the mind of the spectator, the narrative is too fragmentary and the images too separate for a coherent whole to emerge. Thus, Moffatt's works document the post-modern loss of narrative described by Jean Baudrillard, while at the same time their narrative imagery satisfies a collective desire for storytelling.

Ulrike Lehmann

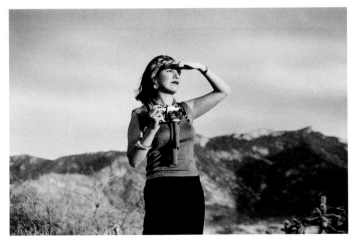

Tracey Moffatt

Mariko Mori

* 1967 in Tokyo, Japan; lives and works in Tokyo and New York (NY), USA

Selected solo exhibitions: **1995** "MADE IN JAPAN", Shiseido Gallery, Tokyo, Japan / **1999** "Empty Dream", Brooklyn Museum of Art, New York (NY), USA; "Esoteric Cosmos", Kunstmuseum Wolfsburg, Wolfsburg, Germany / **2000** "Link", Centre National de la Photographie, Paris, France / "Dream Temple", Rooseum Center of Contemporary Art, Malmö, Sweden

Selected group exhibitions: **1995** "New Histories", The Institute of Contemporary Art, Boston (MA), USA / "Ironic Fantasy", The Miyagi Museum of Art, Miyagi, Japan / **1999** "Heaven", Kunsthalle Düsseldorf, Düsseldorf, Germany / **2000** Johannesburg Biennial, Johannesburg, South Africa / "Apocalypse", The Royal Academy of Arts, London, England

Synthetic pictorial visions between yesterday and tomorrow

Like many artists these days, multimedia artist Mariko Mori lives in two worlds – her home town is Tokyo, her elective home New York. Her performances and fashion designs, videos and photos reflect the contrast between the old and the new world, between East and West, synthesising the two worlds in hyperrealistic visions. They involve not only Japanese Buddhism and Shintoism, but also the latest technology, digital picture manipulation, science fiction, techno and Neo-Pop, comics and advertising.

In her earlier photographic works, Mori herself poses as a female cyborg dressed in a gleaming silver hi-tech suit, surrounded by Japanese from the ordinary everyday life of this world and yet isolated: in an underground train, which because of the way the photo is taken looks like a round UFO (*Subway*, 1994); in front of an office building, where she offers passing business people tea (*Tea Ceremony III*, 1995); or as a mixture of Barbie doll and Fritz Lang's mechanical woman from *Metropolis* in a pachinko amusement arcade (*Play with me*, 1994).

The 3D photo-installations *Birth of a Star*, 1995, marked a turning point in her work. Mori presented herself alone in front of a white background, while gaily coloured balls floated around her like stars. She depicts herself with thick earphones, miniskirt and plastic stockings like a computer-generated pop idol of mixed 1970s and 1990s inspiration. Two yellow plastic bows, fixed to her upper arms like wings, recall the figure of an angel as intermediary between heaven and earth. Since then, her outsize colour photos and videos have been produced by an 8- to 19-strong team of associates and numerous sponsors.

"My work is a revelation of thought.
I positively enjoy projecting the esoteric gesture
through the inner world."

1 **Dream Temple,** 1999. Audio, metal, glass, glass fibre threads, Vision Dome, 3D semi-circular
 display, 5 m (h), diameter 10 m
2 **Mirror of Water,** 1998. Glass with photo interlayer, 5 panels, overall 302 x 610 x 2 cm
3 **Pure Land,** 1998. Glass with photo interlayer, 5 panels, overall 302 x 610 x 2 cm
4 **Entropy of Love,** 1996. Glass with photo interlayer, 5 panels, overall 302 x 610 x 2 cm
5 **Burning Desire,** 1998. Glass with photo interlayer, 5 panels, overall 302 x 610 x 2 cm

Miko no inori

Mori's lavish productions require specialists in costumes and jewellery, stylists, hairdressers and make-up artists, technicians, lighting and camera crews, composition and sound artists, computer animation and design experts to make a perfect picture set-up. Mariko Mori is the director, play writer, singer and main actress in her photos, videos and performances. Just as perfect as the presentation, each visual statement or cinematic action is multi-layered. The artist completely integrates new visual worlds hovering between past, present and future, dream and fiction, tradition and modernity, religion, nature and technology, profundity and persiflage with her own cyber-realism. She mixes and unites contrasts, whose boundaries oscillate fluidly in the pictures. She manipulates, synthesises and harmonises in the hope of a better world on the other side, though without adopting a critical note, because her mission is to depict enlightenment in Nirvana. Buddhists believe in rebirth and a condition of blessed peace. Mori's pictorial visions make tomorrow's possibility today's reality.

Clothed in a gleaming whitish-pink suit and with pointed blown-up plastic angels wings, she stands in an airport in Japan holding a crystal ball in her hand. Her eyes are indicated by rays of light as she looks in the crystal ball, i.e. the future. This video work, titled *Miko no inori*, 1996, seems to be programmatic for Mori's whole oeuvre, in which she endeavours to unite her art and philosophy, her religious and magico-spiritual visions.

Kumano

In the photograph *Kumano*, realised two years later, Mori seems to have found her future self-portrait. On the left of the picture, she kneels in front of a red bridge, such as is found in Japanese temple compounds. Wearing a tall headpiece made of pearls and precious clothing, she is the embodiment of traditional Japan. In the background, a waterfall appears between trees. On the right of the picture, she stands in front of a futuristic-looking polygonal temple, the *Dream Temple*, the form of which is reminiscent of old Japanese architectural traditions. Her figure itself is almost transparent, to this extent constituting a virtual shadowy apparition of the future. As if standing wreathed in mist or gleaming light, she appears either no longer corporeal or not yet palpable. The two scenes are linked by the common forest backdrop and the old characters written above, which are painted on the surface of the photo.

Dream Temple

In her latest work, *Dream Temple*, 1999, Mori has taken the digital temple from *Kumano* a step further, transforming it into a veritable "Gesamtkunstwerk" or total work of art. This, her most multi-layered project to date, combines architecture, computer graphics, 3D effects, a vision-dome system and virtual reality in order to explore the nature of human consciousness as such. With a diameter of 33 feet (10 m) and a height of 16 feet (5 m), the octagonal *Dream Temple* consists of ordinary and dichroic glass, whose softly gleaming, iridescent surface changes with the light. It is based on the Yumedono temple in Nara, built in the 8th century to house the statue of the Bodhisattva in a meditative atmosphere. In Mori's temple, the divinity is of course lacking, its place being taken by the viewer, who enters the central building to discover himself in an all-over video projection, in which abstract images of astral bodies turn into images of germination and growth. But, because of Mori's perfect image manipulation and presentation, which both recall genetic engineering and combine the real with dreamlike futuristic utopias, the term "Cyborg Surrealism" – coined by Donna J. Haraway – seems apt for Mariko Mori's work. *Ulrike Lehmann*

Mariko Mori

Shirin Neshat

* 1957 in Qazvin, Iran; lives and works in New York (NY), USA

Selected solo exhibitions: **1996** Centre d'Art Contemporain, Fribourg, Switzerland / **1997** Museum of Modern Art, Ljubljana, Yugoslavia /
1998 Tate Gallery, London, England / **1999** The Art Institute of Chicago, Chicago (IL), USA /
2000 Kunsthalle Wien, Vienna, Austria

Selected group exhibitions: **1999** "Zeitwenden", Kunstmuseum Bonn, Bonn, Germany; XLVIII Esposizione Internazionale d'Arte,
la Biennale di Venezia, Venice, Italy / **2000** Whitney Biennial, Whitney Museum of American Art, New York (NY), USA /
Sydney Biennial, Sydney, Australia / "Ich ist etwas anderes. Kunst am Ende des 20. Jahrhunderts",
Kunstsammlung Nordrhein-Westfalen, Düsseldorf, Germany

Between two worlds

Given an ever more global world, increasing migration and greater receptiveness to non-western cultures, public interest has grown in recent years in artists who come from other cultural milieus and whose works deal with multicultural influences.

Shirin Neshat grew up in Iran and went in 1974 to study in California. She did not revisit her homeland until 1990, when she found society there completely transformed. Meanwhile the Iran of Reza Pahlevi had turned into an Islamic republic. Based on the result-ing cultural shock she herself experienced and described, she began to depict the role of women in Iran and the phenomenon of veiling behind a black chador.

Her first works in the photo series *Women of Allah* date from 1993. They are black-and-white photographs of uncovered body parts such as faces, feet or hands, against which a weapon or flower has been juxtaposed. Neshat has overwritten the pictorial parts of these exposed body parts beneath the veil in Farsi, because without this addition she found the images "naked". The artist selected texts from female Iranian writers, metaphors of carnal lust, sensuality, shame and sexuality, which had prompted her pictures in the first place. For Western viewers, of course, the texts are not legible and thus look like ornamental calligraphy or arcane decorative elements. In Iran, by contrast, where they could be read, Neshat's pictures are not shown. Despite the indecipherability, Neshat has fascinated the public at numerous Western exhibitions and world-wide biennials with her enigmatic, voyeuristic, symbol-laden, powerful and exotic photos, and she rapidly conquered the market.

In 1997, she looked for new ways to introduce further narrative components into her work, and began to experiment with film. In the same year she produced the four-part video work *The Shadow under the Web*. In the various film projections, which are screened simultaneously on all four walls of the exhibition room, a woman in a chador (Neshat herself) is seen running uninterruptedly beside a historic city wall, through a mosque or bazaar, and down empty narrow alleys. We hear only her heavy breathing and panting. Because of the difficult political situation in her native country, Neshat moved the filming to Istanbul, carrying out the shooting jointly with Iranian film-makers. It was important for her to have an Islamic setting, where public places are male and the private ones female. Here the chador becomes a protection for a woman who seems hounded and in flight, fleeing her confined existence in Islamic society and search-ing for herself. But running is frowned on and untypical in the places of repose or commerce shown. It is much more an expression of

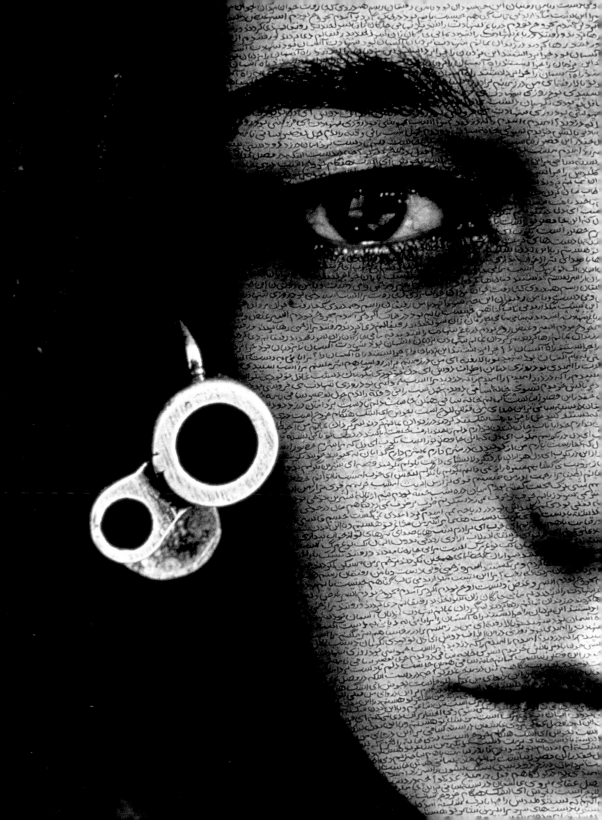

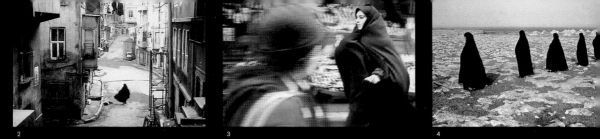

2

3

4

1 **Speechless,** 1996. Gelatin silver print, ink, 119 x 86 cm

2 **The Shadow under the Web,** 1997. Video still
3 **The Shadow under the Web,** 1997. Video still
4 **Untitled from the series Rapture – Women Scattered,** 1999 (detail). C-print, 102 x 152 cm
5 **The Shadow under the Web,** 1997. Video still
6 **Soliloquy,** 1999. Production still
7 **Untitled from the series Rapture – Women Scattered,** 1999 (detail). Gelatin silver print, 108 x 171 cm

8 **Rebellious Silence,** 1994. Gelatin silver print, ink, 36 x 28 cm
9 **Untitled (Woman of Allah),** 1994. Gelatin silver print, ink, 36 x 28 cm
10 **Stories of Martyrdom,** 1994. Gelatin silver print, ink, 28 x 36 cm

5

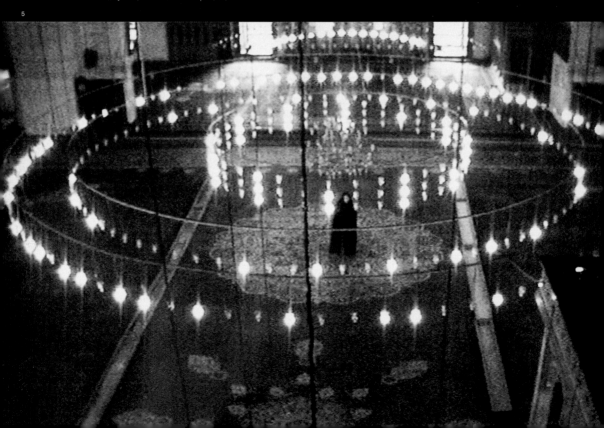

"I see my work as a pictorial excursus on the topic of feminism and contemporary Islam – a discussion that puts certain myths and realities under the microscope and comes to the conclusion that these are much more complex than many of us had thought."

6

7

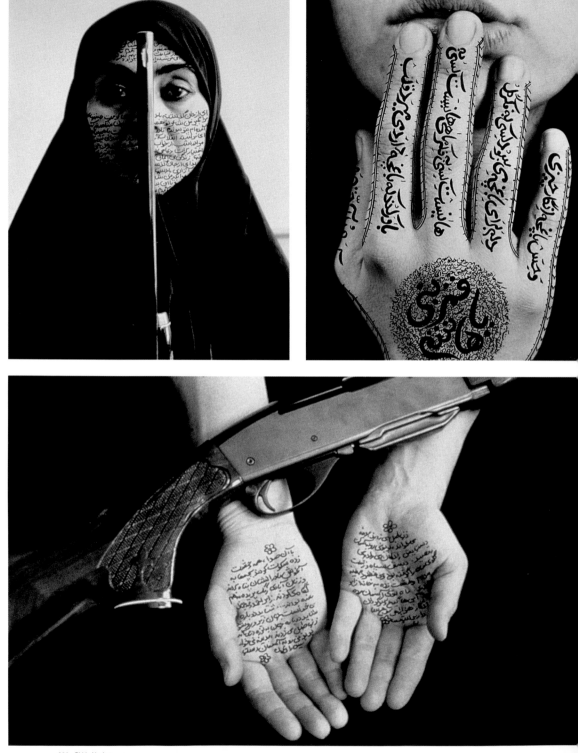

our Western civilisation, and so becomes here a symbol of a stressed modern society – not least because the viewers themselves have to run in the middle of the projection surfaces in order to be able to see all four films at once, which is ultimately impossible. Neshat's film, which contains biographical features and whose subject is the transition between two worlds, contains – like her subsequent videos as well – deliberate inconsistencies that bring out the different social structures, patterns of behaviour and thought, taboos and contradictions of Western and Islamic society.

Her second film, *Turbulent* (1998), which won an award at the Venice Biennale in 1999, acted as a magnet for the public. In two projections opposite each other, a man and a woman (both from Iran) apparently sing to each other. When the woman's voice begins, the man's falls silent, and vice versa. The woman sings wordlessly, isolated in an empty room. The man, who directly faces the camera, stands with his back to a male audience. It is an emotionally charged duel between the sexes that could never actually take place in patriarchal Islam because women are largely excluded from musical performances. But in this black-and-white film, the legendary voice of the woman is victorious, while the man falls silent.

Rapture

In the thoroughly pathos-laden and symbolically charged video work *Rapture*, 1999, which shows on the one hand a group of men in a fortress and on the other a group of women in a desert-like seaside landscape, Neshat again uses the means of double projection to generate fictitious communication, action and reaction between the two, but also to show the separation of the sexes in public life in Iran.

Soliloquy

In the two-part film *Soliloquy*, shot in Turkey and the US and completed in 1999, Neshat contrasts the worlds of two women: East and West, the traditional and the modern, community and the individual. On the one side, we see the veiled woman of the Orient, and, on the other, the woman of the West, in New York. As if in an unequal mirror image, they stroll up and down their respective home locations, performing their religious observances in the church or mosque. The correspondences of localities highlight the contrasts between their different ways of life and social structures.

Shirin Neshat's films, in which the action is deliberately scaled down and which build on the suggestive force of the images, are the expression of her experiences in two cultures. They therefore always follow a dualist principle. In a perfect blend of fiction and reality, they depict two worlds (man and woman, West and East, freedom and fundamentalism, tradition and modernity) with total respect. Needing no words, her films touch deeply emotional levels by means of picture and sound alone, presenting a narration of reality without being real, while at the same time remaining ultimately enigmatic.

Ulrike Lehmann

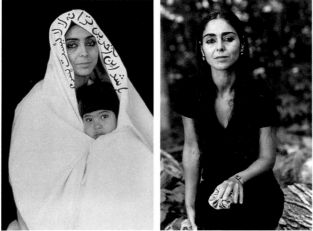

"My Beloved", 1995.
Gelatin silver print, ink, 36 x 28 cm

Shirin Neshat

Louise Nevelson

*** 1899 in Kiev, Russia; ✝ 1988 in New York (NY), USA**

Selected solo exhibitions: **1941** Nierendorf Gallery, New York (NY), USA / **1961** Staatliche Kunsthalle Baden-Baden, Baden-Baden, Germany / **1967** Retrospective Whitney Museum of American Art, New York (NY), USA / **1973** Moderna Museet, Stockholm, Sweden / 1974 Neue Nationalgalerie, Berlin, Germany

Selected group exhibitions: **1935** "Young Sculptors", The Brooklyn Museum of Art, Brooklyn (NY), USA / **1958** "Nature in Abstraction", Whitney Museum of American Art, New York (NY), USA / **1962** XXXI Esposizione Internazionale d'Arte, la Biennale di Venezia, Venice, Italy / **1964** documenta 3, Kassel, Germany / **1976** XXXVII Esposizione Internazionale d'Arte, la Biennale di Venezia, Venice, Italy

Architect of shadows

Louise Nevelson was born in Kiev as the daughter of Mina Sadie and Isaac Berliawsky. In Nevelson's case, genealogy makes sense – the invisible threads that connect us with the past are present everywhere in her oeuvre. Her grandfather was a lumber dealer, as was her father, and she herself seems to have inherited this family affinity with wood. She selected wood as her material both because she wanted to become a sculptress and because she did not want "colour to help" her.

In 1905, her family emigrated to the United States, settling in Rockland, Maine, where there were only 30 Jewish families. Nevelson's family ties were very strong, especially to her father. He was an advocate of equal rights for women, while her mother was a free-thinker. Despite being doubly stigmatised as a Jew and an aspiring artist, Nevelson nevertheless believed her path to be predestined and art to be her one true calling. Her marriage with Charles Nevelson, whom she wed after finishing her studies in 1918, was doomed to failure. Because she was fascinated by everything that had to do with art – singing, dancing, painting, acting and piano lessons – her husband's expectation of her that she should live the life of a middle-class wife and mother could not be fulfilled, and the two separated in 1931, while their son Myron, born in 1922, went to live with his grandparents.

Meanwhile Nevelson moved to Munich, where she continued her training with Hans Hofmann. On a trip to Paris she saw African art for the first time, at the Musée de l'Homme. One thing that intrigued her here was that she felt entirely familiar with these works of art, as if she had known them forever. She had the same feeling with regard to American Indian ceramics. In the 1920s and 1930s Nevelson amassed a large collection of these ceramics, as well as African and Pre-Columbian art.

She kept her distance from group, including the then highly influential representatives of the 1950s New York School, such as Barnett Newman, Mark Rothko and Jackson Pollock. Nevelson had her first show in 1941, at the age of 40, at New York's Nierendorf Gallery, but it was not until 1959 that her work was represented in the Museum of Modern Art. Looking back, she saw the reason for this belated recognition: "I took wood from the streets, old wood with nails and all sorts of things. Now when you think of monied people, they will invest in materials that are expensive. And actually the majority of people don't have homes; rather they live in showplaces, exhibition rooms. Consequently, they are never going to take old wood and give it its true meaning."

Nevelson was a woman who viewed her position on the art market with critical detachment. In 1966, at the age of 68, she finally received international recognition. In 1967, the year of her retrospective at the Whitney Museum, capping the most successful phase of her career, she relinquished nearly all her possessions and completely refurnished her house with grey metal cabinets and furniture. This courage to jettison the extraneous again and again advanced Nevelson's life and career. In 1957, she began dipping every element of her sculptures in matte black paint. By divorcing things from their functions she lent them poetry.

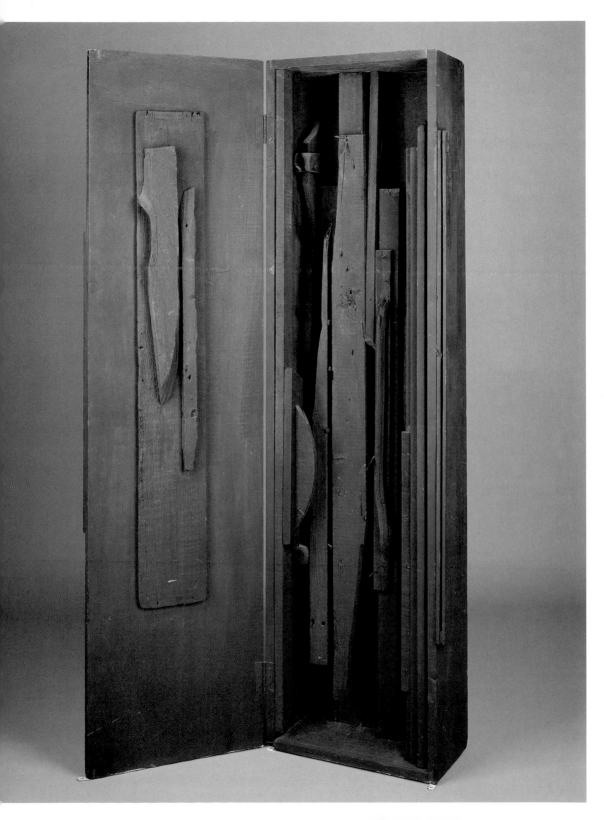

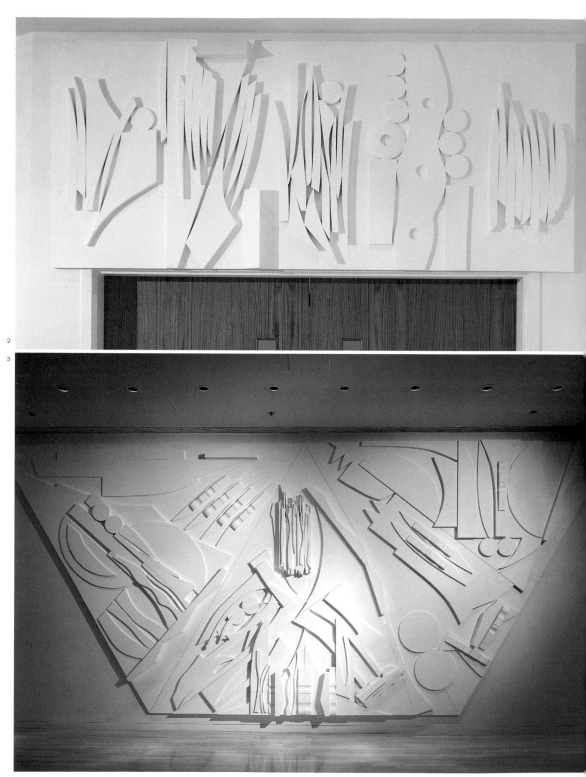

2

3

"Life in its essence is a mystery."

1 **World Garden IV,** 1959. Wood, painted black, 152 x 40 x 28 cm

2 **Grapes and Wheat Lintel,** 1977. St. Peter's Lutherian Church, Chapel of the Good Shepherd, Citicorp, New York (NY), USA

3 **Sky Vestment-Trinity,** 1977. St. Peter's Lutherian Church, Chapel of the Good Shepherd, Citicorp, New York (NY), USA

4 **Cross of the Good Shepherd,** 1977. St. Peter's Lutherian Church, Chapel of the Good Shepherd, Citicorp, New York (NY), USA

5 **Royal Tide IV,** 1960. Wood, with gold spray technique, 323 x 446 x 55 cm

6 **Shadows and Flags,** 1977/78. 7 Sculptures, Cor-Ten-Steel, Louise Nevelson Plaza at the Legion Memorial Square; crossing Williams Street, Liberty Lane and Maiden Lane, New York (NY), USA

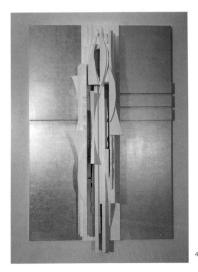

4

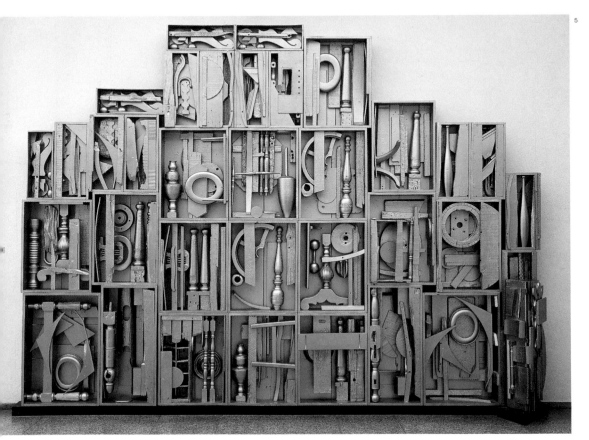

5

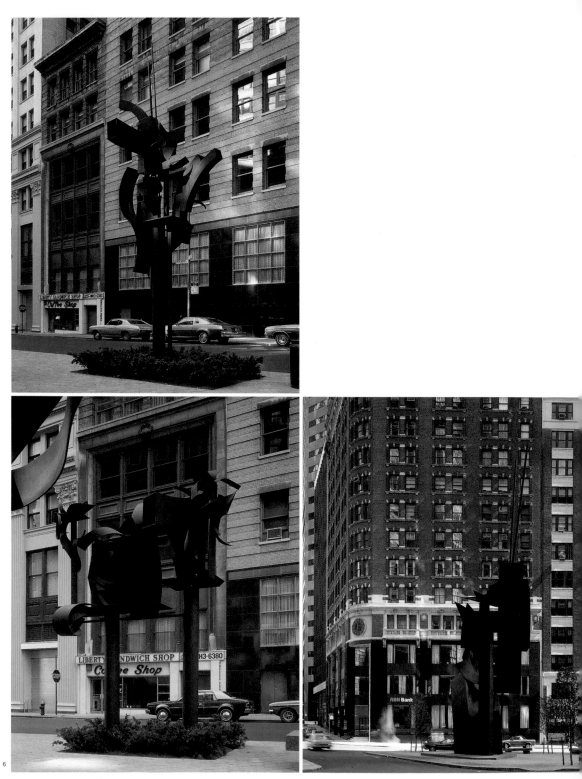

Many talents and skills went into Nevelson's sculptural works. Their flowing moving aspects derived from theatre and dance, her first points of contact with art. The artist herself viewed her works as collections of elements that were in continual flux and interplay, a never-ending dialogue of contradictory relationships. In the mid-1940s, she began to create sculptures with a performance aspect, such as the figurative group *Moving-Static-Moving*, which exemplified the dynamic character of her approach – anonymous terracotta figures that rotated around their own axis, establishing continually changing relationships with the surrounding space. Even the sometimes massive block-like forms in her work retained the light-footedness of dancers. Whereas other sculptors strove for permanence, as reflected in materials like steel, in predetermined compositions, and in consistent combinations of form, Nevelson preferred the more malleable material of wood.

Found objects with previous lives

The works that established Nevelson's reputation were emblematically abstract, dark boxes, configurations resembling bookcases hung on the wall and filled with wood pieces and fragments in seeming disarray, as if in an old curio shop. Most of these wall sculptures were painted a unified black, which lent them a shadowy, Gothic character. They consisted of wine crates, parts of chairs, lengths of wood jutting with nails, all found in the Manhattan streets – *objets trouvés* of various kinds and ages with traces of wear and tear that bore witness to their previous importance in someone's life. Fragments of old chests of drawers, window shutters, barrel lids, chair legs, split boards and objects of undefinable origin, all acquired a new context in small-format boxes.

The fact that these objects seemed to find the artist rather than the other way round, confirmed Nevelson in her calling. And she set out to make them her own by covering them with an all-consuming black that erased the traces of their previous existence. For Nevelson, black was not merely black, nor was any colour simply a colour per se. Colour was "the essence of the universe", she stated, continuing the line of thinking that had found its abstract apex in Malevich's *Black Square*. In Nevelson's hands, the colour black again took on this symbolic quality, becoming the quintessence of self-referentiality. Her interest focused on her own personal perception of the world, "because what my life is about is what everybody's life is about", and her aim was to reveal this world despite the fact that "life in its essence is a mystery."

The essence of the universe

In order to reveal something of this mystery, Nevelson paradoxically rendered its outlines clearer by spreading a veil of black over every object. With *Moon Garden plus One*, 1958, this approach found international recognition. The work consisted of boxes filled to bursting with old household items, dissolved into shadows by black paint, and stacked one over the other to form columns, which in turn formed walls, like Babylonian "cathedrals of heaven" – massive environments which, like African sculptures, were intended to be seen largely frontally. The boxes – initially collected, later made to measure – formed the framework within which found objects of daily use revealed their pure essential form. Louise Nevelson died in 1988, after a life of enviable artistic rigour and faith in her calling.

Frank Frangenberg

Louise Nevelson, 1968

Cady Noland

Born 1956 in Washington, DC, USA; lives and works in New York (NY), USA

Selected solo exhibitions: **1991** Museum Fridericianum, Kassel, Germany (with Felix Gonzalz-Torres) /
1994 Paula Cooper Gallery, New York (NY), USA / **1998** "Scratches on the Surface", Museum Boijmans Van Beuningen,
Rotterdam, The Netherlands / "Unfinished History", Walker Art Center, Minneapolis (MN), USA /
2000 "Over the Edges", Ghent, Belgium

Selected group exhibitions: **1991** "Metropolis", Martin-Gropius-Bau, Berlin, Germany / **1992** documenta IX, Kassel, Germany /
1994 "Temporary translation(s)", Deichtorhallen Hamburg, Hamburg, Germany; Museum für Gegenwartskunst, Basel, Switzerland /
1995 "Public Information: desire, disaster, document", San Francisco Museum of Modern Art, San Francisco (CA), USA

Selected bibliography: **1992** Cady Noland, *Towards a Metalanguage of Evil/Zu einer Metasprache des Bösen,* Stuttgart/Kassel, Germany

The reflection
of the psychopath

Cady Noland's appearance marked a sort of interruption to the art practice of the day. It brought a premature end to the 1980s and a warning of the recession setting in. Turning against the commercial glitter of a decade of unlimited possibilities and the boom of irony and kitsch, she wrote a treatise and collected fragments of a banal society.

Just as Noland cared little about agitating through her art, so her treatise was no manifesto. It carried the scientific-sounding title "Towards a Metalanguage of Evil", and dealt with the rules of play in a society where the successful are the psychopaths. Cady Noland's psychopath is obstinately boring. He is, according to Noland, a droning moody machine with a predilection for acts of malice. He is compared in a grimly medieval fashion with rotten eggs and wormy apples, whose outer skin hides nothing but a stinking core. The psychopath can be exposed, and will then show his true face. But exposing him is dangerous, because the psychopath will revenge himself bitterly each time his role is threatened. Cady Noland has made such risky exposure her task. The species she attacks is widespread. The businessman, she says by way of example, is a psychopath. A successful opportunist is the ultimate psychopath. Above all, however – and this is her point – the psychopath is a metaphor for contemporary art, the form of opportunism most craving for recognition. It is at this that her polemic is aimed.

Cady Noland's work is shock therapy for art. Her means are a contortion of sculpture and installation. She arranges heaps of consumer items, domestic goods and industrial articles typical of contemporary society, organised by barriers and barricades, as if it is necessary to hold in check what is insidiously being propagated within the gallery walls. Car parts and shopping trolleys, handcuffs and drinks cans represent polished items of merchandise as the fetishes of a pathological petty bourgeoisie which, with its frenzy to conform, dominates an entire society. The objects are here skilfully thrown down, there obsessively chained together. Finally, the heaps and piles which thus lie around the gallery are supplemented by panels of visual found objects. The American history of time is displayed like criminological evidence. It forms the background to the ubiquitous objects. Both combine in an argument with no express goal, in a socio-mythological stocktake. Objects and history fuse in a confrontation. It is a therapeutic confrontation whose political expressiveness has often been remarked on. What is being treated here, however, is not society, but one of its particularly typical deputies. Cady Noland's patient is art itself.

3

"I'm interested in the difference and similarities between blank identity and iconography as well as anonymity and fame."

Although her treatise identifies only the psychopath by name, her examples are taken from the world of art. At the end of the 1980s, on the threshold of recession, Noland talks of last resorts, of the reconfiguration of a morbid condition, of a method of treatment for better or worse as the last chance for a happy ending. She thus puts her Americana on display with the same decisiveness and logic as the Minimalists with their reduced forms. What tumbles across the gallery floor as *Celebrity Trash Spill* (1989) – a tabloid magazine, a perforated rubber doormat, a red runner, pieces of camera equipment, tripods and a torch, alongside several pairs of sunglasses – to be spread out flat in a "variable arrangement", is an inventory of the garbage of a star culture, whereby no one knows whether it is indeed an aesthetic statement or simply discarded rubbish. What is rampant here is a culture of horror. It is rampant in all things familiar, and the director of this inventory of collective experience has admitted that the materials on which she draws are things which she likes, which have something comforting about there for her. She describes her feelings for these objects as a sense of kinship.

Malice adaptation

It is a sense of kinship with the psychopathological aspect of a culture. The empty but insidious conformity of which she spoke in a new essay, published in conjunction with the 1992 documenta exhibition, appears in the accumulations of objects which she deposits in exhibition spaces. Documenta saw her method exemplified in the most appropriate location imaginable – an underground garage beneath Friedrichsplatz in Kassel, underneath the sites of industrial art, but in the therapeutic proximity one might expect. The toppled wreck of a delivery van with freshly-shattered window panes, fragments of her treatise on the "Metalanguage of Evil", graphics by artist friends, all counterchecked by plastic ribbons blocking entry and a pile of electrical equipment. Grilles and warning signs, foil and painting form a perfect horror scenario in the neon light, its atmosphere enriched by violence and the liberating gesture of rebelliousness by the iconoclastic artist. The Kassel catalogue called the installation a "stage set", seeing in it the "beginnings of a language of dissent which needs to be learned afresh".

Rebellion rules in place of PR

Here, rebellion rules in place of PR. The artist remains an artist insofar as she orders her material according to structures, composes it; insofar as she helps the things which are striving to become aesthetic objects to achieve the "destructive power of a focused everyday reality" (Roland Nachtigäller) by intentionally illuminating the catastrophe. A droning and moody machine was what she called the psychopath, who stood accused of a predilection for acts of malice. Fragments of malice are here projected onto the arts, without conveying a message, without a decipherable plan, without conclusion. The psychopath, Cady Noland established, is only a mirror of the expectations which he feels projected onto him. He reacts mechanically, and only the therapist can hold up the mirror in front of him so that the shock thwarts his strategy. The artist must know that she cannot cure the psychopathology of society. Cady Noland took the risk of holding up the mirror to art itself, with all its desire for recognition: through her choice of materials, by her renunciation of pleasing exteriors, by throwing the signs into disarray. Above all, too, through the risk that the work of the therapist can become entangled in the reflection of the pathological. And one should not forget that, at the end of the day, Cady Noland's therapy is paid for handsomely by her patient.

Gerrit Gohlke

Georgia O'Keeffe

* 1887 in Sun Prairie (WI), USA; ✝ 1986, in Santa Fe (NM), USA

Selected solo exhibitions: **1917** Gallery 291, New York (NY), USA / **1927** "Retrospective", The Brooklyn Museum of Art, Brooklyn (NY) / **1943** The Art Institute of Chicago, Chicago (IL) / **1946** The Museum of Modern Art, New York / **1966** Amon Carter Museum, Fort Worth (TX) / **1970** "Retrospective", Whitney Museum of American Art, New York / **1979** Whitney Museum of American Art, New York; The Art Institute of Chicago, Chicago (IL); The San Francisco Museum of Art, San Francisco (CA) / **1987** National Gallery of Art, Washington, D.C.

Selected bibliography: **1978/79** *Georgia O'Keeffe: A Portrait by Alfred Stieglitz*, New York (NY) / **1977** *Georgia O'Keeffe*, Harmondsworth, Middlesex, England

A rose is a rose is a rose

Her hands, everywhere these hands. Spread over a dark bunch of grapes, toying with a bright chrome car wheel, caressing a steer skull, or simply gesturing in the void, as if underscoring an important point in an unheard speech. For a long time, the famous portrait and nude photographs made of her by her partner, Alfred Stieglitz – over 300 from 1917 to 1937 – were far better known than Georgia O'Keeffe's own paintings. In Stieglitz' photographs, she even seems to reach out with her hands for her paintings as if for exquisite objects – when the paintings were being made, i. e. during the work in her studio, Stieglitz never took portraits of her.

Stieglitz, with whom O'Keeffe had a both symbiotic and difficult relationship from 1918 to 1946, the year of his death (they married in 1924), admired her work enormously. "At last – a woman on paper", he exclaimed when he first saw her charcoal drawings and watercolours in 1916 at his own Gallery 291 in New York. In his photographs, Stieglitz established a dual relationship between the artist's body and her work: first, by picturing her hands in front of the paintings, suggesting a woman of discernment, surrounded by beautiful things, receptive to aesthetic pleasure; and second, by naturalising her body, her torso, often by equating it with the open flowers in her paintings, as if art were foremost the fruit of woman's physical being, rather than the autonomous conscious result of artistic subjectivity.

O'Keeffe's recognition would hardly have been thinkable without the support of Stieglitz, who exhibited her work several times from 1916 onwards at his Gallery 291, where early on he had shown works by Picasso, Matisse and Cézanne. Nevertheless, the reception of her work long stood in the shadow of a conventional view of female art. In some idealised art-historical descriptions of this almost prototypical 20th-century artist-couple, her role was reduced to little more than that of a muse, who made variations in paint of the maestro's motifs. Her oils, inspired by the Texas and New Mexico deserts, were celebrated as depictions of the great American myth and were thus lent the status of national monuments.

In fact, O'Keeffe's true achievement was to have explored new territory for American painting on the margins of and beyond objectivity. It began with a reading of Wassily Kandinsky's essay *On the Spiritual in Art*, which inspired her to do abstract charcoal drawings at the start of her career (*Special No. 5*, 1915), and continued with correspondences to Stieglitz' photographs and their emphasis on the abstract patterns in landscapes, natural scenery, and cloud formations. The results included such paintings as *Dark Abstraction*, 1924, in which landscape motifs are only vaguely detectable, if at all.

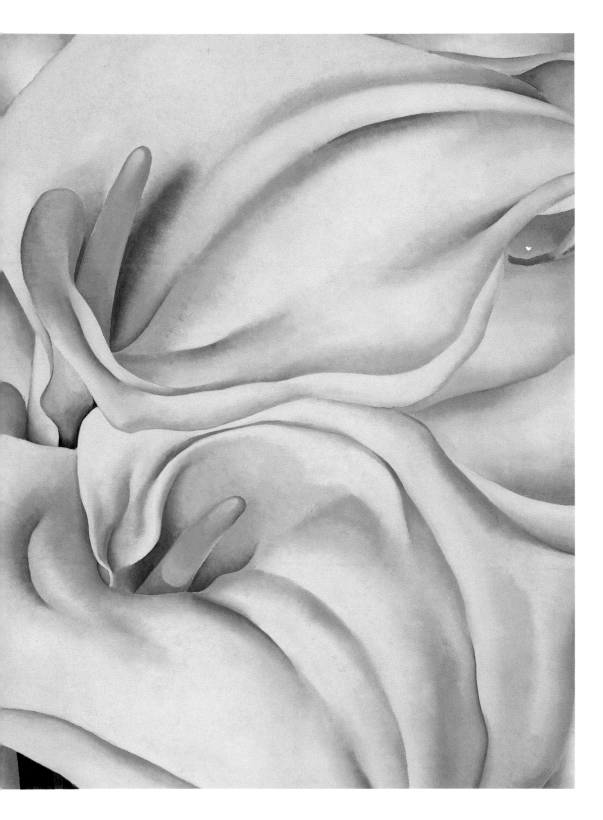

"Most people in the city rush around so, they have no time to look at a flower. I want them to see it whether they want to or not."

1 **Two Calla Lilies on Pink,** 1928. Oil on canvas, 102 x 76 cm
2 **Oriental Poppies,** 1928, Oil on canvas, 76 x 102 cm
3 **Red Mesa,** 1917. Watercolour on paper, 23 x 31 cm
4 **Arazee III (Jack-in-the-Pulpit III),** 1930. Oil on canvas, 102 x 76 cm
5 **Cow's Skull with Calico Roses,** 1932. Oil on canvas, 91 x 61 cm

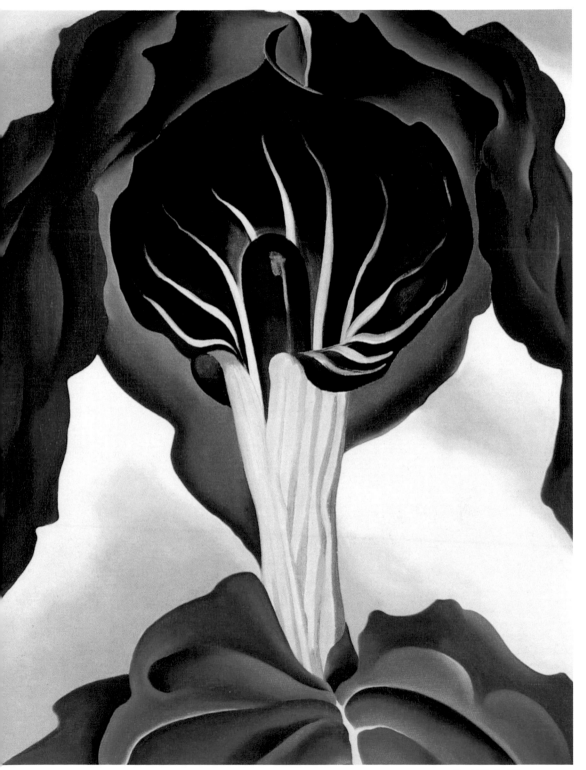

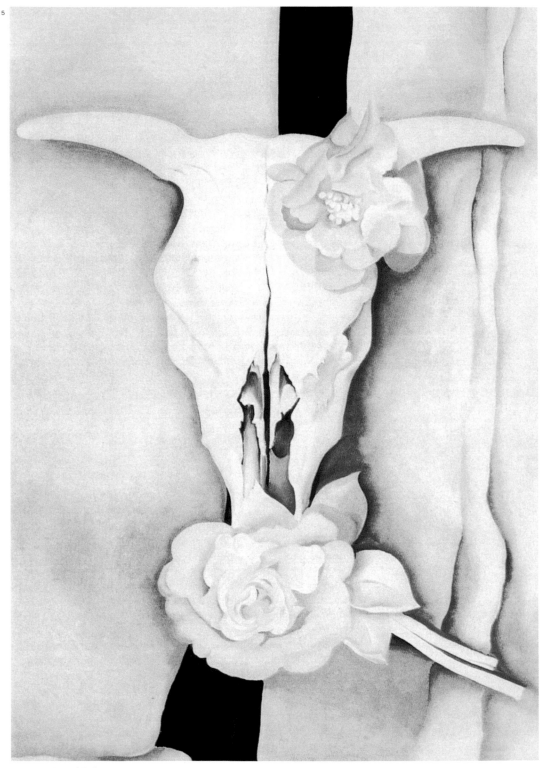

Active as an art teacher, O'Keeffe had studied in 1915 at Columbia University with Arthur Wesley Dow, an advocate of a synaesthetic theory of art. At this period she loved ragtime music and Picasso's painting, and once referred to her art works as "music", adding that "Since I cannot sing, I paint" (although she did play the violin). O'Keeffe experimented with charcoal, tracing great sweeping lines, waves, diagonals and rhythmical vortexes across the paper. Stieglitz mounted a show of her drawings without asking her beforehand, and later "remunerated" her with photographs of the works on display. The act marked the beginning of the artistic and existential liaison between photographer and painter. In 1916, O'Keeffe returned to paint and to watercolour, the medium which, according to Kandinsky, was the point of departure for spiritual reflection in art. In her *Blue Lines X,* 1916, the lines that project like steles into the empty pictorial space recall this source.

From Manhattan ...

O'Keeffe's first solo show took place at Gallery 291 in 1917. In June of 1918, she moved in with Stieglitz in New York. Subsequently, the two regularly spent their summers together working at the Stieglitz family place on Lake George in the Adirondack Mountains. During the long winter months in New York, O'Keeffe painted her first large-format floral motifs in 1924, and in 1925, inspired by the view from their apartment on the 30th floor of the Shelton Hotel, she did her first skyscraper picture, *New York with Moon.* Exhibitions of her work were held annually until 1929 at the Intimate Gallery.

O'Keeffe established a painting style that very seldom overstepped the boundary into abstraction, in which every brushstroke or physical trace was expunged from the surface. Flatness and precision of handling dominated especially in her flower pieces, such as *Calla Lilies,* 1923, *Petunia and Coleus* or *Red Canna,* both 1924, but also in architectural motifs such as *The Shelton with Sunspots,* 1926. Occasionally, photographic effects such as reflection points in blinding backlight were employed. Notwithstanding the great charm of her motifs, O'Keeffe's style appeared quite unemotional, reflecting a detached coolness that corresponded to the cognitive step coming between an experience of nature and the shaping of aesthetic form. The rose as an artefact rather than as a projection screen for feminine feeling.

... into the desert

In May 1929, O'Keeffe undertook a journey with a friend to Taos, in the New Mexico desert. The spacious countryside, with its thin air and harsh light, became the artist's most important source of inspiration over the following decades. The sheer infinity of space in northern New Mexico encouraged her to call this vanishing point of her artistic quest "The Faraway". She collected animal bones scattered across the desert, and the wooden crosses set up by the Penitentes, a Catholic sect, also appeared in her compositions. In the following years, until Stieglitz' death in 1946, O'Keeffe alternated between Manhattan and the desert. Then she settled permanently in the Southwest, on a hacienda in Abiquiu near Ghost Ranch, where she worked for the following three decades. It was not until 1972, when her eyesight grew poorer, that she gave up painting.

Holger Liebs

Georgia O'Keeffe and Alfred Stieglitz,
Lake George, 1938

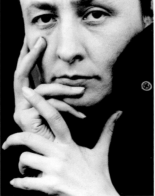
Georgia O'Keeffe, photo
by Alfred Stieglitz, 1918

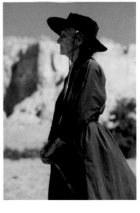
Georgia O'Keeffe at the age of 90 at the
Ghost Ranch, New Mexico, 1977

Yoko Ono

* 1933 in Tokyo, Japan; lives and works in New York (NY), USA

Selected solo exhibitions: **1971** "This is not here", Everson Museum, Syracuse (NY), USA / **1990** "Insound/Instructure",
Henie Onstad Arts Centre, Høvikodden, Norway / **1993** Frauenmuseum, Bonn, Germany / **1998** "Have you seen the horizon lately?",
Museum of Modern Art, Oxford, England / **2000** Japan Society, New York (NY), USA

Selected group exhibitions: **1966** "Destruction in Art Symposium (DIAS)", London, England / **1967** Filmfestival Knokke, Belgium /
1972 documenta 5, Kassel, Germany / **1990** "Sky Piece for Jesus", XLIV Esposizione Internazionale d'Arte, la Biennale di Venezia, Venice, Italy /
1993 "Two Rooms", XLV Esposizione Internazionale d'Arte, la Biennale di Venezia, Venice, Italy

Selected bibliography: **1970** Yoko Ono, *Grapefruit*, New York (NY) / **1995** Yoko Ono, *Instruction Paintings*, New York (NY)

On stage with Yoko

Ever since the *Bed In*, 1969, with which she and John Lennon demonstrated against the war in Vietnam, Yoko Ono has been associated in the public mind primarily with the world of music. Only in recent years has attention begun to focus on her as an artist who has created a substantial body of work that includes conceptual objects, Instruction Pieces, Event Scores, performances, large-scale installations and experimental Voice Pieces. Indeed, it is only now that the enormous importance of her position as a key figure in the avant-garde of the 1960s is starting to be fully appreciated. It was to no small degree the debate on performance and gender in art that helped to shed new light on her work in the course of the 1990s. Apart from the famous Fluxus films, Ono was best known for the events and performances in which she created model situations to explore the ways in which words and actions are used as a means of describing gender and ethnic differences. Ono has always presented female identity and body awareness as the mutable product of complex attributive processes. In this respect, she was one of the first women artists to place the gender issue firmly at the centre of her work.

Yoko Ono has often associated her restless biography with her need to explore her ethnic background and her role as a woman. Born in Tokyo in 1933, she spent two years in the USA, separated from her parents, during the war. After training as a singer in Japan, she moved in 1953 with her family to New York, where she studied philosophy and attended composition classes by John Cage. This experience was to surface later in her Voice Pieces, and is also reflected in the work of the Plastic Ono Band, which she founded with John Lennon in 1969. The influence of Cage and her resulting interest in ephemeral and procedural art forms led in 1955 to *Lighting Piece* – an instruction to strike a match and watch it burn and go out.

Soon after her marriage to the Japanese composer Toshi Ichiyanagi in 1956, Yoko Ono was one of the founding members of the Fluxus movement. Between 1959 and 1961, LaMonte Young held at her loft in Chamber Street a number of events that were performed by various artists. The Fluxus movement was interested in the transformation of traditional concepts of authorship and work. In her early gallery shows, Ono presented conceptual objects that called upon the spectator to participate in some way – real or imagined

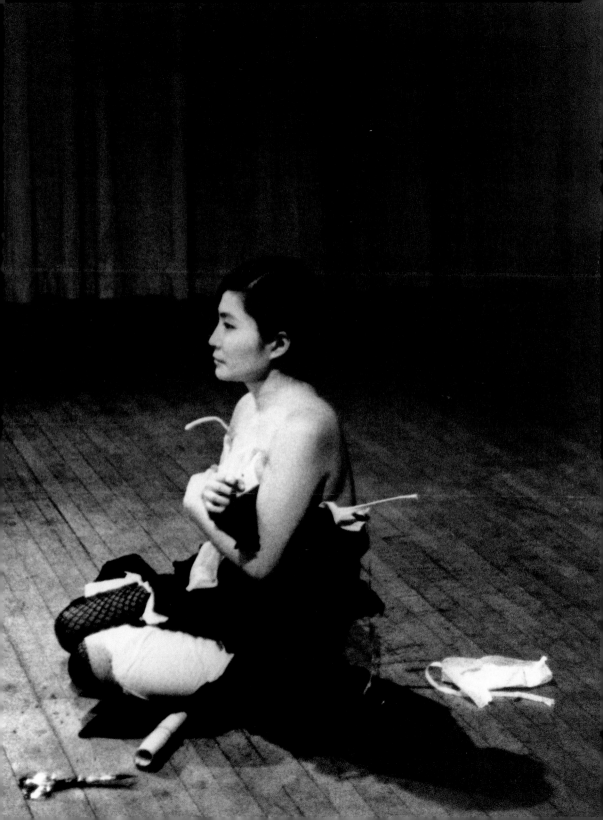

"Art is a process-oriented tool. With the help of this tool, you can better understand life's complexity."

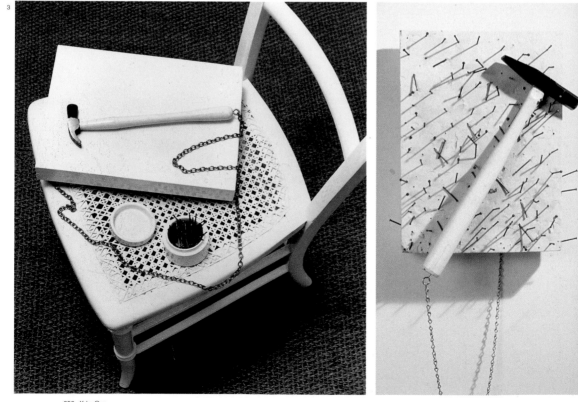

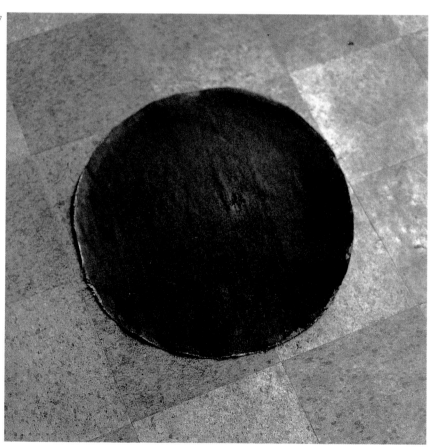

WATERDROP PAINTING

Let water drop.
Place a stone under it.
The painting ends when a hole is drilled
in the stone with the drops.
You may change the frequency of the
waterdrops to your taste.
You may use beer, wine, ink, blood, etc. instead
of water.
You may use a typewriter, shoes, a dress, etc.
instead of stone.

Autumn 1961

– in the execution or development of the work. Her *Painting To Be Stepped On*, 1961, was a piece of fabric placed on the ground. Ono sought to break the traditional aspect of art as sublime and heroic by removing the canvas from the frame and making it a part of the viewer's sphere of action. Many such Instruction Pieces, including her *Painting To Hammer A Nail In*, 1961/1966, play with the possibilities of rolling back the boundaries of the auratic artwork and stripping away its taboos. Other works contain imaginary or impossible instructions which address or even parody the relationship between language, image or object and action: a sewing needle placed vertically on a base bears the caption "Forget It" (1966). The textual work *Painting to Be Watered*, 1963, laconically demands "Water Every Day".

Physical presence

Apart from linking the procedural and the conceptual, Ono also represents an early feminist stance. Since the early events, Ono has criticised the bipolar heterosexual gender model in her work. This reflects her experience of being marginalised not only as a woman, but also as a member of an ethnic minority. The study of her own socio-cultural locus spawned works that touch upon the problem of physical presence and observing, overstepping and destabilising normatively exclusive and protective boundaries. The shared responsibility of the audience is tested by means of participation and intervention possibilities. Her event *Cut Piece*, performed in London at the Destruction in Art Symposium (DIAS) in 1965, attracted considerable attention. For an hour, Yoko Ono knelt on stage. The audience was invited to cut off her clothes with a pair of scissors. Embarrassment and the will to transgression, but also the risk to which the performer exposed herself, were tested in a precarious situation.

Voyeuristic capture

In the films she made from the mid-1960s onwards, Ono concentrated on the body, working with close-ups that capture simple serial sequences of movement by means of a fixed camera position – a smile as in *Disappearing Music for the Face* (1964/1966 by Yoko Ono and Mieko Shiomni) and the rhythmically moving bottoms in *Film No. 4 (Bottoms)*, 1966, which was banned from the screens on several occasions. For *Rape*, 1969, a feminist response to the 1966 feature film *Peeping Tom*, Ono had an actress pursued by an aggressively intrusive camera team. The voyeuristic ensnarement of the subject by the camera is also the subject of *Fly*, 1970, in which the "protagonists" of the film are flies that move on the body of a woman as though through a landscape, giving out atonal humming sounds, which are in fact produced by Yoko Ono's own voice. The conceptual use of the voice is also a key feature of the work of the Plastic Ono Band. Between 1971, when she had a major solo exhibition at the Everson Museum in Syracuse (New York), and 1988, Ono presented no further works in museums or galleries. Since the 1990s, she has started exhibiting again, presenting large installations and bronze objects that follow on from her earlier conceptual works. *Ilka Becker*

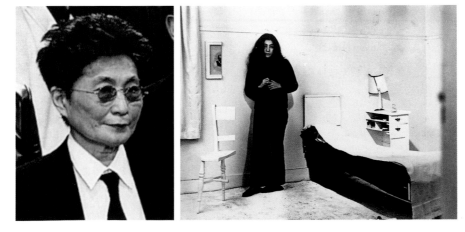

Yoko Ono, 2000

Yoko Ono at the exhibition "Half-a-Wind" in the Lisson Gallery, London, England, 1967

Meret Oppenheim

* 1913 in Berlin, Germany; † 1985 in Basle, Switzerland

Selected solo exhibitions: **1936** Galerie Schulthess, Basle, Switzerland / **1967** Moderna Museet, Stockholm, Sweden /
1984 Musée d'Art Moderne de la Ville de Paris, Paris, France / **1987** "Meret Oppenheim. Legat an das Kunstmuseum Bern",
Kunstmuseum Bern, Berne, Switzerland / **1989** Institute of Contemporary Arts, London, England /
1996 Solomon R. Guggenheim Museum, New York (NY), USA / **1992** "Territorium Artis", Kunst- und Ausstellungshalle
der Bundesrepublik Deutschland, Bonn, Germany

Selected group exhibitions: **1936** "Fantastic Art, Dada, Surrealism", The Museum of Modern Art, New York (NY), USA /
1959 "Expositon inteRnatiOnale du Surréalisme (EROS)", Galerie Cordier, Paris, France / **1982** documenta 7, Kassel, Germany

Selected bibliography: **1957** "Enquêtes", in: *Le Surréalisme même*, No. 3, 1957, pp. 77, 82 / **1984** Christiane Meyer Thoss (ed.), *Husch,
husch, der schönste Vokal entleert sich*, Frankfurt am Main, Germany / **1986** Christiane Meyer Thoss (ed.), *Aufzeichnungen, 1928–85,
Träume*, Berne/Berlin / **1987** *Kasper Hauser oder die Goldene Freiheit: Textvorlage für ein Drehbuch*, Berne/Berlin

"Freedom is not something you are given, but something you have to take"

Meret Oppenheim's oeuvre comprises more than a thousand works, yet her name remains forever linked with a single early work: the *Fur Covered Cup*, 1936, a coffee cup, saucer and spoon covered in Chinese gazelle fur. The idea for this object, one of the most famous of all Surrealist works, came by pure chance, as she once related in an anecdote. At a meeting with Dora Maar and Pablo Picasso in the Café de Flore in Paris, Oppenheim was wearing a bracelet she had designed herself, lined with ocelot fur. Picasso remarked that one could cover anything in fur, and Oppenheim agreed. Apparently, when the tea in her cup had gone cold, she called the waiter for "a little more fur". She would later transform this spontaneous association into a work of art that would be shown the same year at a Paris gallery and included in the New York Museum of Modern Art's "Fantastic Art, Dada, Surrealism" exhibition, where it was purchased by the director, Alfred Barr, for the museum's own collection. It was not until two years later, in 1938, that the *Fur Covered Cup* was given its "official" title – *Le déjeuner en fourrure* – by André Breton, one of the leading spokesmen of the Surrealist movement. Breton was referring, of course, not only to Edouard Manet's famous painting *Le déjeuner sur l'herbe*, 1863, which shows two naked women and two fully dressed men picnicking in a clearing, but also to Leopold von Sacher-Masoch's erotic novel *Venus im Pelz*, 1869, whose protagonist Severin maintains that a woman can only be a man's mistress or his slave, but never his equal partner. In giving the work this title, Breton projected onto it this hierarchical notion of the relationship between the sexes – a view that Oppenheim certainly did not share.

"One is used to artists
leading a life that suits
them and to citizens
turning a blind eye to this.
But when a woman
does the same,
they all open their eyes."

1 **Ma gouvernante – my nurse – Mein Kindermädchen,** 1936. Metal, leather, paper,
 14 x 21 x 33 cm
2 **Object (Le Déjeuner en fourrure),** 1936. Fur Covered cup, saucer, spoon; cup: diameter
 11 cm; saucer: diameter 24 cm; spoon: (l) 20 cm; overall (h) 7 cm
3 **Der grüne Zuschauer (Einer der zusieht, wie ein anderer stirbt),** 1933/1973. Green
 marble, gilded copper plate, 332 x 100 x 36 cm (without pedestal)
4 **Eichhörnchen,** 1969, Multiple, beer glass, foam material, fur, 23 x 18 x 8 cm
5 **Andenken an das Pelzfrühstück,** 1970–1972. Multiple, mixed media, 17 x 20 x 5 cm
6 **Einauge,** 1933. Gouache, 27 x 18 cm
7 **Weltuntergang,** 1933 (detail). Pen drawing on paper, 21 x 39 cm

6

A Man Ray, "Erotic voilée", 1933. Photo-
 graphy, 29 x 20 cm
B Albert Winkler, "Re-Photo M. O.", 1967.
 Photography, 11 x 14 cm
C Meret Oppenheim X-Ray, 1964
D Meret Oppenheim, portrait with tattoo,
 1980
E Meret Oppenheim, 1982

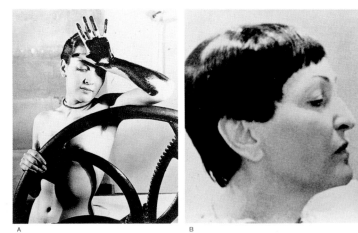

A B

Meret Oppenheim grew up in southern Germany and Switzerland, and in 1932 – at the age of 18 – went to Paris to become an artist. She enrolled at the Académie de la Grande Chaumière, but preferred to work as a self-taught artist. In 1933, Alberto Giacometti and Hans (Jean) Arp visited her studio and introduced her to the Surrealist circle with whom she would exhibit regularly in the years that followed. During this time, she created drawing and paintings, poems and reports of dreams, as well as eccentric designs for appliances, with a remarkable blend of anthropomorphic and animal elements, including a pair of fur gloves with red-varnished fingernails peeping out (1936) or her *Table with Bird's Feet*, 1939, which stands on two legs with claw feet.

The public image of Meret Oppenheim was not shaped by her works alone, such as her *Seated Figure with Crossed Fingers*, 1933, generally regarded as a self-portrait with no individual facial traits or clear gender, allowing attributes to be projected on it from outside. In 1933, Man Ray asked the young artist to be his model for a series of erotic photographs. Probably the most famous of these images was created in the studio of the painter Louis Marcoussis. It shows Oppenheim seemingly lost in thought, leaning with an air of amusement on a printing press that looks for all the world like some medieval instrument of torture, her left forearm and palm covered in printer's ink. In May 1934, this photograph was published with Oppenheim's permission in the magazine *Minotaure*, and fuelled the myth of the fascinating child-woman that inspired an older generation of Surrealists.

Early fame and creative crisis

The fame that came so soon and – as it seemed – so effortlessly was to prove a heavy burden on Oppenheim's identity as an artist. She did not wish to be reduced to a recognisable style. In 1937, she returned to Switzerland because of the political situation and the threat of war. Her return marked the beginning of a period of creative crisis that continued until about 1954, dominated by a sense of having her "hands tied". Her last collaboration and final break with the Surrealists came in 1959, on the occasion of the Paris "Exposition inteRnatiOnale du Surréalisme (EROS)". Breton had invited Oppenheim to repeat the *Spring Banquet* she had organised in Berne for a circle of close friends: a feast served up on the body of a naked woman to be eaten by the guests without cutlery. Yet the Paris version of the banquet was transformed, in Oppenheim's view, into the very opposite of what she had originally intended as a feast for both men and women. Now the body became the passive object of a voyeuristic spectacle for a male audience.

It was not until the late 1960s that Oppenheim's complex and multifaceted oeuvre began to be rediscovered by a young generation of women artists in search of emancipation. When Oppenheim was awarded the Kunstpreis der Stadt Basel in 1975, she called on women, in her frequently-cited speech, "to prove through their way of life that they no longer accept the taboos that have held women in subjugation for thousands of years. Freedom is not something you are given, it is something you have to take." She herself had, in the meantime, taken the liberty of parodying her own myth. In 1970, she created a multiple entitled *Souvenir du déjeuner en fourrure*. It is a deliberately kitsch miniature version of the *Fur Covered Cup*, domesticated to a two-dimensional set with fake fur under an oval glass dome recalling a mass-produced museum-shop article. The fact that Oppenheim withdrew the seductive surface of the *Fur Covered Cup* from the reach of touch also indicates a tongue-in-cheek reminder that consuming is not the same as pleasure. *Barbara Hess*

C

D

E

Elizabeth Peyton

* 1965 in Danbury (CT), USA; lives and works in New York (NY), USA

Selected solo exhibitions: **1997** "Currents 71: Elizabeth Peyton", The Saint Louis Museum, Saint Louis (MS), USA /
1998 Museum für Gegenwartskunst Basel, Basle, Switzerland / **1998** Seattle Art Museum, Seattle (WA), USA; Kunstmuseum Wolfsburg,
Wolfsburg, Germany / **2000** "Tony", Westfälischer Kunstverein Münster, Münster, Germany
Selected group exhibitions: **1996** "wunderbar", Kunstverein in Hamburg, Hamburg, Germany / **1997** "Longing and Memory",
Los Angeles County Museum, Los Angeles (CA), USA / "New Work: Drawings Today", San Francisco Museum of Modern Art,
San Francisco (CA), USA / **1998** "Young Americans II", Saatchi Gallery, London, England; "Auf der Spur", Kunsthalle Zürich, Zurich, Switzerland
Selected bibliography: **1998** Elizabeth Peyton, *Craig*, Cologne

Star-cult(ure)

In a sense, Elizabeth Peyton, who lives in New York City, was destined to be an artist from the very start, given that her parents were a hobby painter and a hobby writer. The influence of these two fields are evident in the work of this painter, draughtswoman and photographer. Her early drawings in particular include both portraits of pop and rock musicians such as John Lennon or Johnny Rotten – indeed Peyton is primarily known today for these quasi "post-modern icon paintings" – and scenes after Marcel Proust and William Shakespeare, as well as portraits of historical figures such as Napoleon's lover Mademoiselle George or Ludwig II. These portraits are based on her reading of biographies and novels, or on her interpretation of visual models such as drawings or photographs. Peyton almost never paints live models, not even nude ones; her models are almost always existing artefacts. Today, reading is still an important point of departure for her artistic work. That reading, however, is never just passive consumption, but is active in character, expressing itself, above all, in her sensitive revaluation, her emotional recording of the aesthetic models.

Peyton does not distinguish between "high" and "low" in her artistic work. She treats her protagonists from the supposedly "low culture" of pop and rock music in exactly the same way as she does the representatives of the "high culture" of literature or so-called "serious music". The artist herself once put it as follows: "I read *Melody Maker* much as I read Marcel Proust." What her "models" have in common is that they have all created a world for themselves, only to come to grief in that wonderful aesthetic act of creation. Yet in their time, they were an important source of inspiration for others. This applies to the Beatles' *Octopus' Garden* or to Marcel Proust's *Things Past* just as much as it does to Elvis Presley's Graceland or to the visions of Ludwig II of Bavaria. Peyton painted the latter king several times, like all her "stars". In *Ludwig*, 1994, painted in oil on wood – a clear allusion to traditional icon painting – he is standing against a vaguely suggested background, wearing a sky-blue suit, with his hair blowing in the wind, and with his eyes shining with pride and melancholy. As is the case here, Peyton's portraits are imbued with a mood of happiness and early sorrow. The "corporate identity" of the gallery

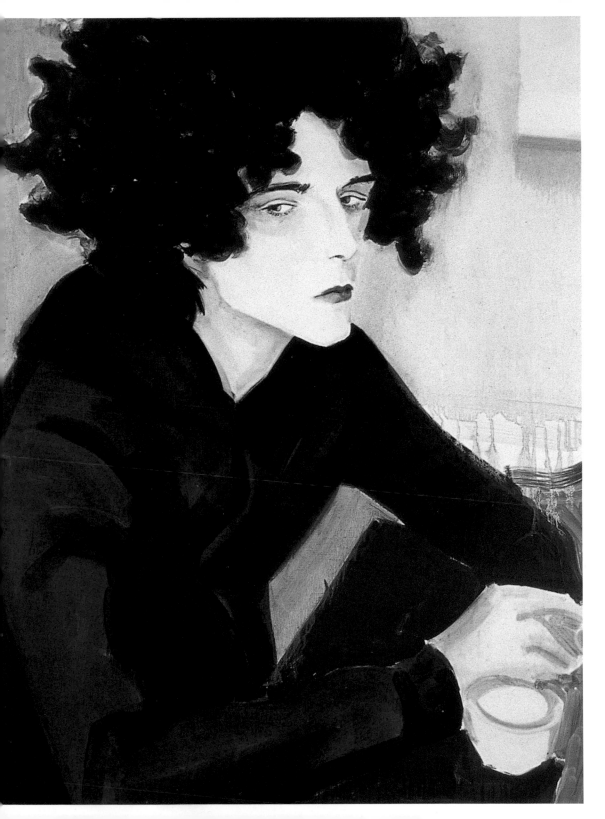

4

1 **Berlin (Tony),** 2000. Oil on canvas, 102 x 76 cm

2 **Rob in Trafalgar Square,** 1999. Oil on board, 153 x 102 cm

3 **Savoy (Self-Portrait),** 1999. Coloured pencil on paper, 21 x 15 cm
4 **Irving Plaza (Elliott),** 1999. Oil on board, 39 x 31 cm

5 **Liam,** 1996. Oil on wood, 26 x 21 cm
6 **Piotr Passport Painting,** 1996. Oil on wood, 23 x 18 cm
7 **Ludwig,** 1984. Oil on wood, 36 x 28 cm
8 **Gavin sleeping,** 1998. Oil on canvas, 77 x 102 cm

"In a way, you can be much more intimate with people you do not know."

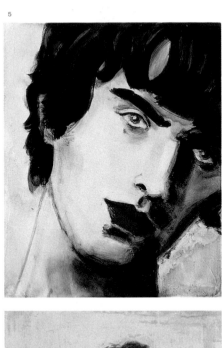

5

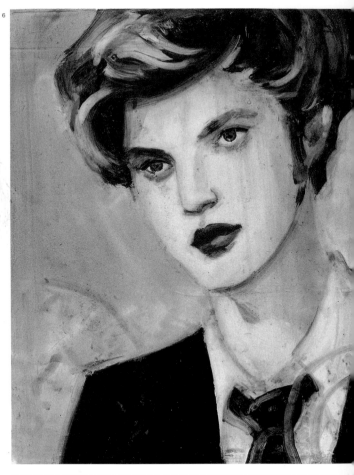

6

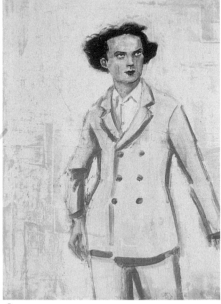

7

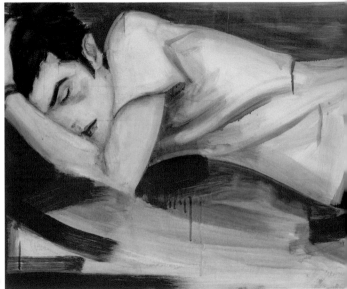

8

of ancestors which she has selected is characterised by a tension between the utopian promise of pleasure and tragic self-destruction: the gallery includes, for example, the Sex Pistols punker Sid Vicious and grunge rock musician Kurt Cobain, both of whom, like Ludwig II long before them, committed suicide. And then there is Princess Di, who died young, and Oscar Wilde, whose demise resulted from his imprisonment for homosexuality.

Beyond place and time

Elizabeth Peyton's "stars" have another trait in common: their androgynous character, evident, for example, in the painting *Piotr*, 1996, which depicts her artist colleague Piotr Uklanski, who lives in New York, with a mug of coffee in his hand and wearing a red shirt in the tasteless style of the 1970s. The slim young man, seated slightly bent at the hip, is gazing melancholically out of the painting as if into the depths of a paradise he is dreaming of, his narrow eyes bright blue and full of longing. The work looks as if was painted with lipstick, and the background, too, is glaring red. Piotr's short dyed honey-blond hair and shapely lips are what give him an androgynous, almost feminine look. This not only bears witness to the artist's identification with her model; the androgynous aura is also a rejection of any attempt to construe genders as strictly separate. As a result, the person portrayed seems almost disembodied, suddenly becoming "essential", as Marcel Proust might have put it, in the sense that he has found his ideal essence beyond the customary understanding of roles and beyond the constraints of place and time. To achieve this very effect, Peyton portrays her sitters very much younger than they are. Like Oscar Wilde's Dorian Gray, they seem immune to the ageing process and thus to death.

Beyond intimacy and publicity

In her more recent works and exhibitions, the artist has often combined different media. Painting and photography, drawing and video enter into a dialogue with equal rights. This is seen, for example, in her artist's book *Craig*, 1998, where a photograph of the 16-year-old Ludwig II stands alongside a photo of Peyton's friend Craig, who in turn crops up in various drawings and paintings in the book. And then there are newspaper articles on the death of Elvis Presley and on the funeral of the "Queen of Hearts" Princess Di, as well as a watercolour of the coronation of Elizabeth II. The punk rocker Johnny Rotten pops up again, as do numerous drawings and paintings of Princess Di, whose early death provides the thematic counterpoint to Peyton's passion for her friend Craig. Here Peyton deals with the eternal drama of "Death and Glory", pacing out the intricate scenes both historically and in the charged area between intimacy and publicity. As she largely abandons authorship to the anonymous producers of the found (newspaper) photographs included in *Craig* and repeatedly alludes to popular figures, she succeeds in uncovering the collective character of longing and wishful thinking. She thus comes full circle, back to her early works.

Raimar Stange

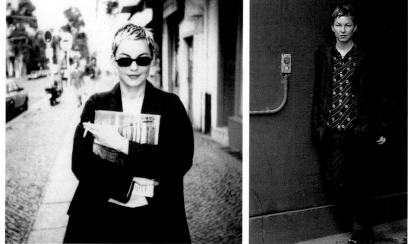

Elizabeth Peyton in Berlin, 1996

Elizabeth Peyton, 1998

Germaine Richier

* 1902 in Grans, France; ✝ 1959 in Montpellier, France

Selected solo exhibitions: **1934** Galerie Kaganowitsch, Paris, France / **1948** Galerie Maeght, Paris / **1958** Walker Art Center, Minneapolis (MN), USA / **1956** Musee d'Art Moderne de la Ville de Paris, Paris / **1963** Kunsthaus Zürich, Zurich, Switzerland

Selected group exhibitions: **1951** São Paulo Biennial, São Paulo, Brazil / **1958** XXIX Esposizione Internazionale d'Arte, la Biennale di Venezia, Venice, Italy / **1959** documenta 2, Kassel, Germany / **1964** documenta 3, Kassel / **1997** Akademie der Künste, Berlin, Germany

Motion in Stasis

The French sculptress and graphic artist Germaine Richier was among the first women in 20th-century art to self-confidently go her own way – and this in the traditionally male-dominated field of sculpture. She began with a conventional academic training, first entering the Ecole des Beaux-Arts in Montpellier in 1920, then, six years later, going to Paris to continue her studies with Antoine Bourdelle, a student of Rodin's. Until late 1929, Richier honed her skills; especially in modelling, casting and stone-working. As she herself later put it, she went through the "hard school of the bust." Realistic busts, nudes and portraits, based on what she termed a rigorous "formal analysis," were her prime concern at the time.

Despite her many artist-friends, Richier remained a loner who initially took hardly any notice of Parisian avant-garde trends such as Constructivism and Surrealism. Yet she enjoyed early success, culminating in a solo show at the renowned Galerie Kaganowitsch in Paris. That same year Richier began to develop a personal, innovative sculptural idiom that would represent her pioneering contribution to the modern tradition. *Bust No. 2*, 1934, reflected the tension between abstraction and objectivity, expressiveness and rigorous construction, that would become typical of her work. The piece had a mask-like face, brutal and delicate at the same time. Deprived of all individual character, it possessed a visionary objectivity, in the form of a crystalline shell that hovered between the organic and the inorganic, hermetically self-contained. Concentration, introspection, even an evocation of blindness were the marks of Richier's new aesthetic.

There began a logical if circumspect exploration of her discoveries, which led, above all, to an alteration of the relationship of the sculpture with the surrounding space. In this regard, Richier – by now almost 40 – stood very much in the contemporary context of the sculptural reinterpretations of space and time then being introduced by the Constructivists (Russian and otherwise), Cubists and Surrealists. Visual reality and its depiction were supplanted by the creation of dynamic, autonomous configurations in space.

"My figures are autonomous beings. Autonomous and independent – that is what I think sculpture should be."

1 **Le Grain,** 1955. Bronze, dark patina, 145 x 33 x 31 cm

2 **Femme assise,** 1944. Plaster, 49 x 25 x 29 cm

3 **La Sauterelle, petite**, 1944. Bronze, dark patina,
26 x 23 x 33 cm

4 **Le Crapaud,** 1940. Bronze, dark patina, 20 x 31 x 26 c

5 **Guerrier n° 9,** 1956. Bronze, dark patina, 20 x 17 x 7 c

6 **Guerrier n° 4,** 1953. Bronze, dark patina, 33x 10 x 20

7 **Le Cheval à six têtes, petit,** 1953. Bronze,
34 x 30 x 43 cm

8 **La grande spirale,** 1956. Bronze, dark patina,
288 x 57 x 57 cm

For Richier, this implied representing the human body – increasingly in the form of the full-length figure rather than the bust – in strongly reduced formal terms. Her figures became slender, almost skeletal, as if starved and on the verge of decay, with rough, fissured surfaces that evoked open wounds. Like architecturally calculated scaffoldings, the figures occupied space, and at the same time, opened it up around them, rendering space transparent and malleable. Again the conventional approach of her teacher, Bourdelle, proved fruitful to Richier, enabling her to combine the academic tradition skilfully with avant-garde tendencies.

In 1940 she began to develop her characteristic "hybrid creatures," mutants of human and animal, mineral and plant that linked up both with Surrealist ideas and Romantic symbolism. Five years later Richier expanded her aesthetic vocabulary by beginning to work with stretched wires that crisscrossed in space, connecting certain parts of the figurations with each other and the sculpture with the plinth. The sculptures, such as the somewhat frightening *Ant*, 1953, seemed on the one hand to actively manipulate these wires, yet on the other to be caught, passive, in a confusion of nets. The artist herself described this dualism of motion and stasis as follows: "I am not trying to reproduce movement. My intention is directed, above all, at making motion imaginable. My sculptures are meant to create the impression of being immobile and at the same time capable of motion."

The Top

Eight years before her untimely death, Richier began to set her sculptures in front of painted backdrops provided by colleagues in the Ecole de Paris, such as Hans Hartung, Maria Viera da Silva, and Zao Wou-Kia. Hans Hartung, for instance, created the painted background panel for *The Top*, 1953. The piece consisted of two figures, made of lead, standing on a rectangular pedestal and leaning backwards. While the smaller figure recalled the spinning top of the title, the larger represented a human figure. The elongated limbs, emaciated torso, and flat head reduced to geometric forms, made the figure appear as if "thinned out" to a mere cipher, anxiously yet persistently following its path through life, led by an incessantly spinning object. Existential interpretations along Sartrean lines suggest themselves, but these are just as inadequate as an explanation in terms of psychological or Surrealist associations. This is exactly what makes Richier's art so challenging – despite being laden with symbolic content, no single interpretation can do it justice, and it eludes ultimate determination.

"We behave like insects," wrote the American author Douglas Coupland in his cult book *Generation X* in 1991. This feeling of living in an anonymous, in many respects even totalitarian mass society, is what makes Richier's "hybrid creatures" so relevant to our concerns in the early 21st century. Her experience of the aberrations of a full-blown modern society, gained in Europe before, during, and after the Second World War, rings a familiar chord in the post-modern mind. Totally networked structures that, via the Internet, mobile phone or fax, permit faceless communication among individuals increasingly alienated from one another – precisely this disquieting picture was anticipated in Richier's "wired and wire-caged" sculptures. The "motion in stasis" prognosticated by French philosopher Paul Virilio, the loss of every sense of space and time in a simulation of all possible life worlds, likewise found prophetic expression in Richier's art.

Raimar Stange

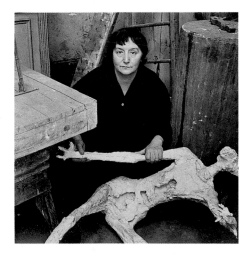

Germaine Richier in her Paris studio

Bridget Riley

* 1931 in London, England; lives and works in London and Cornwall, England, and in France

Selected solo exhibitions: **1962** Gallery One, London, England / **1970/71** Kunstverein Hannover, Hanover, Germany / **1993/93** "Bilder 1982–1992/According to Sensation", Kunsthalle Nürnberg, Nuremberg, Germany / **1999/2000** "Bridget Riley. Ausgewählte Gemälde/Selected Paintings 1961–1999", Kunstverein für die Rheinlande und Westfalen, Düsseldorf, Germany / **2001** Dia Art Foundation, New York (NY), USA

Selected group exhibitions: **1965** "The Responsive Eye", The Museum of Modern Art, New York (NY), USA / **1968** XXXIV Esposizione Internazionale d'Arte, la Biennale di Venezia, Venice, Italy / **1995** "From Here", Waddington Galleries, London, England / **1998** "White Noise", Kunsthalle Bern, Berne, Switzerland

Selected bibliography: **1999** *The Eye's Mind: Bridget Riley*, London

The eye

Due to their serial structuring, various Op Art works – such as those of Victor Vasarely – have been rediscovered in the context of electronic lounge projects and experimental music, and, as synaesthetic analogies between acoustic and visual phenomena, have become part of the "planetary folklore" with which Vasarely always associated them. Since our perceptions are now being reconditioned by the new media, it makes sense to recall the optical experiments of the 1960s, which at the time were something like the signature of the period, later becoming its everyday myth and design icon. Riley's work can also be considered within this context of retroactive reception, although that does not do complete justice to her art.

From the start, Riley has been concerned with what she terms the "formal structures of seeing", just as were the Impressionists and Pointillists in the 19th century. When the French painters of classical Modernism began working *en plein air*, they trusted, like the empirical scientists of the day, to the evidence provided by their eyes rather than to the conventional schemes of imitating nature, understanding what they saw as primarily a spectacle of light and colour. Now, it may seem a large leap from 19th-century colourism to Op Art, and indeed, the first exhibition of modern painting Riley ever saw, in 1947, was a show of van Gogh's work at the Tate Gallery in London. Her achievement, as Robert Kudielka has pointed out, has consisted in using the means of abstract painting to take the step from imagery oriented primarily to the colour spectrum to a spatial plastic approach to colour on the plane.

Riley grew up in Cornwall, spending the war years in the Padstow area. She received private instruction, which allowed her largely to follow her own bent, and studied at Cheltenham College, where she concentrated on art education. From 1949 to 1952, Riley attended Goldsmith's College of Art in London, later recalling that drawing from the nude was about all she learned at art school. Until 1955, she continued her studies at the Royal College of Art, where her fellow students included Frank Auerbach and Peter Blake. The urge to stake out a unique position in the art world led to a period of deep self-doubt and eventually to a nervous breakdown. Riley turned to commercial art.

In 1958, she saw a Jackson Pollock show at the Whitechapel Art Gallery, and the following year, at a summer academy, her interest in Futurism and Neo-Impressionism was awakened. Riley met Maurice de Sausmarez, who became her friend and mentor. She copied Georges Seurat's *Le Pont de Courbevoie*. Yet her last figurative picture, *Pink Landscape,* 1960, was not so much in the vein of divisionistic colour separation rather it aimed at a complete synthesis of landscape depiction and chromatic event.

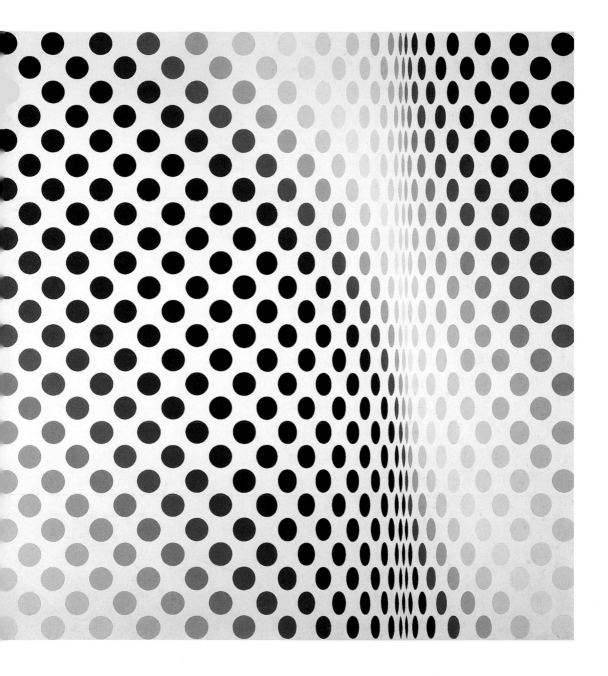

2

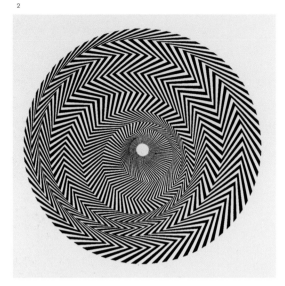

"To treat images of the past as historical documents or as evidence of outmoded concepts is wrong: they are specific solutions to ongoing artistic problems – and this is what makes them of interest today."

3

5

Following another creative crisis as well as her separation from de Sausmarez, Riley entered her "black and white period" 1961, the most famous phase of her career, in which she took light-dark contrasts to the extreme. The visual effects of her geometric formal repertoire were all too rapidly appropriated by trivial culture. She found a new partner in the painter Peter Sedgley. A key work at this time was *Kiss,* 1961, in which two monochrome black areas impinge such that the white dividing line can be read as a horizon. If this work was still indebted to hard-edge painting, the visual effects of permutations of black and white triangles (as in *Shiver,* 1964) or of black waves on a white ground (*Crest,* 1964), induced optical illusions of the kind seen in scientific experiments.

Op Art

Riley became a star. Her 1965 exhibition with Richard Feigenbaum in London was sold out before it opened. New York fashion boutiques decorated their display windows and clothing fabrics with Riley motifs. Other artists tried to turn this sudden popularity to their own ends, for example Josef Albers, who called Riley his "daughter", or Ad Reinhardt, who sought to protect her from "wolves". Riley undertook legal steps to prevent the unauthorised reproduction of her works, but in vain. Nevertheless, the disputes over the countless Op imitations did result in changes in American intellectual property law. Still, Riley was afraid her imagery had been worn out, as it were, for a long time to come. And, in fact, the reception of her works in the 1960s prevented a clear view of her later production.

Waves, stripes and lozenges

After using tinted grey values from 1965 to 1967, Riley again turned to straight colours (*Chant* and *Late Morning I,* both 1967). In 1968, she became the first woman painter ever to win the Grand Prize at the Venice Biennale, although the award ceremony was prevented by student demonstrations. Her first retrospective (1970/71) was seen by 40,000 visitors, more than any other solo exhibition of contemporary art at that period. Stripe combinations were used to cancel out individual colour identities in favour of a single colour "flow". Later paintings brought an even more intensive concern with colour. Like the earlier works, they were concerned with rhythm, dynamics and an exploitation of the tensions between individual colours and the colour continuum. At this point, Riley switched from acrylic to oil paint. After the artist had become acquainted with ancient Egyptian grave paintings during a trip to Egypt, she can be seen to be making an attempt in her pictures, which are now mainly organised on the basis of vertical stripes, to break up the unified colour effect in favour of individual colour values.

In the 1980s, Neo-Conceptual artists such as Philip Taaffe or Ross Bleckner took up Riley's insights, making obvious references to them in their work. Riley, who was meanwhile active as a guest professor and curator and advisor to museums, began to concentrate in 1986 on combinations of trapezoids. Her most recent work has combined wave and trapezoidal elements (*Rêve,* 1999).

Holger Liebs

Bridget Riley in her studio, 1960s

Bridget Riley

Pipilotti Rist

* 1962 in Rheintal, Switzerland; lives and works in Zurich, Switzerland, and Rotterdam, The Netherlands

Selected solo exhibitions: **1989** "Die Tempodrosslerin saust", Kunsthalle St. Gallen, St. Gallen, Switzerland / **1995** "I'm not the girl who misses much", Neue Galerie Graz, Graz, Austria; Kunstverein in Hamburg, Hamburg, Germany / **1996** "The Social Life of Roses or Why I'm Never Sad", Museum of Contemporary Art, Chicago (IL), USA; Kunsthalle Baden-Baden, Baden-Baden, Germany / **1998/99** "Remake of the Weekend", Nationalgalerie im Hamburger Bahnhof, Berlin, Germany; Kunsthalle Wien, Vienna, Austria; Kunsthalle Zürich, Zurich, Switzerland; Musée d'Art Moderne de La Ville de Paris, Paris, France

Selected group exhibitions: **1994** Steirischer Herbst 94, Graz, Austria / **1995** "fémininmasculin. Le sexe de l'art", Musée national d'art moderne, Centre Georges Pompidou, Paris, France / **1997** "Unbeschreiblich weiblich. Bilder von Frauen und Frauenbilder von 1800 bis heute", Kunstmuseum St. Gallen, St. Gallen, Switzerland / XLVII Esposizione Internazionale d'Arte, la Biennale di Venezia, Venice, Italy / **1999** "VideoCultures", ZKM Zentrum für Kunst und Medientechnologie, Karlsruhe, Germany

A magic chamber full of moving pictures or video means: I see

Pipilotti Rist's emotional videos and pop-style installations, and her interdisciplinary work with music and moving images, as well as her witty cultivated personality and her constantly changing outfit, make her a pop star of the art scene. In 1997, she was even appointed director of the Swiss Expo, a position she gave up a year later.

Rist's colourful videos and video installations are exactly in keeping with the mood of the time. Her computer-manipulated films do not look cool, objective or intellectual, but very sensuous. A harmonious combination of soft music and dreamy pictures penetrates our subconscious, enabling the viewer to submerge him- or herself in the world of visions and everyday myths generated by the artist, whose associative sequence of images displays no linear narrative structure (with an explicit beginning and end). Underwater shots with splendid plant worlds, a kissing mouth filling a whole screen, bare feet in a yellow flowerbed or a naked female body decorated with strass crystals à la Ophelia in a meadow, a harmonious combination of body and nature, and trance-like music: Rist's richly imaginative and poetic images, sometimes deliberately kept blurred or distorted, allow us to forget everyday life.

As a child of the 1960s, Rist grew up with the medium of television but also with pop culture, and the popularity of her works is attributable to her effortless handling of the phenomena of mass culture. While studying at the College of Applied Art in Vienna, she made trick and super-8 films. In 1986, she changed to the video department of the Basle College of Design, at the same time changing her first name from Charlotte to Pipilotti. This latter was because her friends called her Pipi – after Pipi Longstocking – while her family called her Lotti. She appeared as a musician with the Les Reines Prochaines rock group, incorporating their music into her videos.

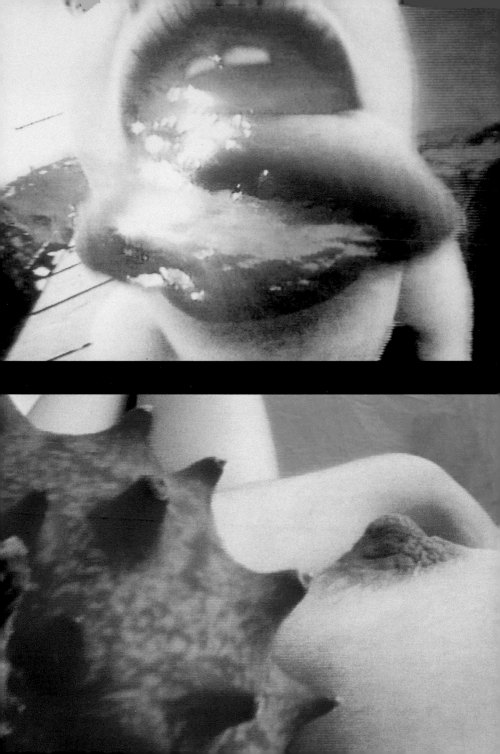

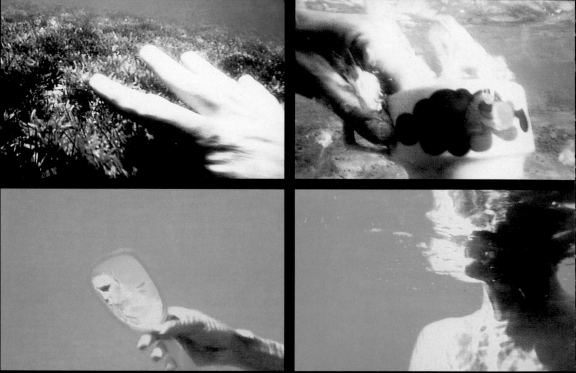

2

1 **Pickelporno,** 1992. Video stills
2 **Magnanimity Mate With Me /Sip my Ocean,** 1994-1996. Video stills
3 **Ever Is Over All,** 1992. Video stills
4 **Pickelporno,** 1992. Video stills

3

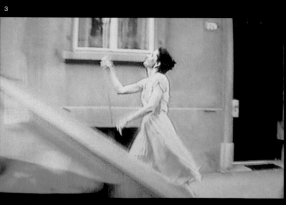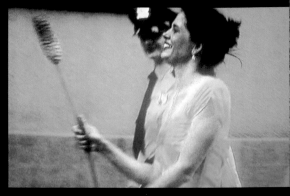

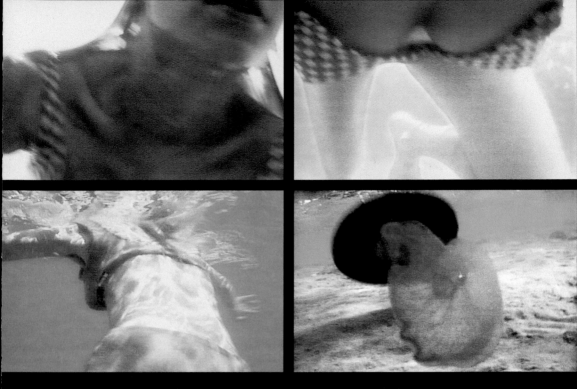

"With no respect for technology, I ride towards the sun in the computer and with my brain tongue, mix the pictures just in front or just behind my eyelids."

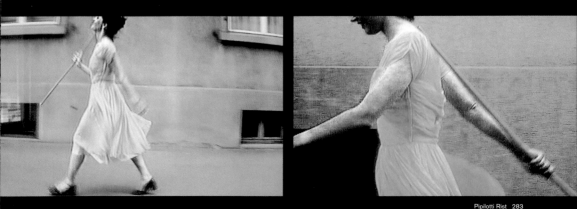

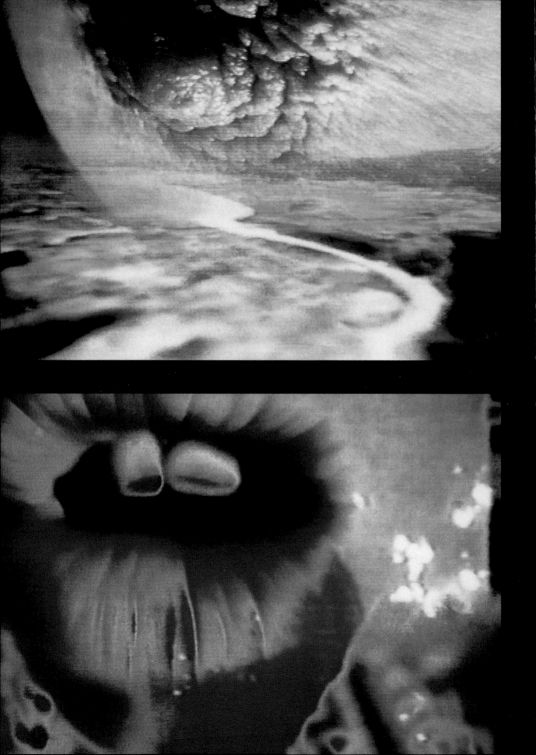

Between kitsch and dream

Her first video, *I'm not a girl who misses much*, was created in 1986, and shows her skipping up and down calling out the sentence of the title. In the clip *Entlastungen (Pipilotti's Fehler)* [Absolution (Pipilotti's Mistakes)], 1988, she worked with abstract-painterly TV screen interference, distorting and thus fictionalising the image of reality. In 1989, she produced the video installation *Die Tempodrosslerin saust* (The Speed Throttler Roars) jointly with Muda Mathis: on the wall hung 175 different handbags, while in front of them 14 monitors were set up alluding to the road to Calvary. Rist later compared the video "with a compact handbag with room for everything: painting, technology, speech, music, movement, crummy running images, poetry, hustle and bustle, intimations of mortality, sex and friendliness." The video clip *Pickelporno* (Pimple Porno), 1992, was what finally made her famous. Numerous natural features – icebergs, waves, flowers, clouds and fire – provide an obbligato accompaniment to a couple physically coming together. Her subsequent videos likewise take up the topics of eroticism, sensuality, sexuality and the female body. In *Selbstlos im Lavabad* (Selfless in the Bath of Lava), 1994, she looks at the viewer from a small monitor recessed into a wooden floor, her upper body naked, surrounded by sea of flame, screaming for help. The installation *Das Zimmer* (The Room) dates from the same year. An outsize red couch with two armchairs and a huge remote control and small TV are a humorous but critical reference to the importance of the mass medium in a consumer world. Adults become children, re-recalling the magic that the goggle box exercised on the first TV generation. Her extensive, symmetrically constructed video projection *Sip My Ocean*, 1996, is installed in the corner of a room, the corner forming a central axis. The floor of the dark room is laid with soft blue carpet. The video pictures, accompanied by melodious music and soft female song, are underwater shots of a swimming woman and colourful plants as well as everyday objects – such as kitchen appliances and a mini TV – that are falling into the sea. They all drift about and then meet on the central axis, before vanishing out of the room together.

Cocky, shrill and colourful

Pipilotti Rist stirs up the mind using art and pop, everyday life and TV, addressing all the senses and arousing positive emotions. She also undermines taboos and clichés with kitsch and humour. In her video installation *Ever is Over All*, 1997, a woman with an outsize phallic flower stalk cheerfully smashes the windows of parked cars, benevolently watched by a policewoman. The "flowers instead of weapons" motto of the Flower Power generation is translated into a light-hearted picture story as realistic satire. *Nothing*, a machine that produces and fires thick, milky-white and smoke-filled soap bubbles like cannonballs at set intervals, was exhibited at the Venice Biennale in 1999. In the same year, Rist was awarded the Wolfgang Hahn Prize in Cologne, where she installed two amply laid-out, tapering, flesh-coloured wall sculptures in the Ludwig Museum. If the visitor stuck his head in the circular openings, he saw various videotapes inside. Rist's work *Eine Spitze in den Westen, ein Blick in den Osten* (A Point to the West, a Glance to the East) is formally reminiscent of the visual line of a videotape and the projection head of a video beamer: it isolates the viewer, separates head and body and concentrates the gaze on the videos – a move that brings seeing and experiencing into harmony.

Ulrike Lehmann

Pipilotti Rist in Times Square, New York (NY), USA

Susan Rothenberg

* 1945 in Buffalo (NY), USA; lives and works in Galisteo (NM), USA

Selected solo exhibitions: **1981** Kunsthalle Basel, Basle, Switzerland / **1982** Stedelijk Museum, Amsterdam, The Netherlands /
1983 Los Angeles County Museum, Los Angeles (CA), USA / **1992** "Retrospective" Albright-Knox Art Gallery, Buffalo (NY), USA /
1999/2000 Museum of Fine Arts, Boston (MA), USA

Selected group exhibitions: **1978** "New Image Painting", Whitney Museum of American Art, New York (NY), USA /
1979 Whitney Biennial, Whitney Museum of American Art, New York (NY), USA / **1984** "An International Survey of Recent Painting and Sculpture",
The Museum of Modern Art, New York (NY), USA / **1992** documenta IX, Kassel, Germany / **1999** "Circa 1968", Fundação Serralves, Oporto, Portugal

Painted split

Modern painting has a schizophrenic trait, and Susan Rothenberg has made it her subject. In 1974, barely 30 years old, she painted her first horse on a tempera ground of muted red on an almost square unstretched canvas. The painting, programmatically titled *First Horse*, marked the start of a programme which aroused astonishment and unease. Seven years after graduating from art college, she had staked out her ground. She had confronted painting with the split in its identity. After a period involved in contemporary dance, and having herself appeared as a dancer at a time when performance art was the genre of the moment and the body emerged as the medium of painting, Susan Rothenberg turned to canvas to stage a different sort of performance: the display and virtuoso variation of a very specific object.

At that time, painting still obeyed a dogma of ecclesiastical rigidity. Its axiom was to be nothing but painting. And in order that painting might be nothing but painting, free from deceitful misrepresentation, it was – so its doctrine held – to close the shutters firmly upon the outside world. It was to be hard and honest work as layers of paint on a flat panel. Thus the appearance of a horse, or rather horses, on an indisputably brilliantly painted canvas must have struck the public as a mirage. The horses appeared one after another, often as transparent contours, as linear figures tilted off balance, as the rudimentary emblem of a moving body or as a closed plane, an almost heraldic animal. The first horse appeared on the loosely mounted canvas like a cave painting. And like many of the horses which Susan Rothenberg subsequently painted in the 1970s, it always posed the same enigma. Was it an emblem, was it the figure of an animal? Was it an experimental contrast medium for grounds of carefully worked colour, or was it the symbol of an intellectual threat which disavowed pure painting as innocuous?

Whatever the case, an overview exhibition of 1979 left her critics emotionally drained and subdued as if after a horror film, and her seemingly harmless subject was experienced as chilling violence. Susan Rothenberg had found an appropriate symbol and object.

2

3

4

"I would hate to think that you could walk into
room and identify the sex of the painter.
You shouldn't really be concerned with the sex of a
painter when you look at a piece of art."

5

1 **Vertical Spin,** 1986/87. Oil on canvas, 330 x 286 cm

2 **Mondrian,** 1983/84. Oil on canvas, 277 x 213 cm
3 **Hector Protector,** 1976. Acrylic, tempera on canvas, 170 x 284 cm
4 **Squeeze,** 1978/79. Acrylic on canvas, 234 x 221 cm

5 **Red Head,** 1980/81. Acrylic on canvas, 272 x 273 cm
6 **Impending Doom,** 196/97. Oil on canvas, 175 x 239 cm

6

As a symbol, it was clear at a glance, but as an idea, it was so potent that it defied categorisation either as an artistic exercise or as a likeness of an outside world. The horse was not some mere trademark. It could be the starting point for an allusion to physical distortion or a study of movement. In details which filled the canvas, it became a cipher of physical contact and a mystical symbol. It was, above all, the experimental medium of a painting which sought to make contact with the outside, but without ever wishing to give up the self-contained canvas as the field of experimentation.

The collision of painting and world

This conflict between experience and artistic autonomy, between biography and abstract tradition, remained the real continuity in Susan Rothenberg's work. In 1981, following her divorce, she took a room on Long Island in New York and started working in oils, filling her pictures with landscape motifs and animated figures.

Her paintings give the impression that here a force is at work that "pulls and pushes pictorial impressions around the surface of the painting" (Michael Auping). Her application of paint competes formally with the turbulence of her objects. The narrative implied by the figuration is obscured and exceeded in dramatic impact by the division and articulation of the pictorial spaces. When Susan Rothenberg painted her *Mondrian* series in 1984, she drew a sharp contrast between the inner meaning of the pictorial motifs and the tradition from which Rothenberg's artistic process continuously separates and liberates itself. Mondrian, the father figure of an abstract-geometric style of painting, is like a figurative apparition who has only got his name in retrospect because of a chance similarity. The figure is the result of biographical introspection. Its attribute, a pack of cards, recalls stations in the life of the artist's father. The pictures celebrate their impressionistic opulence. They are like a dream sequence. The homage to Mondrian is acted out in a representational medium like a grotesque stage play.

That is Susan Rothenberg's method. She infiltrates a fascination with abstraction with fluctuating amounts of unmistakable realism, thereby becoming for a time the highest-paid painter in the art market. In ever new variations, all she does is make the internal logic of her painting comparable with objects, events and impressions which are to be found outside art. It is not the collision of painting and world that is unusual. What is surprising is that this collision itself becomes an image. It is portrayed like a challenging reservation which the outside world has about the world of art and vice versa.

Since moving to New Mexico in 1990 – her marriage to Bruce Nauman means she works alongside his own pictorial world, which similarly includes fragmented animal bodies – Rothenberg has revised her horse motif yet again. The horse extremities galloping in coloured planes, the reins and hands, the dogs and geese are once more foreground events on a coloured ground of complex structure. But the half-stylised, half-detailed figures are not variations upon the outlines of 1974; they disavow the methodical reproduction of painting from a new perspective. On Rothenberg's ranch in Galisteo, her animal figurations become an inventory of daily rural life. The figures of the 1970s, which were still primarily skeletal, are transformed into flesh and blood as they pass through this new physical experience of nature. The painting, a breakaway from everyday perception which obeys its own logic, is enriched with the chaos of nature as with sketches of an accident. The sphere of painting is further compelled to clash against the sphere of events. From the collisions emerge pictures.

Gerrit Gohlke

Susan Rothenberg, 1996

Niki de Saint Phalle

*** 1930 in Neuilly-sur-Seine, France; † 2002 in San Diego (CA), USA**

Selected solo exhibitions: **1980** "Exposition rétrospective", Musée national d'art moderne, Centre Georges Pompidou, Paris, France /
1987 "Bilder – Figuren – Phantastische Gärten", Kunsthalle der Hypo-Kulturstiftung, Munich, Germany / **1993** Kunst- und Ausstellungshalle
der Bundesrepublik Deutschland, Bonn, Germany / **1999** "Insider/Outsider World Inspired Art", Mingei International Museum of World Art,
La Jolla (CA), USA / **2000** "La Fête – Schenkung Niki de Saint Phalle", Sprengel Museum Hannover, Hanover, Germany

Selected group exhibitions: **1961** "Bewogen Beweging", Stedelijk Museum, Amsterdam, The Netherlands / **1967** "Expo 67", Montreal, Canada /
1988 XLIII Esposizione Internazionale d'Arte, la Biennale di Venezia, Venice, Italy / **1991** "The Pop Art Show", The Royal Academy of Arts, London. England /
1993 "Territorium Artis", Kunst- und Ausstellungshalle der Bundesrepublik Deutschland, Bonn, Germany

Selected bibliography: **1986** *AIDS, you can't get it holding hands*, Munich/Lucerne / **1994** *Mon secret*, Paris /
2000 *Traces, Eine Autobiographie, Remembering 1930–1949*, Lausanne

Power to the Nanas

During her lifetime, Niki de Saint Phalle has already become the immortal heroine of a whole generation of women, the myth of a woman who has succeeded in breaking out of the traditional role ascribed to her and achieving self-fulfilment in her art. Christened Catherine Marie-Agnès Fal de Saint Phalle, she was born in 1930 near Paris to a wealthy French-American banking family, subsequently growing up in New York. At first, Saint Phalle's career promised to be everything that might be expected of the daughter of such a privileged family. However, having been abused by her father at the age of eleven, she suffered from a behavioural disorder and had to change schools several times. At the age of 18, she ran away from home, married Harry Mathews and worked as a photo model. She gave birth to a daughter when she was 20, then attended acting school. Four years later her son was born. After a serious nervous breakdown which required treatment in hospital, she decided to become an artist, because painting had helped her to deal with the crisis.

In 1960, Saint Phalle met the sculptor Jean Tinguely in Paris and left her husband and children to live with him. She started making assemblages of plaster and found objects, into which she integrated plastic bags full of paint. In staged happenings, she took pot shots at these reliefs, with the result that the paint was splattered on the white plaster. She called the resulting works *Tirs* (Shots). "I was shooting at men, society and its injustice, and myself… I was totally addicted to this macabre but delightful ritual." The art critic Pierre Réstany nominated Saint Phalle for the artists' group Nouveaux Réalistes, to which Arman, César, Christo, Yves Klein, Daniel Spoerri and other male artists belonged. After two years of provocative shooting happenings, she retreated into an inner, more feminine world and began to paint brides, pregnant women and whores, "different roles which women can assume in society".

In 1965, Niki de Saint Phalle created her first Nanas – those voluminous, brightly coloured sculptures of women that have made her world famous. Inspired by her pregnant friend Clarice Rivers, she initially formed them out of wool, wire and papier mâché, later out of polyester. The following years were highly productive. In Stockholm, she had a 28-metre-long reclining Nana *Hon* (She) erected (1966); together with Jean Tinguely she produced a 15-part group of figures for the roof of the French pavilion at the World Exposition in Montréal (1967); her play *All About Me* was staged in Kassel (1968); in the South of France she had three Nana houses built and undertook her first architectural project (1969–1972); and her film *Daddy* was premièred in New York (1973).

A place to dream

In 1971, the year in which her granddaughter was born, Saint Phalle married Jean Tinguely. As a result of inhaling poisonous polyester fumes while producing her Nanas, her lungs were irreparably damaged, with the result that in the mid-1970s she spent time in several Swiss health resorts to alleviate the problem. On lonely walks in the mountains, the artist hit on the idea for a sculpture park, "a place to dream, a garden of joy and fantasy". Italian friends of hers placed a piece of land at her disposal in Garavicchio in Tuscany, and at her own expense she set about laying the *Giardino dei Tarocchi*: monumental metal figures based on the 22 tarot card motifs, covered in cement and inlaid with mosaics of mirror, glass and ceramic. The largest of these is a sphinx representing the card of the empress. During the more than ten years required to lay out this tarot garden, Saint Phalle set up house inside that Sphinx-like figure, living and working in her belly and sleeping in her left breast. "Twenty years ago I left my children for my art. Here, I myself lived inside a mother figure, and in those years I grew closer to them again." In 1993, the garden was declared part of the French cultural heritage on Italian territory and opened to the general public.

In late summer 1991, Jean Tinguely died suddenly. Although the two had lived with different partners, they had never really fully separated and remained good friends, telephoning daily and collaborating on several works: the *Fontaine de Stravinsky*, 1983, beside the Centre Georges Pompidou in Paris, and the *Château Chinon* fountain, 1988, in Château-Chinon, the home town of the former French president François Mitterrand. They had been planning a 15-metre-high stele for the patio of the Bundeskunsthalle in Bonn.

A new Noah's Ark

As Tinguely's widow, Niki de Saint Phalle had to administer the artist's estate and decided to donate his works to the city of Basel, where a new Tinguely Museum was to be built. Before it opened in 1996, she left Europe to move to southern California. Her lung problem had become a cause of serious concern, and she hoped it would improve in a warm climate. Moreover, she was half American, and the Americans loved her art. Saint Phalle worked over the death of her former partner in her moving reliefs, the *Tableaux éclatés*, 1992/93, the motifs of which – controlled by motors – fall apart and back together again. She calls these reliefs "Méta-Tinguely" and they remind her of Jean Tinguely's kinetic sculptures and the beginning of their work together.

The home the artist had chosen for herself soon began to exert an influence on her new works: the glowing colours of the houses in La Jolla, and in particular the indigenous animals. She models gulls, dolphins, seals and killer whales, painting them in bright colours. A project she had repeatedly postponed assumed a new relevance: a Noah's Ark with 39 animals for Jerusalem. Unlike the biblical Ark, the work is to depict the animals not entering but leaving the ark – for safe ground. Niki de Saint Phalle, too, seems to have finally reached her destination.

Uta Grosenick

Niki de Saint Phalle has always been believed that artists are part of a movement whose members are not assessed and distinguished according to race, religion or gender. For this reason, she has refused to be part of numerous exhibitions and publications devoted exclusively to women artists, and also did not make any pictures available for this book.

Niki de Saint Phalle in front of her sculpture "L'Ange Protecteur" in Zurich's main railway station, Switzerland, November 1997

"If a woman really wants to take the path to the pinnacle of world art, then she can. I am proof of this!"

Carolee Schneemann

* 1939 in Fox Chase (KY), USA; lives and works in New York (NY) and New Paltz (NY), USA

Selected solo exhibitions: **1972** University Art Museum, University of California, Berkeley (CA), USA / **1979** Stichting De Appel, Amsterdam, The Netherlands / **1981** Washington Project for the Arts, Washington, DC, USA / **1984** Kent State University, Department of Fine Arts, University Gallery, Kent (OH) USA / **1995** Kunstraum Wien, Vienna, Austria / **1996** New Museum of Contemporary Art, New York (NY), USA

Selected group exhibitions: **1980** "A Decade of Women's Performance Art", Contemporary Art Center, New Orleans (LA), USA / **1993** "In the Spirit of Fluxus", Walker Art Center, Minneapolis (MN), USA / **1994** "Outside the Frame: Performance and the Object", Cleveland Center for Contemporary Art, Cleveland (OH), USA / **1994** "fémininmasculin. Le sexe de l'art", Musée national d'art moderne, Centre Georges Pompidou, Paris, France / **1995** "Hall of Mirrors: Art and Film Since 1945", Museum of Contemporary Art, Los Angeles (CA), USA

Selected bibliography: **2000** Carolee Schneemann, *The Body Politics of Carolee Schneemann*, Boston (MA) / **2001** Carolee Schneemann, *Imaging Her Erotics: Essays, Interviews, Projects*, Boston (MA)

Body writing

Carolee Schneemann's work polarises opinion. The provocative use of her own body and her abrupt changes of medium in particular have triggered harsh criticism, even sexist-motivated marginalisation, but also admiration on the part of younger video and performance artists. Her contribution to American Body Art is now considered a major one, while her unique blend of painting, happening, Living Theatre and Fluxus is seen as revolutionary.

Legendary status attaches to Schneemann's performance *Up To and Including Her Limits,* first presented in 1973. Influenced by Abstract Expressionist painting, she developed the idea of *écriture corporelle,* in which Pollock's principle of Action Painting was extended to the movement of the entire body in space. In this work, the artist was suspended, naked, from a free-hanging rope like an acrobat, and marked the trance-like oscillations of her body by means of coloured chalk. The result was a rhythmical interweave of lines on a surface as a record of her physical exertions. Pollock's gestural painting process was transmuted into a kinetic theatre in which the energies of the female body found direct visual expression.

When she came to New York in the early 1960s and began her career as a painter, Schneemann was intrigued by the attempts of the renowned New York School to overcome the restrictions of traditional easel painting. Like Robert Rauschenberg, she combined various materials to lend dynamics and a spatial dimension to the flat picture plane. Her *Cutting Boards* reflected the influence of Joseph Cornell's object boxes. In series such as *Native Beauties,* 1962–64, Schneemann addressed the female body as object of male perception. Her first performances also date from this period. In *Labyrinth,* 1960, she acted in front of an audience for the first time, and in 1962, she participated in Claes Oldenburg's performance *Store Days I.* As dancer and choreographer for the Judson Church Theatre she had the dual identity of an artist and a performer, much like Rauschenberg and Robert Morris, for whom she appeared in the guise of Manet's *Olympia* in 1965.

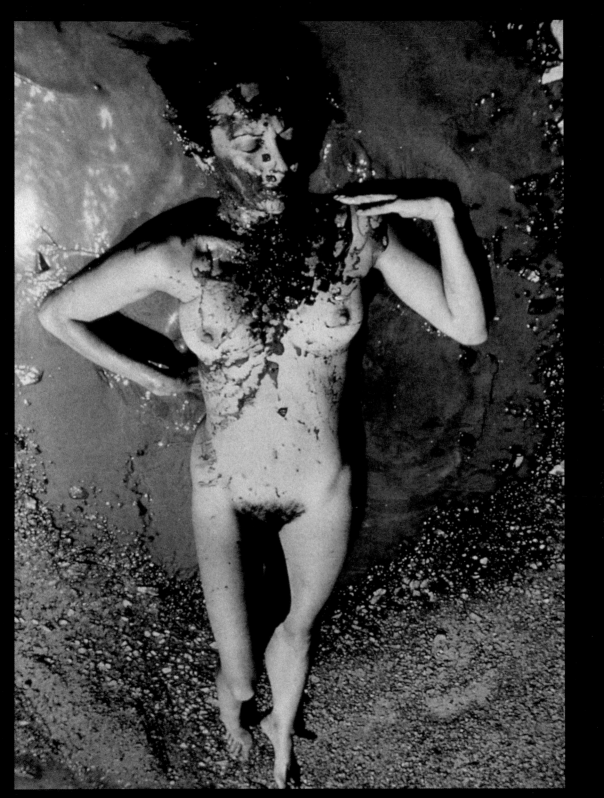

2

1　**Evaporation-Noon,** 1974. Performance
2　**Blood Work Diary,** 1972 (detail). Menstrual blood on fabric
3　**Eye Body: 36 Transformative Actions,** 1963
4　**Meat Joy,** 1964
5　**Up To And Including Her Limits,** 1973–76. Chalk on paper, rope, straps, super-8 film "Kitch's Last Meal". Performance
6　**Up To And Including Her Limits,** 1973–76. Chalk on paper, straps, super-8 film "Kitch's Last Meal". Performance
7　**Vulva's Morphia,** 1995. Wall installation, each panel 28 x 22 cm
8　**Mortal Coils,** 1993/94. Multimedia installation

"If the body is rooted in the eye, visual sensations take hold of the whole organism."

3

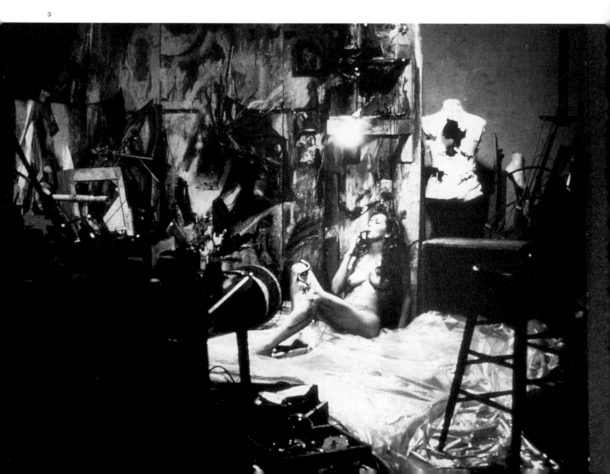

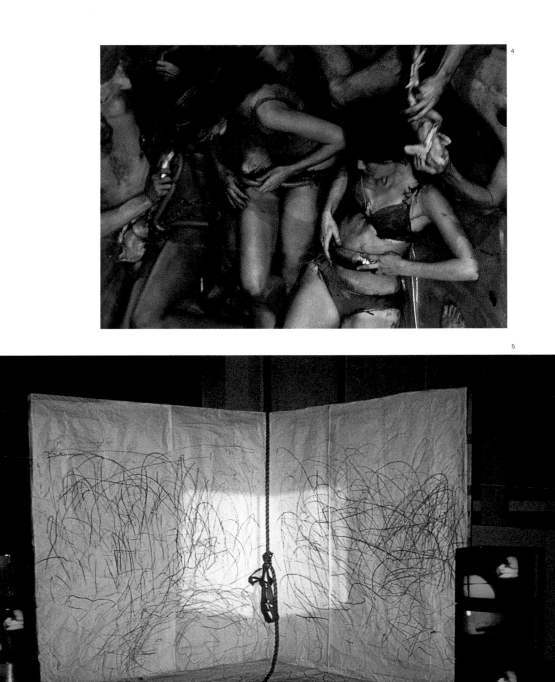

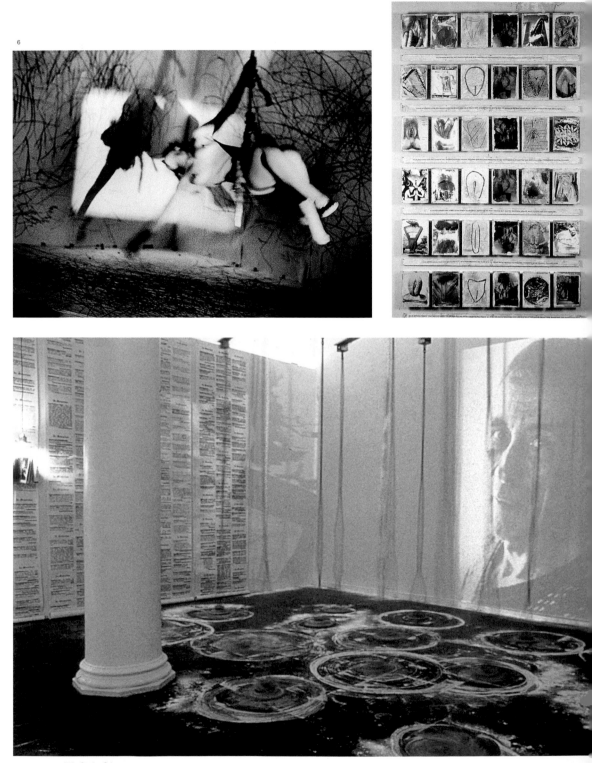

298 Carolee Schneemann

A breakthrough came with the work *Eye Body (Thirty-Six Transformative Actions for Camera),* 1963. Here the studio became a stage for a play with mirrors, ropes, foil, feathers, glue, and naturally paint – the artist's body was only one material among others, and like these, was subject to her "creative female will". An insistence on the authenticity of physical experience characterised American Body Art in general, and was influenced by the phenomenology of the French philosopher Maurice Merleau-Ponty. In the mid-1960s, Schneemann went a step further. In the performance *Meat Joy,* 1964, the sense of touch and tactile experience stood at the centre of a orgiastic interaction intended to liberate the communicative energies of the body. The handling of animal food by the naked actors in the piece was considered especially provocative. Two years later, Schneemann systematically broke with social norms, transgressing the conventional borders of modesty, when in *Fuses,* 1966, she used a hand-held camera to film herself having sex with the composer James Tenney. The film was more than a record of a certain physical experience. As a medium for obsessive self-observation, it represented a counter-project to the pornographic exploitation of the female body.

Cézanne was a great female artist

Like Hannah Wilke or VALIE EXPORT, Schneemann addressed the culturally determined perception of the female body, focusing attention on the taboos surrounding the female libido. Her most significant work in this regard was the performance *Interior Scroll,* 1975, in which the naked artist pulled a folded strip of paper from her vagina. Printed on the paper was a dialogue with a "structuralist film-maker", which Schneemann proceeded to read to the audience. Like many other of her works, this one had definite autobiographical traits – from 1971 to 1976 Schneemann lived with the film-maker Anthony McCall. In *Interior Scroll* she confronted the privileged position of the voyeur with a poetics of the female body.

Schneemann's artistic practice has always stood in conflict with cultural institutions and social conventions. In her book *More than Meat Joy,* first published in 1979, she implicitly developed a theory of performance. A lesson on the academic restrictions of art history was provided by the work *Naked Action Lecture,* 1968, which, as Schneemann stated, could be reduced to the question of whether a naked woman could obtain intellectual authority. An involvement with the artistic canon dominated by male artists was also the thrust of her book *Cézanne: She Was a Great Painter,* 1976. Schneemann's thinking has influenced such prominent feminist theorists as Judith Butler and Donna Harraway, as well as artists like Matthew Barney.

The body as creative locus

In her photo works and installations of the late 1980s and 1990s, Schneemann made reference to other artists' works. The action *Hand Heart for Ana Mendieta,* 1986, not only paid homage to a marginalised female artist, but directly quoted Mendieta's artistic practice. Using paint, blood, ashes and syrup, Schneemann made heart-shaped traces in snow, just as Mendieta had left impressions of her body in soft substances. In scenographic installations such as *Video Rocks,* 1989, or *Mortal Coils,* 1993/94, which contained allusions to the roots of her work, Schneemann combined various media, such as painting, sculpture, video and performance. *Petra Löffler*

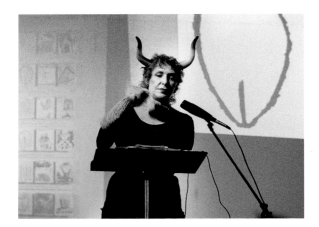

Carolee Schneemann performing "Vulva's Morphia", New Museum of Contemporary Art, New York (NY), USA, 1997

Cindy Sherman

* 1954 in Glen Ridge (NJ), USA; lives and works in New York (NY), USA

Selected solo exhibitions: **1987** Whitney Museum of American Art, New York (NY), USA / **1991** Kunsthalle Basel, Basle, Switzerland / **1995** Deichtorhallen Hamburg, Hamburg, Germany; Malmö Konsthall, Malmö, Sweden; Kunstmuseum Luzern, Lucerne, Switzerland / **1996/97** Museum Boijmans Van Beuningen, Rotterdam, The Netherlands / **1997** "Cindy Sherman: The Complete 'Untitled Film Stills'", The Museum of Modern Art, New York (NY) / **1997–2000** "Cindy Sherman: Retrospective", an exhibition tour through the USA, Czech Republic, Spain, France, Australia, and Canada

Selected group exhibitions: **1982** XL Esposizione Internazionale d'Arte, la Biennale di Venezia, Venice, Italy / documenta 7, Kassel, Germany / **1989** "A Forest of Signs: Art in the Crisis of Representation", Museum of Contemporary Art, Los Angeles (CA), USA / **1993** Whitney Biennial, Whitney Museum of American Art, New York (NY), USA / **2000** "Die verletzte Diva", Kunstverein München, Munich, Germany; Städtische Galerie im Lenbachhaus, Munich; Galerie im Taxis Palais, Innsbruck, Austria; Staatliche Kunsthalle Baden-Baden, Baden-Baden, Germany

Selected bibliography: **1992** Cindy Sherman, *Fitcher's Bird*, New York (NY)

Peeping Cindy

In the 1970s, Performance Art and Body Art increasingly addressed the pictorial media, especially the blueprints of femininity disseminated by them. In the artistic fallout, the body was consequently often presented as an interchangeable symbol within the system of the mass media or deployed as malleable artistic material. For other artists, the embodiment of self was what mattered, the body serving to ensure an authentic female essence. Cindy Sherman's early works could easily be explained by this artistic context, but also by her own way of life or by the pleasure she took – as she has said in interviews – in dressing up and in making use of disguise. Yet a biographical interpretation would fail to appreciate that she has only ever seen herself as an actress participating in her photographic sets and that it has never been a matter of Cindy Sherman the person. This applies to the *Untitled Film Stills*, started in 1977, a series of black-and-white photos that first brought her to international attention. In these stills, she presents imaginary scenes from films never made, films in the style of B or horror movies as well as the *nouvelle vague*. She stages herself, mostly rather clumsily, in cliché-ridden female poses hinting at a melodramatic or kitschy story. As both photographer and actress, Sherman is always simultaneously the subject and object of her work. She thus plays out culturally defined women's roles that are reproduced in the various mass-media genres.

One of her working methods is to expose structurally the voyeuristic aspect of looking, as in *Untitled Film Still No. 2*, 1977. Through an open door, we see a woman looking at herself in a bathroom mirror. Such similar constellations of gazes, which at one and the same time create themes and subvert the seductive character of bodies but also the gloss of a photographic image, are also typical of *Centerfolds*, realised in 1981. This series of photos shows women reclining or huddled up after being photographed for the centrefold of a porn magazine. Admittedly, a subtle sense of absence seems to withdraw them from the visual probe of the camera, since they

"A degree of hyper-ugliness has always fascinated me. Things that were considered unattractive and undesirable interested me particularly. And I do find things like that really beautiful."

1 **Untitled,** 1990. Colour photograph, 176 x 119 cm

2 **Untitled,** 2000. Colour photograph, 76 x 51 cm
3 **Untitled,** 1987. Colour photograph, 121 x 182 cm
4 **Untitled,** 1989. Colour photograph, 170 x 142 cm

5 **Untitled,** 1999. Black-and-white photograph, 86 x 80 cm
6 **Untitled,** 1999. Black-and-white photograph, 60 x 60 cm
7 **Untitled,** 1994. Colour photograph, 169 x 109 cm
8 **Untitled Film Still,** 1978. Black-and-white photograph, 20 x 25 cm

2

3

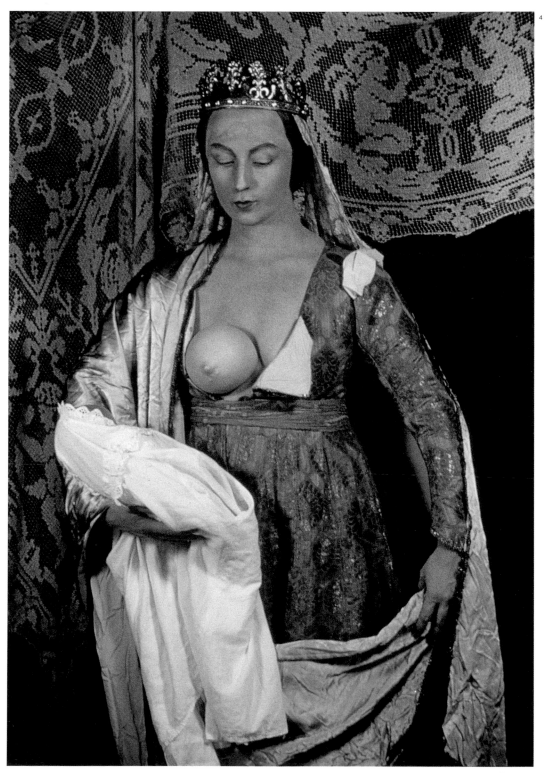

5

6

8

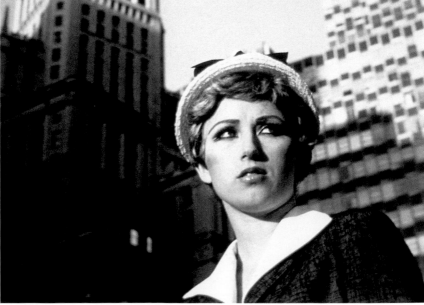

do not look at the camera in the normal way of porn photography. Rather, their gaze seems to be directed towards an indeterminate distance outside the pictorial field. Their bodies, too, stray beyond the pictorial borders or vanish in shadow, so that they are not visually comprehensible as complete figures.

Since the 1980s, Sherman has also accepted commissions from fashion designers, creating for example adverts that run grotesquely counter to the usual clichés of female beauty by means of absurd theatricalities such as false teeth, scars, grimaces, deformed body parts and unflattering poses. Thus, typically enough, a work commissioned by Dorothee Bis was rejected by the company, while in the late 1990s Comme des Garçons commissioned a whole series from her. In *Fairy Tales*, shot between 1985 and 1989, Sherman explored the tales and fairy tales of the Grimm brothers. The viewer is exposed to scenarios that evoke eerie sensations, but which – unlike children's fairy stories – do not leave behind a promise of happiness. What remains are open changeable bodies without definite tangible form.

History portraits

Whereas 1960s and 1970s performance artists still used their bodies as strategic alternatives to the public representation of women by bringing their corporeal features into play, Sherman has increasingly withdrawn from her pictures as an actress, leaving the field to dolls and artificial limbs. In her *History Portraits*, 1988–90, she contrives old-master-style portraits, playing with pictorial symbols and arrangements familiar from the originals which she deploys in a disturbingly altered manner. She swaps sexes around and presents the illusionist techniques of an apparently authentic but in fact idealising portrait painting. In *Sex Pictures*, 1992, Sherman works more explicitly than before at taking the lid off erotic fetishism and the cultural attributes of the female body. The latter is seen not as a locus for finding definite identify, but as an unstable changeable construct, always in danger of becoming a scene of horror and fragmentation. The female body becomes a traumatic agent constantly subverting the orderliness of the visible: body fluids that are no longer clearly classifiable, sexes that are not defined unambiguously, hybrids formed from man and beast. Phenomena of dissolution on the frontiers between the subject and otherness are formally run through, while undertones of parody constantly colour the atmosphere. For Sherman's creatures claim no naturalness for themselves. Theirs is an artificiality theatrically presented with the aid of cheap tricks such as exaggerated coloration or visible seams joining artificial body parts.

Sherman adopts a similar approach in her first cinema film *Office Killer*, 1997, which is about a shy female office worker who turns the dilemma of her social marginalisation into criminal energy, making a career as a serial killer. The corpses of her colleagues pile up in her cellar like the utensils and artificial limbs in Sherman's studio. In her latest series, *1999*, which alludes to the surrealist photographic sets of Man Ray or Claude Cahun, Sherman returns to black-and-white photography, creating set pieces of battered, dismembered and reassembled plastic figures which with their gaze appear to address the viewer often directly, sometimes scornfully, and in a traumatised or almost aggressive manner. Cindy Sherman's ability to disturb lies in both this ambiguity and these fractures, but also in her changing strategies and orientations, as well as in her turns of parody, all of which characterise her work. *Ilka Becker*

Cindy Sherman

*Cindy Sherman,
1990*

Kiki Smith

*** 1954 in Nuremberg, Germany; lives and works in New York (NY), USA**

Selected solo exhibitions: **1982** "Life Wants to Live", The Kitchen, New York (NY), USA / **1993** "Silent Work", Österreichisches Museum für Angewandte Kunst, Vienna, Austria / **1997** "Convergence", Irish Museum of Modern Art, Dublin, Ireland / **1998** "All Creatures Great and Small", Kestner Gesellschaft, Hanover, Germany; Hirshhorn Museum and Sculpture Garden, Washington, DC, USA

Selected group exhibitions: **1979** "Doctor and Dentist Show", Colab (Collaborative Projects, Inc.), New York (NY), USA / **1990** "The Body", The Renaissance Society at the University of Chicago, Chicago (IL), USA / **1993** "Aperto", XLVI Esposizione Internazionale d'Arte, la Biennale di Venezia, Venice, Italy / **1995** "fémininmasculin. Le sexe de l'art", Musée national d'art moderne, Centre Georges Pompidou, Paris, France / **2000** "Regarding Beauty", Haus der Kunst, Munich, Germany

Art as journey into the cosmos

As the daughter of opera singer Jane Smith and Minimalist artist Tony Smith, Kiki Smith grew up in an artistic family. She and her sisters helped their father by building paper models for his sculptures. As a teenager, Kiki joined the hippie movement and enthused about back-to-nature ideas. She took an interest in popular art and in crafts, and admired the work of Frida Kahlo. She spent a year in San Francisco living with the Tubes rock group. At the age of 24, she studied at the Hartford School of Art in Connecticut for three terms, drawing still lifes, mainly round pill boxes and cigarette packets. Later, she saw her encounter with these noxious substances as the beginning of her artistic fascination with the body.

In 1976, Smith moved to New York, worked in the Tin Pan Alley Bar, and became a member of the Collaborative Projects Inc. group of artists (Colab for short), whose particular thing was creatively transforming everyday objects, selling the products in A More Shop. The breakdown of the barriers between artwork and utilitarian object, between applied, decorative and fine art, was also characteristic of Smith's later work. In 1979, a year before he died, her father gave her a copy of *Gray's Anatomy*, and she drew the cell structures and innards of the human body from it. In 1980, she exhibited her large-scale anatomical drawings for the first time, in a group exhibition. The death of her father "heralded my real birth as an artist". Her first reaction to his death was to put a latex hand she had found in the street into her aquarium (later into a preserving jar) and let algae accumulate on it. *Hand in Jar*, 1983, was a key experience for her that was to influence her subsequent artistic work. She investigated the interdependence of nature and world as collaboration and teamwork, and took an interest in parasitic infestation, symbiotic relationships and the interfaces of life and death. The algae growing in the *Hand in Jar* as dead matter became for their part a living body again. Resurrection, reanimation and regeneration became henceforth leitmotifs in her work. She delved into the relevant literature to read about the way the human body was treated and how its significance evolved from Antiquity to the Middle Ages and the Renaissance. The embroidered drawings *Nervous Giants*, 1987, were a further investigation of the body as a system, of its symbolic values and significance.

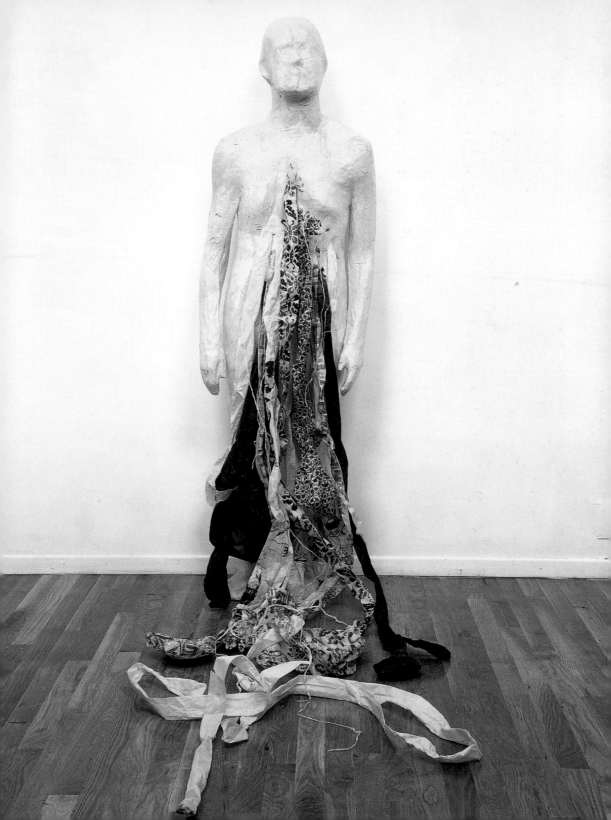

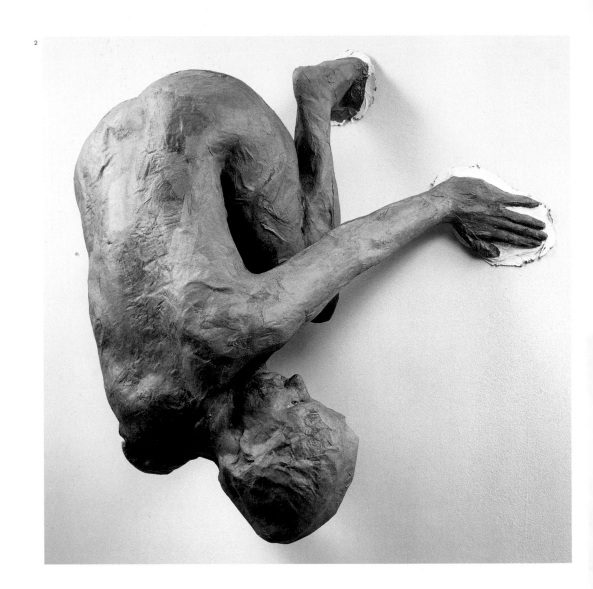

"The body is our common denominator and the stage for our pleasures and our sorrows. I want to express through it who we are, how we live and die."

1 **Untitled,** 1993. Nepal paper and methyl cellulose, 160 x 47 x 390 cm
2 **Lilith,** 1994. Papier mâché and glass, 43 x 80 x 81 cm
3 **Untitled (Moth),** 1993. Bronze, 32 x 20 x 31 cm
4 **Jersey Crows,** 1995. 27 parts, each 16 x 45 x 28 cm to 41 x 50 x 60
cm. Installation view, PaceWildenstein, New York (NY), USA
5 **A Man,** 1990. Collage, 198 x 308 cm
6 **Installation view, "Silent Work",** Österreichisches Museum für
Angewandte Kunst, Vienna, Austria, 1992

3

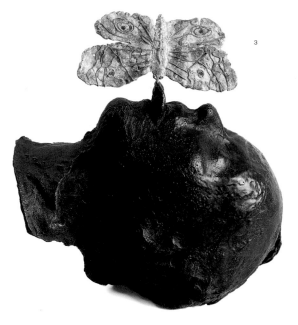

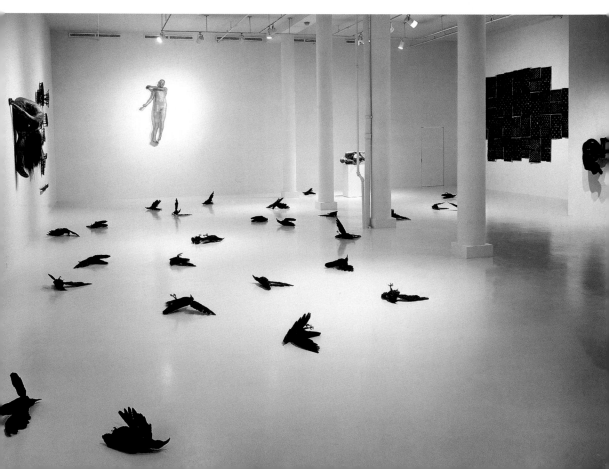

5

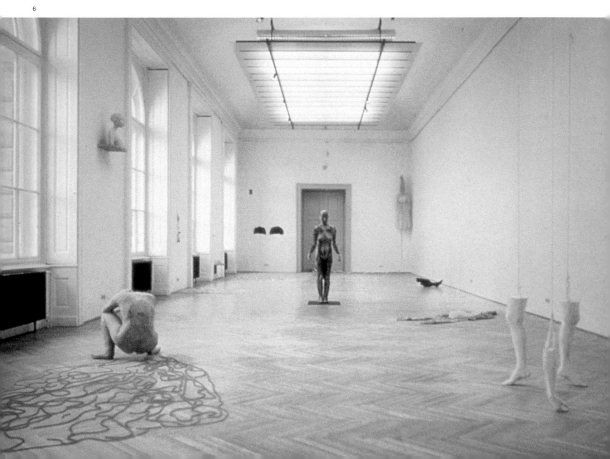

6

Numerous drawings and sculptures date from this time, made of sundry materials such as glass, porcelain, paper, clay or bronze. They depict innards and parts of the body, such as *Ribcage*, 1987 (a ribcage), *Shield*, 1988 (a pregnant belly as a shield), *Womb*, 1986 (a womb in the form of two empty nutshell halves) or *Second Choice*, 1987 (various organs sitting like fruit in a ceramic fruit bowl, as a reaction to the trade in organs). At the same time, Smith did drawings of embryos as symbols of birth, e.g. *All Souls*, 1988. She is not interested in scientific presentation (unlike Leonardo da Vinci for example), but in expressing emotional and sensuous connotations related to her own experiences. The body parts shocked the public, and, appropriating Mary Shelley's homunculus hero, whom she had admired in her youth, Smith called herself Kiki Frankenstein.

"Kiki Frankenstein"

Her first whole-body figure was *Untitled*, 1987, which was contrasted with X-ray photos. When Kiki's sister Beatrice died of AIDS the following year, her sculptures became more potent symbols of inner injury and vulnerability, such as the erect flayed *Virgin Mary*, *Tale*, 1992, a female figure crawling on all fours dragging a long trail of excrement behind her, or *Blood Pool*, 1992, a reclining female body in embryonic position, her spine open at the back.

Kiki Smith draws inspiration from art historical works such as Grünewald's Isenheim altar, from biblical and mythical figures such as Lilith, Lot's wife or Mary Magdalene, but also from fairy stories and her own dreams. When, in 1992, she dreamt that she was to liberate a bird, it became at one and the same time a blow for freedom and a turning point in her own artistic endeavours. In *Getting the Bird Out*, 1992 – a bird hanging on a thread rising from the mouth of a human head – she related man to animal, increasingly foregrounded the ambivalent humanity-nature-the cosmos relationship between romanticism and exploitation, and began to see the world as a whole in the reality of its dichotomies. Alongside pictures of the moon (*Moon* or *Thirteen Moons*, both 1997), of the stars and of the continents, she developed enchanted poetic ensembles that seem – like a fairy story – as if transported from the world or to come from another age, while remaining eloquent of it. For the *Paradise Cage* exhibition in the Museum of Contemporary Art in Los Angeles in 1996, she and the Coop Himmelb(l)au group of architects produced an impressive cosmic scenario of stars and 28 glass animals, which were placed on a large, circular, blue ground surrounded by tall steel rods, recalling Noah's Ark or other legends. In soft hatching, Smith depicted animals like the wolf that are partly threatened with extinction and yet live on in fairy stories and fables as ambiguous symbols, combining them with representations of hands, crystals and stars (*Peabody [Animal Drawings]*, 1996). In her video *Night Time Wolf*, 1999, a digital animation of drawings, a white wolf is shown against a black background, loping untiringly towards an unknown destination – the future – yet looking the viewer meantime directly in the eye.

Kiki Smith's works unite past and future with a view to making the excesses of the present and the individual's role in the world more comprehensible. She creates a new feeling for nature and the human body, re-animates its significance in a technologically and scientifically oriented world, and provokes reflection with shocking but also poetic images.

Ulrike Lehmann

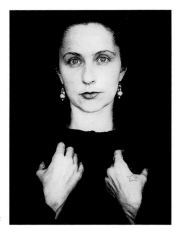

Kiki Smith, 1994

Elaine Sturtevant

*** 1926, in Lakewood (OH), USA; lives and works in Paris, France, and at Harvard, Cambridge (MA), USA**

Selected solo exhibitions: 1967 The Store of Claes Oldenburg, New York (NY), USA / **1993** Deichtorhallen Hamburg, Hamburg, Germany / **1993** Villa Arson, Nice, France / **1998** Wiener Secession, Vienna, Germany / **1999** Musée d'Art Moderne et Contemporain, Geneva, Switzerland

Selected group exhibitions: **1989** "Prospect 89", Frankfurter Kunstverein, Frankfurt am Main, Germany / **1993** "Objects for an ideal home", Serpentine Gallery, London, England / **1996** "NowHere", Louisiana Museum of Modern Art, Humlebæk, Denmark / **1999** ZKM Zentrum für Kunst und Medientechnologie, Karlsruhe, Germany / **2000** "Copy Right / Copy Wrong", Ecole des Beaux-Arts, Nantes, France

The double as original

"My intentions are to expand and develop our current notions of aesthetics, probe originality, investigate the relation of origins to originality, and open space for new thinking." Thus Elaine Sturtevant in 1993, describing her aims as an artist. At first it may seem a surprising way for the American artist to characterise herself, given that she has made her name largely through faithful copying of the works of other (mostly male) artists. Sturtevant's approach polarised the public and the critics so completely that in 1973 she left the US and went to Paris, not exhibiting again until 1985/86. But what appears at first to be a provocative denial of the concept of the original and of artistic autonomy, proves on closer examination to be a meticulous engagement with the structures of artistic work, and the question of what originality means in the conditions of mass culture.

Sturtevant began her career as an artist in 1960s New York, at a time when Pop Art had thrown down the gauntlet to Modernism's compulsive innovativeness and purism, elevating banal everyday objects into the subject matter of art. So it was that in 1965, in her first solo show at the Bianchini Gallery in New York, Sturtevant took her bearings chiefly from precursors and artists associated with that movement. Under the title "Seventh Avenue Garment Racket" she exhibited, among other works, replicas of one of Jasper Johns' famous flag paintings, a Claes Oldenburg soft sculpture, and a brushstroke picture by Roy Lichtenstein – hung up on a clothes rack like the latest fashion collection. The works, which can be interpreted as a comment on the commercialisation of art, were displayed in a room completely papered with reproductions of Andy Warhol's *Flowers*.

Sturtevant by no means considers herself a pop artist. She frequently defines her own approach in contradistinction with other artistic projects, especially 1980s Appropriation Art, which re-coded existing images from the history of art, the mass media and advertising by means of a variety of techniques, from pastiche to quotation to recapitulation. Sturtevant is often viewed as the precursor of this line. Closely as her work is linked to the artistic originals it follows, though, she insists on the difference from those originals, highlighting the difference through her titles and signature. Admittedly, the titles of her films, pictures and sculptures – such as *Study for Various Beuys Actions*, 1971; *Duchamp Fontaine*, 1973; *Stella Marriage of Reason and Squalor*, 1990; or *Kiefer Jason*, 1990/02 – do point to the sources; but, by virtue of their being signed (generally the gesture that certifies the authenticity of a work of art), these replicas are identified as original Sturtevants.

4

"There is a difference between probing originality
and saying it is the death of originality.
You'd have to be a mental retard to claim the death
of originality."

The original of the original

The sophisticated games Sturtevant plays with the original, with authenticity, and with the signature, hark back to Marcel Duchamp. Duchamp's ready-mades – industrially manufactured everyday articles which he introduced into the context of art – were a challenge to conventional views of art in the opening decades of the 20th century: it was not the skilful mastery and craftsmanship that were foregrounded here, but the idea and the intention. Elaine Sturtevant has raised Duchamp a power or two. Her strategy of duplication and alienation turns Duchamp's principle of appropriation and reinterpretation of a given work inside out. Thus, in 1969, she substituted her own portrait for Duchamp's image in the latter's *Wanted, $2000 Reward*, 1923/63 – where Duchamp ironically presents himself, as Rose Sélavy, as an outsider in society. Moreover, for his pseudonym she substituted her own actual name, which through this substitution appears in turn as a cover name, raising doubts about the genuine authenticity of the attribution. To this work, Sturtevant gave the richly ambiguous title *Duchamp Wanted*, describing it as a "corrected ready-made" – an allusion to Duchamp's "aided readymades". Sturtevant made a similar "correction" to another work dating from the same period, Duchamp's suggestive reworking of the Mona Lisa, to which in 1919 he added a moustache and the initials L. H.O. O.Q. – translating, when the French letters are read aloud, as "Elle a chaud au cul", or "Her ass is hot". Sturtevant's 1971 version is titled *Duchamp Rasée L. H.O. O.Q.* and shows Leonardo da Vinci's original painting of the Mona Lisa. By quoting the original (da Vinci) of the original (Duchamp), Sturtevant is, on the face of it, restoring the image to its original state. But despite the similarity, the significance of the new work is importantly different from that of da Vinci's: it now occupies a place in an entire chain of attributions, reinterpretations and misprisions.

"All current art is fake"

The sources Sturtevant draws upon – be they works by Duchamp, Warhol, Oldenburg, Lichtenstein, Stella, Beuys, Anselm Kiefer or younger artists such as Keith Haring or Robert Gober – serve as catalysts for the exploration of "the understructure", and they function, as Sturtevant put it in 1993, "through the dynamics of repetition, reference, opposites as the same, and non-identity through identity". Rather than making the same thing appear new – which to Sturtevant's mind is the hallmark of that innovativeness which was the driving force of Modernism and is a key factor in capitalism – she aims for a changed perception of what is supposed familiar, for an originality that makes progress in art possible through repetition. In adopting this strategy, she hopes to break out of the stasis she has diagnosed in contemporary art. For, as Elaine Sturtevant observed in 1999: "All current art is fake, not because it is copy, appropriation, simulation or imitation, or because it shows similarities (all of which it is and does). but because it lacks the crucial push of power, guts and passion."

Astrid Wege

Portrait, 1992. Black-and-white photograph by Timothy Greenfield Sanders, 31 x 24 cm

Rosemarie Trockel

* 1952 in Schwerte, Germany; lives and works in Cologne, Germany

Selected solo exhibitions: **1983** Galerie Philomene Magers, Bonn, Germany; Monika Sprüth Galerie, Cologne, Germany /
1992 Museum Ludwig, Cologne / **1995** "Familienporträts", Galerie Metropol, Vienna, Austria / **1998/99** "Werkgruppen 1986–1998",
Hamburger Kunsthalle, Hamburg; Germany; Whitechapel Art Gallery, London, England; Staatsgalerie Stuttgart, Stuttgart, Germany;
M.A.C. Galeries Contemporaines des Musées de Marseille, Marseille, France

Selected group exhibitions: **1991** "Das Bild nach dem letzten Bild", Galerie Metropol, Vienna, Austria / **1995** "Museum in progress",
Kunsthalle Wien, Vienna, Austria / **1996** "Von Beuys bis Trockel", Musée national d'art moderne, Centre Georges Pompidou, Paris, France /
documenta X, Kassel, Germany (with Carsten Höller) / **1999** XLVIII Esposizione Internazionale d'Arte, la Biennale di Venezia,
German Pavilion, Venice, Italy / **2000** "In between", EXPO 2000, Hanover, Germany (with Carsten Höller)

Between feminism and science

Rosemarie Trockel is an artist who works with every conceivable medium and form. Her previous, continually changing and ambivalent oeuvre, shot through with arcane references to art history, might at first appear not to be from a single hand, and yet numerous self-references are detectable.

Trockel, who originally planned to become a biologist, and who attended a school of applied art, the Cologne's Werkkunstschule, from 1974 to 1980, especially likes to take as her subject matter anthropological and scientific phenomena. Animals (dogs, but above all, monkeys as alter egos and "mimickers" of human beings) have appeared in every medium and phase of her career as subjects and symbols. She investigates patterns of thought and behaviour, and her videos suggest the empirical approach of scientific observation and study. A case in point is the video *Julia, 10-20 Years,* 1998, a long-term study of a girl's development. Yet despite her apparently rational methods, Trockel's pieces abound with irony (sometimes directed against herself), humour and poetry. And not rarely they are based on feminist convictions. In reply to Beuys' statement that "Every man is an artist", Trockel's motto since 1993 has been: "Every animal is a female artist."

Trockel's reputation was established by knitted images, first shown in 1985 at the Rheinisches Landesmuseum, Bonn, which were, and still are, a provocation to the art world. Abstract patterns or familiar symbols – such as the Playboy rabbit, hammer and sickle, or woolmark – were introduced into the knitted image as integral parts of the picture support. By choosing the material of yarn and the activity of knitting, considered typically female, Trockel set out to test the validity of this underrated medium in the context of fine art. At the same time, she subverted the issue by having each one-off image made industrially by computer, rather than creating it by hand. This ran counter not only to the classical idea of painting, but also to accepted methods of mass production.

In addition, many of Trockel's knitted pictures represented ironic commentaries on works by other artists. Thus *Joy,* 1998, with its repeating pattern of blue sailboats in tile-like squares, was a reply to Sigmar Polke's *Carl Andre in Delft,* while *Cogito ergo sum,* 1988, referred to Kasimir Malevich's *Black Square.* The theme of yarn and knitting continued to inform subsequent works. The object *I See Red Wool,* 1985/92, a ball of red yarn with an eye gazing from its centre, was a self-ironic commentary on Trockel's own early knitted pictures. Her video film *Untitled (Woolfilm),* 1992, showed a woman in a black sweater which was unravelled from the bottom up until the woman in the small image was naked, a large empty white surface appearing at the end, as if to invoke a *horror vacui.* Trockel's one-minute black-and-white short film *A la motte,* 1993, was a well-nigh analytic study of the destruction of knitwear by moths. At the end,

"Art about women's art is just as boring as art by men about men's art."

6

7

1 **Untitled,** 1989. Wool, 185 x 150 cm

2 **Untitled (Mobile),** 1992. Wool, polystyrene foam balls, 6 balls: diameter each
 40 cm, 3 balls: diameter each 16 cm

3 **Continental Divide,** 1994. Video, paint, sound, length 18 min. 30 sec.

4 **Es war Nacht, es war kalt und wir hatten viel getrunken,** 1999. Video,
 paint, sound, length 5 min. 20 sec.

5 **Fury I,** 1993. Mixed media, 100 x 100 cm

6 **Fury II,** 1993. Mixed media, 100 x 100 cm

7 **Untitled,** 1996. Textile print, 300 x 350 cm

8 **Die Marquise von O.,**1993-1998. Video, paint, sound, length 3 min. 11 sec.

9 **Kevin at Noon,** 2000. Coloured pencil on paper, 71 x 100 cm

the film was repeated in reverse, suddenly making the process appear productive and creative. At a 1995 show in Vienna's Galerie Metropol, the artist presented psychologically penetrating portraits of her family, in the media of plaster and drawing. Her self-portrait, by contrast, was done by means of stitches, in reference to her knitted imagery.

With the *Electric Range Pictures* (from 1991), Trockel took up another femininely connoted medium, simultaneously commenting on the emergent Neo Geo style. The video *Interview,* 1994, was linked with this group of paintings and sculptures. It represented a burner plate, multiplied with the aid of a computer and juxtaposed to form diverse configurations, creating the impression of a heated question-and-answer debate.

Human beings as observers

The video medium, adopted in 1978, took on increasing weight in Trockel's oeuvre. In *Animal Films,* 1978–90, she combined sequences from animal films and photographs taken from television. Further films on the subject followed, such as *Parade,* 1993, abstract configurations formed by caterpillars in a natural setting, or *Napoli,* 1994, a flock of birds that created the impression of moving abstract imagery, accompanied by music. In 1994, Trockel's videos had their first showing, under the title *Anima,* at the Museum für Angewandte Kunst, Vienna. In 1999, she represented Germany at the Venice Biennale, presenting three related films at the German Pavilion. On view in the main room was a greatly enlarged, black-and-white eye that looked from left to right – a symbol of the perception of art, but also evoking the Orwellian vision of "Big Brother Is Watching You" as well as the ancient symbol of the Eye of God. In the room on the left, Trockel showed a small-format projection of a film about a playground and children in a soapbox race, in which the role of the spectator and the factors of time, speed, behaviour and memory were addressed. By means of double exposures, slow motion and blurring, Trockel reawakened memories of her own childhood. In the room to the right, the film *Sleeping Pill* was on view. It showed a room full of people who, as if in a behavioural experiment, were resting or sleeping in cocoons suspended from the ceiling or on mattresses spread around the floor. Yet continual disturbances from the people's coming and going, getting up and lying down again, dominated the surreal scene. Here, too, the artist toyed with viewers' expectations regarding the normality of certain behaviour.

In 1996, Trockel began collaborating on joint projects with Carsten Höller, an artist and biologist. For documenta X in Kassel, they built a *House for Pigs and People,* a sort of experimental lab and observation post for behavioural research which drew crowds of viewers. At Expo 2000, the Hanover World Fair, the two artists displayed an eye-shaped pavilion as a *House for Pigeon, Person and Rat (1:1 Scale Model).* At irregular intervals, 20 animal models made of aluminium moved mechanically through the air, emerged from the wall, or crept along the floor. In their midst, on a ramp, stood a person, in the role of observer.

Rosemarie Trockel's works address the themes of perception and recognition, memory and experience, and an involvement with her art elicits reactions of this very nature. Yet her work never allows for any hard and fast interpretation. The diversity of media and themes within her oeuvre as a whole is matched by the complexity and ambiguity of each individual work. *Ulrike Lehmann*

Rosemarie Trockel,
1989

Adriana Varejão

* 1964 in Rio de Janeiro, Brazil; lives and works in Rio de Janeiro, Brazil

Selected solo exhibitions: **1988** Thomas Cohn Arte Contemporânea, Rio de Janeiro, Brazil / **1995** Annina Nosei Gallery, New York (NY), USA / **1997** Galerie Ghislaine Hussenot, Paris, France / **1999** Galeria Camargo Vilaça, São Paulo, Brazil / **2001** Victoria Miro Gallery, London, England

Selected group exhibitions: **1994** "Mapping", The Museum of Modern Art, New York (NY), USA / **1995** "TransCulture", Palazzo Giustinian Lolin, XLVI Esposizione Internazionale d'Arte, la Biennale di Venezia, Venice, Italy / Johannesburg Biennial, Johannesburg, South Africa / **1998** São Paulo Biennial, São Paulo, Brazil / "Der Brasilianische Blick", Haus der Kulturen der Welt, Berlin, Germany / **1999** Liverpool Biennial of Contemporary Art, Tate Gallery, Liverpool, England / **2001** "O Espírito da Nossa Epoca", Museu de Arte Moderna, São Paulo, Brazil

No victims, no perpetrators, but a new world

The label "Latin American art" doesn't adequately describe the rich diversity of culture that is found in the Brazilian part of the South American continent. The European inclination to categorise becomes more unrealistic and alien the closer you get to South America.

The continent's cultural multiplicity has encouraged its artists to take an interest in events far beyond their national frontiers. From the sun-drenched terraces of the Brazilian south, they observe the activities of the art market in America and Europe. But Brazilians also look inwards and explore their own identity. As they gaze out to sea, they are always looking back at their nation's history. From that sea came the ships of the Portuguese conquerors, carrying men in search of gold and diamonds, men who forced African slaves to work the soil of Brazil and decimated the native Indian population. After them came revolution and dictatorship, which in turn claimed their own victims.

Brazilian artists prefer to see things from the point of view of the colonised rather than the colonisers. Few take on the role of perpetrator; there have been too many victims in the continent's history.

A peculiar state of uncertainty seems to surround art in Brazil, a young nation by European standards and one in which the door has only just been closed on the past. Adriana Varejão is the best-known representative of the younger generation of Brazilian artists. She has taken hold of the history of Brazil, making the events of the past visible and bringing them right into the present. She creates an awareness of the multifaceted nature of the nation's past, with both the changes imposed by colonial history and the forms of expression that were derived from former black slaves and assimilated over the passage of time into Brazilian culture.

Taking the sea as the key, Brazil's cultural history is an apolitical starting point from which to view the work of the artist, who was born in 1964 in Rio de Janeiro. The vast horizon of the sea creates an obvious link extending from Portugal through to Brazil. The viewer must keep the sea in mind, for it forms the backdrop to Adriana Varejão's pictorial installations.

Her tactile sense attracted the artist to the ceramic decoration introduced by the Portuguese invaders. Even after centuries, the cool, smooth gloss and bare sun-resistant surfaces of the tiles have lost none of their beauty. It was from Macao, the former Portuguese colony on the coast of China, that the conquerors imported the ancient technique of decorative ceramic tiling in the 16th century. Since then, cobalt blue tiles have become characteristic of both Portugal and Brazil. Blue tile decoration can be seen in some private buildings

"My way of telling stories does not belong to any
era, to any time, it is shaped by violations.
In my work, Brazilian culture,
from the colonial era to the present day,
becomes a metaphor for the modern world."

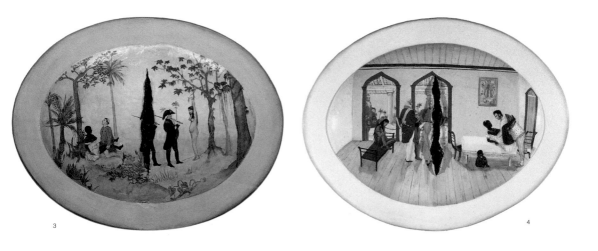

1 **Azulejaria de Rodapé s/Pratos,** 2000. Oil on canvas on ceramic plates, 262 x 186 cm

2 **Figura de Convite (Entrance Figure),** 1997. Oil on canvas, 200 x 200 cm

3 **Filho Bastardo (Bastard Son),** 1992. Oil on wood, 110 x 140 cm

4 **Filho Bastardo II (Bastard Son II),** 1992. Oil on wood, 110 x 140 cm

5 **Azulejão,** 2000. Mixed media on canvas. Installation view

6 **Língua com Padrão em Sinuoso (Tongue with Winding Pattern),** 1998. Wood, aluminum, canvas, polyurethane, oil paint, 200 x 170 x 57 cm

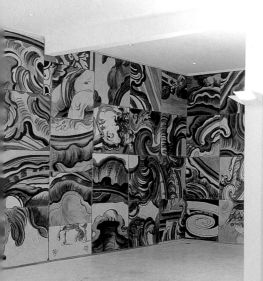
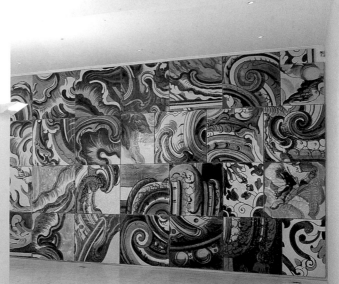

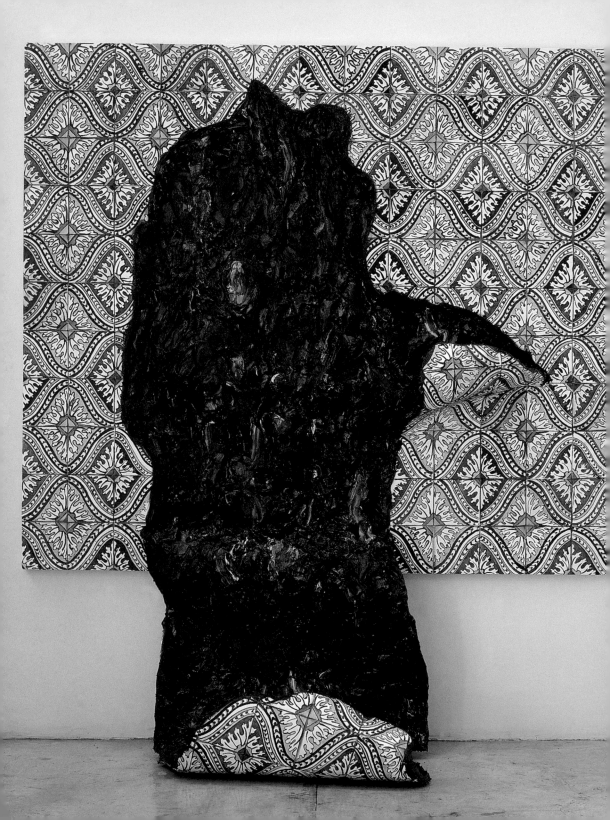

in Brazil and in the country's many baroque churches, where they tell stories of saints and myths of martyrdom. Adriana Varejão's methods and pictorial content exploit the blemishes and surface damage wrought by time. The fragmented nature of the tiles echoes the agonising torture of the martyrs, the degradation of the flesh and cultural disruption. It is also an expression of the Brazilian ability simply to patch things together. With her *azulejos* (tiles) Adriana Varejão is able to allude to her homeland's repressive past without having to discredit her native culture or its value as a metaphor.

Global link

All Adriana Varejão's work is imbued with the feeling of light and charm associated with the cobalt blue tiles as they reflect the global link between Portugal, China and Brazil. She casually and confidently oversteps the boundaries between art, pornography and mysticism. As a painter, she moves freely between art-historical movements. Her exhibition career began in 1988, bringing her into contact with the 1980s generation of artists, "Geração 80", who were in turn close to the Italian Transavanguardia, a movement which set out to make sensual experience the fountainhead of painting, and whose members revelled in the use of different materials. Adriana Varejão makes three-dimensional paintings using material from Brazil's colonial past. She draws on the rich reserves of art history for her subject matter: sculptures, monuments, porcelain, etchings, maps and votive offerings. She frequently uses a two-dimensional canvas, to which she applies other materials such as porcelain, ceramics and heavy, palpable streaks of oil paint, saturated with deep, red blood. In a meaty red reminiscent of Francis Bacon, they bulge aggressively from the smooth surface of the canvas, breathtaking in their physicality. Full-bodied and cannibalistic, the thick layers of paint seek to emulate sculpture.

Removing the mask

Filho Bastardo (*Bastard Child*), an oval painting on canvas and wood dating from 1992, is executed in an old-fashioned and naïve style, which at first masks the picture's content. It takes a second look to recognise the harmoniously structured scenes of violation it represents. On the left, a priest is seen looming over a black woman. On the right, two soldiers in historical costume manhandle a shackled, naked white woman. Across the whole scene a sharp, blood-red gash is cut into the canvas, its open edges protruding outwards. The shape can only be interpreted as that of a vagina. As it juts out from the two-dimensional surface and assaults the eye of the viewer, this wound also becomes a weapon, slicing into the picture and asserting a higher authority than the powers that be, depicted here as abusers.

Perhaps Fontana's slashed canvases provide the clearest illustration of how Varejão's vision differs from the European conceptual standpoint. For Lucio Fontana, they indicate a sublime exploration of the relationship between the inner and outer world. For Varejão they are bloody, physical manifestations of an oppressive past, charged with Freudian meaning. The title *Filho Bastardo* goes beyond the scene. The artist Adriana Varejão shoulders the responsibility by creating this fine picture. *Frank Frangenberg*

Adriana Varejão

Kara Walker

* 1969 in Stockton (CA), USA; lives and works in Rhode Island (NY), USA

Selected solo exhibitions: **1995** "The High and Soft Laughter of the Nigger Wenches At Night", Wooster Gardens/Brent Sikkema, New York (NY), USA /
1997 "Presenting Negro Scenes Drawn Upon My Passage Through the South and Reconfigured for the Benefit of Enlightened Audiences Wherever Such My Be Found,
By Myself, Missus K.E.B. Walker, Colored", The Renaissance Society at the University of Chicago, Chicago (IL), USA / **2001** "The Emancipation Approximation",
Tel Aviv Museum of Modern Art, Tel Aviv / "Why I Like White Boys, an Illustrated Novel by Kara E. Walker Negress", Centre d'Art Contemporain, Geneva, Switzerland /
"Kara Walker", Des Moines Art Center, Des Moines (IA), USA

Selected group exhibitions: **1995** "La Belle et La Bête", Musée d'Art Moderne de la Ville de Paris, Paris, France / **1996** "Conceal/Reveal", Site Santa Fe, Santa Fe (NM), USA /
1997 Whitney Biennal, Whitney Museum of American Art, New York (NY), USA / **1999** "The Passion and the Wave", Istanbul Biennial, Istanbul, Turkey /
"Kunstwelten im Dialog", Museum Ludwig, Colgone / **2000** "Age of Influence: Reflections in the Mirror of American Culture", Museum of Contemporary Art, Chicago (IL), USA /
2001 "SchattenRisse, Silhouetten und Cutouts", Kunstbau, Städtische Galerie im Lenbachhaus, Munich, Germany

In the shadow of the other

Following her highly acclaimed solo exhibition in New York in 1995, it was the 1997 Whitney Biennial that drew the attention of the international art world to Kara Walker's life-size works on paper using the cut-out silhouette technique that has come to be regarded as her hallmark. From a self-referential base, this African-American artist explores themes of identity and ethnicity in the USA, shaped by colonialism and slavery. The contrast of black cardboard against the white gallery wall heightens the sense of the silhouette as a graphic medium creating by outlining, while leaving the inner areas unaltered.

Walker takes her figures from the 19th century stereotypes of "slavery literature", presenting the violent and humiliating treatment of the slaves and sexist attacks on female slaves (*Before the Battle [Chickin' Dumplin'],* 1994) in the form of a Victorian-style visual novella. The mordant satire in her blend of literary genre and invented narrative is evident only at second glance, when the scenes reveal their disturbing and cruel undertow, for at first, the eye only recognises the Victorian costumes that harmonise so fittingly with the technique of silhouette. Although Walker bases her portrayals on stereotypes, she does not stop at simply polarising such aspects of power and enthnicity as master/slave or black/white, but actually parodies these attributions, presenting the roles in ways that are far more complex. For example, in Walker's scenes, women also commit acts of violence, sexual harassment or faecal misdemeanor (*Why I Like White Boys,* 2000).

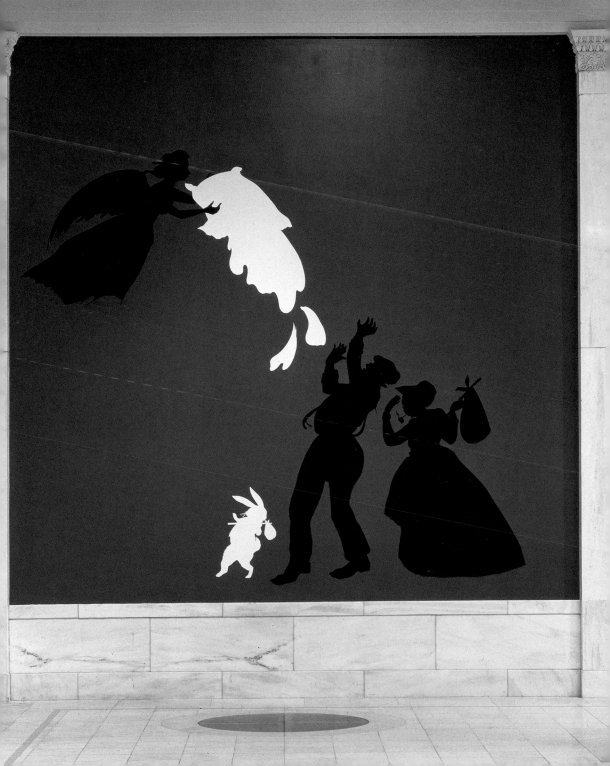

2

"We are all working so hard to change peoples attitudes about race but its like handling a wet eel."

1 **Emancipation Approximation,** 1999 (detail). Cut paper on wall, Installation view "Carnegie International", Carnegie Museum of Art, Pittsburgh (PA), USA, 1999/2000

2 **Untitled,** 1996. Cut paper, watercolor and graphite on canvas, 177 x 168 cm

3 **Camptown Ladies,** 1998 (detail). Cut paper and adhesive on wall, overall dimensions, 2.70 x 20.10 m

4 **No mere words can Adequately reflect the Remorse…,** 1999 (detail). Cut paper on painted wall, overall dimensions, 3 x 19.50 m

5 **Untitled,** 2000. Gouache on paper, 26 x 18 cm

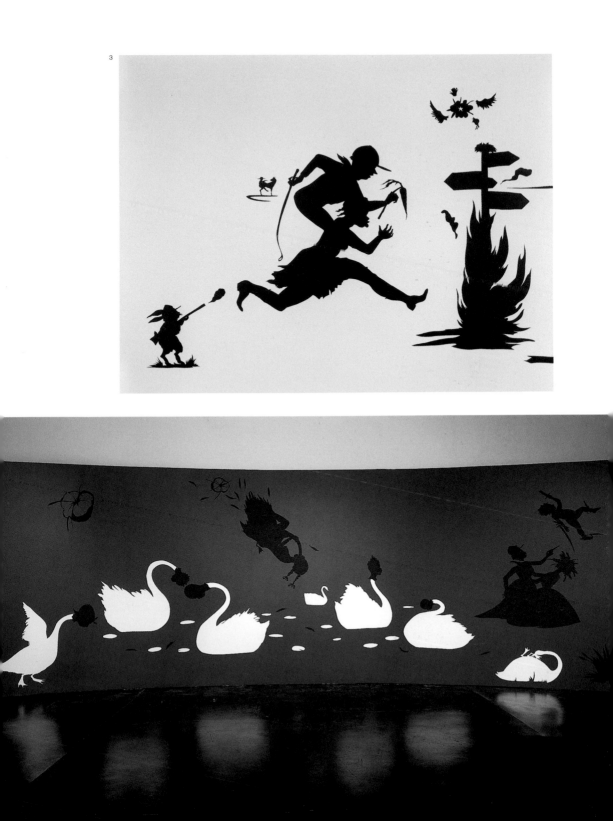

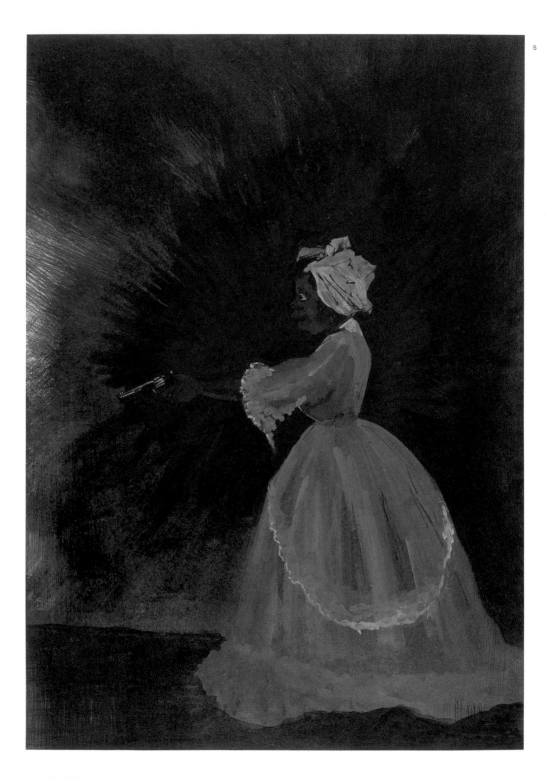

The huge silhouette *Virginia's Lynch Mob,* 2000, gives an arresting insight into Walker's thematic world. It shows an eleven metre long procession headed by a marching drummer in whose wake a grotesque scenario of physical violence unfurls: two black children playing with guns, one of them blasting his brains out, a bearded man swinging a lasso and clearly bent on hanging a black child, another carrying an impaled body on his shoulders, while a girl leaps through the air as though the parade were a travelling circus.

Walker makes a powerful point by adopting a medium generally associated with low art and women's crafts as a vehicle for her themes of ethnic and sexual stigmatisation and exclusion. For Walker, the black cardboard traditionally used for silhouettes had always harboured an association with the need to mask whiteness, in much the same way that white singers and dancers would black their faces to perform the minstrel shows that became popular in the Southern States in the mid-19th century. Moreover, the heyday of silhouette technique was in the 18th and 19th centuries, when slavery was part of everyday life in the United States. There is reference to the conventions of historical modes of entertainment in Walker's installations, which also feature panoramic silhouettes, in the manner of traditional fairground shows. These works present a spectacular cinematic impression of the scenes (as in *The End of Uncle Tom (Grand Allegorical Tableau),* 1995).

The End of Uncle Tom

In the past, silhouettes have also been used for questionable pseudo-scientific purposes. The 10th century Swiss scholar, Johann Caspar Lavater, author of the influential *Physiognomical Fragments,* used silhouette portraits to underpin his dubious anthropological studies, claiming that the profile of an individual's face was a reliable guide to his character and intelligence. His theories led him to the conclusion that blacks were of limited ability. This background is of particular interest in considering Walker's 1998 commission to design the 176 m² fire curtain for the Vienna State Opera, which gave her the opportunity of addressing the role that her chosen medium played in the Third Reich. The original curtain, which had survived, was designed by a state-approved artist of the Nazi era. Walker retained the golden background and the motif of Orpheus and Eurydice, but, having established that jazz was regarded by the Nazis as "degenerate music", she contrasted the sacred music of Orpheus with a black, Jewish jazz musician. In other words, she used this information to adapt her theme of ethnic exclusion to the local context. Her work also pointed out that some of the most famous of all operas (*Madame Butterfly,* for instance, or *Aida*) are based on an exotic notion of the Other. This clearly highlights the universal and cross-cultural validity of the problem of "othering", in which the Other is seen with objectifying detachment. *Nina Möntmann*

Kara Walker

Pae White

*** 1963 in Pasadena (CA), USA; lives and works in Los Angeles (CA), USA**

Selected solo exhibitions: **1995** "Summer Work", Shoshana Wayne Gallery, Los Angeles (CA), USA / **1997** "Animal Flood", I–20 Gallery, New York (NY), USA / **1998** greengrassi, London, England / **2000** China Art Objects Galleries, Los Angeles (CA), USA / **2001** "Thoughts on Owls by Men of Letters", Antiquariat Buchholz, Cologne, Germany; Galleria Francesca Kaufmann, Milan, Italy; neugerriemschneider, Berlin, Germany

Selected group exhibitions: **1997** "International Biennial of Graphic Arts", Ljubljana, Slovenia / **1998** "Love at the End of a Tunnel or the Beginning of a Smart New Day", Center of Contemporary Art, Seattle (WA), USA / **1999** "What If", Moderna Museet, Stockholm, Sweden / "Against Design", Institute of Contemporary Art, Philadelphia (PA), USA / **2000** "Over~", Unlimited Contemporary Art, Athens, Greece / "circles °3 Silverlake Crossings", ZKM Zentrum für Kunst und Medientechnologie, Karlsruhe, Germany

Art on a silken thread

Pae White is a graphic designer and artist, which probably explains her interest in fine lines, as well as the fragility of her work and her attention to the external qualities of her materials. Her training had a fundamental influence on her choice of artistic direction, which has much in common with design. In the early 1990s, she studied at Pasadena's Art Center College of Design, where the design departments – especially automobile design (they are responsible for the new Volkswagen Beetle), product design and graphics – are as important and renowned as the departments specialising in fine arts. As a result White's works can be described as "art-design hybrids", which are far more than exhibition pieces, frequently performing a functional role in the arts business. White also designs exhibition catalogues for artists, including Jorge Pardo and Tobias, and exhibitions, such as the one for the 1995 exhibition of the Schürmann Collection at Munich's Kunsthalle der Hypo-Kulturstiftung. In 1999, she and Pardo designed the exhibition space for "Global Fun – Art and Design by Mondrian, Gehry, Versace and Friends" at the Museum Schloss Morsbroich Museum in Leverkusen. For the 1999 "What If" exhibition at Stockholm's Moderna Museet, whose theme was the relationship between art and architecture and design, White not only designed the catalogue, but also produced a small-format poster for each of the 30 participating artists, on which she graphically interpreted her own vision of their respective works. In general, White's interest in design is driven not so much by socio-political concerns as by her belief that design can motivate the work of the artist.

Не осложняй
怎么简单怎么做
استعمل ما هو سهل
Recurre a lo más sencillo
आसान तरीकों/वस्तुओं का प्रयोग क

خفّض ببساطة
eliminar sin comolicar
simple subtraction

Прислуша**й**ся к себе
आपके शरीर के दिया में ?
tu cuerpo tiene la respuesta
Ask your o y
扪心自问
اسأل جسمك

जिन खोजा तिन पाईया
لا بد من اكتشاف شيء
世上无难事，只怕有心人
Once the search has begun, something will be found
Что-нибудь да подвернётся
SURGIRÁ LO INESPERADO

لأي مناسبة؟
К какому событию это приуроче
किस विशेष आयोजन के लिये थी?
When is it for?
此物何时造？
¿Qué ocasión lo amerita?

Дыши глубже
深深呼一口气
Breathe more
Respira mas profundamente
تنفس بعمق أكثر
गहरी सांस ल

Oblique Strategies
One Hundred Worthwhile Dilemmas

Brian Eno / Peter Schmidt
Peter Norton
Berlitz
Pae White
Christmas 1996

Fourth Again Revised and More Universal Edition

"Some of the most interesting sculptures
I have ever seen were the design of a beer can
or a beautiful car; maybe it's hard to separate
this from the fine art aspect."

2

3

5

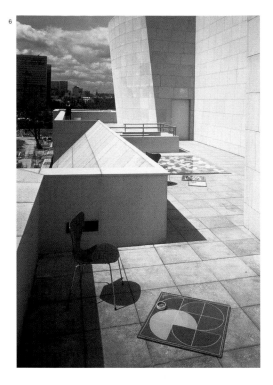

1　**Oblique Strategies, one hundred worthwhile Dilemmas,** 1996 (with Brian Eno and Peter Schmidt). Printed paper and Corian, 17 x 14 x 3 cm

2　**Thoughts on Owls by Men of Letters,** 2001. Installation view, Antiquariat Buchholz, Cologne, Germany

3　**Tawny + Scatter,** 1997. Film gels, adhesive, thread

4　**Storyboard for a Phone Conversation,** 2000. Papier

5　**Web Sampler 2000 (# 7),** 2000. Spiderweb on perfect paper, 44 x 59 cm

6　**A few Vera© Retrospectives, Sun and Moon,** 1994. Tempered glass, ashtray, silicon, Vera© textiles. Installation view, Museum of Contemporary Art, Los Angeles (CA), USA

7　**Installation view "birds and ships",** neugerriemschneider, Berlin, Germany, 2001

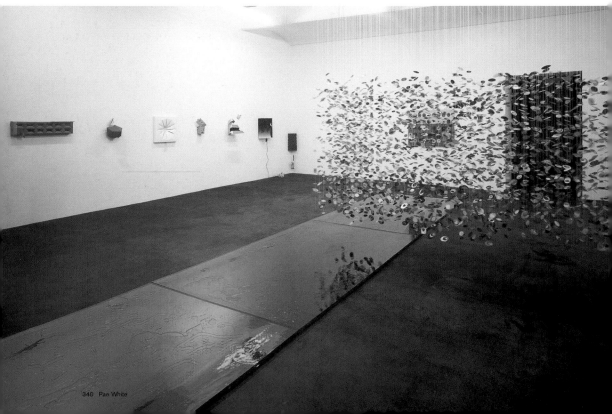

For example, her Plexiglas pieces recall the design aesthetics of 1960s and 1970s. They consist of sheets of Plexiglas laid one on top of the other and stuck together with adhesive. The glue is applied in such a way as to give off air bubbles, lending dynamism to the layered sheet structure. The layered works consist either of several Plexiglas sheets – coloured yellow in the case of *Copy Cat Lab*, 1998 – or a single one stuck onto copper foil, like the shimmering red *Chat*, 1998. Colour and light play an important role in White's work with transparent material. In *Pink Stage*, 1995, the glued-together stack of red Plexiglas is lit from below and colourfully projected onto the wall where the bubbles produce the effect of a retro-look lava lamp. The viewer might get the impression that the glue has been applied "incorrectly" but, on the contrary, it is an element of the overall design. If we look beyond the basic geometric form of White's mostly rectangular work, we see that the "sloppy" creative process is a critique of Minimalism. Her pieces present a challenge to the flawless surfaces of the Minimalist *objets* of artists like Donald Judd.

White is best known for her long mobiles. These usually consist of pieces of cardboard, cut out and painted by hand and fixed onto threads stretched from floor to ceiling. For *Aviary*, 2001, she uses little paper collages, while her earlier work *Chat*, 1998, is made up of hexagons painted in monochrome on both sides, in colours that both complement and contrast with each other. Their different angles of inclination interact with the light sources in the surrounding space. In her mobiles, White communicates her graphic ideas in three-dimensional form, with works resembling drawings shifting turbulently in space. Sometimes, she uses the medium of the mobile figuratively, as in *Second City*, 1998–2000, where the white, hexagonal, cardboard cutouts are suspended in such a way that they trace the skyline of a big city. For some of her mobiles, White utilises leather, textiles or snakeskin instead of cardboard. A feminist perspective can be discerned in the choice of materials and careful handiwork involved; a process carried out in private that demands staying power and attention to every little detail is put on public display.

The beauty of fragility

For White, the term "handmade" also includes the idea of tinkering with things. *Clocks* is a whimsical sequence of twelve cardboard objects created with almost childlike imagination in order to tell stories. Each clock stands for a sign of the zodiac, with its astrological symbol in the form of a seal on the outside. Some of them have battery-driven hands but, more importantly, every clock illustrates the basic concept of each sign, such as two little houses, one inside the other, representing the Gemini twins.

White does not share the conceptual approach of 1970s artists and their criticism of the art market and artistic institutions. With her interest in the "dematerialisation of the art object", she is more concerned with the psychological aspect of the intangible and the aesthetic appeal that lies in perceiving objects as they disappear over the boundary of the immaterial. Her work with many different forms of dissolution and transition is best represented by her spray-painted spiders' webs on mounts in computer-generated colour, for example *Untitled*, 1994–98, on cobalt blue pantone paper. This group of works entitled *Summer Sampler* is the most striking example of White's appreciation of the beauty of fragility.

<div align="right">Nina Möntmann</div>

Pae White

Rachel Whiteread

*** 1963 in London, England; lives and works in London**

Selected solo exhibitions: **1992** "Rachel Whiteread: Sculptures", Stedelijk Van Abbemuseum, Eindhoven, The Netherlands /
1993 "Rachel Whiteread: Zeichnungen", daadgalerie, Berlin, Germany / **1997** Museo Nacional Centro de Arte Reina Sofía, Madrid, Spain /
1998 Water Tower Project, New York (NY), USA / **2001** Serpentine Gallery, London, England

Selected group exhibitions: **1991** "The Turner Prize 1991", Tate Gallery, London, England / **1993** documenta IX, Kassel, Germany /
Sydney Biennial, Sydney, Australia / **1997** XLVII Esposizione Internazionale d'Arte, la Biennale di Venezia, Venice, Italy /
1998 "Emotion", Deichtorhallen Hamburg, Hamburg, Germany / **2001** "Public Offerings", Museum of Contemporary Art, Los Angeles (CA), USA

Spectacular sculptures

"The inner world of the outer world of the inner world" – Peter Handke's phrase would be an apt motto for the sculptural oeuvre of Rachel Whiteread. The London artist, who also works in the media of drawing, photography and video, has focused since 1988 on the theme of the inner life of mundane utilitarian objects and spaces such as bathtubs, closets, washbasins, entire rooms and houses. She has developed a casting process by means of which a negative form can be produced, what she calls a "perfect copy of the interior" of such things.

A good example of Whiteread's technique is the sculpture *Ghost,* 1990. At 468 Archway Road, North London, she found a room in a typical English house of the early 19th century. The room evinced all the elements we associate with such architecture: door, windows, fireplace, wallpaper remnants, plank floor, light switches, skirting boards, window ledges. The artist proceeded to cast this interior in plaster, section by section. She decided to do without moulds and tried to avoid every intermediate step, instead relying on a simple direct casting process. Traces of use on the room's walls were faithfully recorded on the surface of the cast. Finally Whiteread assembled the separate blocks, confronting the viewer with the volume of the room transformed into a solid. We see a walled-in room, a space whose negative impression prevents not only access, but also the existence of any life there.

Set up in an exhibition space, the lapidary yet alien piece *Ghost* conveys an eerie sense of fear that approaches the traumatic. One recalls Freud's theory that the eerie represents a return of suppressed emotions to the surface. And then there is the story of the Arctic explorer who was caught in his igloo during an extreme cold wave. With every breath he took, the exhaled air froze on the inner

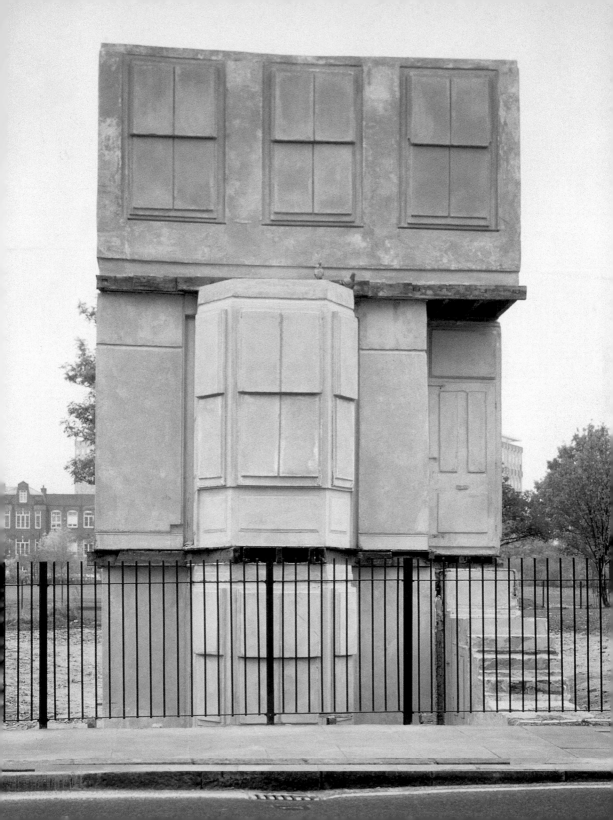

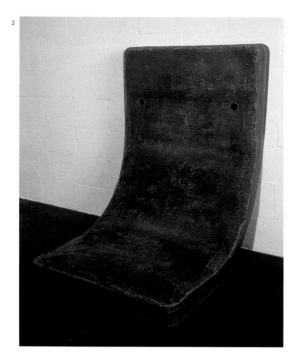

"I look like the you I turned into, being your imprint. You are exactly what is lost since only you would fit the mould which I have become."

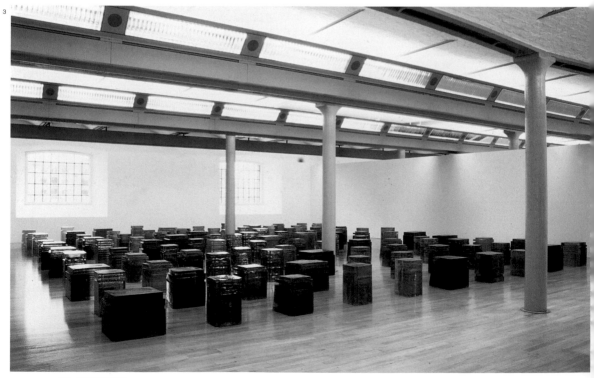

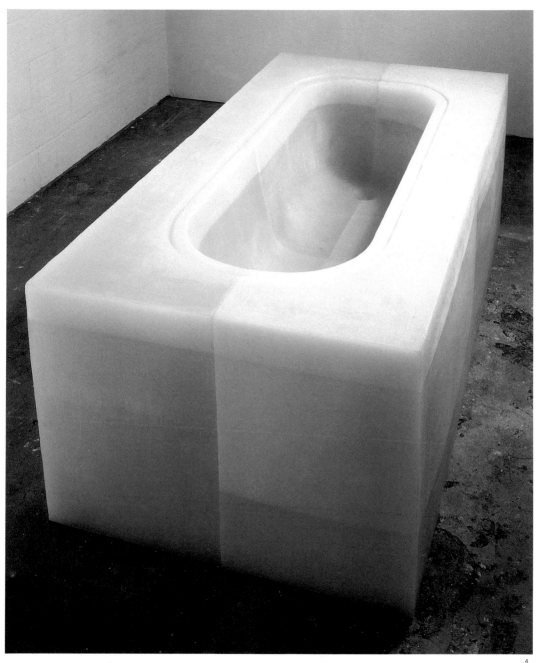

1 **Untitled (House),** 1993. Installation view, corner of Grove Road and Roman Road, London, England
2 **Untitled (Amber Bed),** 1991. Resin, 130 x 92 x 102 cm
3 **Installation view,** Tate Gallery, Liverpool, England, 1996
4 **Untitled (Yellow Bath),** 1996. Cast resin, polystyrene, 80 x 207 x 110 cm
5 **Untitled (Paperbacks),** 1997. Plaster and steel. Installation view, XLVII Esposizione Internazionale d'Arte, la Biennale di Venezia, Venice, Italy, British Pavilion, 1997
6 **Holocaust Memorial,** 1995 (model). Mixed media

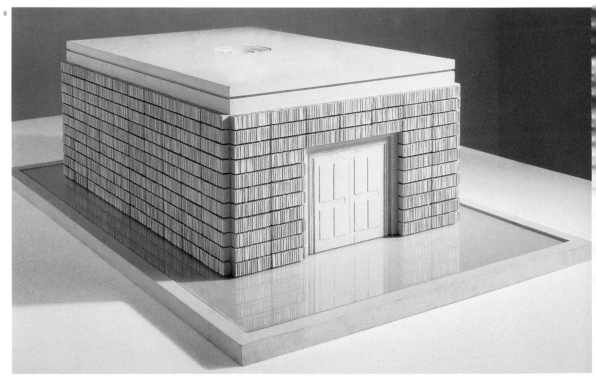

wall of the igloo, so that the man, who had to breathe to stay alive, virtually walled himself in by breathing – a fatal trap between the poles of shelter and confinement.

Among the most compelling aspects of *Ghost* is the negative shape of a light switch. Here we are confronted with a sign of the interaction between the room and the people who once occupied it. Even though they are not present, as is almost always the case in Whiteread's work, these people's existence makes itself felt in the traces they have left behind. The scale of her pieces, neither reduced nor enlarged but life-sized, also makes reference to human existence.

The anthropomorphic character of her closets *(Closet,* 1988), beds *(Untitled [Air Bed],* 1992), or bathtubs *(Esther,* 1990), is further underscored by the body-related mundaneness, the all-too-human nature of the various functions possessed by the objects she casts – dressing, sleeping, washing or dwelling. Indicative of this, Whiteread developed her casting process on the basis of casts taken from her own body during her student years.

A life-sized past

In her sculpture *House,* 1993, the artist's work took on a monumental quality, despite the fact that in this case, too, the original size of the house on Grove Road was retained. After casting it in concrete, she removed the exterior walls and the roof, leaving a block-like solid impression of the rooms standing. Still, compared to artworks intended for showing in a gallery or museum, the dimensions of this three-storey building in London's East End were unusually large, resulting in a sense of monumentality. The private interiors of the former residential building took on an archetypal character. At the same time, the notion of the "security of one's own four walls" was subverted, and the comforting idea of "my home is my castle" was undermined by exhibiting private interiors for all to see. This factor triggered harsh criticism and protest in the immediate neighbourhood, and, in January 1994, *House* was demolished by decision of the irate populace. All that remained were black-and-white photos and a video documentation, which can now be shown at art exhibitions – that is, in other interior spaces.

Memento mori

A design for a Holocaust monument in Vienna is one of Whiteread's more recent projects. This is a "nameless library" cast in light-grey concrete, installed in an area of ten by seven metres on Judenplatz, in the immediate vicinity of the Or Sarua Synagogue. The walls of the library, including bookshelves and a blind door, are turned outwards to public view, as a memorial to the extermination of over 65,000 Austrian Jews by the Nazis. In addition, the piece recalls the fact that the survival of Judaism during its millennia-long diaspora rested not least on books and writings. Rachel Whiteread's "books of horror" are cast in natural rubber and fibreglass, such that each separate page remains visible. Even more clearly than in other works, memory and a record of transitoriness play a key role here.

Raimar Stange

Rachel Whiteread installing an exhibition

Rachel Whiteread in her studio

Photo Credits

Unless otherwise specified, copyrights on the works reproduced lies with the respective artists. / Das Copyright für die abgebildeten Werke liegt, soweit nicht nachfolgend anders angeführt, bei den jeweiligen Künstlern. / Le copyright des œuvres est détenu par les artistes respectifs, à moins qu'il en soit spécifé autrement ci-dessous.

Abramović, Marina: 1–5, 7, 8: Courtesy Sean Kelly Gallery, New York (NY); 1: © Photo: Elio Montanari; 2: © Photo: Bojan Brecelj; 6, portraits: Courtesy of the artists; portrait: © Photo: Tomas Adel (and contents)
Anderson, Laurie: 1–8, portrait (left): Courtesy of the artist and Sean Kelly Gallery, New York (NY); 1: © Photo: Adriane Friere; 2: © Photo: Tim Jarvis; 4, 5: © Photo: Les Fincher; portrait (right and contents): Courtesy Warner Bros. Records, Inc., © Photo: Annie Leibovitz
Antoni, Janine: 1–6: Courtesy Luhring Augustine, New York (NY); 1: © Photo: Ben Blackwell; 6: © Photo: Prudence Cumming Associates
Beecroft, Vanessa: 1–4, portrait: Courtesy Deitch Projects, New York (NY)
Bourgeois, Louise: 1, 3, 5, 6, portraits (centre and right): Courtesy Cheim & Read, New York (NY); 2, 4, 7, portrait (left): Courtesy Galerie Karsten Greve, Cologne, Paris, Milan, St. Moritz; portrait (left): © Photo: Peter Bellamy (and contents)
Darboven, Hanne: 1, 2, 5, 6: Courtesy Galerie Konrad Fischer, Düsseldorf; 3, 4, portrait (right): Courtesy Sperone Westwater, New York (NY); 1, 2: © Photo: Daniela Steinfeld
Delaunay, Sonia: 1–6: © L & M Services B. V., Amsterdam; 1: Photo: © Musée d'Art Moderne de la Ville de Paris, Paris; 2–6: © Photos: Musée national d'art moderne, Paris, Paris; 2: © Photo: Philippe Migeat; 4: © Photo: Georges Megerditchian; portrait (left): Bibliothèque Nationale, Paris, © Photo: Florence Henri; portrait (right): AKG, Berlin
Dijkstra, Rineke: 1–10, portraits Courtesy of the artist; portrait (left): © Photo: Koos Breukel
Dumas, Marlene: 1, 3–6, portraits: Courtesy of the artist; 2, 7: Courtesy Galerie Paul Andriesse, Amsterdam; 2, 7: © Photo: Peter Cox; portrait (top left): © Photo: Dieter Schwerdtle (and contents); portrait (top right) © Photo: Katrin Schilling; portrait (bottom left): © Photo: Pieter Dumas; portrait (bottom right): © Photo: Pasquale Lecesse
Emin, Tracey: 1–8: Courtesy White Cube/Jay Jopling, London; 2: © Photo: Stephen White; portrait: © Photo: Johnnie Shand-Kydd (and contents)
Export, Valie: 1–8, portraits: Courtesy of the artist; 1: © Photo: Peter Hassmann; 2: © Photo: Archiv Valie Export/Gertraude Wolfschwenger; 6: © Archiv Valie Export; 7: © Archiv Valie Export/Steffen Rother; 8: © Photo: Hermann Hendrich; portrait (left): © Photo: Gertraude Wolfschwenger; portrait (right): © Photo: Peter Rigaud (and contents)
Fleury, Sylvie: 1: Courtesy Art & Public; Geneva; 2, portrait: Courtesy Galerie Hauser & Wirth & Presenhuber, Zurich; 3: Courtesy Galerie Philomene Magers, Munich; 4–8: Courtesy Mehdi Chouakri, Berlin
Fritsch, Katharina: 1–6, portrait: Courtesy of the artist; 1: © Photo: Thomas Ruff; 2–6: © Photo: Nic Tenwiggenhorn; portrait: © Photo: Anna Giese (and contents)
Gallagher, Ellen: 1, 4: Courtesy Gagosian Gallery, New York (NY); 2, 5, 6, portrait (left): Courtesy Anthony d'Offay Gallery, London; 3, portrait (right): Courtesy Galerie Max Hetzler, Berlin
Genzken, Isa: 1–6, portraits: Courtesy Galerie Daniel Buchholz, Cologne; portraits: © Photo: Wolfgang Tillmans (and contents)
Goldin, Nan: 1–8, portraits: Courtesy of the artist; portrait (right): © Photo: David Armstrong (and contents)
Goncharova, Natalia: 1, 2, 6: Museum Ludwig, Cologne; © Photos: Rheinisches Bildarchiv, Cologne; 3: © Photo: AKG, Berlin; 4, 5, 7: Courtesy Galerie Gmurzynska, Cologne
Hepworth, Barbara: © Alan Bowness, Hepworth Estate; 1: Courtesy PaceWildenstein, New York (NY); Photo: © Ellen Page Wilson; 2: Courtesy the New Art Centre Sculpture Park & Gallery, Salisbury; Photo © Garrick Palmer; 3: Courtesy Tate Gallery, London; Photo: © Tate Gallery Picture Library; 4: Courtesy Tate Gallery, London; Photo: © Tate Gallery Picture Library; 5: Courtesy the New Art Centre Sculpture Park & Gallery; portrait (left): Courtesy the Hepworth Estate; Photo: © Alan Bowness, Hepworth Estate; portrait (centre and right): Courtesy the Hepworth Estate; Photo: © Alan Bowness, Hepworth Estate
Hesse, Eva: 1–3, 5, portraits: © The Estate of Eva Hesse, Courtesy Galerie Hauser & Wirth, Zurich; 4: The Art Institute of Chicago, Chicago (IL); 6: Museum Ludwig, Cologne; © Photo: Rheinisches Bildarchiv, Cologne; portrait (centre): © Photo: John A. Ferrari (and contents)
Höch, Hannah: 1: © Staatliche Museen zu Berlin – Preußischer Kulturbesitz, Nationalgalerie; © Photo: Jörg P. Anders; 2: © Kupferstichkabinett. Staatliche Museen zu Berlin – Preußischer Kulturbesitz; © Photo: Jörg P. Anders; 3, 4, 6: © Berlinische Galerie, Hannah-Höch-Archiv, Berlin; © Photo: Hermann Kiessling; 5: © Photo: AKG, Berlin; portrait A: © Berlinische Galerie, Hannah-Höch-Archiv, Berlin; portrait B: © Berlinische Galerie, Hannah-Höch-Archiv, Berlin; © Photo: AKG, Berlin; portrait C: © Berlinische Galerie, Berlin; portrait E (and contents) © Photo: AKG, Berlin
Höfer, Candida: 1–8, portraits: Courtesy of the artist; portrait (left): © Photo: Herbert Burkert; portrait (centre): © Photo: Benjamin Katz (and contents); portrait (right): © Photo: Barbara Hofmann
Holt, Nancy: 1–6, portraits: Courtesy of the artist; portrait (left) © Photo: Matthew Coolidge; portrait (right): © Photo: Osnio Rauhala
Holzer, Jenny: 1–8, portraits: Courtesy of the artist; 1: © Photo: David Regen; 2: © Photo: Brenton McGeachie; 3: © Photo: David Heald; 4: © Photo: Hayashi Tatsuo; 5: © Photo: Salvatore Licitra; 6: © Photo: Hans-Dieter Kluge; 7: © Photo: Attilio Maranzano, 8: © Photo: Alan Richardson; portrait © Photo: Nanda Ianfranco (contents)
Horn, Rebecca: 1–8 Courtesy of Rebecca Horn Photo Archives; 1: © Photo: John Abbott; 2: © Photo: Attilio Maranzano; 6, 8: © Photo: Achim Thode; portrait (left): © Photo: Ute Perry (and contents)
Jetelová, Magdalena: 1–7, portraits: Courtesy of the artist; 1–7: © Photo: Werner J. Hannappel
Kahlo, Frida: © Instituto Nacional de Bellas Artes, Mexico City and Banco de México, Mexico City; 1: © Photo: The Museum of Modern Art, New York (NY); 2–7, portraits © Photo: Rafael Doniz (and contents)
Khedoori, Toba: 1–6, portrait: Courtesy Regen Projects, Los Angeles (CA); 1, 3, 5: © Photo: Douglas M. Parker; 2: © Photo: Joshua White; 4: © Photo: Robert Wedemeyer
Krasner, Lee: 1–7, portraits: Courtesy Pollock–Krasner Foundation, Inc., New York (NY); © Photos: Courtesy Robert Miller Gallery, New York (NY); 1: © Photo: Phillips/Schwab; portrait (left): © Photo: Halley Erskine; portrait (right): © Photo: Ann Chwatsky (and contents)
Kruger, Barbara: 1, 3, 5, 6: Courtesy Monika Sprüth Galerie, Cologne; 2: Courtesy Deitch Projects, New York (NY); 4: Courtesy Mary Boone Gallery, New York (NY); 2: © Photo: Tom Powel; 4: © Photo: Zindman/Fremont
Lawler, Louise: 1, 3–5: Courtesy Monika Sprüth Galerie, Cologne; 2: Courtesy Metro Pictures, New York (NY); 6: neugerriemschneider, Berlin
Lempicka, Tamara de: 1–5, portraits: Courtesy of the artist; 1: © Photo: AKG, Berlin; portrait (left): © Photo: Therese Bonney; portrait (centre): © Photo: Cecil Beaton
Levine, Sherrie: 1–5, portraits: Courtesy Jablonka Galerie, Cologne; 1: © Photo: Alexander Troehler; 5: © Nic Tenwiggenhorn; portrait: © Photo: Jorge Saia (and contents)
Martin, Agnes: 1–4, portrait: Courtesy PaceWildenstein, New York (NY); 1: © Photo: Gordon Riley Christmas; 3: © Photo: Ellen Page Wilson
Moffatt, Tracey: 1, 3–5: Courtesy Matthew Marks Gallery, New York (NY); 2: Courtesy Paul Morris Gallery, New York (NY); portrait: © Photo: Lylie Fisher (and contents)
Mori, Mariko: 1: Courtesy Fondazione Prada, Milan; 2–5: Courtesy Deitch Projects, New York (NY); 1: © Photo: Attilio Maranzano
Neshat, Shirin: 1, 2, 3, 4, 5, 9, portraits: Courtesy Galerie Thomas Rehbein, Cologne; 6, 7, 8, 10: Courtesy Barbara Gladstone Gallery, New York (NY); 8, 10: © Photo: Cynthia Preston
Nevelson, Louise: 1, 2, 3, 4, 6, portraits: Courtesy PaceWildenstein, New York (NY); 1, 5: Museum Ludwig, Cologne; © Photos: Rheinisches Bildarchiv, Cologne
Noland, Cady: 1–7 Courtesy of the artist
O'Keeffe, Georgia: 1: Philadelphia Museum of Art: Bequest of Georgia O'Keeffe for the Alfred Stieglitz Collection; © Photo: Graydon Wood
Ono, Yoko: 1–7, portrait (left): Courtesy of the artist; 1: © Photo: Minoru Niizuma; 2, 5: © Photo: Courtesy of Lenono Photo Archive © Yoko Ono; 3 © Photo: Iain Macmillan, Courtesy of Lenono Photo Archive © Yoko Ono; 4: © Photo: Miguel Angel Valero, Courtesy of Lenono Photo Archive and Generalitat Valenciana; 6: Courtesy of Lenono Photo Archive © Yoko Ono; 7: © Photo: George Maciunas Courtesy Gilbert and Lila Silverman Fluxus Collection, Detroit (IL); portrait (left): © Photo: Tony Cox, Courtesy of Lenono Photo Archive © Yoko Ono
Oppenheim, Meret: 1: Collection Moderna Museet, Stockholm, © Photo: Moderna Museet, Stockholm; 2: Collection The Museum of Modern Art, New York (NY); © Photo:

Art

Petra Lamers-Schütze / p.lamers-schuetze@taschen.com
Gilles Néret / g.neret@taschen.com
Ingo F. Walther / ingofwalther@compuserve.de

"Opening this lavishly illustrated book is one of sumptuous celebration of the visual aspects of Leonardo's œuvre."
—*The Art Newspaper*, London

"He was like a man who woke up too early, in the darkness, while everyone else was still sleeping."

—*Dmitri S. Merezhkovsky*, 1901

"Perhaps one day fine books, like museums, will be equipped with light beams and alarm systems. The curiosity of anyone getting too close to a page in their desire to examine a detail would then be rewarded in the same unpleasant way as in the Louvre. TASCHEN's books are gradually acquiring the character of precious objects worthy of protection, though their purpose is quite different."
—*Frankfurter Rundschau*, Frankfurt am Main

LEONARDO DA VINCI
THE COMPLETE PAINTINGS AND DRAWINGS
Frank Zöllner, Johannes Nathan / Hardcover,
XXL-format: 29 x 44 cm (11.4 x 17.3 in.), 696 pp.
€ 150 / $ 200 / £ 100 / ¥ 25.000

KIPPENBERGER
Hardcover, format: 29.7 x 42 cm
(11.7 x 16.5 in.), 188 pp.
€ 49.99 / $ 59.99 / £ 34.99 / ¥ 8.900

TASCHEN COLLECTION
Hardcover, format: 29.7 x 42 cm
(11.7 x 16.5 in.), 254 pp.
€ 49.99 / $ 59.99 / £ 34.99 / ¥ 8.900

Petra Lamers-Schütze / p.lamers-schuetze@taschen.com
Gilles Néret / g.neret@taschen.com
Ingo F. Walther / ingofwalther@compuserve.de

ART NOW

J. Uta Grosenick, Burkhard Riemschneider /
Flexi-cover, format: 19.6 x 24.9 cm.
7 x 9.8 in.), 640 pp.
29.99 / $ 39.99 / £ 19.99 / ¥ 5.900

ART OF THE 20th CENTURY

K. Ruhrberg, M. Schneckenburger, C. Fricke,
K. Honnef / Ed. Ingo F. Walther / Flexi-cover,
format: 19.6 x 25.8 cm (7.7 x 10.1 in.), 840 pp.
€ 29.99 / $ 39.99 / £ 19.99 / ¥ 5.900

*"…the definitive introduction
to the scope and range of Picasso's
work."* —*The Times*, London, on *Picasso*

IMPRESSIONISM

Peter H. Feist / Ed. Ingo F. Walther / Flexi-cover,
format: 19.6 x 25.8 cm (7.7 x 10.1 in.), 712 pp.
29.99 / $ 39.99 / £ 19.99 / ¥ 5.900

MASTERPIECES OF WESTERN ART

Ed. Ingo F. Walther / Flexi-cover, format:
19.6 x 25.8 cm (7.7 x 10.1 in.), 768 pp.
€ 29.99 / $ 39.99 / £ 19.99 / ¥ 5.900

MONET OR THE TRIUMPH OF
IMPRESSIONISM

Daniel Wildenstein / Ed. Gilles Néret / Flexi-cover,
format: 19.6 x 25.8 cm (7.7 x 10.1 in.), 480 pp.
€ 29.99 / $ 39.99 / £ 19.99 / ¥ 5.900

PICASSO

Carsten-Peter Warncke, Ingo F. Walther / Flexi-cover,
format: 19.6 x 25.8 cm (7.7 x 10.1 in.), 740 pp.
€ 29.99 / $ 39.99 / £ 19.99 / ¥ 5.900

VAN GOGH – THE COMPLETE PAINTINGS

Ingo F. Walther, Rainer Metzger / Flexi-cover,
format: 19.6 x 25.8 cm (7.7 x 10.1 in.), 740 pp.
29.99 / $ 39.99 / £ 19.99 / ¥ 5.900

WHAT GREAT PAINTINGS SAY. VOL. I

Rose-Marie & Rainer Hagen / Flexi-cover,
format: 19.6 x 24.5 cm (7.7 x 9.6 in.), 496 pp.
€ 29.99 / $ 39.99 / £ 19.99 / ¥ 5.900

WHAT GREAT PAINTINGS SAY. VOL. II

Rose-Marie & Rainer Hagen / Flexi-cover,
format: 19.6 x 24.5 cm (7.7 x 9.6 in.), 432 pp.
€ 29.99 / $ 39.99 / £ 19.99 / ¥ 5.900

WOMEN ARTISTS
IN THE 20th AND 21st CENTURY

Ed. Uta Grosenick / Flexi-cover, format:
19.6 x 24.9 cm (7.7 x 9.8 in.), 576 pp.
€ 29.99 / $ 39.99 / £ 19.99 / ¥ 5.900

ALCHEMY & MYSTICISM

The Hermetic Museum / Alexander Roob /
Flexi-cover, Klotz, format: 14 x 19.5 cm
(5.5 x 7.7 in.), 712 pp.
19.99 / $ 29.99 / £ 14.99 / ¥ 3.900

ENCYCLOPAEDIA ANATOMICA

Museo La Specola, Florence / M. von Düring,
M. Poggesi, G. Didi-Huberman / Flexi-cover, Klotz,
format: 14 x 19.5 cm (5.5 x 7.7 in.), 704 pp.
€ 19.99 / $ 24.99 / £ 14.99 / ¥ 3.900

WWW HR GIGER COM

HR Giger / Hardcover, format: 23.8 x 29.7 cm
(9.4 x 11.7 in.), 240 pp.
€ 19.99 / $ 29.99 / £ 16.99 / ¥ 3.900

Imprint

To stay informed about upcoming TASCHEN titles, please request our magazine at www.taschen.com or write to TASCHEN America, 6671 Sunset Boulevard, Suite 1508, USA-Los Angeles, CA 90028, Fax: +1-323-463.4442. We will be happy to send you a free copy of our magazine which is filled with information about all of our books.

Original edition: © 2001 TASCHEN GmbH
© for the illustrations by Marina Abramović, Louise Bourgeois, Valie Export, Katharina Fritsch, Natalia Goncharova, Hannah Höch, Candida Höfer, Nancy Holt, Jenny Holzer, Rebecca Horn, Lee Krasner, Tamara de Lempicka, Georgia O'Keeffe, Meret Oppenheim, Germaine Richier, Susan Rothenberg, Carolee Schneemann, Rosemarie Trockel: 2005 VG Bild-Kunst, Bonn
© for the photographs of Roy Lichtenstein, Man Ray, Nic Tenwiggenhorn, Berlinische Galerie: 2005 VG Bild-Kunst, Bonn

Texts by Ilka Becker, Frank Frangenberg, Gerrit Gohlke, Barbara Hess, Ulrike Lehmann, Holger Liebs, Petra Löffler, Nina Möntmann, Helen Simpson, Raimar Stange and Astrid Wege

Translation by Paul Aston, Sherborne, Dijkstra, Holzer, Kruger, Mori, Neshat, Rist, Sherman, Smith); Pauline Cumbers, Frankfurt am Main (Fritsch, Peyton, Saint Phalle); Ishbel Flett, Frankfurt am Main (Bourgeois, Goldin, Kahlo, Khedoori, Moffatt, Ono, Oppenheim, Walker); John W. Gabriel, Worpswede (Abramović, Anderson, Beecroft, Darboven, Dumas, Emin, Genzken, Goncharova, Höfer, Holt, Jetelová, Krasner, Lawler, de Lempicka, Martin, Nevelson, O'Keeffe, Richier, Riley, Schneeman, Trockel, Whiteread; Isabel Varea for Grapevine Publishing Service Ltd., London Varejão, White); Malcolm Green, Heidelberg (Horn); Michael Hulse, Amsterdam (Preface, Delaunay, Export, Fleury, Hesse, Höch, Levine, Sturtevant); Karen Williams, Whitley Chapel (Antoni, Gallagher, Noland, Rothenberg)

Editorial coordination by Simone Philippi, Yvonne Havertz, Cologne
Co-editorial coordination: Anne Sauvadet, Cologne
Copy-editing by Yvonne Havertz, Cologne
Design by Sense/Net, Andy Disl & Birgit Reber, Cologne
Production by Ute Wachendorf, Cologne

Printed in China
ISBN 3-8 228-4122-6